Babylon Berlin, German Visual
Spectacle, and Global Media Culture

Visual Cultures and German Contexts

Series Editors

Deborah Ascher Barnstone (University of Technology Sydney, Australia)
Thomas O. Haakenson (California College of the Arts, USA)

Visual Cultures and German Contexts publishes innovative
research into visual culture in Germany, Switzerland, and Austria,
as well as in diasporic linguistic and cultural communities
outside of these geographic, historical, and political borders.
The series invites scholarship by academics, curators, architects, artists, and
designers across all media forms and time periods. It engages with traditional
methods in visual culture analysis as well as inventive interdisciplinary
approaches. It seeks to encourage a dialogue among scholars in traditional
disciplines with those pursuing innovative interdisciplinary and intermedial
research. Of particular interest are provocative perspectives on archival
materials, original scholarship on emerging and established creative visual fields,
investigations into time-based forms of aesthetic expression, and new readings
of history through the lens of visual culture. The series offers a much-needed
venue for expanding how we engage with the field of Visual Culture in general.
Proposals for monographs, edited volumes, and outstanding research studies
are welcome, by established as well as emerging writers from a wide range of
comparative, theoretical, and methodological perspectives.

Advisory Board

Donna West Brett, University of Sydney, Australia
Charlotte Klonk, Humboldt Universität Berlin, Germany
Nina Lübbren, Anglia Ruskin University, UK
Maria Makela, California College of the Arts, USA
Patrizia C. McBride, Cornell University, USA
Rick McCormick, University of Minnesota, USA
Elizabeth Otto, University at Buffalo SUNY, USA
Annette F. Timm, University of Calgary, Canada
James A. van Dyke, University of Missouri, USA

Titles in the Series

Babylon Berlin, German Visual Spectacle, and Global Media Culture

Edited by Hester Baer and
Jill Suzanne Smith

BLOOMSBURY VISUAL ARTS
LONDON • NEW YORK • OXFORD • NEW DELHI • SYDNEY

BLOOMSBURY VISUAL ARTS
Bloomsbury Publishing Plc
50 Bedford Square, London, WC1B 3DP, UK
1385 Broadway, New York, NY 10018, USA
29 Earlsfort Terrace, Dublin 2, Ireland

BLOOMSBURY, BLOOMSBURY VISUAL ARTS and the Diana logo
are trademarks of Bloomsbury Publishing Plc

First published in Great Britain 2024

Cover design: Elena Durey
Cover image: Nikoros performs at the Moka Efti in season one of *Babylon Berlin* © X-Filme
Creative Pool GmbH/ARD Degeto Film GmbH/Das Erste/Sky Deutschland/Beta Film GmbH.
Photography: Frédéric Batier

A catalogue record for this book is available from the British Library.

Library of Congress Cataloging-in-Publication Data
Names: Baer, Hester, editor. | Smith, Jill Suzanne, 1972- editor.
Title: Babylon Berlin, German visual spectacle, and global media culture /
edited by Hester Baer and Jill Suzanne Smith.
Description: London ; New York : Bloomsbury Visual Arts, 2024. | Series: Visual
cultures and German contexts | Includes bibliographical references and index.
Identifiers: LCCN 2023023837 (print) | LCCN 2023023838 (ebook) | ISBN
9781350370067 (hardback) | ISBN 9781350370050 (paperback) | ISBN
9781350370074 (epub) | ISBN 9781350370081 (pdf) | ISBN 9781350370098
Subjects: LCSH: Babylon Berlin (Television program) | Television programs–
Germany–History–21st century. | LCGFT: Television criticism and reviews. | Essays.
Classification: LCC PN1992.77.B2425 B33 2024 (print) | LCC PN1992.77.B2425
(ebook) | DDC 791.450943–dc23/eng/20230926
LC record available at https://lccn.loc.gov/2023023837
LC ebook record available at https://lccn.loc.gov/2023023838

ISBN: HB: 978-1-3503-7006-7
 PB: 978-1-3503-7005-0
 ePDF: 978-1-3503-7008-1
 eBook: 978-1-3503-7007-4

Series: Visual Cultures and German Contexts

Typeset by Integra Software Services Pvt. Ltd.
Printed and bound in India

To find out more about our authors and books visit www.bloomsbury.com
and sign up for our newsletters.

Contents

Part Four Weimar Intertexts

List of Illustrations

Notes on Contributors

Abby Anderton is Associate Professor of Music at Baruch College and the Graduate Center at the City University of New York. Her research and teaching interests include post-catastrophic music-making, performance and Holocaust testimony, and female composers. She is currently writing a book about music and Holocaust survival entitled *Audible Testimonies*, and her first monograph, *Rubble Music: Occupying the Ruins of Postwar Berlin* was published in 2019. Her work has appeared in *Twentieth-Century Music*, *German Studies Review*, and *Music & Politics*.

Hester Baer is Professor of German and Cinema & Media Studies at the University of Maryland, College Park. Her research focuses on German cinema and feminist media studies. She is the author of *Dismantling the Dream Factory: Gender, German Cinema, and the Postwar Quest for a New Film Language* (2009), *German Cinema in the Age of Neoliberalism* (2021), and a volume for the series *German Film Classics* on Ula Stöckl's 1968 film *The Cat Has Nine Lives* (2022). She currently serves as co-editor of *The German Quarterly*.

Darcy Buerkle is Professor of History at Smith College. She is the author of *Nothing Happened: Charlotte Salomon and an Archive of Suicide* (2014) and the co-editor of *Contemporary Europe in the Historical Imagination* (2023). She has published numerous essays on Jewish visual and cinematic cultures and the history of emotion, including most recently on the work of director Fred Zinnemann; she has also written about the specificities of her pedagogical experiences at Smith College. Buerkle's current project concerns neglected and gendered imaginaries of democracy, guilt, and complicity in Germany following the Second World War.

Carrie Collenberg-González is Associate Professor of German Studies at Portland State University and Director of the Deutsche Sommerschule am Pazifik. Her research interests focus on visual culture in Romantic literature, the aesthetics of terrorism, and twentieth-century cinema and media studies. She is the co-author of *Cineplex: Intermediate German Language and Culture*

Through Film (2014), *Moving Frames: Photographs in German Cinema* (2022), and *Heinrich von Kleist: Aesthetic and Artistic Legacies* (forthcoming).

Mila Ganeva is Professor of German and Affiliate Member of the Film Studies Program at Miami University. She has published numerous articles on fashion journalism, fashion photography, the history of modeling, beauty pageants, film, and film history. Her books include *Women in Weimar Fashion: Discourses and Displays in German Culture, 1918–1933* (2008), *Film and Fashion Amidst the Ruins of Berlin: Between Nazism and Cold War, 1939–1953* (2018), and an edited volume of collected articles by Helen Hessel: *Ich schreibe aus Paris. Über die Mode, das Leben und die Liebe* (2014).

Sara F. Hall is Associate Professor of Germanic Studies at the University of Illinois Chicago and President of the German Studies Association (2023–24). Her research interests include cinema and law enforcement, transnational film networks and discourses, and gender and cultural production. She has published on Weimar cinema, New German Cinema, economics and gender, and the representation of German history in serial and limited series television in diverse edited volumes as well as journals including *Communication, German Studies Review, German Quarterly, The Historical Journal of Film, Radio and Television, Modernism/Modernity*, and *Transit*.

Jochen Hung is Assistant Professor of Cultural History at Utrecht University, the Netherlands. His research focuses on the cultural history of the media, and he has published widely about the history of the Weimar Republic, most recently *Moderate Modernity: The Newspaper Tempo and the Transformation of Weimar Democracy* (2023).

Doria Killian is Assistant Professor of German and Director of the Center for Jewish Studies at the University of North Carolina, Asheville.

Florian Krauß is a researcher at the University of Siegen, Germany. In 2022–23, he was a visiting scholar at the universities of Bologna, Copenhagen, and Utrecht. He previously served as a visiting professor at the Technische Universität Dresden, a lecturer at the University of Siegen, and a research associate at the Film University Babelsberg, Potsdam. In 2022, he received his habilitation (the highest degree in German academia) with the thesis *Qualitätsserien aus Deutschland* ("Quality Drama from Germany," 2023; forthcoming in English in 2024). He has

published widely in journals including *Critical Studies in Television, Journal of Popular Television*, and *VIEW: Journal of European Television History and Culture*.

Curtis L. Maughan is Director of the World Languages and Digital Humanities Studio at the University of Arkansas.

Javier Samper Vendrell is Assistant Professor in the Department of Francophone, Italian, and Germanic Studies at the University of Pennsylvania. His research focuses on LGBTQ+ history, film, literature, and print culture in the early twentieth century. He is the author of *The Seduction of Youth: Print Culture and Homosexual Rights in the Weimar Republic* (2020).

Michael Sandberg is a PhD candidate in the Department of German, with a Designated Emphasis in Film & Media, at University of California, Berkeley. Their research focuses on early twentieth-century Northern European visual cultures, German film history, affect theory, and critical theory. Their dissertation is titled "Breakdowns and Short Circuits: Media and Modernity, 1895–1920."

Camilla Smith is Senior Lecturer in History of Art at the University of Birmingham, UK. Her research interests include German modernism, *Neue Sachlichkeit*, and the censorship of visual culture. Essays on topics such as Weimar erotica, modern art and nightlife, and how sexology and art history intersect have featured in the journals *Art History*, *Oxford Art Journal*, and *The Art Bulletin*. Her most recent book is *Jeanne Mammen: Art Between Resistance and Conformity in Modern Germany, 1916–1950* (2023), which explores artistic dissent under National Socialism.

Jill Suzanne Smith is Associate Professor of German at Bowdoin College in Maine. She is an affiliated faculty member in Cinema Studies, Gender, Sexuality & Women's Studies, and Urban Studies. Her research focuses on gender and sexuality, Jewish studies, and the city of Berlin from the Wilhelmine era to the present. She is the author of the book *Berlin Coquette: Prostitution and the New German Woman, 1890–1933* (2013) and a volume editor in the forthcoming Bloomsbury series *A Cultural History of Prostitution*.

Julia Sneeringer is Professor of History at Queens College and the Graduate Center, City University of New York. Her research interests include twentieth-

century popular music, youth culture, and gender in modern Germany, as well as the history of Hamburg. She is the author of *A Social History of Early Rock 'n' Roll in Germany: Hamburg from Burlesque to the Beatles, 1956–69* (2018) and *Winning Women's Votes: Politics and Propaganda in Weimar Germany* (2002).

Cara Tovey is Lecturer in German in the Department of European Languages and Transcultural Studies at the University of California, Los Angeles. Her research interests include early twentieth-century literature, modern dance, film, and critical disability studies. She has published on Mary Wigman and German expressionist dance, Deaf West Theater's revival of "Spring Awakening" on Broadway, and Red Vienna. Her current research focuses on Sir Ludwig Guttman and the origins of the Paralympics.

Acknowledgments

We begin by expressing our gratitude to Raleigh Joyner, whose inspired suggestion to develop a series of online events about *Babylon Berlin* in the early days of the COVID-19 quarantine in Spring 2020 offered the initial spark for this volume. Sponsored by the Goethe Institut in Washington, DC, the Watch Klatsch series, brilliantly titled and organized by Raleigh and presented by Hester with Jill's participation, brought us together in conversation about *Babylon Berlin* for the first time and laid the groundwork for a generative and sustaining collaboration during trying times. Jill is particularly grateful to Katrin Sieg of Georgetown University for telling her about the first Watch Klatsch and to Hester and Raleigh for inviting her to co-host one Watch Klatsch mega-session.

We began our collaborative writing of what became the seed of our introduction as we wrote an essay for a special issue of the journal *EuropeNow* on European Culture and the Moving Image (2021), and we thank the editors Randall Halle, Michael Gott, and İpek Azime Çelik Rappas for their feedback and encouragement. Thanks also to Thomas O. Haakenson and Deborah Barnstone for including our volume in the series *Visual Cultures and German Contexts*, and to everyone at Bloomsbury for their support of the project, especially Alexander Highfield and Ross Fraser-Smith. Bowdoin College awarded us a grant to underwrite publication costs, and we appreciate the College's generosity. A special thank you to *Babylon Berlin* showrunner Henk Handloegten for making season four available to us before its North American release and for his overall enthusiasm about our project. We also thank Ryan Long for his excellent editorial suggestions. Our deepest gratitude goes to our daughters, Della Baer and Helena Rueger, for all the happiness, laughter, and love they bring to our lives.

Finally, it has been a joy to work with the contributors to this volume, whose excitement about the project and deep engagement with the series are a testament to the kaleidoscopic qualities of *Babylon Berlin*. We dedicate this volume to them.

Introduction to *Babylon Berlin*

Hester Baer and Jill Suzanne Smith

Kaleidoscopic Berlin

The opening sequence of *Babylon Berlin* begins with an auditory cue: pairs of deep kettle drum beats throb over a black screen before we hear a voice uttering the words, "Breathe very calmly. Breathe in … and out. Don't try to put your thoughts in order. Just let them go." Spoken by Dr. Anno Schmidt, these words are addressed to his patient and the series' protagonist Gereon Rath, but they also hail viewers of *BB*, summoning us into the hypnotic storyworld of this highly bingeable series. A title card locates us in "Berlin 1929" as the pulsing tones of the series' kinetic score—reminiscent of a beating heart—kick in. Shot from the perspective of the hypnotized subject, a blurred image slowly comes into focus: we see the contours of Dr. Schmidt's hand emerge as he waves his fingers before Gereon's, and our own, eyes. "Breathe in very deeply, in and out," the hypnotist intones, "And when I say 'now' you will open your eyes." With a violent slap to his patient's forehead, Dr. Schmidt utters the word "now," testing the hypnotic state of Gereon, who gazes back at the doctor blankly, his jaw slack. "Good, good," Dr. Schmidt murmurs, "And now delve twice as deeply into your relaxed state than before. Take your time. I will now take you back … to the source. To the source of your fear."

These words initiate a cascade of images that are simultaneously marked as traumatic flashbacks to violent episodes experienced by the shell-shocked war veteran Gereon, who is inadvertently subjected to treatment with Dr. Schmidt for what we now call PTSD, and as flash forwards to the audiovisual attractions that await us, offering a kind of trailer or highlight reel for the first two seasons of *BB*. Accompanied by the intensifying rhythm of the thrumming music, whose techno-inspired beats now recall a ticking clock, this rapid montage interlaces disparate temporalities and remixes a broad array of familiar images

and styles—two elements that will emerge as characteristic of *BB*'s unique aesthetic construction and its refraction of both Weimar history and culture and German cinema and media. We see images that remediate classic shots from Weimar films, including those well known for their representation of hypnosis. An extreme close-up of an opening eye and its swiftly narrowing pupil acts as a reverse image of *BB*'s signature use of iris shots in the action that immediately follows each episode's opening credits. The twin motifs of the opening eye and the dilating mechanical pupil of the camera underscore the series' preoccupation with vision and spectatorship in the age of streaming television (see Figure 0.1). The close-up of the single eye also serves as our first introduction to Charlotte (Lotte) Ritter, *BB*'s female lead, who appears repeatedly in the images that supposedly reel through Gereon's mind. As the music picks up and the pace of the editing accelerates, a series of fast-motion reverse shots shows bodies literally moving backward in time, falls averted and injuries undone, in a virtuoso exhibition of the capacity of the audiovisual apparatus to intervene into time and space.

The manipulation of media images and the power of hypnotic suggestion are intertwined in the opening sequence of *BB*, which references the early twentieth-century moral panic about the ability of cinema and advertising to exert control over social behavior, as well as the interest in hypnosis as a treatment for war trauma following the First World War—but also as a harbinger of authoritarianism.[1] *BB*'s opening can also be read as a nod to contemporary concerns about the power of media platforms to manipulate political outcomes

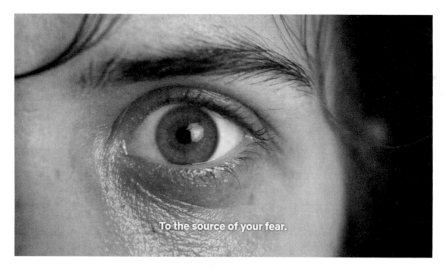

Figure 0.1 Lotte looks back. Screenshot, *Babylon Berlin* (S1, E1).

through the falsification of information. Indeed, deception and lies drive the ensuing narrative action in *BB*'s first two seasons: Gereon goes to Berlin in order to find and destroy a pornographic film under the false assumption that doing so will prevent a political scandal; police and government officials use the Weimar press to deflect their own responsibility for political violence in the infamous Blood May riots and concoct a story of Communist subversion, losing sight of the growing threat from the right; and right-wing revanchists, gangsters, and Trotskyites vie for the possession of the storied Sorokin gold, only to find out that the gleaming gold bars are nothing but humble coal briquettes. And even after the truth behind these three lies is revealed to the series' viewers, the final episode leaves us with a radio news broadcast that still clings to the "red threat" of Communism and remains ignorant of fascist racism and violence, a media narrative that seems uncannily familiar.

If *BB* offers Weimar Germany as a historical precedent for the endemic social and economic precarity, fragile democracy, and resurgent populism of the twenty-first-century present, it does so first and foremost through a preoccupation with the materiality of media and the epistemology of looking that ultimately unsettles our comprehension of both the Weimar period and our present time, and of the relationships between them. *BB* envisages Weimar through the lens of Hollywood noir, telescoping us backward through film, music, and pop culture history—with particular attention to the 1970s and 1980s as the hinge between then and now—via a unique process of remediation, a mode of assembling new images by repurposing found materials that itself recalls the salient Weimar cultural form of collage.[2]

This collage aesthetics—already evident in the opening sequence's summoning of the somnambulist Cesare from Robert Wiene's *The Cabinet of Dr. Caligari* (1920), Fritz Lang's master of criminal control first introduced in *Dr. Mabuse the Gambler* (1922), and the concert pianist Orlac who, in Wiene's *The Hands of Orlac* (1924), finds himself possessed by the hands of a murderer— is made palpable by the credit sequence that follows, which enacts in miniature the mashup form of the series.[3] The opening credits draw attention to the history of German cinema by duplicating the logo of the UFA film company that dominated film production in the Weimar period, and much of *BB* was shot at the Potsdam-based Studio Babelsberg, on the grounds that formerly housed the UFA studios. The credits are rife with stylistic effects that were common in films produced by UFA as well, including double exposure, montage, iris effects, and tinting. Invoking the materiality of analog film, the credits capture the speckling of chemical deterioration and the scratches and bubbles of the

fragile celluloid form. As Sara F. Hall has observed, the credits imitate cinematic projection as well:

> [T]he words on the screen shift ever-so-slightly left and right, as if projected from celluloid. The segment has been mastered to mimic "gate weave," the horizontal darting that occurs when a warped film's perforation does not hug snugly to the sprocket. This effect recalls the experience of watching a silent-era movie projected from celluloid onto the big screen, awakening the historical awareness of the spectator.[4]

At the same time, this sequence is redolent with digital effects, layering, and manipulations, forming a palimpsest of past and present film aesthetics.

The words "Babylon Berlin" unfurl in a circular motion at center screen around a pulsating red oculus upon which the names of the series' stars appear. The title logo is itself superimposed against a backdrop depicting Berlin's Alexanderplatz—a key setting for the series and a nod to the eponymous novel by Alfred Döblin that inspired the series' title in the first place—followed by salient, and often salacious, images from coming episodes.[5] Animated by changing colors that continue to unspool in a clockwise rotation, the titular letters at first give the impression of a spinning gramophone record, an impression emphasized in the ominous score by Tom Tykwer and Johnny Klimek, a mix of free-jazz, post-punk, and techno sounds rife with percussive tones, dissonance, and blasts of brass. With its distinctive melding of musical styles from multiple eras, this score accentuates *BB*'s collage aesthetics; and the visual track that accompanies it here, which features a range of manipulations familiar from early music videos—including radial wipes, mirroring, and negative effects—recalls an earlier moment of Weimar appropriation, in the transformative 1970s' and 1980s' subcultural practice of bricolage.

As the credit sequence proceeds, the oculus at center screen transforms into the lens of a kaleidoscope displaying geometric optical patterns superimposed against a backdrop of symmetrically arranged images that mirror and reflect back on one another in an ever-changing refraction of perspectives. The kaleidoscope emerges as an organizing aesthetic and thematic principle for *BB*, which fragments and reassembles an array of cultural elements, some of which are historically grounded in Weimar Berlin, some of which reflect Weimar's influence on the global pop culture of subsequent decades, and many of which are key components of the German capital's mythical alter ego of Babylon, city of sexual excess and impending doom, an image that remains as potent in the twenty-first century as it was in the 1920s.[6] As the music crescendos, the oculus

transforms into a seething fireball that eventually explodes in a portentous omen of what is to come.

The essays in this volume, the first of its kind on the critically acclaimed and popular series, examine the diverse elements that make up *BB*—historical and mythical, borrowed and original, and auditory and visual—from a range of disciplinary perspectives, including art history, fashion, film, gender and sexuality, Jewish studies, media studies, and music. A dynamic portrayal of Weimar Berlin as a site of sexual emancipation, political intrigue and unrest, modern artistic and literary experimentation, economic volatility, vibrant mass culture, and as a home to Jews, Eastern European emigrés, and Black American performers, *BB* requires precisely this form of multiperspectival, interdisciplinary analysis. Indeed, the series invites an even more complex view of history than the "bifocal gaze" Kim Wilkins proposes in her analysis of *BB*, one that simultaneously sees both the spectacle of Weimar and the coming Nazism that "is inevitably embedded in its very fabric."[7] The essays included here examine how Weimar history and culture is rediscovered, refracted, and reimagined through numerous historical lenses, including the first wave of Weimar rediscovery in the 1970s and 1980s as well as the present centenary of the era and our own fear-filled present. The conception of Weimar engaged here is thus not confined to our retrospective knowledge of National Socialism and its genocidal horrors. We hope this volume, which emphasizes a transhistorical and intermedial approach to *BB*, will serve as a valuable resource to students, teachers, scholars, critics, and fans of the series.[8]

A Paradigm Shift in German Visual Media Culture

A series that offers a kaleidoscopic representation of the Weimar era even as it engages critically with the way moving images mediate our apprehension of history writ large, *Babylon Berlin* also marks a paradigm shift in contemporary German visual media culture.[9] *BB*'s sui generis status is reflected in its hybrid funding structure, underwritten by a groundbreaking public-private partnership; in its unique approach to writing, development, and shooting, which combines the collaborative authorship common to television with an auteur-driven production style derived from the European art cinema where showrunners Achim von Borries, Henk Handloegten, and Tom Tykwer got their start; and in its remarkably successful transnational distribution model. *BB*'s novel mode of production underpins both its spectacular audiovisual

attractions and its narratively complex long-arc storytelling in the German language, qualities that distinguish the series in the mediascape of Germany, which has lagged behind other European nations in the creation of quality television for a global market.[10]

BB draws its inspiration and main characters from the best-selling hard-boiled detective novels by Cologne-based author Volker Kutscher. Seasons one and two of the series both draw on Kutscher's first Gereon Rath novel, *Der nasse Fisch* (2007; published in English as *Babylon Berlin*, 2016), while season three reworks Kutscher's second novel, *Der stumme Tod* (2009; *The Silent Death*, 2017). Kutscher has said that, in writing the novels, he was inspired not only by classic Weimar films like Lang's *M* (1931), but also by twenty-first-century Hollywood period movies like *Road to Perdition* (Sam Mendes, 2002) and by serial television, especially the groundbreaking HBO series *The Sopranos* (David Chase, 1999–2007).[11] The novels combine common generic tropes from contemporary crime fiction with a deep dive into the Weimar underworld; their popularity also derives from the way they restage key historical events in settings that are familiar from today's Berlin (for instance, the first novel is set around Hermannplatz in Neukölln and uses the original construction of the Karstadt Department Store as a backdrop to the action). Clearly, the novels were ripe for adaptation as a series—in fact, they were written with this idea in mind. The series, however, defies the simple concept of a page-to-screen adaptation, transcending both the genre conventions of detective fiction and the confines of any single media platform. Kutscher's texts themselves have been transformed and enhanced by the series' popularity, and the *BB* universe has spawned spin-offs that span the range of forms from graphic novels to audio plays, from live cultural events to video games.[12]

Tykwer initially seized on the idea of developing *BB* for X-Filme Creative Pool, bringing on board as collaborators von Borries and Handloegten, veteran filmmakers who had both worked with the production company on previous projects. X-Filme, founded by Tykwer together with fellow filmmakers Wolfgang Becker and Dani Levy and producer Stefan Arndt in 1994, has a long tradition of creating successful German films for an international market. Like *BB*, the company's breakthrough hit *Run Lola Run* (1998), written and directed by Tykwer, also focuses on the kinetic movement of a young woman through the city of Berlin, drawing on familiar images from German film history while reflecting on the medium of cinema in the context of the digital turn. X-Filme pursues an integrated production model, shepherding its own productions

from development all the way through marketing and distribution, and it has long taken a pioneering role in attending to new technologies and formats in order to pursue its program of making "films that have a distinctive authorship with the goal of finding large audiences."[13] Following the founding of a new TV department in 2010, X-Filme has increasingly focused on developing projects for television and streaming media.

In the case of *BB*, the company spearheaded a public-private partnership to fund the series, which was co-financed by the German public television station ARD/Das Erste (through its fiction programming arm ARD Degeto), the private subscription channel SkyTV, and a brand-new federal subvention program, created specifically for *BB*, to support the creation of internationally marketable prestige series made in Germany and shot in the German language. Through a combination of funds that also included regional and European subventions (from the Film- und Medienstiftung Nordrhein-Westfalen, Medienboard Berlin-Brandenburg, and Creative Europe), X-Filme secured a nearly €40 million ($45 million) budget for the first two seasons of *BB* (whose sixteen episodes were shot and distributed together), making it not only the most expensive German-language television series to date but also the most expensive non-English-language show of all time.

The gambit paid off for X-Filme: due to deals brokered by co-producing partner Beta Film with cable conglomerates and streaming giants, including HBO Europe, Netflix, and an array of national distributors, the series has been sold to and viewed in over 100 countries and territories around the world.[14] It was also immensely popular at home in Germany. In an unusual arrangement for a publicly financed show, *BB* first aired on SkyTV—where it was available only to paid subscribers of the cable channel or its streaming service—and was later broadcast on the public television channel ARD, where it achieved an astonishing 24.5 percent market share.[15] The series has also garnered numerous awards, first and foremost for its opulent sets and costumes, innovative musical score, and cinematography. It swept the German Television Awards in 2018 in each of the aforementioned categories, and it won the German Television Award, the Bambi, and the distinguished Adolf Grimme Prize for best series in that same year. Proving *BB*'s impact beyond German national borders, the showrunners received the European Film Academy's inaugural award for European Achievement in Fiction Series in 2019, an award category created to reflect the twenty-first-century transformations in visual media creation and distribution.[16]

Recreating Weimar for a Global Audience

BB's success derives from its dynamic approach to visual spectacle and narrative complexity: the series embraces an emphasis on worldmaking—with careful attention to art direction, costuming, and mise-en-scène—even as it offers a metacritical take on the historicity of the images it deploys. The series' global distribution on streaming services like Netflix exemplifies the shift to "engagement" rather than "appointment" viewing, which media scholar Henry Jenkins has defined as a modality that is both enabled and demanded by the "new economic imperative" of media conglomeration.[17] Like the transmedia productions Jenkins examines, whose complexity cannot be contained by one platform, *BB* blurs the lines between historical reality and fiction and promotes a cult status that relies on quotes, archetypes, and references. The placement of clues, Easter eggs, and allusions requires collective intelligence to decipher, driving the proliferation of blogs, Wikis, and subreddits devoted to the show. The modes of extradiegetic engagement that have become hallmarks of the digital age underscore Jenkins's argument that transmedia storytelling promotes a participatory mode of viewing that contrasts with older models of passive media consumption. Doria Killian explores one example of the vibrant fan culture dedicated to *BB* in her analysis of the popular Wiki TV Tropes. As Killian's chapter shows, fans of the series engage in equal measure with the specific historical context of Weimar Berlin and the transnational, transmedial worlds of the Hollywood action film, neo-noir, and melodrama. In this regard, fan interaction with *BB* constitutes an analysis not only of the series itself, but also of its interconnections, in Killian's words, "with other narratives and with historical and present realities."

These interconnections—the layering and blurring of temporalities through *BB*'s trademark citational aesthetic—are facilitated by its unique development process and unparalleled production values. The series' lavish budget underwrote 185 days of shooting for the first two seasons, with a cast of 400 actors (many of them prominent stars of stage and screen) and more than 5,000 extras. Not least because they prioritized location shoots—70 percent of *BB* was shot on location in Berlin—the showrunners employed a somewhat unusual model for writing and filming the series, one that media scholar Florian Krauß documents in detail in his contribution here. The series' unique funding structure, Krauß argues, "shaped by its co-financing and transnational distribution," enabled *BB*'s creators to substantially "modify standard production practices." Tykwer, Borries, and Handloegten co-wrote the scripts together during a lengthy,

three-year development period, in which they adapted practices common to the US television industry, including the collaborative model of the writers' room—albeit in a nonhierarchical form that encouraged the authors' creative autonomy and facilitated *BB*'s complex mode of storytelling. Following X-Filme's emphasis on auteur-driven productions, all three writers also directed all episodes of the series. Working with three separate cinematographers, they shot scenes for the sixteen episodes of *BB*'s first two seasons on a location-by-location basis—for instance, all scenes in the Moka Efti club were shot at once—only putting the full series together in the editing room at the end of the seven-month shoot.

Informed by interviews with TV industry professionals, including *BB* showrunner von Borries, Krauß documents the exceptional amount of time and money that the team devoted to researching myriad facets of Weimar culture, including dance crazes, sexual mores, popular films, and historical events. The creative team's close attention to detail, as mentioned above, is evident in the series' meticulously constructed mise-en-scène, its soundtrack, and its costumes, elements that appeal to both experts of the era and more casual viewers. Taking Pierre-Yves Gayraud's costumes for *BB* as her focus, fashion scholar Mila Ganeva defines *BB*'s chosen style as a "composite image of the long 1920s" that "dips into various artistic currents (from expressionism to *Art Noveau* to *Neue Sachlichkeit*), borrows freely from the archives of different media (novels, films, illustrated magazines, and advertising), and blends the sartorial fetishism of globally popular series like *Downton Abbey* and *The Crown* with prevailing Weimar mythologies." That said, Ganeva argues that *BB* does not fully indulge in the nostalgia for the 1920s and 1930s characteristic of German heritage films; rather, the "carefully crafted gritty appearance" of working-class characters and of the two protagonists runs counter to "the glamour of Hollywood and the impeccable gloss of BBC productions." This grittiness, combined with the series' hybrid approach to historical accuracy and contemporaneity, "push[es] against the nostalgic pull of traditional heritage productions."

In its departure from the conciliatory politics and affirmative aesthetics of the heritage genre—until recently, the most globally successful production trend in German film and media—*BB* suggests a paradigm shift as well. Even as its depiction of Weimar is marked by equivocations and absences, *BB* nevertheless flouts the tendency to normalize German history so characteristic of heritage films like Wolfgang Petersen's *Das Boot* (1981), Joseph Vilsmaier's *Comedian Harmonists* (1997), Max Färberböck's *Aimée & Jaguar* (1999), and Florian Henckel von Donnersmarck's *The Lives of Others* (2006).[18] This difference is already evident in the series' focus on the Weimar period—a surprisingly

underrepresented period in contemporary German moving image culture—rather than the Nazi era or the years of state socialism in the GDR, epochs that form the backdrop for the majority of heritage productions. This shift is further visible not only in the "push against" nostalgia identified by Ganeva, but also in *BB*'s approach to German cultural heritage itself. In contrast to the blockbuster productions of the German cinema of neoliberalism, which co-opt and instrumentalize the vibrant legacy of German modernism for narratives of individual redemption, *BB*'s attention to the materiality and historicity of German art and culture, and its metacritical incorporation of archival images, offers a more complex engagement with these traditions.[19]

The analyses collected here develop a multiplicity of approaches to thinking through the interrelationship of history-making, media transformations, and the way *BB*'s aesthetic choices frame Weimar culture as a key historical imaginary not only in the German context but in global pop culture and political discourse as well.[20] As Michael Sandberg and Cara Tovey propose in their chapter, *BB* "both critically acknowledges and unabashedly participates in the alluring fetishization and commodification of space" in the global age by foregrounding the mix of analog and digital production of iconic spaces in Berlin. The series' production style made it possible to take advantage of unusual shooting locations like Alexanderplatz, which was shut down for 24 hours to serve as a setting for *BB*. The very use of Alexanderplatz as a shooting location, however, emphasizes the historical disjunctures and the mix of technologies found in the series. After all, Alexanderplatz was still a massive construction site in 1929, not the sleek, modern central square that viewers of *BB* see.[21] The series was partially shot on a brand-new set, the "Neue Berliner Straße," that was custom built for *BB* at the Babelsberg Studio.[22] While that set, much like Alexanderplatz itself, was enhanced with the use of CGI and digital effects (e.g., to create upper stories of buildings, because the set itself was only three-stories tall), it is the real shooting locations within Berlin that now serve as tantalizing tourist attractions for fans of the show who visit the German capital city. In the case of the Moka Efti, for instance, Sandberg and Tovey reveal how the showrunners combined the name of a lavish Weimar-era café (Moka Efti), a shooting location that bridges Weimar's and today's Berlin (the Theater im Delphi in Weißensee, a building that served as a cinema during the era of silent film), and digital enhancements of that concrete location. *BB*'s version of the Moka Efti, therefore, "rests at the crossroads between indexical space, stage construction, and digital retouching" that is a hallmark of the series.

If the image of Berlin that viewers encounter in *BB* is an amalgamation of digital effects, set pieces, physical locations, and remnants of the Weimar historical imaginary, the series' musical score is no less of a mixture of styles (classical, jazz, techno), original compositions, and popular songs from both the Weimar and 1980s post-punk eras.[23] Musicologist Abby Anderton demonstrates through her careful analysis of the series' score "how musical selections complement, complicate, and enrich auditors' understanding of Weimar politics and culture." At times, listeners get to hear what they might expect from a story set in Weimar Berlin: a peppy Charleston played by the Moka Efti Orchestra or a brazen cabaret song by Claire Waldoff. But more often than not, the sounds of the score defy expectations by broadcasting Wilhelmine-era classical music through the radio, combining the style of Weimar-era chansons with the art rock of Roxy Music, and transitioning from Delta Blues to pulsating techno beats, all to mark pivotal, often traumatic, moments in the narrative. Indeed, in the instrumental score, sonic cues often precede visual transitions among scenes.[24] This at times jarring defiance of expectations is what activates (rather than alienates) listeners, Anderton argues.

BB rewards careful and repeated listening and watching: its densely textured mise-en-scène is rife with audiovisual clues and cultural references that demand decoding and position the viewer as a co-creator of meaning. Art historian Camilla Smith's meticulous examination of *BB*'s mise-en-scène demonstrates how the visual composition of the series comprises far more than a lush backdrop for the action (as in the heritage genre): rather, it constitutes a key locus for the series' engagement with the politics of Weimar aesthetics. Smith, like Anderton, begins by addressing which canonical Weimar images viewers expect and get when they watch *BB*, including corrupt military and industrial elites, back-alley prostitutes, and disfigured war veterans that bring familiar works by artists like Otto Dix, George Grosz, Jeanne Mammen, and Heinrich Zille back to life. But these immediately recognizable motifs and figures are not Smith's focus. She argues instead that "*BB* consistently demonstrates the close intersections of art and everyday life and as a result, instead of assessing whether a scene or figure 'looks like' an artwork, it reminds us that it is the mediation and dissemination of artworks during this period that is crucial to our full understanding of them." She therefore shows, first through a close examination of interiors (sculptures on desks, paintings on walls, and objects in cabinets), how the art objects chosen for the mise-en-scène offer clues to the political leanings of their private owners. Then, through an analysis of the urban spaces of the street, the iconic form of the *Litfaßsäule*, and the posters that adorn it, Smith turns to public battles over gender

roles. Challenging popular narratives of the Republic that privilege modernist inventions, Smith treats popular entertainment posters, Dadaist montages, and historicist architecture with the same degree of seriousness. This does not diminish the cultural innovations of Weimar, Smith argues, but it does alert us to the fact that Weimar culture was not always in opposition to reactionary forces: "There can be little doubt that *BB* succeeds in reinforcing the widespread understanding of Weimar as a period of cultural efflorescence. Nonetheless, the extent to which the series presents culture as a contributing factor in the rise of the right is perhaps self-evident in its name." The Babylonian doom that the series' title portends is not simply caused by the Nazis and opposed by left-leaning avant-garde culture, as one of the still dominant historiographical narratives of Weimar would have us believe.[25]

Indeed, the way that *BB* treats the Weimar modernist canon as the expected narrative and then enhances and disrupts that narrative with rich references to mass culture and the technical apparatus used in its creation (cameras, film projection equipment, gramophones, radios) shifts viewers' focus to earlier versions of the audio-visual media that continue to shape our own political affiliations, leisure time, and individual identities. And while the technical apparatus serves at times in the series as a means to revealing the truth (as it does at the end of season three, when a rudimentary wiretap records Colonel Gottfried Wendt's boastful confession of his own misdeeds), more often than not it aids in mass deception, with the showrunners offering today's viewers a peek behind the curtain.[26] In our own digital age of social media, binge watching, and advertising algorithms, this peek behind the curtain can also act as a mirror.

Historical and Cultural Refractions and Erasures

In Irmgard Keun's popular 1932 novel *The Artificial Silk Girl*, illustrated newspapers like the Ullstein tabloid *Tempo* are central motifs in the street scenes consumed and recounted by Keun's teenage protagonist Doris: "I saw [...] lots of newspapers, very gay, the Tempo lilac-pink, and late editions with a red stroke across and a yellow one from corner to corner."[27] Numerous scholars have, with good reason, explored the filmic nature of Keun's narrative, a strategy Keun likely employed in order to appeal to the increasing primacy of visual culture in the Weimar era.[28] The fact that both Keun's Doris, who is often read as one of the era's most witty and endearing depictions of the New Woman, and Ullstein's *Tempo* appear in *BB* is an especially illustrative example of how the

series cites and refracts Weimar history and culture. The figure of Doris and various scenes from Keun's novel adhere to multiple characters and plot points over all three seasons, making popular literature by Weimar women authors a consistent intertext for the series, even if it is less obviously articulated than, say, the overt titular reference to Döblin. The citation of *Tempo* pairs well with Keun's novel, not only because it appears within its pages, but also because it exemplifies the way *BB* itself thematizes the visual turn and the role that images play in metropolitan mythmaking. Cultural historian Jochen Hung examines the depiction of journalism in the series with a particular focus on *Tempo*, succinctly stating that "Berlin made the modern mass media, and the mass media made modern Berlin." If Keun's novel deconstructs the urban *Glanz* of movie posters and advertisements, and thereby casts critical light on the idea of women's social mobility, *BB*, Hung argues, reveals the key role that the illustrated press played in the construction of the glamorous yet dangerous metropolis. In his analysis of a humorous yet poignant dialogue between the inimitable investigative journalist Samuel Katelbach and the intrepid *Tempo* editor Gustav Heymann in season three of *BB*, Hung marks the sometimes painful transition from print to illustrated media in late Weimar Berlin. Connecting Weimar's visual turn and the digital turn of our own century, accelerated in 2007 by the market premiere of Apple's iPhone, Hung writes, "Katelbach's negative image of this new media audience, visually stimulated by tabloids and the cinema, echoes the criticism by contemporaries […], but it also establishes a link with *BB*'s own audience, who grew up during a time of profound media transformations." Through Katelbach's tirade about readers being replaced by "gawkers" ("Gucker"), the series once again throws up a mirror to present-day viewers who gawk at the screens of their mobile devices.

A pivotal year for the digital turn, 2007 also marked a new phase in visual media consumption, as the DVD-subscription service Netflix and the upstart channel Hulu launched streaming services for film and television content. By 2013 Netflix was producing its own original content, just as it was funding and distributing an unprecedented number of films and series, an expansion in services that was soon followed by media giants like Amazon, while more traditional cable channels like HBO and Showtime increased production and offered their own streaming platforms. With the social isolation and closing of public entertainment venues caused by the COVID-19 pandemic, streaming platforms became the dominant mode of viewing. The new "Golden Age of Television" shaped by the Netflix model of individually tailored programming opened up spaces for series and films that cater to feminist and/or queer viewers rather than to the traditional cis-gendered heterosexual male viewer. As historian

and queer studies scholar Javier Samper Vendrell shows in his nuanced reading of queerness in *BB*, the series "is part of a global media landscape in which the representation of gender and sexual diversity has become a fashionable political statement and a financial calculation." *BB*'s showrunners walk a fine line between celebrating and condemning non-normative gender expression and sexuality, one of the key factors in Weimar Berlin's reputation as a hedonistic haven. While the series allows its lead characters to frequent queer clubs and even to experience playful moments of queer desire, more often than not it channels their desire back into the heterosexual romance and enacts violence on its most gender-bending characters. And yet, Samper Vendrell shows, the heterosexual relationship is also embattled, dissatisfying, and filled with grief and shame. Ultimately, *BB*'s depiction of the instability of gender and sexual norms and its deferral of heterosexual closure offer what Samper Vendrell identifies as moments of "queer possibility," even as the series succumbs to common pitfalls of LGBTQ representation on television, in which its most sexually emancipated characters are also its most battered ones. Reading queer possibility in *BB* also entails finding queerness "in its aesthetic choices and generic transgressions. It disrupts period, and even history, through its combination of generic police procedural, historical drama, and use of fabulation."

If women and queer figures are frequently subjected to violence in the series, the way that *BB* represents Jews is even more fraught. Just as Samper Vendrell matter-of-factly states that *BB* depicts queer life in Weimar Berlin with very few historical details—for example, Dr. Magnus Hirschfeld and his Institute for Sex Research are never mentioned—historian Darcy Buerkle argues that *BB*'s creators present viewers with a Berlin that is, at least at first glance, almost completely devoid of Jews. Considering that Berlin was home to the largest Jewish population in German-speaking Europe in the Weimar era, this seems a disturbingly odd choice. That many German Jews in Weimar Berlin were highly acculturated should not be an excuse to make them invisible to the untrained eye.[29] And while the series plays consciously with anachronism, the near absence of Jews is a glaring inaccuracy, particularly in a project that relies so much on the works of Weimar-era Jewish writers, filmmakers, and artists for its own intertexts and visual style. As Buerkle so pointedly argues:

> Despite the relevance of Jewish contributions to the cultural production that the series celebrates, *BB* elides this specificity. And despite the political events that the series narrates, the role Jews played and their clear impact on the trajectory of German history, Jewishness remains barely present. In addition to the absences thus produced, the decision to equivocate produces an affective

and political economy that relies on a definition of Jewish difference that is, for twenty-first-century viewers, impossible to decouple from antisemitic violence. What is the status of imagination galvanized in terms that specifically evade Jewish presence, let alone the details of such presence?

Buerkle answers her own question by emphasizing how the evasion of Jewish presence reminds twenty-first-century viewers of what came after Weimar rather than the vibrancy of Weimar itself, and with this reactivated knowledge of Jewish death and destruction under Nazism, the series "reifies the representation of Jewish life as only emblematic of tragedy." Still, Buerkle suggests that *BB* is rife with markers of "claims of political innocence where there can be none," visible especially in the series' attention to the contingency of events and its narrative fixation on the destruction of evidence. In this regard, Buerkle asserts, "historical time and its relation to visual or auditory evidence remains perhaps the most understated and persistent mashup in *BB*."

Indeed, the series' destabilization of historicity, especially through its citational style, forms its most intriguing—albeit often ambivalent—attraction for scholars and fans alike. In her groundbreaking 2019 article on *BB*, Sara F. Hall approaches the question of historicity through the concept of pastiche. Drawing on Richard Dyer's work, Hall understands pastiche as an aesthetic practice that "draws on the perceptions of the thing it pastiches and thus pastiches not just the substance but also the 'idea' of that which it imitates, which makes it [in Dyer's words] 'always and inescapably historical.'"[30] Because pastiche and related practices (including collage, mashup, and remix) repurpose source materials by recombining them in new contexts, they necessarily "disturb any sense of the fixedness of the past and challenge a teleological concept of twentieth-century German history."[31] Expanding on this argument, Hall's contribution here demonstrates precisely how *BB* creates this sense of disparity between past and present via a careful close reading of one specific instance of archival appropriation: footage of street-fighting on May 1, 1929, from a non-fiction short directed by the communist filmmaker Piel (Phil) Jutzi. This archival footage, which documents the violent confrontations between communist demonstrators and the Berlin police that came to be known as *Blutmai*, or Blood May (a key plot point in the first two seasons of the series), is seamlessly integrated into the diegesis of *BB*, where it appears as a newsreel prior to a screening of *People on Sunday* (1930) at a neighborhood cinema visited by the characters Greta and Fritz (S2, E11). Although it has been digitally remastered and incorporated into *BB* stripped of its origins as a KPD-sponsored documentary, this footage is nonetheless clearly marked as emerging from a different temporal register and evinces

the sense, for viewers of *BB*, of having been made for another purpose, what Jaimie Baron refers to as "the archive effect."[32] As Hall argues, the sequence's "energy and urgency pique spectatorial curiosity, and its aesthetic of temporal and intentional disparity generates an awareness of the historicity of the image. Together these effects fissure the text." Such fissures occur throughout *BB*, though they no doubt stand out to viewers in this emblematic sequence, whose attention to the conjunction of party politics, police brutality, and the evidentiary power of recorded images resonates with the interrogation of police violence and corruption—and in particular the role of cell phone recordings and social media in capturing and disseminating evidence of police brutality against unarmed Black people—in the twenty-first century.

Humans, Machines, and Human-Machines: Beyond Weimar and Now

Even as they highlight resonances (between the visual and digital turns, between structures of violence and power, between the income inequality and precarity of life exacerbated by the rise of the right, between the role of media and technology in exerting control over the masses) that bind Weimar and now, effects that fissure the text of *BB* also create an awareness of historical differences across the century that separate the 1920s and the 2020s. Crucial here is the series' preoccupation with "the long 1980s," a period known for its own Weimar nostalgia and one that also gave rise to new waves of pop music, burgeoning subcultures, alternative lifestyles, and revitalized forms of political activism in the face of Cold War militarism, the specter of nuclear war, and the threat posed by HIV/AIDS. As Julia Sneeringer demonstrates, West Berlin was the "spiritual capital" of this era—a last enclave for nonconformists before the triumph of neoliberal capitalism in the 1990s—whose heady mix of post-punk music, club culture, and repertory cinemas exerted a powerful influence on *BB*'s showrunners von Borries, Handloegten, and Tykwer, all of whom lived in the city during this time. Sneeringer highlights the many affinities between the 1920s and the 1980s that *BB*'s mashups bring to light, including the "pervasive sense of uncertainty and threat that proved inspiring to culture creators," whose experiments with convention were ultimately foreclosed upon by subsequent developments. By refracting its "fantasy of Weimar through the lens of 1980s post-punk West Berlin," as Sneeringer puts it, *BB* averts reflexive nostalgia for the 1920s while also complicating direct parallels between Weimar and the historical present.

Looking back on the pivotal music of the post-punk era, Kraftwerk's 1978 concept album *Die Mensch-Maschine* stands out. Inspired by Lang's *Metropolis* and featuring cover art based on a graphic design by Russian constructivist El Lissitzky, *Die Mensch-Maschine* proffers a techno-futurist vision of a world dominated by robots and machines in songs like "Metropolis" and "Die Roboter," whose hypnotic synthesizer rhythms revolutionized popular music, catalyzing the synth-pop wave that was an important precursor of techno. Simultaneously a celebration of new technologies and a harbinger of their destructive potential, the prophetic vision of *Die Mensch-Maschine* serves as a crucial intertext for *BB*.[33] The series' preoccupation with the technological domination and mechanization of the human body—sometimes sinister, sometimes jubilant—can be seen in Dr. Schmidt's experimental treatments for war neurosis via a form of mind control achieved through a mix of hypnosis, radio transmissions, and barbiturates; in the motif of "kaputte Automaten" (broken automatons, a derogatory term for disabled war veterans); and in the robotic movements of Sorokina/Nikoros and the stage dancers in the lavish musical number "Zu Asche, zu Staub." This preoccupation is also evident in the series' thematization of technologically augmented forms of vision—especially photography, but also cinema and even weaponry—and their role in transforming epistemological regimes in the fields of psychology and criminology, among others.

In season three of *BB*, the trope of the *Mensch-Machine* achieves even greater prominence: it is explicitly invoked by the character of Esther Kasabian, who saves the stalled film production *Demons of Passion* by rewriting the script to include this trope. In her chapter on *BB*'s mise-en-scène, Camilla Smith discusses the magazine that Esther studies, featuring infographics by Fritz Kahn, whose influential Weimar-era works envisioned fusions of machines and human bodies. For Smith, the emblematic figure of the *Mensch-Maschine* demonstrates how "Technology serves a double logic, [...] acting as both the cause of disquiet and ultimately the creative resolution," in both *Demons of Passion* and *BB* itself. Indeed, the final scene of season three, which takes place in the Berlin Stock Exchange on the day of the Wall Street crash of 1929, envisions the transformation of three key characters—Gereon, Helga Rath, and Alfred Nyssen—into *Mensch-Maschinen*.

In their close reading of the scene, which forms a fitting conclusion for this volume, Carrie Collenberg-González and Curtis Maughan examine this transformative vision as part of *BB*'s metacritical reflection on the manipulative power of mass media technologies. Collenberg-González and Maughan argue that *BB*'s narrative consists of an extended set of screen memories—in the

Freudian sense of fabricated memories that mask more painful truths, but also in the broader sense of how screens mediate our perception of reality and history. Within the diegesis of *BB*, these screen memories are set in motion by Dr. Schmidt; as revealed by the frame story that the final scene forms in tandem with the opening scene of hypnosis discussed at the outset of this introduction, Dr. Schmidt is engaged in a quest, as his voiceover describes it, "to create the new human. [...] the human-machine. An android, free of pain and fear" (S3, E12). Collenberg-González and Maughan demonstrate how this quest is realized through Dr. Schmidt's appropriation (and *BB*'s remediation) of the Siegfried myth, which is repeatedly invoked across the three seasons of the series and explicitly named in this scene, when Dr. Schmidt directly interpellates Gereon as Siegfried, and when Gereon, in the guise of Siegfried, sees a dragon crawling beneath him through the grating of a subway vent in the final enigmatic image of the episode. "One of the first examples of an enhanced human machine in Germanic literature" and an avatar of German cultural heritage (from the medieval *Nibelungenlied* through Richard Wagner's operas to Fritz Lang's two-part 1924 epic *Die Nibelungen*), Siegfried offers a potent figure for *BB*'s simultaneous celebration of the apparatus and its critical stance regarding the dangers of the *Mensch-Maschine*. As *Babylon Berlin* compels us to keep watching, look closely, and decipher its constellation of citations, it continues to refract, multiply, and turn back on itself, returning our attention to the materiality of the image and our own contested relationship with the screen.

Notes

1 On the use of hypnosis and suggestive therapy to treat wartime "hysteria" among soldiers, see Paul Lerner, *Hysterical Men: War, Psychiatry, and the Politics of Trauma in Germany, 1890–1930* (Ithaca, NY: Cornell University Press, 2003), 86–123; on direct links between the Weimar-era Berlin Psychoanalytic Institute (BPI) and the Göring Institute established under National Socialism, see Veronika Fuechtner, *Berlin Psychoanalytic: Psychoanalysis and Culture in Weimar Republic Germany and Beyond* (Berkeley: University of California Press, 2011), 7. Both Fuechtner and Lerner discuss the utilization of film by medical practitioners to promote psychotherapeutic methods (Fuechtner, *Berlin Psychoanalytic*, 119–20; Lerner, *Hysterical Men*, 86–8). It is important to note that the hypnotic therapy depicted in *BB* was generally discredited well before the late 1920s, just one of the many examples of anachronism within the series. In his seminal retrospective study of Weimar film, Siegfried Kracauer (in)famously analyzed the cinematic medium

as the key to understanding the psychological manipulation of the German masses under National Socialism. See Kracauer, *From Caligari to Hitler: A Psychological History of the German Film* (1947; repr., Princeton: Princeton University Press, 2004).

2 In her exploration of collage and montage as dominant artistic practices in the Weimar era, Patrizia McBride defines these practices as "premised on quoting, combining, and juxtaposing materials that straddle the bounds of old and new media […] and an optimistic willingness to draw inspiration from the world of consumer culture, advertisement, and the mass media." According to McBride, Weimar artists came to prefer "montage" over the French term "collage" because montage "directly evoked the world of machines, industrial production, and mass consumption, thus emphasizing the constructed quality of artifacts and their reliance on found materials and ready-made parts." McBride, *The Chatter of the Visible: Montage and Narrative in Weimar Germany* (Ann Arbor: University of Michigan Press, 2016), 14–15.

3 On *BB* as a "mash-up," see Veronika Fuechtner and Paul Lerner, eds., "Forum: *Babylon Berlin*: Media, Spectacle, and History," *Central European History* 53 (2020): 845–8. For a reading of *BB*'s citations of Caligari and Mabuse, see Caitlin Shaw, "To the Truth, to the Light: Genericity and Historicity in *Babylon Berlin*," *Journal of Popular Film and Television* 50, no. 1 (2022): 24–39, especially 31–3. On *The Hands of Orlac* as a more recently rediscovered Weimar film than the more immediately recognizable "classics" *Caligari* and *Mabuse*, see Anjeana Hans, "'These Hands Are Not My Hands': War Trauma and Masculinity in Crisis in Robert Wiene's *Orlacs Hände* (1924)," in *The Many Faces of Weimar Cinema: Rediscovering Germany's Filmic Legacy*, ed. Christian Rogowski (Rochester, NY: Camden House, 2010), 102–15.

4 Sara F. Hall, "Babylon Berlin: Pastiching Weimar Cinema," *Communications* 44, no. 3 (2019): 308.

5 The repeated allegorical reference to Berlin as the Whore of Babylon comes from Alfred Döblin, *Berlin Alexanderplatz* (1929), trans. Michael Hofmann (New York: New York Review of Books, 2018). See also Frank Junghänel, "Weltpremiere 'Babylon Berlin': Die große Hure in Bestform," *Berliner Zeitung*, September 28, 2017. For a more extended analysis of the Whore of Babylon as an allegory for Berlin, see Jill Suzanne Smith, *Berlin Coquette: Prostitution and the New German Woman, 1890–1933* (Ithaca, NY: Cornell University Press, 2013).

6 On the many ways in which *BB* employs and enhances the mythical status of Weimar Berlin, see Hanno Hochmuth, "Mythos Babylon Berlin: Weimar in der Populärkultur," in *Weimars Wirkung: Das Nachleben der ersten deutschen Republik*, ed. Hanno Hochmuth, Martin Sabrow, and Tilmann Siebeneichner (Göttingen: Wallstein, 2020), 111–25. On the kaleidoscope as a motif often used to describe *BB*,

see Shaw, "To the Truth, to the Light," 26, and Noah Soltau, "'Zu Asche, zu Staub': Netflix Acquisitions and the Aesthetics and Politics of Cultural Unrest in *Babylon Berlin*," *The Journal of Popular Culture* 54, no. 4 (2021): 728–49.

7 Kim Wilkins, "*Babylon Berlin*'s Bifocal Gaze," *Screen* 62, no. 2 (2021): 136; 148.

8 Contributors to this volume have taught the series in Weimar-focused seminars or intensive summer courses (Baer, Collenberg-González, Smith, Sneeringer). Kathryn Sederberg offers a convincing case for making BB the focus of an intermediate language and culture course in "Teaching *Babylon Berlin*: Language and Culture through a Hit TV Series," *Die Unterrichtspraxis/Teaching German* 54, no. 2 (2021): 200–16.

9 Filmmaker and head of the UFA film production company Nico Hoffmann emphasizes the transformative moment for German media signaled by *BB* in an interview with Michael Hanfeld: "Jeder braucht heute Bilder, die bewegen," *Frankfurter Allgemeine Zeitung* (hereafter FAZ), June 21, 2018.

10 See also Hester Baer and Jill Suzanne Smith, "Babylon Berlin: Weimar-Era Culture and History as Global Media Spectacle," Spec. Iss. European Culture and the Moving Image, *EuropeNow* 43 (2021), https://www.europenowjournal.org/2021/09/13/babylon-berlin-weimar-era-culture-and-history-as-global-media-spectacle/. Our thinking and some of our formulations here draw on this previous work.

11 Kutscher has repeatedly mentioned these influences in interviews, readings, and discussions of his work. See for example his public reading and talk at the Center for German and European Studies, Brandeis University, October 3, 2018; and Jackie McGlone, "Babylon Berlin: Kutscher's World of Crime and Sex in the Shadow of Nazism," *The Herald*, October 28, 2017, https://www.heraldscotland.com/life_style/arts_ents/15625762.babylon-berlin-kutschers-world-crime-sex-shadow-nazism/; on the specific inspiration of *The Sopranos*, see the interview with Kutscher and illustrator Kat Menschik, "Bis die Augen schmerzen," *Die Zeit*, November 2, 2017.

12 On the adaptation of Kutscher's novels to streaming television, see Juliane Blank, "Berlin, Capital of Serial Adaptation. Exploring and Expanding a Political Storyworld in *Babylon Berlin*," *Interfaces* 47 (2022): 1–21.

13 Co-founder Wolfgang Becker, qtd. in Martin Blaney, "Founders of Germany's X-Filme Creative Pool Talk 25 Years in the Business, Move into High-End TV," *Screen Daily*, December 6, 2019, https://www.screendaily.com/features/x-filme-creative-pool-founders-talk-25-years-in-the-business-move-into-high-end-tv/5145385.article.

14 For an extensive list of the various broadcasters that made deals with Beta Film to air the series, see Stewart Clarke, "HBO Europe Picks up German Drama 'Babylon Berlin,'" *Variety*, October 12, 2017, https://variety.com/2017/tv/news/hbo-europe-buys-babylon-berlin-1202588085/.

15 *BB* drew an audience of over 800,000 viewers on Sky, second only to the HBO megahit series *Game of Thrones*; see "Zuschauerrekord," FAZ, October 17, 2017. The series premiered nearly one year later, on September 30, 2018, on ARD; see "Ab nach Babylon," FAZ, June 22, 2018, and Scott Roxborough, "How the 'Babylon Berlin' Team Broke the Rules to Make the World's Biggest Foreign-Language Series," *Hollywood Reporter,* December 26, 2018, https://www.hollywoodreporter.com/news/general-news/how-babylon-berlin-team-broke-all-rules-make-worlds-biggest-foreign-language-series-1171013/.

16 For *BB*'s awards, see the databases filmportal.de and IMDb: https://www.filmportal.de/en/movie/babylon-berlin-staffel-1, and https://www.imdb.com/title/tt4378376/awards. See Baer and Smith, "Babylon Berlin," on the series' status as an exemplary European audiovisual production.

17 Henry Jenkins, *Convergence Culture: Where Old and New Media Collide* (New York: New York University Press, 2006), 98.

18 On the German heritage film, see Lutz Koepnick, "'Amerika gibt's überhaupt nicht': Notes on the German Heritage Film," in *German Pop Culture: How 'American' Is It?*, ed. Agnes C. Mueller (Ann Arbor: University of Michigan Press, 2004), 191–208, and "Reframing the Past: Heritage Cinema and Holocaust in the 1990s," *New German Critique* 87 (2002): 47–82.

19 On heritage as a primary genre of the German cinema of neoliberalism, see Hester Baer, *German Cinema in the Age of Neoliberalism* (Amsterdam: Amsterdam University Press, 2021), esp. Chapter 2.

20 On Weimar culture as historical imaginary, see Thomas Elsaesser, *Weimar Cinema and After: Germany's Historical Imaginary* (New York: Routledge, 2000).

21 See Ganeva in Fuechtner and Lerner, "Forum," 838, and Hochmuth, "Mythos *Babylon Berlin*," 111.

22 Production designer Uli Hanisch is the creative driving force behind the Babelsberg set; see "Kaum zu glauben, was da alles zu sehen ist," FAZ, October 5, 2017.

23 Nils Grosch, Roxane Lindlacher, Miranda Lipovica, and Laura Thaller, "Rekonfigurationen der Weimarer Republik: Musikalische Vergangenheiten und Pastiches in *Babylon Berlin* (2018–2020)," *Archiv für Musikwissenschaft* 79, no. 1 (2022): 43–60.

24 For specific examples of moments in the series when sonic transitions act as preludes to visual ones, see Jill Suzanne Smith, "Lotte at the Movies: Gendered Spectatorship and German Histories of Violence in *Babylon Berlin*," *Germanic Review* 97 (2022): 254–71.

25 On the entrenched dichotomous portrayal of Weimar history and some scholarly works that counter it, see Jochen Hung's review essay, "'Bad' Politics and 'Good' Culture: New Approaches to the History of the Weimar Republic,"

Central European History 49 (2016): 441–53. As Hung argues, "some of the most modernist aspects of the culture of the Weimar era were far from friendly toward parliamentary democracy, and democratic politics were not as weak as they were often portrayed" (443).

26 It is important to note that, as cultural historian Corey Ross has shown in his work on the rise of mass media in Germany, mass audiences were not as homogenous and manipulable as they were assumed to be; indeed popular responses to mass media were often critical and differed across classes, genders, political affiliations, and urban versus provincial locations. See Ross, *Media and the Making of Modern Germany: Mass Communications, Society, and Politics from the Empire to the Third Reich* (Oxford: Oxford University Press, 2008), 9; and "Cinema, Radio, and 'Mass Culture' in the Weimar Republic: Between Shared Experience and Social Division," in *Weimar Culture Revisited*, ed. John Alexander Williams (New York: Palgrave Macmillan, 2011), 23–48.

27 Irmgard Keun, *The Artificial Silk Girl*, trans. Basil Creighton (London: Chatto & Windus, 1933), 128.

28 See, for example, Patrizia McBride, "Learning to See in Irmgard Keun's *Das kunstseidene Mädchen*," *German Quarterly* 84, no. 2 (2011): 220–38.

29 On the subtle references to Jews and Jewishness in *BB*'s first two seasons, see also Kerry Wallach, "Digital German-Jewish Futures: Experiential Learning, Activism, and Entertainment," in *The Future of the German-Jewish Past: Memory and the Question of Antisemitism*, ed. Gideon Reuveni and Diana Franklin (West Lafayette, IN: Purdue University Press, 2021), 248–9.

30 Hall, "*Babylon Berlin*," 304.

31 Ibid., 315.

32 Jaimie Baron, *The Archive Effect: Found Footage and the Audiovisual Experience of History* (New York: Routledge, 2014).

33 See also Hochmuth, "Mythos *Babylon Berlin*," 116.

Part One

Babylon Berlin, Global Media, and Fan Culture

Quality TV Drama with Transnational Appeal: Industry Discourses on *Babylon Berlin* and the Changing Television Landscape in Germany

Florian Krauß

Since the 2010s the concept of "quality TV" drama, a term borrowed from the Anglosphere, has been widely discussed by scholars, critics, and television producers in Germany. In keeping with the term's roots, discussions of quality TV have often focused on drama serials from the United States, developments in the US market, and US scholarly discourses, and have largely neglected German examples. Commentators have frequently criticized German narratives as "old fashioned," inferior counterparts to US quality TV and asked why the German industry is not able to produce "valuable" content that can travel beyond German-speaking regions. As a scholar of television and media studies, I, too, have focused on the alleged lack of quality TV drama in the German context and the associated industry debates.[1] To be sure, the notion of quality TV, so often taken for granted by industry representatives, is problematic from the perspective of media studies. In 1996, Robert J. Thompson tried to define quality TV with his well-known, repeatedly invoked, and still controversial criteria.[2] Since then, the term has been justly criticized for multiple reasons, including its inaccuracy, elitist and judgmental tendencies, and bias. Already in 1990, Charlotte Brunsdon demonstrated that notions of quality are linked to issues of power. She posed the questions, "Quality for whom? Judgment by whom? On whose behalf?," thereby highlighting a range of context-specific "contenders" for defining quality television.[3]

Babylon Berlin can be seen as a contribution to, and a result of, the discourse on quality TV drama and its supposed absence in Germany. Due to pressure from the media public and from within the television industry, the public service broadcaster ARD—Arbeitsgemeinschaft der öffentlich-rechtlichen Rundfunkanstalten (consortium of the public-law broadcasting institutions)

agreed to co-finance this costly period drama together with Sky Deutschland, a move that constituted a significant departure from traditional structures of funding and development of fictional productions. *BB* broke the mold by demonstrating that Germany can indeed produce television drama that is both popular and critically acclaimed, that combines both public and private funding, and that has both national and transnational appeal. What changes needed to take place in the German television landscape in order to make such a series possible? This chapter analyzes how television practitioners have negotiated *BB* and, through it, ideas of German quality TV drama with transnational appeal.

In order to examine what is unique about *BB* (but also representative for the transforming television landscape in Germany), this chapter begins with a discussion of funding and distribution before turning to the increased convergence of the film and television sectors and the transnational orientation of the German television industry. In *BB*, two very different forms of television— pay TV and public broadcasting—come together; the increased importance for television drama of both venture capital with the aim of foreign sales and federal funding becomes apparent. Transnational traits can be seen not only on the macrolevel of platforms and production, but also on the microlevel in *BB*'s screenwriting process. The second half of this chapter therefore focuses on the showrunner and writers' room and discusses the conjunction of writing and directing among the three main creators.

My multidimensional analysis of financing structures and production cultures builds on the notion of the "screen idea system" described by Eva Novrup Redvall. Redvall names three main forces: the gatekeepers, who possess a certain mandate and specific managerial ideas about what to produce, but limited budgets; the people creating new dramas based on their particular talents, training, and track records; and the television dramas and films that already exist in the domain and shape "trends, tastes and traditions."[4] Ideas about quality TV drama discussed, observed, and approached in the German television industry reflect these textual influences and trends. Redvall's model is highly influenced by the "Screen Idea Work Group" (SIWG), a key group that shapes discourses in the screenwriting process. According to Ian MacDonald, the members of this flexible and semi-formal work unit congregate around the screen idea, which is "any notion of potential screenwork held by one or more people whether it is possible to describe it on paper or by other means."[5] To a large extent, the SIWG is compatible with the project network, long the dominant organizational form in the German television industry.[6] According to this model, writers, producers, directors, commissioning editors from the broadcasters, and

other production members come together only for temporary projects, across different companies, with prior practices and business relationships playing an important role.

Drawing on methodologies of media industry studies, this analysis of *BB* is based on three interviews with key members from the show's project network: Achim von Borries, one of the three directors and head writers; Gebhard Henke, former head of fiction from Westdeutscher Rundfunk (WDR, West German Broadcasting Cologne), part of the ARD network; and Frank Jastfelder, head of drama production at Sky Deutschland. The interviews were conducted before the COVID-19 pandemic in 2018 and 2019 and prior to the shooting of the fourth season, which was impacted by pandemic-related restrictions. Further interviews from my broader production study on current television drama from Germany are taken into account in cases where the participants—production members from other recent TV series from Germany, such as *Dark* (2017–20) and *Deutschland 83/86/89* (2015–20)—referred to *BB* or to crucial issues pertaining to industry discourse. The method of the interviews was complemented by participant observations at multiday industry workshops on television drama production in order to foster my own impartiality as a researcher. Trade publications on *BB* from the period between 2015 and 2021 are also considered: 115 articles in the online trade magazine *DWDL.de*, which is well-known in the German television industry, and 27 from the international *variety.com* were surveyed and categorized. Already on the *DWDL.de* site, trade journalists observed a certain "secret-mongering" around *BB*.[7] My own research contended with a certain opacity, as some key producers and creatives refused interviews or stayed away from the observed workshops. Still, these varied sources give researchers valuable information on how *BB* is perceived in the industry, whether or not its model is seen as a successful one, and whether or not this success can be duplicated.

Co-Financing and Distribution

Regarded as "Europe's most expensive non-English-language drama," *BB* constitutes an exception in the German television industry.[8] Several practitioners have highlighted the show's special situation in regard to budget, thereby questioning its representative status as a German drama production.[9] Nonetheless, an examination of its co-financing arrangement offers insight into

the pervasive economic and structural transformations of the German television industry in recent years.

The involvement of pay TV group Sky Deutschland points to the diversification of broadcast commissioners. Until the early 2010s, only a handful of broadcasters regularly commissioned TV drama series and films: the two main public-service stations (Das Erste, run by the ARD network, and Zweites Deutsches Fernsehen, or ZDF); and a few commercial, ad-funded channels, especially RTL and Sat.1, run by two opposing media conglomerates, the RTL Group of the Bertelsmann corporation and ProSiebenSat.1 Media. Sky Deutschland and its predecessor Premiere initially focused on broadcasting sports, especially soccer, and did not invest in fictional originals, since pay TV generally played a minor role in Germany compared to many other European and Western markets. Today, together with video on demand (VOD) services, pay TV forms a growing branch in the German television landscape.[10] For Sky Deutschland, *BB* marked the beginning of its turn to "exclusive" local drama; subsequent productions included *Das Boot* (2018–), the serial sequel to Wolfgang Petersen's film (1981) and miniseries (1985) of the same name. Given the competition for content among (new) commissioners on the German market, von Borries and others from the industry have spoken of a "gold-rush era" for contemporary German television.[11]

With a transformed and diversified television landscape and the demand for quality TV drama with transnational appeal, new production and funding methods have been called for. *BB* particularly exemplifies a departure from the model of 100 percent financing by one broadcaster, which has traditionally characterized fictional television productions in Germany. Media economists have criticized this model for creating a power asymmetry in favor of the commissioner, thereby hindering innovation, quality, and transnationality. Under this financing scheme, the production company may not be motivated to obtain further sources of funding or to sell a drama to other markets and distributors.[12] Corresponding arguments were voiced in the interviews and the observed industry workshops as well. Joachim Kosack, one of the CEOs of the UFA production group, which includes the influential production company UFA Fiction (well-known for historical miniseries such as *Deutschland 83/86/89*) even diagnosed a "Kulturkampf," a cultural battle between the producers, on one side, and the broadcasters and platforms, on the other, with respect to the 100-percent financing model.[13] According to Kosack, in order for production companies to make better investments, especially in script development, it is crucial that they are able to acquire additional income through license sales and distribution.

By combining funding from different investors instead of serving only one commissioning broadcaster, *BB* offers the German industry fruitful and innovative ways of strengthening the producer's role and building new networks. The cooperation of the commercial, niche pay TV provider Sky Deutschland and the longstanding public-service ARD network represents one particularly salient example. Their collaboration on the project *BB* was announced already in 2013, but the financing deal continued to be negotiated subsequently. Whereas different parties usually discuss budget issues internally, in the case of *BB* they went public, arguably to put pressure on involved or potential financers; at times, rumors even arose that the funding deal was falling apart.[14]

Since the ARD network consists of nine regional broadcasters, it was inevitable that different opinions about the project would emerge and that the process of bringing it to fruition would be an intricate one. This federalism results in quite diverse perspectives and financing within the ARD organization. In the case of *BB,* WDR from North Rhine-Westphalia (the biggest of ARD's regional broadcasters) took responsibility. For costly fictional productions it is common that regional broadcasters are economically supported by Degeto Film. This subsidiary of ARD is a centralized television rights trader and production company which can operate commercially, thereby exemplifying the expansion of public-service broadcasting in a neoliberal age. Christine Strobl, Degeto's general manager from 2012 to 2021 and now program director of the ARD network, is said to have been a crucial force behind *BB* and its financing structure. Within the ARD network and Degeto Film, *BB* represents a turn to quality or "high end" dramas beyond the very few established time slots for television films and more conventional drama series (often procedurals) and the fixed budgets and editorial departments. Financing is increasingly decoupled from scheduling, as online distribution gains in importance.[15]

As a co-production with Sky, *BB* in particular represents an experiment in distribution for ARD: it first premiered on Sky's linear channel Sky 1 and online-based VOD service Sky Ticket (now titled Wow) in autumn 2017, almost one year before the ARD release. According to Martina Zöllner, then head of documentary and fiction at ARD's local broadcaster Rundfunk Berlin Brandenburg (RBB), the distribution cooperation turned out to be a very convenient construction because of the limited coverage of Sky.[16] Indeed, the pay TV broadcaster has fewer subscribers than Netflix or Amazon Prime Video in Germany where a premiere might have been more problematic for ARD. Even so, the cooperation with Sky Deutschland met with immense criticism in the ARD network, in the broader television industry, and in the German public. Some industry representatives,

especially from competitive commercial broadcasters, complained that Sky Deutschland, which was not well-known for German "original" dramas, was supported and strengthened through broadcasting license fees.

Convergences between Television Drama and Film

In addition to bringing together public-service broadcasting and commercial pay TV, *BB* also exemplifies intensified convergences with the film sector, pointing to further transformations in the television industry. In general, German film production is highly dependent on television. Still, it appears to be a rather new development that German quality TV projects like *BB* take an approach to funding reminiscent of independent films by raising money from various sources.

In the case of *BB*, approaches similar to the financing of independent films first became visible through the contributions of several funding institutions. Medienboard Berlin-Brandenburg and Film- und Medienstiftung NRW (North Rhine-Westphalia), two big players in Germany's federal funding landscape, as well as the national German Motion Picture Fund, supported the project. These groups have more comprehensively opened up to funding television dramas, in accordance with other film subsidy institutions in Germany and throughout Europe. Co-financing, in contrast to the 100-percent financing model, is typically a basic condition for the financial support of television dramas, and only producers, not platforms and broadcasters, can apply for it. The regional funding institutions usually aim for "local effects," economic benefits in their territories, such as Berlin and the neighboring state of Brandenburg in the case of the Medienboard.

Convergences between film and television can also be found in X-Filme Creative Pool, the production company behind *BB*, which is regarded as the main initiator of the project. It optioned the rights to Volker Kutscher's best-selling crime novels about inspector Gereon Rath in 1920s' and 1930s' Berlin and approached ARD representatives about making the novels into a television drama. By then, X-Filme Creative Pool was well-known for arthouse cinema productions in German-speaking (e.g., *Das finstere Tal*/The Dark Valley, 2014), European (e.g., *The White Ribbon*, 2009), and transatlantic contexts (e.g., *Cloud Atlas*, 2012). However, years before the COVID-19 pandemic, the theatrical distribution of arthouse films had already become increasingly difficult, as some production members of *BB* emphasized. At the Berlin-based media conference *re:publica*, Stefan Arndt,

longstanding managing partner of X-Filme Creative Pool, noted that, because of these economic challenges in cinema, the production company made a "16-hour feature motion picture" for television with *BB*.[17] In this statement, a certain set of cultural aspirations comes to light, recalling former German miniseries such as *Berlin Alexanderplatz* (1980) and their categorization as multipart films. But the statement also refers to economic transformations; since the inception of *BB*, X-Filme Creative Pool has increasingly embraced the production of television dramas, for instance with the crime miniseries *Die verlorene Tochter* (The Lost Daughter, 2020) for ZDF. The example of X-Filme Creative Pool suggests that especially companies associated with arthouse cinema, which have experience with transnational film distribution, can fulfill the need for German quality TV drama with transnational appeal.

Transnational and National Orientations

Transnational orientation already played an important role in the early financing stages of *BB*. Beta Film, a transnational distributor based in Munich, serves as a co-producer of the serial. As former WDR head of fiction Gebhard Henke explained, Beta Film contributed "risk capital" and hoped that its investment would be recouped through sales to other markets.[18] In this regard, *BB* differs from most fictional productions of the German television industry, which has generally been quite restricted to national or at least German-speaking audiences, a fact that some practitioners have lamented.[19]

In *BB*, a transnational orientation can also be seen through the involvement of Tom Tykwer, who played a crucial role in the early acquisition of funds and fees for foreign licenses, according to several production members.[20] As the director of feature films that have circulated beyond Germany (especially *Run Lola Run*, 1998) or were conceived as international, English-language productions from the start (*Perfume: The Story of a Murderer*, 2006), Tykwer surely represents the transnationalism which, according to several television professionals, is required by new funders and distributors such as pay TV and VOD services.[21]

At the same time, *BB* points to the continuing relevance of national and local financiers, as all investors have their roots in Germany. The national role in funding television drama has not diminished, but rather changed. Given the concurrency of local and transnational funding, *BB* might be more precisely categorized as "glocal" rather than just transnational. The term "glocal" linked

to concepts of "glocalization" refers to the fact that local, national, regional, transnational, and global processes go hand in hand.[22]

BB's national and transnational aspects are also visible in the practitioners' negotiation of the show's distribution. The programming of *BB* in Germany and especially within the ARD network, and the response by the audience there, formed crucial topics in the coverage of the show on *DWDL.de* as well as in several interviews.[23] The TV ratings for linear distribution on ARD's national channel Das Erste decreased after the start of the first episodes of seasons one and three during the prominent time slot of *Tatort* (1970), the popular crime procedural that airs on Sunday nights.[24] Whereas in 2018 the first three episodes of season one reached almost eight million viewers (a number almost comparable with *Tatort*), the subsequent ratings of the linear broadcasting of seasons one and two fell to an average of 3.7 million viewers.[25] The finale of season three, which aired in October 2020 on Das Erste, was seen by only 2.9 million viewers.[26] On many nights, *BB* episodes drew fewer viewers than other German drama programs such as *Lena Lorenz* (2015–), the popular ZDF procedural about a midwife in the Bavarian countryside.[27] According to official public announcements, *BB* was still a great success for ARD because it reached many viewers on the commissioning channel's online service.[28] However, some commissioning editors from broadcasters in the ARD network indicated a certain skepticism regarding this claim and viewed performance in linear distribution as still very relevant for determining the overall success of the show.[29] Given the decreasing ratings, some pointed toward broader tensions between quality TV or "high end" serials with transnational appeal, on the one hand, and more episodic and traditional series linked to established schedules, on the other.[30] Still, in *BB* criteria other than just TV ratings in the context of linear, national distribution were significant. The show's performance on online services and beyond the German-speaking area were benchmarks that make visible the transformation of the German television industry.

Writing and Development

BB signals the emergence of a new era of German television not only in the areas of financing and distribution, but also in the realm of screenwriting and producing. Negotiations among interconnected production modes coming from the United States—including SIWGs, the figure of the showrunner, and the use of the writers' room—are closely linked to ideas of quality TV. As the leading writer-producer

behind a serial, the showrunner has been understood as a protector of quality and of "one vision," both in academic studies and in self-reflections by television professionals.[31] Still, in Germany writers do not usually produce. Only a very few established writers have been able to position themselves as creative producers who are integrated in areas beyond script development by, for example, having a say in casting. Similarly, the writers' room is often used only in rudimentary form, due to a production culture in which the individual writing of single episodes and TV films has dominated, and because of limited budgets.[32]

Nonetheless, because it enjoyed a larger budget, *BB* was able to modify standard production practices. In the *DWDL* trade magazine, Torsten Zarges argued that the investments by Beta Film, with the aim of foreign sales, were decisive in funding a more comprehensive development process.[33] The writing of the show was thus shaped by its co-financing and transnational distribution. It was due to the increased financial resources that the collaborative development of the *BB* scripts was comparatively long and intense, lasting almost three years for the first two seasons (episodes one to sixteen) according to von Borries. He explained that the writing primarily took place in an actual physical room, where he, Tykwer, and Handloegten were together "every day from nine to five."[34] They only worked separately when they were writing the respective scripts, after which they revised each other's drafts until everything became coherent. This scenario differs from the practices of many other so-called writers' rooms in Germany, in which writers typically come together for only a few meetings, as for example in the case of *Wir Kinder vom Bahnhof Zoo* (We Children from Bahnhof Zoo, 2021).[35]

Von Borries explained that there was no strict division of labor in the development process. He framed the writers' room mainly as a way of structuring multiple storylines and as a "creative space." He described how everyone was encouraged first to brainstorm without any restrictions; they later selected from the ideas that emerged in collaborative discussion. Other television professionals in Germany have similarly discussed the writers' room as a method of creativity.[36] In these accounts, it hardly appears to constitute the hierarchical, burdensome, or exploitative way of working portrayed by some scholars from media industry studies.[37]

Originating with just three writers, *BB* did not involve the kind of formal ranking that often characterizes US writers' rooms, with the showrunner at the top and the staff writer at the bottom. Rather, the three key creatives enjoyed equal rights in writing and later on in directing, a point that von Borries emphasized (in contrast to some press coverage which one-sidedly focused on

Tykwer, the most well-known of the trio). This three-person team recalls the small and also less hierarchical writers' room for drama series by the Danish public-service broadcaster DR.[38] According to von Borries, this size was crucial because it already enabled "the smallest unit of an audience." Two people, von Borries suggested, can give feedback differently than just one writing partner. Beginning with the fourth season, two women writers have also become involved in *BB*, Khyana el Bitar and Bettine von Borries, the sister of writer-director Achim von Borries. In this regard, the show's writers' room practice now more closely resembles that of other recent quality TV projects from Germany, where a head writer cooperates with several writers on the basis of an already clearly outlined concept.[39] In *BB*, this "head" comes in the form of a trio, and a clear concept is given through previous episodes and the novels by Kutscher.

With the two additional women members in the writers' room, *BB* has become somewhat more diverse. Given the key creatives, the show is in general narrated from a "male point of view," a criticism articulated by Annette Hess, well-known writer of the miniseries *Wir Kinder vom Bahnhof Zoo* and *Weissensee* (2010–18).[40] Hess has a loose connection to Achim von Borries and Henk Handloegten: she wrote the draft on which they based their script for *Love in Thoughts* (2004), an arthouse drama also set in Berlin during the late 1920s. Hess suggested that the heroine Charlotte Ritter always caters to the male protagonists of the show in ways similar to other German dramas with "chauvinistic" tendencies. Hess traced these tendencies back to male dominance among screenwriters and even more so among directors, arguing that "men look differently at this." In light of constructivist gender theories and their adaptation in film and television studies, such a dichotomous differentiation between a male and female gaze is questionable. But it surely makes sense to address gender in an analysis of quality TV discourses, especially if we consider gendered value judgments and Brunsdon's important notion that quality is linked to issues of power.[41] In *BB* and several other examples of serial quality TV, male dominance on the production side clearly exists, not only in writers' rooms but also in the broader development and decision-making process.

As the *BB* scripts developed further, the multivocality of the screenwriting process increased through different notes offered by the co-financing institutions. Almost twenty people, mostly men, are said to have taken part in the script reviews, with representatives from Degeto, WDR, Sky Deutschland, Beta Film, and X-Filme Creative Pool in addition to the three writer-directors. Whereas frequently practitioners had criticized such a polyphony as a bureaucratic challenge and as a hindrance to the concept of "one vision,"[42] members of *BB*'s project network

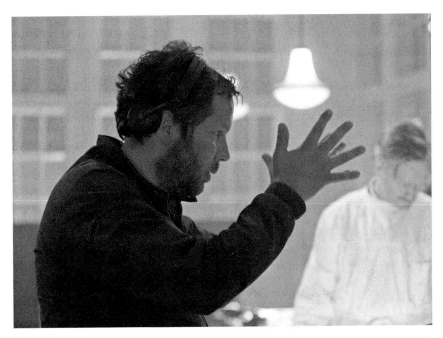

Figure 1.1 Showrunner Achim von Borries on the set of *Babylon Berlin*. Courtesy of X-Filme Creative Pool.

described it as productive.[43] Von Borries highlighted the strong autonomy he and the other two writer-directors enjoyed, suggesting that as a trio of very established creatives, they were in a strong position when presented with constructive criticism. Arguably, their agency was also linked to the fact that von Borries, Tykwer, and Handloegten served not only as writers but also as directors (see Figure 1.1).

Directing

With its trio of writer-directors, *BB* not only reflects a specific approach to showrunning and the writers' room but also registers the influence of the auteur film. Von Borries described the double role of writer and director as a decisive advantage, because it enabled the team to consider feedback on the script during shooting and to make changes even at this late stage. In directing, all three collaborators continued the intense cooperation begun during script development, whereby von Borries attributed to them particular focus areas: "There are things that Henk [Handloegten] can do best, others that Tom [Tykwer] can do best, and others that I can do best," he stated without specifying their respective qualities. According to von Borries, some interesting things

resulted from situations in which, for organizational reasons, one of them took over a task outside of his alleged priority area or supervised the editing of scenes directed by someone else. Such chances and mixtures, von Borries suggested, made the process of making *BB* "very lively."

Generally, *BB* was shot in parallel in three different units that were divided by location; the show was then edited in three different editing rooms, with the three directors switching back and forth among them. In the trio's ongoing participation from early development until postproduction, and in their realization of the "one vision," they have assumed the role of showrunners, in the sense of creators controlling different production steps. Indeed, von Borries ascribed the title showrunner to himself and his two colleagues, defining it as "the creative, artistic decider behind all things." With von Borries, Handloegten, and Tykwer also taking on the roles of writing and directing, they resemble the auteurs of European cinema more than the writer-producers of US television drama, which usually forces directors of single episodes to subordinate their work to the show's general style. In *BB*, quality TV drama with transnational distribution has not necessarily led to a loss of power for the director. In von Borries's description, screenwriting and directing often merged into each other, especially in research and the use of different historical sources. The three writer-directors wove results from their historical research into the story, thereby changing the template of Kutscher's novels. They often combined historical materials with tropes from existing dramas and films, which Redvall categorizes as "trends, tastes and tradition" in her model of the "screen idea system."[44] Moreover, "jour fixe" nights for the whole team took place, with lectures by historians, film screenings, and Charleston dance classes, "just to develop an understanding for the time," as von Borries put it. Certainly, in the German television landscape such events are only possible in a high-budget, time-intensive drama. Television professionals and especially writers from other shows complained that usually there was no funding for such research, attributing the supposed quality deficits in German television drama to this lack.[45] Against this backdrop, *BB* again appears as an exception in the German television industry and its fiction productions.

Conclusion and Outlook

In spite of the exceptional status of *BB*, my analysis of the industry discourse on this show demonstrates several components that are broadly pertinent

to the current transforming and transnationalizing television landscape in Germany. First, *BB* points toward changes in funding that arguably have to take place to make quality TV dramas in the German context possible. The complex co-financing of *BB*, including federal subsidies, indicates fruitful and innovative ways of gaining higher investments for shooting and especially for script development, highlighted by many practitioners as a particularly crucial basis for quality. However, the move to quality TV serials with larger budgets may mean that the broadcasters' output of smaller productions in the form of one-off TV films will decrease. "We need to do less, but sell it more as an event," Gebhard Henke has suggested, predicting the direction taken by public-service broadcasters, which continue to be by far the most important commissioners on the German television market.[46] For many television professionals in Germany, this is a worrisome scenario, since both their self-conception and their income are closely linked to the single TV film, and only a small established elite may have the chance to contribute to expensive quality TV drama like *BB*.

Together with financing, *BB* displays new partnerships and increased flexibility in a diversified television landscape. However, the cooperation by ARD and Sky Deutschland underlying the series' co-financing so far remains an individual case. In respect to public-service broadcasting, the liaison might be viewed critically as a continuing commercialization in a neoliberal age, one that carries many risks. Public-service broadcasters may become invisible relative to their younger, commercial partners. They may find themselves submitting to the commercial laws of the transnational streaming market and forgetting their traditional orientation to public and cultural value. For transnational streaming providers, which often aim for speed in production and distribution, public service partners pose a challenge due to their institutional complexity and bureaucracy. Furthermore, these commercial platforms are often interested in exclusive "original" content that will attract new subscribers in a local context and may be distributed simultaneously in different territories. Netflix in particular operates according to the studio model by undertaking significant portions of production alongside distribution and by binding some key creatives with exclusive contracts. Thus, the 100-percent financing by only one broadcaster (from which *BB* marks a crucial departure) is by no means obsolete.

BB hardly represents the only scenario for the German television industry, something that is also evident on the micro level, in screenwriting and production. To be sure, the embrace of writers' rooms and showrunners can also be found in other recent quality TV projects such as *Deutschland 83/86/89*. But

compared to *BB*, most of these projects are miniseries with significantly fewer episodes. Collaborative script development and a leading writer-producer figure make even less sense for one-off TV films, which continue to be a decisive part of public-service fiction in Germany.

The director-centric vision that has arguably resulted from the traditional and lasting focus on single TV films is questioned in the industry's ongoing discourse on German quality TV. Several practitioners argue that the director must step back in serial quality TV drama and give the writer more space and power. Against the backdrop of such reasoning, *BB*, with its convergence of writer and director and bonds to the auteur model, appears to represent a problematic and outdated form of television drama production.

By focusing on industry debates about *BB*, this chapter has mainly touched on production issues and less on textual aspects. But in consideration of Redvall's "screen idea system," existing texts, including films and television dramas, are of course a crucial force as well, shaping practitioners' negotiations. In the context of their discourse on quality TV, *BB* marks a step toward increased serialization, with more episodes and seasons than many other "quality" dramas from Germany and a very clear difference from the single television film. But *BB* hints at textual traditions, too, for example by its affiliation to the crime genre, which dominates today's television drama in Germany especially among public-service broadcasters. Furthermore, in terms of the era, topics, and setting, certain linkages can be seen to "German Historical 'Event Television,'" which has achieved success by dealing with historical issues and especially the era of National Socialism in two or three ninety-minute parts.[47] Von Borries has expressed a very critical view of this recent trend of historical event television, which he indicts as a formulaic "falsification of history" lacking in originality. By contrast, he suggests that *BB* is a more nuanced, less stereotypical show.

As in the case of possible predecessors from historical event television, *BB* points to both transformations and traditions of German television drama. Traditions can also be seen in the German roots of all financiers, whereas the transnational orientation through the investing distributor Beta Film reflects television's more general transition "from a national, largely broadcasting, market to a transnational, multiplatform market."[48] Linked to the rapid growth of internet-distributed television services worldwide, there are now greater possibilities for foreign sales of non-English-language content. In the German context especially, *BB* represents these prospects, because it stands out in its budget size, its funding structure, and in its specific style of writing and producing.[49]

Acknowledgment

This article is an outcome of the research project *"Quality Series" as Discourse and Practice: Self-theorizing in the German TV Series Industry* that was funded by the German Research Foundation (DFG).

Notes

1 Florian Krauß, "'Quality Series' and Their Production Cultures: Transnational Discourses within the German Television Industry," *Series—International Journal of TV Serial Narratives* 4, no. 2 (2018): 47–59.

2 Robert J. Thompson, *Television's Second Golden Age: From Hill Street Blues to ER* (New York: Continuum, 1996).

3 Charlotte Brunsdon, "Problems with Quality," *Screen* 31, no. 1 (1990): 77.

4 Eva Novrup Redvall, *Writing and Producing Television Drama in Denmark: From the Kingdom to The Killing* (Basingstoke: Palgrave Macmillan, 2013), 31.

5 Ian W. MacDonald, "Behind the Mask of the Screenplay: The Screen Idea," in *Critical Cinema: Beyond the Theory of Practice*, ed. Clive Myer (London: Wallflower, 2011), 113.

6 Arnold Windeler, Anja Lutz, and Carsten Wirth, "Netzwerksteuerung durch Selektion: Die Produktion von Fernsehserien in Projektnetzwerken," *montage AV* 10, no. 1 (2001): 91–124.

7 Torsten Zarges, "2.200 Stunden Material—und nun auch noch ein Nachdreh: TV-Mammutprojekt 'Babylon Berlin,'" *DWDL.de*, February 8, 2017, https://www.dwdl.de/nachrichten/60035/2200_stunden_material__und_nun_auch_noch_ein_nachdreh/.

8 Stewart Clarke, "'Babylon Berlin,' Mainland Europe's Most Expensive Show, Set for Third Season," *Variety*, August 23, 2018, https://variety.com/2018/tv/news/babylon-berlin-season-three-sky-ard-beta-tom-tykwer-volker-bruch-1202818468/.

9 Gabriela Sperl, interview by Florian Krauß, November 22, 2018.

10 Susanne Eichner and Andrea Esser, "Key International Markets: Distribution and Consumption of Danish TV Drama Series in Germany and the UK," in *Danish Television Drama: Global Lessons from a Small Nation*, ed. Anna Marit Waade, Eva Novrup Redvall, and Pia Majbritt Jensen (Cham, Switzerland: Palgrave Macmillan, 2020), 190.

11 Martina Zöllner, interview by Florian Krauß, October 26, 2018.

12 Oliver Castendyk and Klaus Goldhammer, *Produzentenstudie 2018: Daten zur Film- und Fernsehwirtschaft in Deutschland 2017/2018* (Leipzig: Vistas, 2018), 38.

13 Joachim Kosack, interview by Florian Krauß, January 29, 2019.

14 Uwe Mantel, "Wackelt 'Babylon Berlin'? Alle Partner wiegeln ab," *DWDL.de*, October 20, 2015, https://www.dwdl.de/nachrichten/53133/wackelt_babylon_ berlin_alle_partner_wiegeln_ab/.

15 Florian Krauß, "From 'Redakteursfernsehen' to 'Showrunners': Commissioning Editors and Changing Project Networks in TV Fiction from Germany," *Journal of Popular Television* 8, no. 2 (2020): 186–7.

16 Zöllner, interview.

17 Stefan Arndt, "Neue Player, frisches Geld: Goldene Zeiten für Film und TV," panel at *re:publica*, Berlin, May 8, 2017.

18 Gebhard Henke, interview by Florian Krauß, March 8, 2018.

19 Edward Berger, interview by Florian Krauß, November 26, 2018.

20 Frank Jastfelder, interview by Florian Krauß, November 16, 2018.

21 Kosack, interview.

22 Kim Toft Hansen, "Glocal Perspectives on Danish Television Series: Co-Producing Crime Narratives for Commercial Public Service," in *Danish Television Drama*, ed. Waade, Redvall, and Jensen, 84–5.

23 Liane Jessen, interview by Florian Krauß, January 17, 2019.

24 Timo Niemeier, "'Babylon Berlin' endet einstellig, ZDF bei Jüngeren stark: Die ARD ist trotzdem zufrieden," *DWDL.de*, October 23, 2020, https://www.dwdl. de/zahlenzentrale/79944/babylon_berlin_endet_einstellig_zdf_bei_juengeren_ stark/?utm_source=&utm_medium=&utm_campaign=&utm_term.

25 See Alexander Krei, "Starker Auftakt: 'Babylon Berlin' startet auf 'Tatort'-Niveau," *DWDL.de*, October 1, 2018, https://www.dwdl.de/zahlenzentrale/69006/starker_ auftakt_babylon_berlin_startet_auf_tatortniveau/; and Uwe Mantel, "'Babylon Berlin' kehrt auf 'Tatort'-Sendeplatz zurück: Am 11. Oktober geht's los," *DWDL.de*, June 24, 2020, https://www.dwdl.de/nachrichten/78206/babylon_berlin_kehrt_auf_ tatortsendeplatz_zurueck/.

26 Niemeier, "'Babylon Berlin' endet einstellig."

27 Alexander Krei, "'Babylon Berlin' fällt hinter Hebammen-Serie im ZDF zurück," *DWDL.de*, October 12, 2018, https://www.dwdl.de/zahlenzentrale/69197/babylon_ berlin_faellt_hinter_hebammenserie_im_zdf_zurueck/.

28 Timo Niemeier, "'Babylon Berlin' bricht in der ARD-Mediathek Rekorde," *DWDL. de*, October 10, 2018, https://www.dwdl.de/zahlenzentrale/69174/babylon_berlin_ bricht_in_der_ardmediathek_rekorde/?utm_source=&utm_medium=&utm_ campaign=&utm_term; and Niemeier, "'Babylon Berlin' endet einstellig."

29 Jessen, interview.

30 Claudia Simionescu and Harald Steinwender, interview by Florian Krauß, November 7, 2018.

31 Redvall, *Writing*, 103; Kosack, interview.

32 Florian Krauß, "Writers' Room and Showrunner: Discourses and Practices in the German TV Industry," in *Handbook of Script Development*, ed. Craig Batty and Stayci Taylor (Cham, Switzerland: Palgrave Macmillan, 2021), 251–66.

33 Torsten Zarges, "Endlich mehr Output für High-End made in Germany: Serien-Preview 2017," *DWDL.de*, January 10, 2017, https://www.dwdl.de/magazin/59485/endlich_mehr_output_fuer_highend_made_in_germany/.

34 Achim von Borries, interview by Florian Krauß, February 21, 2019.

35 Annette Hess, interview by Florian Krauß, March 7, 2019.

36 Krauß, "Writers' Room."

37 John Thornton Caldwell, *Production Culture: Industrial Reflexivity and Critical Practice in Film and Television* (Durham, NC: Duke University Press, 2008), 211–16.

38 Redvall, *Writing*, 132.

39 Krauß, "Writers' Room."

40 Hess, interview.

41 Brunsdon, "Problems," 73.

42 Redvall, *Writing*, 132.

43 Henke, interview.

44 Redvall, *Writing*, 31.

45 Hanno Hackfort, Bob Konrad, and Richard Kropf, interview by Florian Krauß, February 14, 2018.

46 Henke, interview.

47 Paul Cooke, "Heritage, *Heimat*, and the German Historical 'Event Television': Nico Hoffmann's teamWorx," in *German Television: Historical and Theoretical Approaches*, ed. Larson Powell and Robert Shandley (New York: Berghahn, 2016), 175.

48 Graeme Turner, "Netflix and the Reconfiguration of the Australian Television Market," *Media Industries Journal* 5, no. 2 (2018): 137.

49 As this volume was going to press, Sky Deutschland announced that, beginning in 2024, it would no longer commission scripted original drama series in Germany. The announcement, which came as a surprise to industry insiders and media commentators, cited as reasons for the decision the rising cost of producing scripted content and the proliferation of streaming providers. Sky Deutschland's move to immediately disband its scripted originals arm could have led to the cancellation of *Babylon Berlin*, which had not yet begun production of its fifth season when the announcement came. However, ARD quickly proclaimed its intention to proceed with season five without the participation of Sky Deutschland. It is thus very likely that other producers will step in to take over Sky Deutschland's role and facilitate completion of the series' final season.

Defective Detective Meets Sassy Secretary, Plot Ensues: *Babylon Berlin*, TV Tropes, and Pop Narratology

Doria Killian

As the opening credits to the first episode of *Babylon Berlin* fade from view, a curious scene appears on screen. A middle-aged man, his skin severely pockmarked, speaks softly, hypnotizing a patient who will later be introduced as the protagonist Gereon Rath. Over a montage of shots shown in reverse, the man's voice intones: "I will now take you back. To the source. To the source of your fear. I will guide you. Step by step. Step by step. All the way to the source of your fear. To the truth" (S1, E1). From there, the hypnotist guides his patient's thought to a specific time and place: Cologne before the First World War. For the character Gereon, this is the "source" that the hypnotist has vowed to lead him back to. For the nascent viewer, however, who knows nothing of either of these characters, the "source" of this enigmatic scene is whatever took place in the narrative before this moment, leading these men— whoever they may be—to find themselves in these curious positions: hypnotist and hypnotized. This sort of framing device is hardly novel. Following a form of the *in medias res* technique first identified by Horace around 19 BCE, countless narratives have relied on this structure to open a story.[1] The specific form of the technique deployed in *BB*—in which a beginning in medias res is followed by a retelling of the events leading up to that point—was termed "anachrony" by narratologists of the late twentieth century. The fan-created website TV Tropes dubs it much more colloquially "How We Got Here," listing among its many examples *The Odyssey, Citizen Kane, The Lorax*, and a 2012 ad for Diet Mountain Dew.[2]

Given the setting of the series in late 1920s' Berlin, cued for the viewer by the title card at the outset of the show's pilot, the hypnotist's statement takes

on significance beyond the beginning of the story. Commencing a mere four years before Hitler would assume power as chancellor of Germany, *BB* tells the story of the social, cultural, and political events leading up to one of the most brutal and horrific regimes of modern European history. While the narrative of *BB* focuses on fictional mysteries solved by fictional characters—the aforementioned detective Gereon Rath alongside stenotypist-cum-prostitute-cum-sidekick Charlotte (Lotte) Ritter—an undeniable part of the appeal of a series set in late 1920s' Germany is its temporal proximity to the Nazi era. Nearly every review of the series bears this out, invariably mentioning Hitler, Nazis, or the Third Reich, often before the end of the first paragraph. Articles in *The Washington Post* and *The New Republic* explicitly treat the series as a history lesson about rising fascism, while reviews of the first season in the *Frankfurter Allgemeine* and the *Süddeutsche Zeitung* are headlined, respectively, "In rapture, before the downfall" and "It could have all happened differently."[3] Read along these lines, the origin that the viewer is being led back to can be interpreted as the historical period preceding the foregone conclusion of Hitler's dictatorship. In its details, the ending of *BB* is uncertain: we don't know what will happen to protagonists Gereon and Lotte. But from a wider scope, the ending is all too obvious: we know what happens to Germany. The opening scene of *BB* thus introduces two narrative enigmas simultaneously: one of content, asking how events in the narrative have unfolded up to this point, and one of context, asking how the sociocultural circumstances of Weimar-era Germany gave way to the Nazi dictatorship.

Fan-created paratexts of the series have engaged with both of these enigmas, from Reddit threads discussing narrative developments to YouTube videos providing background information on interwar Germany to fan fiction with such categorization labels as "WW1," "PTSD," "Goethe," and "Survivor Guilt."[4] Yet nowhere in the realm of *BB* fandom is the link between narrative and culture, between content and context, as apparent as on the fan-created-and-maintained website TV Tropes, which catalogues narrative devices and conventions (the "tropes" of its name) across cultures, eras, and media. While certain tropes occasionally overlap with the scientific narratology of the last century—seen in the similarity between anachrony and How We Got Here—the analysis on the TV Tropes page for *BB* extends beyond the scope of mere narrative mechanics to incorporate the cultural and intertextual dimensions of the series. The website allows fans of *BB* to participate in a form of postclassical pop narratology, in which the show's narrative structure is inextricably bound to its cultural context. Foregrounding the intertextual and transhistorical elements of *BB*, TV Tropes

examines its many borrowings from Weimar-era German media and its reliance on or subversion of cultural stereotype, creating a nuanced understanding of the show's narrative.

tvtropes.org: Fan Culture Meets Postclassical Narratology

Founded in 2004, TV Tropes constitutes a key site for one of the many fan practices that have arisen over the last twenty years, due to the swift advancement in technology and subsequent changes in modes of engagement with media and the narratives contained therein. Changing television consumption patterns, first brought on by the rise of DVD boxed sets and later by streaming video, freed viewers from the constraints of broadcast networks' programming schedules, allowing viewers to begin a new series at any time, to binge-watch many episodes at once, and to rewatch the same episodes or series as often as desired. Although certain fan practices emerged decades before the web went worldwide (the modern phenomenon of fan fiction arose during the 1960s among *Star Trek* fans), internet access at ever increasing speeds coupled with evolving websites and platforms has given rise to new modes of discourse and social interaction, creating myriad opportunities for fans to explore and analyze the media they enjoy. Termed "paratexts" by media scholar Jonathan Gray, these supplemental fan creations take many forms.[5] Internet archives like FanFiction. Net and Archive of Our Own allow users to post, read, and comment on fan fiction; YouTube plays host to innumerable fan videos; and the social news site Reddit enables discursive discussions about any and all subjects of fan interest.

The development of wiki software, which permits multiple users to edit a webpage from within their browser without any coding knowledge, has led to the creation of fan wikis. Because they enable many users to edit webpages asynchronously, incrementally, and transparently, wikis can be "potent collaborative tools," allowing fans to merge their ideas and efforts into a single polyvocal text.[6] Since the early 2000s, fans have created wikis for numerous television shows, film franchises, and video games, the largest of which— Marvel, DC, World of Warcraft, Yu-Gi-Oh!, and Star Wars—now contain more than 90,000 pages.[7] The vast majority of paratextual fan wikis tend, as television scholar Jason Mittell puts it, to "fall under the long shadow of Wikipedia, mirroring the site's encyclopedic approach by striving to document the storyworld and production information of an original text, explicitly serving an orienting function."[8] TV Tropes, which runs on wiki software, is one of the

few fan wikis located firmly outside Wikipedia's penumbra, with its aim and scope diverging vastly from the orienting objectives Mittell describes. Rather than functioning as a central source for information on a specific creative work's storyworld, plotline, or characters, TV Tropes seeks to dissect and decipher the elements that comprise them. At its core, TV Tropes is about explication, not orientation.

Despite the unique function of the website among fan paratexts and the enormous growth the field of fan studies has seen over the last decade, little scholarly attention has been paid to TV Tropes. Fan studies scholar Paul Booth describes the website somewhat disparagingly in his 2015 book as one that "collects particularly overused or obvious clichés on television."[9] The website itself, however, defines its aims much differently. Rather than understanding a "trope" as inherently hackneyed and therefore negative as Booth does, the website offers a much more neutral definition of the term: "Above all, a trope is a convention. It can be a plot trick, a setup, a narrative structure, a character type, a linguistic idiom ... you know it when you see it."[10] Rather than pushing prescriptive narrative norms or denigrating poor storytelling, TV Tropes insists that "tropes are just tools," explaining further: "Human beings are natural pattern seekers and story tellers. We use stories to convey truth, examine ideas, speculate on the future and discuss consequences. To do this, we must have a basis for our discussion, a new language to show us what we are looking at today."[11] On this website, tropes are natural building blocks that enable stories to be told, recognized, interpreted, and valued.

The majority of the website's pages are dedicated either to tropes or creative works. Any work can have a page, regardless of genre or cultural significance. Such pages open with a brief description of the work, including basic plot details and relevant background information. Below this introductory blurb is a list of tropes users have identified in the work, along with a brief explanation of their specific application in the narrative at hand. Trope pages follow a converse structure, with a beginning description including the trope's definition, origins, and variations followed by a list of works that employ the trope and a short description of each instance. Trope names often derive from an initial or particularly significant instance of the trope or from clownish wordplay. The character Gereon Rath is identified as an instance of the tropes "Not in This for Your Revolution," named after a line from *Star Wars*, and "Defective Detective," so named because the words rhyme. The puckish and idiosyncratic names are emblematic of the site's playful tone, fulfilling one of the two dicta in the website's Troping Code: "Fun will be had."[12] As the ad-funded website's

15,000 registered users (known as "tropers"), 550,000 pages, and ongoing translation into twelve languages attest, fun is indeed had.[13] In a review of the website published in *Reference Review*, a journal of library science, TV Tropes is described as an addictive "black hole of popular culture references," as well as "a true manifestation of the power of people linking ideas and information together."[14]

The power of TV Tropes has also been recognized by Mittell, who understands the website's explicative function as an example of what he terms the "operational aesthetic." In his 2015 book *Complex TV: The Poetics of Contemporary Television Storytelling*, Mittell proposes that contemporary television viewers focus not only on the diegetic world of the series, but also on the "creative mechanics involved in the producers' abilities to pull off such complex plot structures."[15] He relates this form of narrative enjoyment to historian Neil Harris's understanding of showman P. T. Barnum's appeal: "Harris suggests that Barnum's mechanical stunts and hoaxes invited spectators to embrace an 'operational aesthetic,' in which the pleasure was less about 'what will happen?' and more concerning 'how did he do that?'"[16] Mittell argues that the rise of what he terms "complex television," that is, narrative television in which conventional episodic forms of storytelling are redefined under the influence of serial narration, has altered the receptive practices of viewers. Complex programming entreats television audiences to move beyond a show's content and to "engage actively at the level of *form* as well."[17] The narratives of complex television feature elaborate backstories, enigmatic mythology, and overarching mysteries that are slowly revealed over the course of a season or longer. Due to their narrative complexity, Mittell explains, these series "convert many viewers into amateur narratologists, noting patterns and violations of convention, chronicling chronologies, and highlighting both inconsistencies and continuities across episodes and even series."[18]

In his discussion of the operational aesthetic, Mittell cites TV Tropes directly: "This operational aesthetic is on display within online fan forum dissections of the techniques that complex television uses to guide, manipulate, deceive, and misdirect viewers, such as the highly popular TV Tropes wiki, suggesting the pleasure of unraveling the operations of narrative mechanics."[19] To a degree, this understanding of TV Tropes is apt. The website got its start by focusing on *Buffy the Vampire Slayer* (1997–2003), an innovative and self-referential show cited by Mittell as a forerunner to the era of complex television.[20] This would indicate that the initial provocation to study storytelling conventions was driven by the increasing narrative complexity recognized by Mittell, but the site has long since moved beyond *Buffy* and complex television. In the

seventeen years since its founding, TV Tropes has cast its thematic net ever wider, accepting within its purview any conceivable medium and genre, including what we might term the "simple" TV of the twentieth century. Rather than concentrating on one text or storyworld, as would befit the operational aesthetic, TV Tropes deliberately draws connections across narrative works and worlds. Two hyperlinked clicks away from the *BB* page, a user might find themselves on the page for Shakespeare's *Titus Andronicus*, Fannie Flagg's *Fried Green Tomatoes*, or Nickelodeon's *SpongeBob SquarePants*.[21] This transmedial, transgeneric, and intertextual orientation—along with the site's inclusion of tropes that have little to do with plot mechanics or characterization—indicate that there is more to the website's appeal than the operational aesthetic alone. TV Tropes does invite fans to engage with stories at the level of form, as Mittell asserts, but on the website, form is constantly in dialogue with the contextual aspects of the narrative as well. If fans are acting as amateur narratologists, their approach and methodology extends beyond the narrative theory of the last century, resembling much more the transmedial and interdisciplinary postclassical narratology of the last thirty years.

The classical narratology of the mid-twentieth century aimed, as Gérard Genette states in his 1972 *Narrative Discourse*, "to identify elements that are universal, or at least transindividual."[22] By the 1980s, however, scholarly inquiries had begun to challenge these universalist underpinnings. The narratological models that arose in response—termed "postclassical narratology" by David Herman—are characterized by substantial cross-pollination from other disciplines, an accentuation of historical and cultural context, a widened embrace of genres and media, and a reader-oriented focus on reception and interpretation—all factors present in the popular narratology of TV Tropes.[23] The narratological inquiry taking place on the site extends well beyond mere mechanics, asking not only the "How did they do that?" of Mittell's operational aesthetic, but also: "Why did they do that? Where have we seen this before? What effect does it have? What meaning does it carry?" By taking seriously this complex interplay of content and context, TV Tropes gives users a common language—however playful it may be—to identify and examine the tropes that comprise the stories we tell and congeal into the ideologies that shape us. As *BB* tropers dissect the show's narrative anatomy, they lay bare the ideological underpinnings of its story and history—some overt, others subliminal. By placing the series in conversation with historical events, Weimar-era intertexts, and contemporary media, TV Tropes provides both method and means to address the twin mysteries established in the pilot: the one concerning the

narrative mechanics of Gereon and Lotte's fictional story; the other, the social, cultural, and political narratives that fostered bigotry in the Weimar Republic and justified genocide under the Nazi Regime.

How We Got Here: The Tropes of *Babylon Berlin*

The TV Tropes page of *BB* begins: "*Babylon Berlin* is an epic and gritty Neo Noir series set in the capital of the Weimar Republic in 1929, in a time of political upheaval, poverty-fueled crime, and lavish jazz parties. It is based on the book series by Volker Kutscher." These two short sentences bear four hyperlinks, with "Neo Noir" linked to a page on the film noir genre, "Weimar Republic" to a page of historical information about the time period, "lavish jazz parties" to information about "The Roaring 20s," and "based on" to a page entitled "The Show of the Books," which lists television adaptations of book series.[24] The introductory section then goes on to describe the main characters, the plots of all three seasons, and the show's production information, as well as to suggest that the show's "Anglosphere equivalents" include the hyperlinked *Boardwalk Empire* and *Peaky Blinders*. This abundance of hyperlinks on TV Tropes (there are eighteen before the end of *BB*'s introduction) enables users to instantaneously connect background information and narrative analysis of the series with further contexts and intertexts. Many pages, such as those on the Weimar Republic and the Roaring 20s, provide extensive historical and cultural details. "Film Noir" walks users through genre conventions and origins, while "The Show of the Books" and the pages for *Boardwalk Empire* and *Peaky Blinders* establish intertextual links between *BB* and other narratives.

Descriptions of a trope's appearance in the show tend to be concise, occasionally including snippets of dialogue to illustrate its point. One of the first tropes listed on the page for *BB* is "Aerith and Bob," a trope in which unusual names appear in the same setting as extremely common names. Next to the hyperlinked trope name is an explanation of its specific enactment in *BB*, which reads, "Most people have normal names, but the Rath family seems to like peculiar names, with brothers Gereon and Anno. The name 'Gereon' isn't really found anywhere in Germany other than 20th century Cologne (after Saint Gereon of Cologne)." Users who desire information about Saint Gereon beyond this succinct statement can click the hyperlink to the saint's page on Wikipedia. The entry is rounded out by a quote from the series, in this case Lotte's comment from the second episode of season one: "What, are you from the Middle Ages?"

This quote is in no way necessary to explain the curious naming conventions of the Rath family; the main entry has already done that. Rather, the inclusion of Lotte's quip serves at least three other functions: first, it indicates that Gereon's name is uncommon both intra—and extradiegetically; second, it brings humor to the trope's entry, which is otherwise sober and informative; and third, it captures in a single sentence the waggishness of Lotte's character, which, combined with her initial job of stenotypist, leads to her being labeled an example of the trope "Sassy Secretary."

This interplay between the humor of *BB* and the playfulness of TV Tropes appears frequently on the *BB* page. Certain tropes highlight in-universe running jokes (both the constant intrusions into photographer Gräf's darkroom and detectives Henning and Czerwinski's incessant bickering over semantics are mentioned on the page twice), while others brighten the graver aspects of the series with comical trope names. Given the setting of the series, historical figures with lesser and greater ties to National Socialism feature frequently. Those who appear fleetingly or in name only usually bear their real names, such as Konrad Adenauer, Paul von Hindenburg, and Marlene Dietrich. More substantial characters based on historical personalities, however, are rechristened, often with a name only a shade or two away from their actual moniker. Tropers list among these pseudonymized characters the Nyssen family of arms manufacturers, understood to be a proxy for the Thyssen family, whose steel manufacturing plant would prove essential to Germany's rearmament policy and war economy. August Benda, meanwhile, is said to be "a fictionalized version of Dr. Bernhard Weiss, the Jewish vice-president of the Berlin police, Chief of Detectives and head of the Political Police, who eventually fled Berlin for London a few days before Hitler became Chancellor in 1933," and Horst Kessler is identified as the Nazi martyr "Horst Wessel, including the prostitute girlfriend Erna, and his ignoble end (being shot in the head at home by a communist pimp)." Little comedy exists in the lives of these characters and even less in the fates of their real-world counterparts, but TV Tropes adds a playful wink to the topic in listing these examples under a trope called "No Historical Figures Were Harmed," a play on the American Humane Association's trademarked phrase "No Animals Were Harmed," often included at the end of film or television credits where animals are featured.

In addition to the humor embedded in the trope name, the *BB* entry for "No Historical Figures Were Harmed" is notable for its foregrounding of rather obscure historical context. Figures like Adenauer and Dietrich, who are identified in the series by name, may be known to the casual viewer, but the individuals

listed under this trope—Weiss, Wessel, and the Thyssen family—appear in the series only allusively and, moreover, are obscure enough to be recognizable only to those with substantial historical knowledge. This collaborative collection of relevant historical and cultural information is found in many other tropes as well. The entry for "Nazi Noblemen," for example, discusses Prussian Junkers, while that of "Right-Wing Militia Fanatic" provides details about the Treaty of Versailles and its disarmament stipulations. Certain tropes point out intertexts from Weimar-era film and theater, such as the films of Fritz Lang, Robert Wiene's *The Cabinet of Dr. Caligari*, and Bertolt Brecht's and Kurt Weill's *The Threepenny Opera*, and still others dissect the show's credit sequence into various cinematographic techniques borrowed from German films of the 1920s (alongside a quick note reading, "That said, German Expressionism had already fizzled by 1929").[25]

A few tropes highlight the handful of anachronisms present in the series, though tropers stress that "the makers invested a lot into historical accuracy." Many of the anachronisms identified on the show's TV Tropes page are also cited in Sara F. Hall's 2019 article "*Babylon Berlin*: Pastiching Weimar Cinema," which argues that the series' many allusions to Weimar-era cinema and culture are not intended to create a sense of historical realism, but to invite historically oriented reflection on the relationships among media, emotion, and democracy. The 1930 film *People on Sunday* appears in the 1929 setting of *BB*, as do two buildings built on Berlin's famed Alexanderplatz in the early 1930s. Hall understands these "historical 'cheats'" as intentional: "[T]hey disturb any sense of the fixedness of the past."[26] The same two anachronisms are listed on the *BB* TV Tropes page under the trope "Anachronism Stew." Like Hall, the tropers do not regard all anachronisms as errors, but make it clear that such instances of chronological hodgepodge are often employed deliberately: "A work might combine large numbers of anachronisms to create a timeless or surreal setting."[27] The similarities between Hall's understanding of anachronism and that of TV Tropes is striking, and all the more so for the fact that one is found in a nearly fifty-year-old peer-reviewed journal and the other on a fan wiki.

In other entries on the *BB* page, historical and cultural context serves as a springboard for interrogating the show's use of cultural stereotypes. The first item listed under the trope "Foreshadowing" touches on the antisemitic currents running through Weimar culture: "The first hint that Greta's Communist friends are not who they say they are is when one of them refers to Benda as 'the Jewish pig.' While some Jews and Communists certainly disliked each other, it didn't hold a candle to the virulent antisemitism of the Nazi movement, which is

later revealed to be their actual allegiance." Of course, one need not know the sociocultural specifics of antisemitism in the Weimar era to understand that this is foreshadowing; vague knowledge of the Nazi era and the Holocaust suffice for a viewer to suspect that this character is a Nazi. But the inclusion of this detail in the trope's description advances a nuanced understanding of Weimar-era German history without the overly neat moral dichotomies that mark many narratives set in or around the late Nazi era. Antisemitism is depicted as particularly "virulent" among Nazis, but widespread in groups across the political spectrum as well, including those ideologically opposed to Nazism.

The casual antisemitism of 1920s' Germany is also discussed under the trope "Deliberate Values Dissonance," which tracks the divergence between the moral values of a creative work's audience and those of its characters or setting. Given that ethical ideologies change over time, the trope is common in historical fiction, with *BB* being no exception. The entry draws an explicit line between viewers' modern sensibilities and Weimar-era culture, stating that many characters, including those not associated with the Nazi party, "express casually antisemitic statements, reflecting the day-to-day discrimination that Jews faced in Germany." Two examples are provided: "In one episode Councilor Benda (who's Jewish) is told in so many words that he isn't really German. Even our hero Gereon shows casual interest in reading *Mein Kampf* and thinks the Hitler Youth will be a positive experience for his nephew." This trope entry captures a delicate nuance of *BB*, expressing sympathy both with Jewish Benda and with Gereon, who, despite being "our hero" is at best indifferent to the antisemitism of the Nazi party. The message articulated by tropers in this entry involves the multivalent nature of identity and the complicity of ordinary—even heroic—individuals in the machinery of hate.

Rhetorical narrative theorist James Phelan has foregrounded the moral aspect of narrative, arguing that texts solicit readers and viewers to form ethical judgments about the storyworld, the story, and its creator(s). Phelan delineates four ethical positions found within a narrative, three of which are addressed by the trope "Deliberate Values Dissonance." The first position involves "the ethics of the told (the character-character relations)"; the next two "the ethic of the telling (the narrator's relation to the character, the task of narrating, and to the audience; and the implied author's relation to these things)"; and the final ethical position "the flesh-and-blood audience's responses to the first three positions."[28] The difference in these ethical positions is evident when considering how issues of sexism and misogyny in *BB* are discussed

on TV Tropes. Under "Deliberate Values Dissonance," tropers note, "the filmmakers make a point about the open sexism of the time almost Once per Episode." Here character-character relations, the relation between the implied author (here implied filmmaker) and the narrative, as well as the audience's relation to these two positions are all hinted at: while many male characters might be openly sexist to female characters within the storyworld, tropers expect that this explicit sexism does not align with the moral attitudes of the show's creators.

Elsewhere on the *BB* page, however, are tropes that examine the implicit sexism in the narrative's construction and depiction. The trope "Most Writers Are Male," for example, addresses the drastic gender imbalance in television and film writing, going on to explain that the male-dominated nature of the industry "results in the male voice being more greatly represented in media than the female voice" and leads to "Fanservice"—that is, the use of sex or sexualized characters to attract or gratify viewers—being "skewed towards the male audience."[29] Notably, *BB*, a show with three male showrunners, has an entry for "Ms. Fanservice" on its TV Tropes page, stating that Lotte often appears topless or in revealing outfits. No similar entry exists for Gereon or other male characters, but the tropes "Damsel in Distress," "Hooker with a Heart of Gold," and "Iron Lady," all of which point to potentially sexist portrayals of women, do. In these examples, the ethical positions delineated by Phelan are shifted from their alignment under Deliberate Values Dissonance. Here, the audience acknowledges sexist elements in the series, but no longer indicates that the creators employed them intentionally, thereby critiquing the extratextual and metadiegetic aspects of the storytelling process (e.g., audience demand).

A similar critique is found with the trope "Fur and Loathing," in which an article of fur clothing both becomes a character's emblem and marks them as immoral. Appearing in *BB* in the form of Edgar "The Armenian" Kasabian's staple mink collar, this trope is notable for its sociocultural contextualization of specific character details. The trope page explains that the iniquity ascribed to fur-wearing characters "is not about the politics of wearing fur, but simply how the mainstream media has portrayed it since the mid-1980s."[30] A lengthy description follows, outlining recent fur-related ethical trends and historical practices of wearing fur in various cultures. It is noted that fictional works set in places where fur clothing is common, such as Russia, "seem to portray these places and times as less enlightened, with wearing fur being a symptom of this."[31] Considering the *BB* character's commonly used moniker emphasizing Edgar's

foreignness—we do not learn his actual name until the end of the second season—and his moral positioning within the corrupt Berlin underworld, the constant presence of his fur collar hardly seems incidental. According to the *BB* fans writing on TV Tropes, the choice to include this detail, whether consciously made or not, activates a network of associations in viewers connecting fur, immorality, and foreignness, ultimately becoming a mental shortcut for Othering the character.

The intellectual rigor and sociocultural significance of the postclassical pop narratology taking place on TV Tropes becomes particularly salient when applied to works that, like *BB*, foreground the inexorable entwinement of narrative content and cultural context. As indicated by the myriad articles stressing *BB*'s topicality, historical fiction has just as much, if not more, to do with the culture of its production than the culture it depicts. *BB* premiered in Germany in October 2017, mere weeks after the federal election that saw a far-right party gain seats in German parliament for the first time since the Nazi era, and appeared on American Netflix three months later, half a year after the "Unite the Right" rally held by white nationalists in Charlottesville, Virginia. The far-right narratives that led to these political events—narratives that define and demonize ethnic and racial minorities, cast religious minorities as devious and depraved, and ascribe malice and vice to opposing beliefs—are all too similar to the narratives Gereon and Lotte encounter in *BB*, leading the particularism of the show's Weimar-era setting to give way to more universalist questions about the fragility of liberal democracy, the allure of extremist ideologies, and the repercussions of everyday complicity. In combining narrative analysis with historical and cultural context—in discerning and dissecting not only the structural elements that form and inform narratives, but their assumptions, prejudices, and ideologies as well— TV Tropes works to answer these questions. As tropers trace the relationship between Edgar's fur collar and his outsider status or compare Lotte's frequent nudity with Gereon's buttoned-up wardrobe, their analysis moves beyond both the fictional narrative of the storyworld and the historical narratives of Weimar Germany to the narratives we tell today and the views and values they communicate. Wending one's way through the labyrinth of hyperlinks found on the *BB* TV Tropes page, it is impossible to separate function from form; cultural context, ideological subtexts, and historical intertexts are woven into each inch of the site's decidedly postclassical narrative analysis. The complexity of shows like *BB* and the analysis of sites like TV Tropes indicate that the narrative turn has stepped out of academia and into pop culture, carrying along with it a critical eye toward both the power and perils of narrative.

Notes

1 M. C. Howatson, ed., *The Oxford Companion to Classical Literature*, 3rd ed. (Oxford: Oxford University Press, 2013), 74–5.

2 "How We Got Here," TV Tropes, https://tvtropes.org/pmwiki/pmwiki.php/Main/ HowWeGotHere. For a detailed description of anachrony, see Seymour Chatman, *Story and Discourse: Narrative Structure in Fiction and Film* (Ithaca, NY: Cornell University Press, 1978), 64–78.

3 Adrian Daub, "What Babylon Berlin Sees in the Weimar Republic," *New Republic*, February 14, 2018, https://newrepublic.com/article/147053/babylon-berlin-sees-weimar-republic; Jochen Hung, "'Babylon Berlin' and the Myth of the Weimar Republic," *Washington Post*, March 20, 2018, https://www.washingtonpost.com/ news/made-by-history/wp/2018/03/20/babylon-berlin-and-the-myth-of-the-weimar-republic/; Joachim Käppner, "Es hätte alles anders kommen können," *Süddeutsche Zeitung*, October 11, 2018, https://www.sueddeutsche.de/medien/ erfolgsserie-babylon-berlin-es-haette-alles-anders-kommen-koennen-1.4165626; Bert Rebhandl, "Im Rausch, vor dem Untergang," *Frankfurter Allgemeine Zeitung*, September 30, 2018, https://www.faz.net/premiumContent?contentId=1.5811726.

4 "Voll und Warm in the Dark," Archive of Our Own, August 6, 2019, https:// archiveofourown.org/works/20132689.

5 Jonathan Gray, *Show Sold Separately: Promos, Spoilers, and Other Media Paratexts* (New York: New York University Press, 2010), 144.

6 Joseph Reagle, *Good Faith Collaboration: The Culture of Wikipedia* (Cambridge, MA: MIT Press, 2010), 6.

7 "Hub:Big wikis," Fandom, https://community.fandom.com/wiki/Hub:Big_wikis/.

8 Jason Mittell, *Complex TV: The Poetics of Contemporary Television Storytelling* (New York: New York University Press, 2015), 276.

9 Paul Booth, *Playing Fans: Negotiating Fandom and Media in the Digital Age* (Iowa City: University of Iowa Press, 2015), 60.

10 "Trope," TV Tropes, https://tvtropes.org/pmwiki/pmwiki.php/Main/Trope.

11 "Tropes Are Tools," TV Tropes, https://tvtropes.org/pmwiki/pmwiki.php/ Administrivia/TropesAreTools.

12 "The Troping Code," TV Tropes, https://tvtropes.org/pmwiki/pmwiki.php/ Administrivia/TheTropingCode.

13 "Page Type Counts," TV Tropes, https://tvtropes.org/pmwiki/page_type_counts. php. Most foreign-language pages are still cursory, and the vast majority of content appears in English. As of this writing, the website does not yet have a page for *BB* in German.

14 Leslie Whitford, "TV Tropes," *Reference Reviews* 29, no. 1 (2015): 35–6.

15 Mittell, *Complex TV*, 42.

16 Ibid.

17 Ibid., 52.

18 Ibid.

19 Ibid., 43.

20 Ibid., 19.

21 Although these narratives vary greatly with regard to medium, genre, time period, audience, tone, and beyond, they all incorporate a plot element known on TV Tropes as "The Secret of Long Pork Pies," in which a meat product turns out to be human flesh (or plankton flesh, in the case of *SpongeBob*); "The Secret of Long Pork Pies," TV Tropes, https://tvtropes.org/pmwiki/pmwiki.php/Main/TheSecretOfLongPorkPies.

22 Gérard Genette, *Narrative Discourse: An Essay in Method* (Ithaca, NY: Cornell University Press, 1980), 23.

23 See David Herman, *Narratologies: New Perspectives on Narrative Analysis* (Columbus, OH: Ohio State University Press, 1999).

24 "Babylon Berlin," TV Tropes, https://tv.tropes.org/pmwiki/pmwiki.php/Series/BabylonBerlin. All subsequent references within the text refer to these pages.

25 See entries for "Iris Out," "Leitmotif," "Retraux," and "Shout-Out" on: "Babylon Berlin," TV Tropes.

26 Sara F. Hall, "Babylon Berlin: Pastiching Weimar Cinema," *Communications* 44, no. 3 (2019): 315.

27 "Anachronism Stew," TV Tropes, https://tvtropes.org/pmwiki/pmwiki.php/Main/AnachronismStew.

28 James Phelan, *Experiencing Fiction: Judgments, Progression, and the Rhetorical Theory of Narrative* (Columbus, OH: Ohio State University Press, 2007), 11.

29 "Most Writers Are Male," TV Tropes, https://tvtropes.org/pmwiki/pmwiki.php/Main/MostWritersAreMale.

30 "Fur and Loathing," TV Tropes, https://tvtropes.org/pmwiki/pmwiki.php/Main/FurAndLoathing.

31 "Fur and Loathing."

Part Two

The Look and Sound of *Babylon Berlin*

Fashion for a Global Audience: 1920s' Glamour and Grit

Mila Ganeva

Weimar fashion constitutes a key element in *Babylon Berlin*'s visual appeal to domestic as well as global audiences. Since its Netflix release in 2018, there has been a proliferation of fashion blogs, fan websites, and Pinterest pages dedicated to the discussion, recreation, and imitation of the clothes and accessories seen on screen.[1] The heightened interest in the show's outfits can be partially explained by the fact that for a long time Weimar Germany—with its electric atmosphere, decadence, and the multitude of historical associations it evokes, including being the breeding ground of the Nazi dictatorship—has been an underrepresented topic in German film and television. The most sumptuously costumed period dramas, often labeled "heritage productions," have dealt with stories primarily related to the Third Reich, the Second World War, and the Holocaust, or zoomed in obsessively on the Stasi and various Cold War conflicts.[2] For a long time, Weimar and the wild 1920s' styles were just a story and a spectacle waiting to be rediscovered. With *BB*, their moment came. And the popularity of *BB*'s fashions sheds light on *how* exactly the series reimagines and reenacts—through costume and mise-en-scène—its own fantasies of Weimar Berlin.

This chapter revisits parts of the first three seasons where sartorial display is tightly connected to the series' characters in order to explore how *BB* brings to life the visual spectacle of Weimar fashion. On one level, the role of fashion is fairly conventional: it provides vivid characterization of the central figures, their fluctuating identities, and their dramatic transformations in the course of the narrative. A closer look at the costuming strategies also conveys a sense of the postmodern mashup or pastiche that mirrors *BB*'s overall approach to recreating Weimar culture. In the same way as *BB* reconstructs an image of the late 1920s made up of various elements of the popular culture

mythologies that the period created about itself, *BB*'s costumes, too, reconstruct Weimar fashion's catalog of styles that were celebrated as sensational even back then.[3] The image of Weimar fashion refracted in the show dips into various artistic currents (from expressionism to *Art Nouveau* to *Neue Sachlichkeit*), borrows freely from the archives of different media (novels, films, illustrated magazines, and advertising), and blends the sartorial fetishism of globally popular series like *Downton Abbey* and *The Crown* with prevailing Weimar mythologies. This mashup is crafted in a way that delights both specialists who understand the subtle historical references and non-specialist viewers who may not be familiar with Weimar. Ultimately, *BB*'s composite image of fashion from the long 1920s becomes a tool to satisfy the hunger of global audiences for period drama that is visually appealing, conforming to the public's understanding of the "Golden Twenties" in Germany, and still relevant to our contemporary mores.

Transformations through Clothes

Sartorial makeovers of women as well as men are lavishly interspersed within the multiple narratives of the first three seasons in *BB* and serve to introduce new characters, outline their psychological states, social standing and aspirations, and hint at major transformations.

A sequence at the beginning of the third season, for example, thematizes men's fashion directly and demonstrates the process by which the uniformed prisoner, Walter Weintraub, is transformed into a dandyishly dressed free man. The gangster fixes his gaze on the clean, white, perfectly pressed shirt that is placed on top of an opened box with his belongings. Only a few seconds later, he has slipped into his civilian clothes. Expensive accessories complement his outfit: cufflinks, a vest, a tie, a hat, and a pocket watch with a gold chain.[4] Stepping onto the sidewalk in front of the jail, he is met by a young underling in the criminal organization, Max Fuchs (known as "Reinstecke" Fuchs) whose slick appearance matches that of Weintraub.[5] We know Fuchs as a minor character from season one, a train-tracks maintenance worker who is associated with one of Berlin's criminal networks. Weintraub's first reaction is of mild surprise: he touches the lapel of Fuchs's elegant coat, rubs the fine wool fabric between his fingers, and exclaims: "Well, well, well! Clothes make the man, huh?" (S3, E1) (Figure 3.1).

Throughout the series, however, fashion's limelight is more prominently directed at the stories of the female protagonists. Again and again, we see

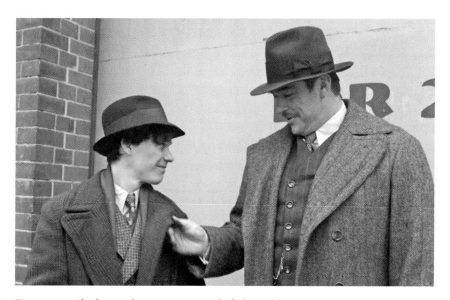

Figure 3.1 Kleider machen Leute: A newly fashionable Fuchs picks up Weintraub from prison. Screenshot, *Babylon Berlin* (S3, E1).

Charlotte (Lotte) Ritter, Greta Overbeck, Svetlana Sorokina, and other characters change attire in order to transition from one role to another, from the public world of work to the realm of private leisure and vice versa. In other words, fashion enables these characters to cross over—sometimes with ease, sometimes with considerable resistance—the fluid boundaries between seemingly irreconcilable spheres in life. Several memorable examples come to mind. The very first episode (S1, E1) introduces Lotte as she returns home to her squalid apartment in the early morning hours. With the assistance of her younger sister Toni, she changes from a sparkling sleeveless dress (golden with a black geometric pattern embroidered in the middle of the torso) she wore at the Moka Efti, where she moonlights as a prostitute, into a modest outfit (a plain off-white shirt and a brown skirt) appropriate for her office job as an aspiring assistant detective. In what looks like a last-minute whim during her ride on the street car, she uses a pair of white silk stockings as a scarf, although in reality she may be needing to cover up the hickey on her neck. After all, the transition from night work to day work requires a bit more coverup than just a fresh application of makeup. Complementing Lotte's day-time outfit is a bright green hat decorated with a feather made out of the same fabric, a hat that makes her stand out in the large group of women job seekers at the Berlin police headquarters. "The lady with the green hat" is noticed and selected for the assignment that opens the door to her future career (S1, E1). Subsequently, as Lotte progresses from

secretarial tasks to real detective work, the green hat disappears; it is replaced by an assortment of different fashionable hats that dazzle with their variety and testify to the improvement in her professional and financial situation.

Throughout this long introductory sequence with Lotte, the camera's voyeuristic attention to the protagonist's changing attire is relentless. The viewer follows every detail of this New Woman's transition from night life to her work day, from the zoom-ins on the stylish shoes and the loose-fitting silk camisole (the piece of underwear that had already replaced the tight corset for this generation of women) to the long tracking shots of Lotte confidently navigating the busy Berlin streets on her way to police headquarters. Lotte's fashion display in the apartment is complemented by her singing of Hermann Leopoldi's "Your Eyes Are Like Magnets," which reinforces the impression that this young woman not only follows the latest trends for clothes but is also familiar with the popular tunes of the time. Matching the visual attractions with aural delights, this sequence is reminiscent of Weimar's musical comedies, and specifically of the film *I by Day, You by Night* (1932), in which a young working-class girl does her morning routine while singing a song made popular by the Comedian Harmonists. Similarly in *BB*, Lotte gets dressed and puts on makeup while at the same time she and her sister break into song in synch with a gramophone playing at an open window across the courtyard.[6]

Lotte's friend Greta, a traumatized transplant from the countryside to the city, undergoes quite a different sartorial metamorphosis that is in line with her particular character development. In a scene I analyze later in this essay, Greta tries out the glitzy outfits that Lotte selects for her at the Moka Efti, but ultimately rejects them, turning down, too, the chance to earn a living as a prostitute; instead, she becomes a domestic servant for the Benda family and dons a neat conventional servant's uniform: a black dress with a white collar. On her day off and in the absence of her mistress, Greta rummages in Irmgard Benda's closet and borrows one of her fashionable day dresses. She looks at herself in the mirror, holding the dress next to her body, and is delighted by what she sees. A few moments later—clad in Frau Benda's bourgeois finery, which immediately wins her a compliment from her date ("nice dress!")—she goes on to enjoy a rendezvous on the shores of the Havel River (S1, E8). The appropriation of the shining white outfit signals an attempt by Greta to regain the innocence lost by her previous missteps: her unwanted pregnancy and the scars of a crudely performed Caesarian section that her clothes cover up. At the same time, the blinding whiteness of the dress seems to foreshadow Greta's continuing naiveté that will later make her a victim of her boyfriend Fritz's schemes.

Most dramatic, of course, is Sorokina's makeover. At night the Russian emigrée appears as the singer Nikoros on the stage of Moka Efti. But as soon as her singing number is over, she removes the makeup, the wig, the tuxedo, and other accessories that give her the appearance of a man, and transforms into a platinum blond seductress. On the morning after spending the night with Alexej Kardakow, also a Russian emigré, Sorokina metamorphoses into yet another private role, that of the purported Russian countess on a mission to recover her family's fortune: she launches a relentless pursuit of the gold that is supposedly hidden in a train car. At the freight yard, Sorokina is appropriately dressed for her dangerous mission: a long winter jacket that resembles—in cut and color—a military coat (S1, E3). It recalls more aptly the styles worn by women during the First World War, rather than the playful civilian elegance associated with the late 1920s. Completing the look is a tightly fitting cloche hat (with three parallel arrows in the front) that covers her head like a protective helmet.[7] She reappears in this severe-looking outfit in multiple scenes throughout the series' first season.

These are just some of the temporary—sometimes redemptive, sometimes symbolic, sometimes purely pragmatic—conversions related to the stories of women in *BB*. Their sartorial makeovers underpin these characters' complex dynamism and at the same time allow the audience to indulge in the spectacle of what appears to be authentic Weimar fashion. The subtle narrative emphases on the change of clothes point to the instability of protagonists' identities. Yet they also highlight the new freedom, flexibility, and variety of roles that—according to the prevailing mass-cultural mythology about Weimar—opened up for a generation of young women often referred to as New Women.

Recreating the "Authentic" Weimar Costume

In her groundbreaking article on *BB*, Sara Hall explores the relationship between the series' production process, its formal attributes, and its global reception history. She convincingly argues that it is through the techniques of pastiching (i.e., selective imitation, adoption, appropriation, and reworking of various film references) that the series creates its specific sense of historic authenticity as well as induces the viewer to reflect on a critical comparison between the fictionalized presentation of the past and the viewer's present moment. "In the case of *Babylon Berlin*," Hall writes:

> [T]he entity that is pastiched is not a single film or even a single genre but a catalog of work that has come to be considered a discrete entry in film history

despite its kaleidoscopic diversity: Weimar cinema. *Babylon Berlin* displays a refined awareness that segments of its viewership will come to the series with expectations about Weimar cinema, and it correspondingly confirms that such an entity exists.[8]

Hall's argument is also applicable to the broader category of Weimar visual culture, and particularly, to one of its constitutive and particularly attractive elements: fashion. The 1920s, like no other decade, introduced a radically new appearance eagerly embraced by a generation of young women who believed in fashion's promise of sexual liberation, social mobility, economic advancement, and narcissistic gratification outside of the confines of traditional identity politics. The emancipated agents of this new fashion were given different labels—flapper, Girl, garçonne—but all of these figures merged in the mythical image of the New Woman, which is prominently present in the visual media of the time. According to these mass-media accounts, the New Woman moved freely in public space, smoked, worked, earned her own money, shopped, and frequented various entertainment venues in her leisure time. She also displayed a fixed set of external features: hemlines raised to the knee, bobbed hair, and a slender androgynous body clad in a jumper dress with clear lines and a tubular silhouette.[9]

References to these key facets of 1920s' fashion abound throughout *BB*'s first three seasons. The version of Weimar fashion that is "pastiched" into the series, however, is not a monolithic entity, but rather a multifaceted, dynamic, and eclectic phenomenon. Women from all social strata participated in it. It was also not exclusively German, as the 1920s' styles were popular in all the big cities throughout Europe, the Americas, and even East Asia. Parisian couturiers such as Jean Patou, Jeanne Lanvin, and Coco Chanel set the tone, and their creations were adapted for mass consumption by the Berlin-based *Konfektion*.[10] It is this international aspect and universal appeal of Weimar-era styles, combined with the ambition to reach audiences beyond Germany, that may have determined the choice of costume designer Pierre-Yves Gayraud for the series. With an established reputation for imaginative historical costumes in *Indochine* (1992), *The Bourne Identity* (2002), *Perfume* (2006), *Albert Nobbs* (2011), and *Cloud Atlas* (2012), the French designer seemed well prepared for the challenges of a German series with global distribution.[11] According to the teaser-trailer produced by German broadcaster ARD, Gayraud's extensive iconographic research involved more than 3,000 documents, including illustrated magazines and newsreel footage. His international team that included German designer Bettina Seifert created costumes for some 400 leading roles, 150 smaller parts,

and close to 8,000 extras in the first three seasons. The preparation for all 28 episodes included a total of 2,500 historic costumes and nearly a thousand dress rehearsals.[12] Thus *BB* surpassed the record set by Rainer Werner Fassbinder's 1980 series *Berlin Alexanderplatz* (also set in Weimar Berlin), which featured lavish costume designs for more than 100 actors and 3,000 extras.[13]

Far more impressive than the numbers is the costumes' actual function in *BB*. On a basic level they fulfill their prescribed subordinate role, namely to support the expansive, multilayered narrative and reflect the genre expectations associated with a fictional historic series set in Berlin in 1929–30.[14] Thus, we see outfits that cover the whole register of possibilities—from professional wear to evening gowns, and from rags for the city's poorest inhabitants to police uniforms, party dresses, drag queen outfits, and even the iconic Josephine Baker banana skirt—all recreated with vintage textiles, a high level of realism, and reflecting the German, but also international versions of 1920s' fashion. There are plenty of scenes that have the effect of an indulgent fashion show—very often a display of hats with fanciful decorative elements—that have no narrative connection to the particular situation. But for the most part the costumes perform a conventional function, namely, in service of the protagonists' consistent identification and nuanced characterization. Gayraud went to great lengths to achieve the most authentic Weimar look tailored to each individual character. Even the lead actors were surprised by the enormous effort and the amount of time spent on finding the right sartorial detail. In ARD's promotional video, Volker Bruch (who plays the leading role of police detective Gereon Rath) recalls that on one occasion he had to try on ten to twelve hats before a final choice was made. As Gayraud himself states in the same making-of featurette, his team "tried to create a small world of its own for each actor and actress" and, at the same time, to maintain that "world" consistently over the course of the series.[15]

Throughout multiple episodes, the costumes of the female protagonists, for example, seem to conform to a prescribed color scheme and contribute to the characters' visual consistency: while Lotte's wardrobe sticks to a predominantly warm palette of creams, yellows, and browns, Helga is often clad in cool colors (bluish- or petrol-colored dresses), and Sorokina's off-stage wardrobe is mostly in dark monochrome grayish or brownish tones. Most conspicuous among the male protagonists is the idiosyncratic character of Alfred Nyssen, a wealthy industrialist with an extravagant lifestyle who aligns himself with Weimar Germany's reactionary forces.[16] With his distinct penchant for colorful ties and scarves (S1, E4), Nyssen stands out as the dandy in the series. In his meeting

with Colonel Gottfried Wendt at the race track, Nyssen appears in striking "Oxford bags," the extremely wide-legged trousers popular among male students at Oxford University starting in 1924 that spread across Europe as a fashion statement.[17] The racetrack scene (S2, E2) features a stark juxtaposition of the respective attire on the two men standing in front of the barn with their backs to the camera—Wendt's riding breeches (a hint at their later becoming part of the Nazi officers' uniform) next to Nyssen's Oxford bags (Figure 3.2). Both eye-catching pieces of clothing clearly differ from the regular bourgeois attire worn by the majority of male characters in the show and suggest not only the relatively wide spectrum of significations within Weimar male fashion, but also the significant roles that both men will play in future political developments.

Gayraud's concept for the costumes' historic authenticity is not averse to mixing of styles nor does it adhere to a strict chronology. In other words, for the episodes

Figure 3.2 Nyssen sports Oxford bags (dramatic wide-legged trousers) at his meeting with Wendt. Screenshot, *Babylon Berlin* (S2, E2).

set in 1929, he recreates an "authentic" Weimar fashion by fusing stylistic elements from diverse trends within the long 1920s and also from different national variations. A closer look at the women's hats, fabric patterns, and the varying cuts and hemline lengths provides plenty of examples of this hybrid approach. Sorokina's and Greta's cloche hats, Lotte's dance dresses, and the bold decoration on Irmgard Benda's blue coat are only a few examples with contrasting geometric patterns, abstract forms, and striking angular lines that are more typical for the expressionist style of the earlier Weimar years (up until 1925–6) than the end of the decade, when longer hemlines, solid colors, and more fluid feminine silhouettes prevail. The latter features are associated with the style of *Neue Sachlichkeit* and are present in the show's costumes for the female office workers and, most prominently of course, in Lotte's professional appearance as a police detective.

There are also the stylistic throwbacks to *Art Nouveau* with its nature-based elements: just think of the big decorative feather on Lotte's green and brown hats, the bold floral pattern of the similar-looking dresses she wears during both visits to the nightclub Der Holländer (S1, E5 and S3, E4), or the more discreet bloomy ornaments on the shirt she often wears at the police station, as well as the tiny embroideries along the collars of her coats. In addition, the show features clothes that are old-fashioned, boring, poor, rumpled, drab, shabby, or even tattered, but these costumes, too, appear diligently researched and designed with care in correspondence to the role, status, and situation of the characters who wear them. In other words, the vast costume inventory includes both the spectacular and the quotidian, and although they are stylistically hybrid, it is obvious that they are based on historical images.

To audiences familiar with lavishly costumed dramas from the 2010s, such as the series *Downton Abbey,* or the couture in 1990s' German films such as *Comedian Harmonists* (1997), *Aimée & Jaguar* (1999), and *Marlene* (2000), *BB* may appear as yet another heritage production updated for the twenty-first-century audience of streaming television. According to Lutz Koepnick, heritage cinema, in contrast to conventional costume dramas, does not simply conjure a historical period as an atmospheric background for the story; it parades "the texture of the past as a source of visual attractions and aural pleasures." Watching a heritage film gives the audience a chance to savor "the materiality of the moment" and to indulge in "the nostalgic aura of dress, hairstyle, dwelling and song."[18] To be sure, *BB* does share some of the features of heritage cinema. The series is full of instances that privilege costume and mise-en-scène over narrative and invite viewers to appreciate the splendor of the clothes, hats, and exquisite fabrics. Its gaze is at moments indeed "museal," "transforming the

past into an object of consumption," to use Koepnick's formulations, which is confirmed by the blogs and websites dedicated to its fashions. One can imagine how *BB*'s costumes—very much like those in *Downton Abbey* or *The Crown*—could soon hit the museum circuit as part of popular exhibits.[19] For the most part, however, *BB* transcends the conventions of the heritage production. Its costumes and hairstyles, especially those of the characters on the lower ends of the social spectrum, have a carefully crafted gritty appearance and are actually a far cry both from the glamour of Hollywood and the British productions' impeccable gloss. The editing is generally fast paced, action-oriented, steadily focused on the narrative, which, for the most part, does not allow for prolonged gazing at the spectacle of clothes and accessories. Finally, the playful stylistic hybridity of Weimar's high fashion on screen, and especially those scenes of sartorial display that reveal the dark sides of the period (discussed below) push against the nostalgic pull of the heritage film productions.

Zooming in on Fashion

Although *BB*'s costumes overall adhere to their conventional functions—to reinforce the protagonists' continuity and realism—there are still multiple scenes in which attire performs a more dynamic, assertive role, and participates in something of a fashion show within the series' interweaving narratives. As film costume scholar Stella Bruzzi points out, costumes sometimes present "spectacular interventions into the scenes in which they appear," adding their own twists and emphases to the narrative.[20] Exactly this happens in the scenes of metamorphoses through clothes that were outlined at the beginning of this chapter. In all of these sequences the camera traces carefully a change of attire that signals a transformation in the life of the character that has already happened (Weintraub), has potential to take place (Greta), or happens habitually, on a daily basis (Lotte). Taken as a whole these scenes provide an apt visual commentary not only on Weimar's obsession with the superficial but also on the real and imagined opportunities for social mobility, as well as the ambiguity, limitations, and contradictions associated with these opportunities.

Of the multiple examples of symbolic sartorial makeover, those involving the two friends Greta and Lotte in the backroom of the Moka Efti demand closer attention. When the aspiring assistant detective Lotte runs into the hungry and homeless Greta, she brings her friend to the club (S1, E4). They quickly change into party outfits in the dressing room at the back of the entertainment

establishment. It is an uplifting female bonding experience: taking a cue from Lotte, Greta dons a sleeveless red dress with golden floral embroidery, puts on make-up, and dances with abandon next to her friend on the floor of the Moka Efti. However, when Lotte leaves the dancefloor to meet a customer and deserts her friend, Greta loses confidence. She is terrified by two young men approaching her with: "Excuse me, miss, your dress is fantastic. Would you care to dance?" Realizing that the compliment on her dress and the invitation to dance could only be a prelude to a sexual encounter, Greta swiftly exits the scene.

When the two women return to the dressing room on the following day (S1, E5), Lotte makes another, more explicit attempt to convince her friend that prostitution would be a quick and easy way out of her financial and emotional misfortune. Absorbed by her own image in the mirror, she encourages Greta to try on one of the dresses she holds next to her body: these outfits are borrowed, she points out; they don't cost anything, they only need to be returned clean. While talking, Lotte realizes that her friend is sobbing at the other end of the room. Surrounded by racks with dazzling outfits, Greta strips her upper body, exposes the signs of the previous trauma—an inflamed Caesarian scar on her stomach—and declares that she cannot do what Lotte does. Lotte's attempt to change Greta's life with the aid of beautiful clothes fails.

It is in these two sequences in the dressing room of the Moka Efti that the fascination with glamorous Weimar fashion in the series reveals not only its liberating and playful sides, but also its dangerous undercurrents. With a pronounced nod to popular works from the Weimar period—from Irmgard Keun's *The Artificial Silk Girl* (1932) to Siegfried Kracauer's poignant social commentaries on the "little shop girls" and white-collar workers, and G. W. Pabst's film *The Joyless Street* (1925)—the series' women demonstrate the conflicted meanings of Weimar's modernity; Lotte, Greta, and minor characters Vera Lohmann and Tilly Brooks are all susceptible to varying degrees to the epoch's credo that a superficial external change—fashionable clothes, a trendy haircut, and appropriate makeup—is not only desirable, but also necessary to achieve upward mobility, personal autonomy, and financial gain, even in the face of moral trade-offs and physical trauma. For these modern Weimar women, the border between freedom and independence, on the one hand, and prostitution and objectification, on the other, remains a porous one. While Lotte embraces a matter-of-fact attitude and manages to crisscross the line between occasional prostitution and white-collar work multiple times, through a simple change of clothes, and without any visible impact on her psyche, such a balancing act is impossible for Greta.[21]

Fashion on and off the Film Set

One of the big changes in the third season of *BB* is that the visual focus shifts from the dancefloor of the Moka Efti club to the stage in the film studio. Correspondingly, the creative energy of the costume designers seems redirected toward outfitting the film within the film: the fictional production *Demons of Passion* shot in a fictional UFA studio. Throughout different episodes of this season, the series' costumes reflect upon, and sometimes bridge, the pronounced division between the world of performance, role-playing, and spectacle, on the one hand, and the rest of everyday life, on the other.

A certain sense of stability in the appearance of the main female protagonist Lotte corresponds to her new status as a regular homicide detective. Now that Lotte has almost entirely given up prostitution, the scenes of sartorial transformation are rare. In several episodes of this season, we see her at work wearing outfits in the beige-brownish color spectrum, including a pair of pants, knickerbockers. The choice of this piece of attire for the character seems quite significant, because knickerbockers (and pants in general), according to historic sources, were not worn by women in the 1920s at all; they are fairly common as part of school boys' uniforms (Helga's son Moritz is seen wearing them), but it is not until the 1930s that they become part of women's winter sports wardrobes, particularly for skiing.[22] Lotte's routine appearance at work in a pair of these slightly longer knickerbockers (knickers) is thus another daring invention of the show's creators; it defies historical authenticity and—more than anything else—reinforces the sense of Lotte's professional success in a men's world. Her androgynous silhouette when dressed in pants adds another facet to her sexual fluidity and fluctuating desires, which is also a new theme introduced to her character in this season: just think of Lotte's return visit to Der Holländer as the prelude to a sensual romantic relationship with Vera Lohmann, and of her growing attraction to Gereon Rath, whom she seduces for a kiss during Reinhold Gräf's birthday party.[23]

The only other female character clad in pants in the third season is Esther Korda (S3, E6). She is a former diva associated with the Viennese musical theater, many of whose star performers, writers, and composers migrated to Berlin in the 1920s in order to transition to the early sound films. Esther is also the wife of the gang boss Edgar Kasabian, "The Armenian," who together with Weintraub invests in the future film *Demons of Passion*. With her clearly demarcated register of clothes, Esther stands for the glamourous style of the stars: nothing about her appearance is ordinary or pedestrian; even when she

is shown in a domestic setting, within her palatial home, she is dressed in sparkly lamés, brocades, and fur coats, wearing eye-catching jewelry, earrings, headpieces, and necklaces. Unlike other female protagonists, the design of her outfits seems to be *haute couture*, unique pieces made out of expensive shimmering fabrics that correspond to the exquisite designs promoted by film actors on the pages of fashion magazines of the time. As Esther Korda defiantly plans her comeback as the female lead, she starts appearing in high-waisted long wide pants that are very different from Lotte's utilitarian knickerbockers. Popularized by Marlene Dietrich when she wore them in *Morocco* (1930) and *Blonde Venus* (1932), these pants from a men's suit are now known as "Marlene-trousers."[24] Esther's appearance in this piece of attire—especially in her confrontation with Weintraub (S3, E3)—is not a historically precise reference to Dietrich. By wearing only one part of the masculine attire—the Marlene pants—and sporting a very short haircut, Esther's character does project some of Dietrich's androgynous allure; yet this appearance is complemented by an unmistakably feminine top—a shiny blouse—and jewelry. Thus, Esther remains the typical diva: she projects the exclusivity and extravagance that challenged the clothing norms of both the Weimar and Hollywood film industries in the early 1930s.

The fashion-conscious world of film is present not only in the image of the fading (and then rising again) star Esther Korda, but in other ways as well. The film *Demons of Passion* in itself presents an amalgam of references to various trends and genres traditionally associated with Weimar cinema: from expressionist set designs à la Robert Wiene's *The Cabinet of Dr. Caligari* (1920) to the iconic image of the "Robot woman" and the fantastical costumes reminiscent of Fritz Lang's *Metropolis* (1927), and the music and choreography of early sound films and revues. Uli Hanisch, *BB*'s set designer, describes this hybrid genre as an "expressionistic musical revue," which never existed in reality.[25] When the fictional UFA film is finally finished and premieres with pomp and pageantry, it is reviewed by Fred Jacoby, a journalist for the Berlin tabloid *Tempo*. Jacoby's fictional article captures the film's whimsical stylistic mishmash: "What the audience witnessed was an indigestible patchwork of outdated expressionism, melodramatic amateurism, and a story that was obviously constructed only in retrospect, making brazen use of various literary classics" (S3, E11). *Demons of Passion*'s extravagant costumes reflect the same hybrid approach as the rest of the film's mise-en-scène and narrative, with its phantasmagorical "expressionist musical revue" figured through the identical shiny robes in which the numerous female and male performers are clad.

For all the extravagant fashion on display in *BB*'s third season, these episodes contain fewer of those scenes of transformation through change of costume that are significant in the earlier seasons. They include, however, a short visit with the chief costume designer of the film within the show and offer some glimpses of the fictional studio's costuming department (S3, E3). The investigation of Betty Winter's death caused by a faulty piece of equipment on the set brings the detectives into the costume designer's studio. This character is identified in the credits as "the architect." The brief sequence offers realistic insights into the process of outfitting an UFA movie in the 1920s. Dressed accordingly (in a white lab coat over an elegant suit with a flamboyant tie), the costume designer shows his fashion drawings and explains authoritatively how he crafts the costumes, in particular the hooded cape worn by the male lead, Tristan Rot. He is assisted silently by his female wardrobe manager. This scene surprises with its subtle realism about the business of dressing the movies in the late Weimar years (1929–33) when this aspect of film production was gradually professionalizing. In the first two decades since the rise of fiction film, it was mainly male architects, artists, and sculptors who doubled occasionally as designers for the main protagonists' costumes, while women assumed the secondary functions of assistants, wardrobe managers, seamstresses, or preparers of fashion drawings.[26] It was only with mega-productions such as Lang's *Die Nibelungen* (1923–4) and *Metropolis* that costume design began to be recognized for its autonomous achievements. In the course of the 1930s the profession would become more established and feminized: a cohort of young, specially trained women would emerge as professional costume designers for film, and a whole new department would be added to UFA.[27]

* * *

Babylon Berlin not only doubles as one giant show of Weimar fashion for a heritage film mega-project, but also foregrounds—in a nuanced and multilayered way—the importance of couture culture in the grandiose endeavor of recreating Weimar's mythology for a global audience. Notable aspects of the period like women's newly gained personal freedoms and professional opportunities, old dependencies and restrictions, stark social conflicts, as well as the mass fascination with popular entertainment and the movies, find direct expression in the lavish and detailed sartorial spectacle of the show. At the same time, as they affirm their aspiration for historical authenticity, *BB*'s costumes also present

a playful blend of styles and trends from different years, places, and media, thus creating a hybrid image of fashion from the long 1920s.

The third season of *BB* ends one day after the Wall Street crash of 1929, a historic event with major economic and political repercussions for the final years of the Weimar Republic. Incidentally (or not), the year 1929 was also a point of dramatic change in women's fashion in Europe and the United States. As the leading fashion magazines in Paris, Berlin, and New York observed, there was a sudden shift away from the daring *garçonne* or Girl fashion of the 1920s and toward longer hemlines and accentuated waists and hips. All of these new features would persist in the more conservative look of the 1930s.[28] Whether and how *BB*'s wardrobe will keep pace with the changes in fashion in the forthcoming seasons, as it continues to invent its own hybrid version of historic style, remains to be seen.

Notes

1 See "How to Dress as in Babylon Berlin—Wardrobes, Vintage Suites, Overcoats, Shoes and More," https://www.youtube.com/watch?v=IMQyYEoA7WU; "Von Berlin der Goldenen 1920er in den Alltag," https://www.cove.de/blog/20er-jahre-berlin/; and http://vintagegal.co.uk/tv-movies/babylon-berlin-sky-atlantic/.

2 For example, *Weissensee* (ARD, 2010–18), *Tannbach* (ZDF, 2015, 2018), the mini-series *Der gleiche Himmel/Same Sky* (ZDF, 2017), and most recently, *Kleo* (Netflix, 2022–).

3 For an analysis of "Weimar's mythologies," see Hanno Hochmuth, "Mythos Babylon Berlin: Weimar in der Populärkultur," in *Weimars Wirkung: Das Nachleben der ersten deutschen Republik*, ed. Hanno Hochmuth, Martin Sabrow, and Tilmann Siebeneichner (Göttingen: Wallstein, 2020), 111–25.

4 Weintraub's suit will reappear (S3, E10) during an occult séance with a medium who demonstrates to the police the ability to locate a missing person using a personal item.

5 There is a clever play on words here: In German "Reinecke Fuchs" is the name for the storied "wily fox" but here "Reinecke" becomes "Reinstecke," a vulgar reference to Fuchs's sexual prowess and particular brand of wiliness.

6 When Lotte and Toni move in together (S3, E1), they sing Claire Waldoff's signature cabaret song, "Chuck out the Men" (1926). In both instances, these songs function as programmatic narrative devices very much as they do in the Weimar musical films. See Abby Anderton's contribution to this volume.

7 See Raffaella Sgubin, "Women and Work during the First World War: Aspects of Clothing," in *Wardrobes in Wartime 1914–1918*, ed. Adelheid Rasche (Leipzig: Seemann, 2014).

8 Sara F. Hall, "*Babylon Berlin*: Pastiching Weimar Cinema," *Communications* 44, no. 3 (2019): 304–5.

9 See Katharina Sykora, "Die Neue Frau: Ein Alltagsmythos der zwanziger Jahre," in *Die Neue Frau: Herausforderung für die Bildmedien der Zwanziger Jahre*, ed. Katharina Sykora (Marburg: Jonas, 1993), 9–24.

10 When she first arrives in Berlin, Helga Rath and her son stay with the Wolters. Helga and Emmi Wolter go to a department store: they shop for clothes and attend a fashion show entitled "Dernier Cri: Paris Fashion" (S2, E3).

11 *Perfume* and *Cloud Atlas* were collaborations with director Tom Tykwer, one of *BB*'s three co-creators. See http://www.pierre-yves-gayraud.com/.

12 See https://www.ardmediathek.de/video/babylon-berlin/extra-kostuembild/das-erste/.

13 See *Filmstoffe! Kostüme Barbara Baum*, ed. Hans-Peter Reichmann and Isabelle Bastian (Frankfurt a. M.: Deutsches Filmmuseum, 2018).

14 See Sarah Street, *Costume and Cinema: Dress Codes in Popular Film* (London: Wallflower, 2001).

15 See "Extravagante Hüte, Helme, pompöse Schuhe," https://www.ndr.de/kultur/film/Historische-Kostueme-am-Set-von-Babylon-Berlin-,babylonberlin168.html, and https://babylon-berlin.com/en/press/video-teaser-9-kostuembild/.

16 This character resembles Fritz Thyssen, a steel magnate and an early supporter of Hitler, who later broke with the Nazis and was persecuted for doing so.

17 *Survey of Historic Costume*, ed. Phyllis G. Tortora and Keith Eubank (London: Bloomsbury, 2006), 480. Nyssen is the series' only character who at the end of the third season provides a glimpse of 1920s' fancy men's underwear (S3, E12), when he wakes up to the news of the crash of the New York Stock Exchange.

18 Both of the previous quotes come from Lutz Koepnick, "Heritage Cinema and the Holocaust in the 1990s," *New German Critique* (Autumn 2002): 49–50.

19 See the virtual exhibit "The Queen and the Crown: The Costumes from *The Queen's Gambit* and *The Crown*" at the Brooklyn Museum, https://www.brooklynmuseum.org/exhibitions/queen_and_crown, as well as "Downton Abbey, the Exhibition: Experience the History, the Fashion and the House," https://www.downtonexhibition.com/.

20 See Stella Bruzzi, *Undressing Cinema: Clothing and Identity at the Movies* (London: Routledge, 1997), xv.

21 The term "occasional" fits Lotte's character, since she is not a full-time, professional prostitute. The series anachronistically plays with the competing concepts of registered versus unregistered prostitutes in a scene between Lotte and policeman

Bruno Wolter (S1, E4). Wolter threatens to hold her status as an unregistered prostitute against her, which would not have occurred in 1929 Berlin.

22 See Gundula Wolter, *Hosen, weiblich: Kulturgeschichte der Frauenhose* (Marburg: Jonas, 1994), 25.

23 The scenes of Lotte and Vera in Der Holländer are cross cut with the get-together of Gereon and Gräf in a different bar. Homoerotic undercurrents of both sets of encounters and both "couples" establish a further emphasis on gender and sexual fluidity (S3, E4), as Javier Samper Vendrell argues in this volume.

24 In her films, Dietrich features masculine accessories such as a vest, tuxedo, tie, and top hat. Only in 1932 did she start wearing pants in public. In the early 1930s, the androgynous Marlene trousers were also adopted by Lilian Harvey, Lina Basquette, and Katherine Hepburn. See Wolter, *Hosen weiblich*; Bruzzi, *Undressing Cinema*.

25 See https://www.daserste.de/unterhaltung/serie/babylon-berlin/videos-extras/ bb3_makingof_szenenbild_-100.html.

26 See Riccarda Merten-Eicher, *Kostümbildner in Film, Fernsehen und Theater* (Leipzig: Henschel, 2012).

27 See Mila Ganeva, "Kleider machen Filme: Die Kostümabteilung der Ufa 1938–1945," in *Ufa International: Ein deutscher Konzern mit globalen Ambitionen*, ed. Jürgen Kasten, Frederik Lang, and Philipp Stiasny (Munich: edition text + kritik, 2021), 353–6.

28 See *Glamour! Das Girl wird Dame: Frauendarstellungen in der spaten Weimarer Republik*, ed. Verena Dollenmaier and Ursel Berger (Berlin: Seemann, 2008).

Liquid Space and Digital Aesthetics in *Babylon Berlin*

Michael Sandberg and Cara Tovey

The first establishing shot of *Babylon Berlin* showcases an overt use of CGI to recreate the iconic Alexanderplatz. Applied again in season three to Babelsberg Film Studios, the technique casts Berlin as simultaneously familiar and distant. While both shots were filmed on location, their unabashedly digital quality eschews an authenticity of the locales, which might otherwise have offered a sense of historical immersion. Instead, the series sets up a logic in which the digital production of Berlin as a space is foregrounded (Figure 4.1).

Through a combination of digital reconstruction and location shooting, *BB* cultivates a tension between the show's digital means and its narrative's analog world. Showrunner Tom Tykwer explains:

> You want to be consistent with the era and at the same time make a very modern film. And that gets in the way sometimes, because we retell stories in a mode also so heavily influenced by … by digital thinking. And we shoot the film digitally as well, but it naturally takes place entirely in an analog world. It's sometimes jarring.[1]

Tykwer's use of the word "jarring" casts the digital reproduction of historical Berlin as a temporal clash that is most overtly manifested through the spaces that the show produces. For this reason, we argue that space could be read as the series' dominant organizing principle.

In this chapter, we propose reading the series' production of Berlin as a self-conscious mode of digital thinking. We argue that the series' digitization of space serves as an index of the contemporary circulation of capital as well as of *BB*'s transnational, decentralized, and digital interface between local and global audiences. Following Zygmut Bauman's characterization of liquid

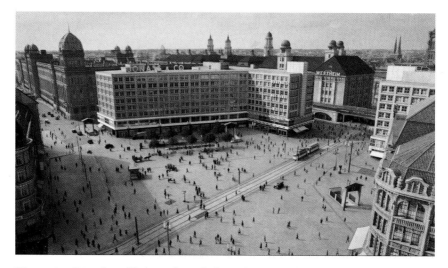

Figure 4.1 Digital establishing shot of Alexanderplatz. Screenshot, *Babylon Berlin* (S1, E1).

modernity as the decentralization of power across various institutions—including economic processes, communicative infrastructure, and the production of consumable media—we understand *BB*'s depiction of Berlin as emblematic for the tensions produced by a digital and transnational economy. By both producing and distributing the digitally constructed spaces of Berlin across digital platforms, the series both critically acknowledges and unabashedly participates in the alluring fetishization and commodification of space. As a consequence, the series demonstrates how "local" Berlin spaces become experiential products for consumption made possible by elaborate transnational networks.

Transposing Liquid Modernity onto Digital Space

Bauman understands modernity as a processual melting or diffusion of institutions perceived to limit individual freedoms.[2] As a result of these transformations, institutional power has spread across large geographic spaces and across multiple institutions—power became and is becoming *liquid*. Ironically, the new order, Bauman argues, has become more "solid"; that is, more resilient and stronger than the old one.[3] With the diffusion of power, it became difficult to identify and thereby resist a single source; power became elusive without sacrificing control.

Bauman explains that this diffusion of power accounts for a proliferation of temporalities, spaces, and experiences: "Modernity starts when space and time are separated from living practice and from each other and so become ready to be theorized as distinct and mutually independent categories of strategy and action. […] Thanks to its newly acquired flexibility and expansiveness, modern time has become, first and foremost, the weapon in the conquest of space."[4] The separation of space and time is apparent in Tykwer's "jarring" digitization of history.[5] In this essay, we argue that liquidity does not occur at the expense of space; rather liquidity *transforms* space and our experiences of it through digital technology. Bauman's theory highlights the mutability of infrastructure and emphasizes dynamic movement rather than static mapping.[6] Ultimately, Bauman's comprehensive framework explains how societal conditions—that is, power relations, labor, the economy, systems of surveillance, and so on—are bound up with digitally mediated experiences of space. We therefore understand the shift from solid to liquid networks of power as running parallel with the depiction and dissemination of space across informational networks.

The shift to liquid networks of space and power is particularly relevant to streaming, the primary mode of distribution for recent high-budget television productions. Streaming employs the same fluidity metaphor as liquid modernity. The implication is that content flows across digital platforms. Yet despite their ubiquity, these platforms are still complex in terms of geographical access. Ramon Lobato argues that Netflix should be viewed as a network of national streaming services that transcends political borders only through established economic and cultural relationships.[7] Accordingly, the first two seasons of *BB* were released on SkyTV in Germany, the United Kingdom, and Ireland, and on Netflix in the United States, Canada, and Australia.[8] This does not, however, negate Bauman's liquid analogy; just as networks of rivers and tributaries intersect and diverge, so too do flows of data across borders. Rather than taking a global approach, we therefore locate our analysis of transnational geographic exchange through *BB* in the European continent and across the Anglosphere.

Streaming television and liquid modernity both lead to what Bauman observes as a "revenge of nomadism over the principle of territoriality and settlement."[9] Michael Kane argues that this nomadism is best represented by the tourist.[10] At their core, the tourist is a consumer and producer of images, who replicates, transforms, and disseminates images of visited locales.[11] Through digital technology—from smartphone cameras to internet platforms that disseminate their images—the tourist position has become nearly universally accessible; anyone can consume images of any place at any time. In the context

of streaming television, the viewer is able to take on the role of the tourist, given access to remote places; and in the case of *BB* also distant eras, albeit through established flows of capital. Therefore, mediated historical space becomes an experiential commodity whose access is predicated upon political economy.

BB, fitting an increasingly popular trend of transnational streaming, both recognizes and capitalizes upon this commodification of images. For one, the establishing shots explicitly index the virtual circulation of a digitized version of historical Berlin and thereby call attention to the creation and consumption of intangible historical spaces. Specifically, the material of these images comprises pieces of data, formatted into a complete picture and circulated across digital networks. Data is mutable and mobile; theorists of digital aesthetics use terms like "interchangeable" (Hoy) and "versatile" (Moschovi, McKay, and Plouviez) to describe it.[12] All these terms speak to the assemblage of parts that characterizes Tywker's temporally "jarring" digital aesthetics. Yet instead of emphasizing the *temporality* of the digital shot—that is, the image's indexicality of something that *was* there—the shots, we argue, should be read as exhibiting a sensibility toward their fluid circulation within transnational digital networks. *BB*'s digital aesthetics grapple with the fluidity of data just as they engage with the fluidity of capitalist Berlin in the Weimar era *and* now.

The show's critics have hinted at *BB*'s occupation with the digital networks in which it circulates. Ross Douthat remarks: "Above all [the series] includes the depiction of Berlin itself, the show's real main character, a self-contained world of deracination and atomization, sexual experimentation and depravity, utopian fantasy and reactionary zeal, old and new bigotries, media frenzies and political radicalization. What is the city, if not the late-1920s version of the internet?"[13] Reminiscent of Friedrich Kittler's essay "The City Is a Medium," which highlights both the city and digital media as hubs of intersecting networks, Douthat's article emphasizes the representation of Berlin as a primarily digital construction.[14] The historical spaces of *BB* become no less "real" as constructions of the show; as in any other actual, contemporary metropolitan space, such historical spaces are part of a vast network of technology systems and popular imagination that facilitate a shared experience despite spatial or temporal dislocation.

On Location at Moka Efti

The Moka Efti nightclub is arguably the show's principal emblem, as each narrative thread passes through its doors; it serves as a cipher for liquid modernity's hybridizations, ambiguities, and identities. First, the space

presents a mixing of classes: sex workers, day laborers, entertainers, politicians, and members of the leisure class intermingle and perform a semi-coordinated, choreographed dance number. Such a composition illustrates Michel Foucault's concept of heterotopias, which he defines as "countersites; a kind of effectively enacted utopia in which the real site, all the other real sites that can be found within the culture, are simultaneously represented, contested and inverted. Places of this kind are outside of all places."[15] Foucault lists the brothel as "a space of illusion"[16] that exists in contrast to so-called real space—a characterization that resonates with Moka Efti's basement brothel and overall decadent atmosphere. But even with the intermingling character arcs of the middle-class detective Gereon Rath, the working-class stenographer (by day) and sex worker (by night) Charlotte (Lotte) Ritter, and the bourgeois elite of Berlin, the architecture of Moka Efti upholds a stark class demarcation: the upper class occupies the balcony level of the club, the middle class the ground-level dance floor, and the working-class prostitutes the basement below. It is only through the show's cinematography and use of montage that the viewer has access to a fluid exploration of these various levels.

One such montage occurs just after Nikoros/Svetlana's performance of "Zu Asche, zu Staub" (S1, E2). The camera crosscuts between the convulsive movements of the dancers in Moka Efti and a group of Trotskyists being shot—unencumbered hedonism runs parallel to a failed proletarian revolution. As this scene develops, the camera traces the movements of Lotte descending into the brothel, where she will enact the Trotskyists' failed vision of a power-reversal in an S&M sex scene with her bourgeois client. Characteristic of a Foucauldian heterotopia, her performed power-reversal never progresses beyond a fantasy. Confined to the physical space of the brothel, Lotte's roleplay remains *virtual*.

Labeling Lotte's work as virtual is more than a matter of rhetoric. The rhythm and content of her labor are indicative of contemporary concerns surrounding the digital economy. Lotte, as the equivalent of today's gig worker, becomes the character on whom working-class hopes for upward mobility within a late-capitalist economy are pinned. For one, Lotte's identity continually shifts relative to the types of labor she performs, enacting Bauman's observation that workers in liquid modernity are more adaptable and mobile than ever.[17] Lotte is a sex worker at Moka Efti, an unpaid (for at least two seasons) investigative assistant to Gereon, and a freelance day laborer for the Berlin police department's menial tasks. These tasks include cataloguing crime scene photos by keywords in a "Schlagwortregister" (keyword register), which signals that her work can be compared with forms of digital labor today, such as hashtagging.[18] Though far from immaterial, the types of labor Lotte performs participate in the labeling,

sharing, and processing of information. Her various "gigs," her efforts to escape precarity, are contrasted with the show's conspiracies and intrigues, its narrative motors. As such, Lotte as a figure represents a more contemporary desperation to ascend to the "top" of a capitalist structure, to master an abundant flow of information unleashed by digital-internet platforms. However, the series' depiction of her continued precarity questions the extent to which such work is effectual or, conversely, a product of fantasy.

The camera is the viewer's entrance into the world of Moka Efti as it follows Lotte's movement across the ground floor and into its lower level through untethered, mobile shots. Similar to the costume changes examined in Ganeva's chapter in this volume, these unmoored and fluid shots align with Lotte's work rhythms, thereby connecting virtuality and digitally mediated labor with the viewer's spatial experience. As the delirious montage reaches its fever pitch, the music, performers, and dancing club attendees all freeze while the camera glides through the space. The freeze frame that estranges the viewer from the historical fiction also denies the viewer a completely static position as the camera continues to wander. Any "frozen" or "suspended" temporality is nevertheless still a kind of virtual movement through space. The temporal relationship between the past and present is, in this light, an aspect of space, in which the viewer remains in perpetual motion.

The economic condition of liquid modernity, mirrored by technologized movement through Moka Efti and Lotte's gigs, is further reflected in the location's history as a site of movement and virtuality. The historical Moka Efti was a coffee house that reached the height of its popularity in 1929 (the year in which *BB* is set). Philip Olterman, writer for the *Guardian*, reports: "The decor inside the original venue [...] was even wilder than the imagination of the TV producers. An elevator took visitors from street level to the first floor—a technical invention so new and laden with the promise of social mobility at the time that many Berliners visited Moka Efti merely for the ride."[19] Siegfried Kracauer, who visited the venue, described its promise of social mobility similarly:

> A moving staircase, whose functions presumably include symbolizing the easy ascent to the higher social strata, conveys ever new crowds from the street directly to the Orient, denoted by columns and harem gratings. The fantasy palace, by the way, resembles a dream image also in that it is not very solidly constructed; rather than on a firm subsoil of capital, it arises on short-term English credit. Up here you do not sit, you travel. "Do not lean out!" is written

upon the train window through which you gaze at nothing but sunny picture-postcard landscapes.[20]

Like the Moka Efti of the series, the historical Moka Efti allowed for a blurring of class and physical space through technologies of mobility that were built on shaky economic grounds; the camera that surveys the Moka Efti in the series replaces the historical elevator. Indeed, the confluence between elevator and camera was present even in the years preceding Moka Efti's establishment. F. W. Murnau's 1924 film *The Last Laugh,* for instance, opens with a historically innovative unchained camera descending in a hotel elevator. Given this film's own thematization of economic volatility, *BB* can be understood as drawing on a historic cultural symbolic equivalence between elevator and camera to convey economic mobility.

The key difference between the historical Moka Efti's elevator and *BB*'s camera is the latter's mode of dissemination—streaming—which liquifies the space of image consumption. The virtual, vertical travel and artificial class mobility signaled by Kracauer is intensified through a digital infrastructure that does not depend on a body's physical presence at a specific site. The virtuality of *BB* is based on a liquification of space, an engagement with space that is unmoored from a concrete, geographical anchor. By extension, class becomes estranged rather than an embodied object of spectacle for the streaming viewer, whose own economic or social class may vary. The experience of mobility in *BB* is no longer vertical, nor is it visible between classes; rather it is characterized by a horizontal circulation of commodities through (cyber)space.[21]

The relationship between immersion, distance, and the series' epitext is underlined by the shooting location for *BB*'s Moka Efti: Berlin's Theater im Delphi (TiD). The TiD is today a cultural arts center with a storied history as a silent film cinema. The institution's self-described history on its website establishes the theater's neighborhood as a site for transnational film connections, not unlike *BB* itself:

> The location in Berlin Weißensee, directly bordering Prenzlauer Berg, was also named "little Hollywood" due to the numerous film production locations. In 1920 Weißensee was integrated into Berlin, which established itself as an international film city. [...] Even when the 1929 world economic crisis spelled a sudden end to most movie theaters, the Delphi survived.[22]

By contrast, the website's English version, which differs from the German, emphasizes the location's national film history: "Direct on Caligariplatz, this relic rests like a hidden jewel, unrecognizable from the outside, and even

unknown to most Berliners. [...] It is one of the best remaining examples of the glamour and flair of this important cultural era—the heyday of German silent film."[23] The descriptions of the site cater to different cultural audiences: the German version emphasizes the site as a portal to the international, while the English version views it as a national tourist attraction. The TiD can thus be understood as a cipher between transnational and national concerns, through which the local or the global is sold as its defining feature, depending on the targeted cultural consumers.

The website ends its description of the TiD's contemporary function with a note on its international fame: "The Delphi in the guise of the legendary 1920s nightclub—the Moka Efti in the TV series *Babylon Berlin*—is world-famous."[24] While perhaps seemingly banal at first glance, the sentence belies the actual transformation that has taken place: the Delphi is known internationally only through its "guise" or "costume" ("Gewand")—produced with the help of digital post-production techniques—as the *BB* nightclub. The TiD has transformed into a veneer, a surface whose notoriety depends on both the transnational viewer's fluidity in the digital era and the image's own circulatory mobility via streaming platforms.

The above description equates the TiD with the Moka Efti without specifying that it is precisely the *interior* that bears the resemblance; the façades of the two institutions are different. In fact, the series' Moka Efti and its surrounding street environs are a stage set, partially constructed through digital technology. The "guise" of the TiD *as* Moka Efti rests at the crossroads between indexical space, stage construction, and digital retouching throughout (Figure 4.2). The TiD thus constitutes a fitting example of liquid space in which local history, contemporary cultural institutions, and transnational economics are intertwined in the presentation and experience of the space via television. Like the gig-working Lotte, the TiD shifts its identity according to cultural, economic, and media contexts to generate interest and ultimately financial capital. The website description once again belies the space's perpetually transforming identity as a "venue" that stages a variety of cultural events and can become "a muse for new artistic ideas." The very transformability and indeterminacy of the space's function therefore resonates well with the show's digital aesthetic practices, in which parts of data or images become malleable, interchangeable, and fluid. The historic location and digital technology share in the production of a larger cultural space upon which a diverse set of desires can be projected. The blurred lines between analog and digital media produce a virtual yet nonetheless real space for the transnational imaginary.

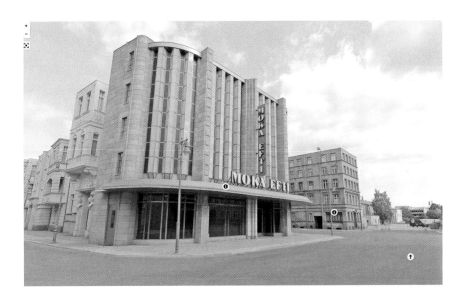

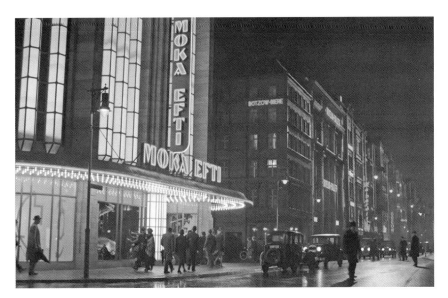

Figure 4.2 The virtual behind-the-scenes Moka Efti and the final product. Screenshot, "Metropolitan Backlot," *Studio Babelsberg*, https://www. metropolitanbacklot.com/en/360-virtual-tour/, *Babylon Berlin* (S2, E5).

The combination of digital space and historic place produces the circulating diegetic image that generates its own consumer interest, fascination, and purchase. The image travels through vast digital networks, most notably through streaming devices. In this state of ubiquitous transmission, the image is simultaneously everywhere and nowhere, an experience of space that is always potentially consumable by the viewer, regardless of physical and geographic location.[25] TiD and Moka Efti thereby fashion themselves as versatile spaces, always prepared to shift their identity, nomadic in their consumption. They demonstrate how a geographical location can be constructed as an experiential commodity that both acknowledges and exploits a locally or nationally historical significance for transnational commercial success.

Liquid Tourism and the Consumption of Space

BB commodifies and markets its own "historical" Weimar Berlin to a contemporary audience, which raises the question: Why is the Berlin of the Weimar Republic so appealing to twenty-first-century viewers? Critics as well as scholars who took part in the forum "*Babylon Berlin*: Media, Spectacle, and History" have noted, for one, that the show's success in the United States is in large part due to the numerous parallels between the political crises of Weimar Germany and western democracies today.[26] Furthermore, scholars and critics alike have shown that the series acts as a grand-scale homage to the early German cinematic tradition or the "Weimar canon" of Fritz Lang, F. W. Murnau, G. W. Pabst, and Robert Wiene.[27] However, we submit that the hidden allure of this comparison is the desire to consume and capture liquid space.

Doreen Massey's notion of a "global sense of place" offers a compelling starting point to articulate the tensions at stake here.[28] Arguing against David Harvey's notion of space-time compression and presciently anticipating Lobato's observations on Netflix, Massey proposes a global sense of place as a network of "routes rather then [sic] roots."[29] Places today are defined more by intersecting network's and information's routes of exchange than by contained histories and traditions. *BB*'s cultivated global sense of place results from the construction and marketing of its spaces; although *BB* is still anchored in a specific time and place, the content is produced with an international audience in mind and, as such, contains characteristics that conform more to global Hollywood style than to a specific national or cultural aesthetic.

If we are assuming that *BB*'s transnational mainstream style might be understood as relying on Hollywood techniques, Massey's optimism appears dubious. While there is no better geographical metonym for transnational success than "Hollywood," this success is predicated on power flows within a network. Even if Massey's "global sense of place" helps articulate how intersecting networks of production and distribution can create transnationally appealing products despite a series' emphasis on a specific time and place, such products cannot be read without investigating the myriad sources of power and influence Bauman seeks to characterize, if not identify. *BB*, just like countless films before it, borrows and subjects itself to traditions and techniques beyond its national and cultural borders, particularly the cultural exchange between Hollywood and Europe.

From this comparison, Bauman's tourist becomes an all-the-more fitting metaphor for how *BB*'s viewers engage with the show. *BB* itself becomes a desirable destination, to which viewers virtually travel via the internet. In addition to the TiD/Moka Efti, the series' diegesis further acknowledges its own status as a tourist attraction with the inclusion of the tourism advertising campaign "Jeder einmal in Berlin." The slogan, invoked repeatedly throughout the first season, not only prompts Helga, Gereon's lover and the widow of his missing brother, to move to Berlin; it also invites viewers to see themselves as tourists of the show's digitally constructed, sensationalized version of Weimar Berlin. Rather than considering the viewer's experience of Weimar Berlin as only vicarious and at a distance, it can instead be seen as the direct experience of the digital city. Digital and streaming technologies have made possible experiences of places that no longer require physical presence yet are no less real. One can trace the outline of a virtual tourist economy whose digitally constructed spaces are no less legitimate than their analog counterparts.

Beyond the virtual tourism that the show offers, *BB* has also produced a more concrete form of tourism among the show's viewership.[30] The city of Berlin now advertises the iconic locations of the show in its own advertising campaign. As Jill Suzanne Smith has pointed out, the visitberlin.de website features several pages dedicated to the series and its shooting locations.[31] Scrolling through the page, one finds a section dedicated to "Berlin as a protagonist of the series," which quotes co-director Achim von Borries: "The city of Berlin is clearly the focal point of our series. In 1929, Berlin was international, magical, a cosmopolitan capital that attracted people all around the world."[32] The Berlin of today is still a cosmopolitan metropolis that welcomes millions of visitors

each year—2019 alone saw over 13 million visitors to Berlin—to explore its counter—and sub-cultures.[33] Twenty-first-century Berlin, like the Berlin of the series, has cultivated its own liquid identity, which has become its main attraction, its product—the experience—that it offers to its consumer viewers/ tourists.

Shooting-location tourism is, of course, not a phenomenon particular to the streaming age. However, the commodification of digital spaces, in terms of both shooting-location tourism and virtual tourism, differs from prior analog tourism in distinct ways. The digital production and circulation of spaces in *BB* are, as per our main argument, reflections of the contemporary digital economy; they highlight the liquidity of identity and mobility across complex networks composed of indexical, fixed, and geographic locations and tangible commodities.

Conclusion

The complex relationship between space and digital media in *BB* is in part due to the increasingly metaphorical use of the term "space." In *The Production of Space* Henri Lefebvre outlines this shift from a purely mathematical definition to an abstract conception thereof, which helps humans make sense of their lives; most spaces, he claims, are constructed to reflect social habits. Like these metaphorical and ultimately ideological spaces, digital space remains elusive, intangible, and nevertheless socially constructed.[34] If these constructions are enabled by digital streaming platforms, as we suggest, they can well be read as both critically indexing and ultimately celebrating the production as well as liquified circulation of capital itself. We have demonstrated throughout this chapter how the constructed spaces of TiD/Moka Efti and the larger setting of Berlin in *BB* demonstrate a preoccupation with a new kind of mobility enabled by digital and communicative infrastructures; mobility to and through Berlin is conditioned by a mediated presence and fascinated distance. The series thereby critically acknowledges, yet ultimately embraces, the capitalist commodification and marketing of local or national spaces for transnational audiences.

The constructed nature of digital spaces does not diminish their significance either in the diegesis of *BB* or in its circulation. By modifying Bauman's "liquid modernity" to apply to space and presenting space as *BB*'s fundamental organizing principle, we have shown that Lefebvre's initial observations on space might be expanded; space continues to take on an increasingly ambiguous

yet central status in liquid modernity. Foucault presciently says as much in his discussion of heterotopia: "We are at a moment, I believe, when our experience of the world is less that of a long life developing through time than that of a network that connects points and intersects with its own skein."[35] The digital networks of *BB* that allow for the production and distribution of digital spaces amplify this shift from a linear, that is, temporal conception of history to a flattened, self-referential, and more spatially oriented network; *BB* eschews a temporalization of space in favor of, to quote *BB*'s iconic song, an "Ozean der Zeit" ("ocean of time"), a spatialization of time. Placing time into liquified space allows viewers of *BB* to imagine the contemporary series and the historical time it depicts as part of the same spatial expanse, as flowing into one another, and as emblems for digital streaming technologies.

Notes

1 Tom Tykwer et al., "Buch und Regie," https://reportage.daserste.de/babylon-berlin#177075. All translations are our own unless otherwise indicated.

2 Zygmunt Bauman, *Liquid Modernity* (Cambridge: Polity Press, 2000), 5.

3 Ibid., 5, 7.

4 Ibid., 8–9.

5 Sara Hall argues similarly that *BB* consciously invites comparisons between the contemporary moment and 1929 Berlin. See Hall, "*Babylon Berlin*: Pastiching Weimar Cinema," *Communications* 44, no. 3 (2019): 308.

6 We opt for Bauman's theorization of space over others such as Harvey's "space-time compression" or Jameson's "cognitive mapping," which leave less room for the malleability of space.

7 Ramon Lobato, *Netflix Nations: The Geography of Digital Distribution* (New York: New York University Press, 2019).

8 A year after it was released on SkyTV, Germany also broadcast the show as appointment television on ARD/Das Erste. See Taylor Antrim, "Your New Winter TV Binge Is Here," *Vogue*, January 30, 2018, https://www.vogue.com/article/babylon-berlin-netflix-review; Kate Connolly, "Babylon Berlin: Lavish German Crime Drama Tipped to Be Global Hit," *The Guardian*, October 29, 2017, http://www.theguardian.com/world/2017/oct/29/babylon-berlin-lavish-german-tv-drama-tipped-global-hit; Kurt Sagatz, "ARD verteidigt Kooperation mit Sky bei ‚Babylon Berlin,'" *Der Tagesspiegel*, November 17, 2017, https://www.tagesspiegel.de/gesellschaft/medien/junge-zuschauer-im-blick-ard-verteidigt-kooperation-mit-sky-bei-babylon-berlin/20600122.html.

9 Bauman, *Liquid Modernity*, 13.

10 Michael Kane, *Postmodern Time and Space in Fiction and Theory* (London: Palgrave Macmillan, 2020), 152.

11 Ibid., 144.

12 Meredith Hoy presents an aesthetics based on the viewer's ability to perceive a work's "digital qualities," which amount to the perceptibility of parts. These individual pieces of data are swappable, emphasize the transfer of information, and can be combined with other parts to construct a whole. See *From Point to Pixel: A Genealogy of Digital Aesthetics* (Lebanon, NH: University Press of New England, 2017), 7; and Alexandra Moschovi, Carol McKay, and Arabella Plouviez, Introduction to *The Versatile Image: Photography, Digital Technologies and the Internet*, ed. Moschovi, McKay, and Plouviez (Belgium: Leuven University Press, 2013), 11–32.

13 Ross Douthat, "'Babylon Berlin,' Babylon America?," *New York Times*, March 31, 2021, https://www.nytimes.com/2021/03/30/opinion/babylon-berlin-weimar-america.html.

14 Friedrich A. Kittler, "The City Is a Medium," trans. Matthew Griffin, *New Literary History* 27, no. 4 (1996): 717–29.

15 Michel Foucault, "Of Other Spaces: Utopias and Heterotopias," *Architecture/Mouvement/Continuité*, trans. Jay Miskowiec (October 1984), 3–4.

16 Ibid., 7.

17 Bauman, *Liquid Modernity*, 32.

18 For scholarship conceptualizing the use of social media as immaterial labor, see Mark Coté and Jennifer Pybus, "Learning to Immaterial Labor 2.0: Facebook and Social Networks," in *Cognitive Capitalism, Education and Digital Labor*, ed. Michael A. Peters and Ergin Bulut (New York: Peter Lang, 2011), 169–94.

19 Philip Olterman, "Sex, Seafood and 25,000 Coffees a Day: The Wild 1920s Superclub That Inspired Babylon Berlin," *The Guardian*, November 24, 2017, https://www.theguardian.com/world/2017/nov/24/babylon-berlin-real-1920s-superclub-behind-weimar-era-thriller.

20 Siegfried Kracauer, *The Salaried Masses: Duty and Distraction in Weimar Germany*, trans. Quintin Hoare (New York: Verso, 1998), 93.

21 Our position is not that streaming platforms entail universal access; rather, we argue that class becomes less visible in an online environment. However, we do acknowledge that Netflix's price model allows for greater socio-economic diversity amongst its North American and European viewership than in less economically privileged countries (Lobato, *Netflix Nations*, 183–4).

22 "Geschichte des Delphi," https://theater-im-delphi.de/geschichte/.

23 "History," https://theater-im-delphi.de/en/history/.

24 Website's translation. "Eine neue Spielstätte," https://theater-im-delphi.de/en/haus/.

25 For a Benjaminian treatment of the selfie, see Kris Belden-Adams, "Everywhere and Nowhere, Simultaneously: Theorizing the Ubiquitous, Immaterial, Post-Digital Photograph," in *Mobile and Ubiquitous Media: Critical and International Perspectives*, ed. Michael S. Daubs and Vincent R. Manzerolle (New York: Peter Lang, 2018), 163–82.

26 Veronika Fuechtner and Paul Lerner, eds., "Forum: *Babylon Berlin*: Media, Spectacle, and History," *Central European History* 53, no. 4 (2020): 835–54; Douthat, "'Babylon Berlin,' Babylon America?"; Siobhán Dowling, "Sex, Drugs and Crime in the Gritty Drama 'Babylon Berlin,'" *The New York Times*, November 7, 2017, https://www.nytimes.com/2017/11/07/arts/television/sex-drugs-and-crime-in-the-gritty-drama-babylon-berlin.html; Mike Hale, "Escaping into 'Babylon Berlin' and 'My Brilliant Friend,'" *The New York Times*, March 22, 2020, https://www.nytimes.com/2020/03/26/arts/television/abylon-berlin-my-brilliant-friend.html; Hester Baer and Jill Suzanne Smith, "Babylon Berlin: Weimar Era Culture and History as Global Media Spectacle," *EuropeNow* 43, September 2021, https://www.europenowjournal.org/2021/09/13/abylon-berlin-weimar-era-culture-and-history-as-global-media-spectacle/.

27 Fuechtner and Lerner, "Forum: *Babylon Berlin*"; Sara Hall, "*Babylon Berlin*," 304–22; Christian Buß, "Weltmeister der Angst," *Der Spiegel*, October 13, 2017, https://www.spiegel.de/kultur/tv/babylon-berlin-von-tom-tykwer-serienmeisterwerk-ueber-die-weimarer-republik-a-1170044.html.

28 Doreen Massey, "A Global Sense of Place," *Marxism Today* (June 1991): 24–9. In considering Rainer Werner Fassbinder's miniseries *Berlin Alexanderplatz* and other internationally popular period dramas, Hester Baer and Jill Suzanne Smith suggest a larger trend in streaming television that seeks to market culturally specific narratives to international audiences. See Baer and Smith, "Babylon Berlin."

29 Tim Cresswell, "Reading 'A Global Sense of Place,'" in *Place: A Short Introduction* (Malden, MA: Blackwell Publishing, 2008), 53.

30 This virtual tourism gained additional significance during the COVID-19 pandemic, when travel was severely restricted globally; the release of *BB*'s third season on Netflix in the spring of 2020 coincided with widespread stay-at-home orders.

31 Fuechtner and Lerner, "Forum: *Babylon Berlin*," 853.

32 "Babylon Berlin: The Spectacular TV series from Berlin," https://www.visitberlin.de/en/babylon-berlin.

33 "Current Figures," https://about.visitberlin.de/en/current-figures.

34 Henri Lefebvre *The Production of Space*, trans. Donald Nicholson-Smith (Malden, MA: Blackwell, 2012).

35 Foucault, "Of Other Spaces," 1.

Recreating the Soundscape of Weimar Berlin: Sound Technologies, Trauma, and the Sonic Archive

Abby Anderton

In season two of *Babylon Berlin*, Police Inspector Gereon Rath, suspicious that his partner, Bruno Wolter, is involved in a plot to overthrow the Weimar Republic, slips into Wolter's apartment to search for clues. As the popular Weimar song "Jede Frau hat irgendeine Sehnsucht" (Every Woman Has Some Kind of Longing) wafts out of the open windows, Emmi Wolter, Bruno's wife, remains oblivious to Gereon's presence in her home. In a carefully choreographed scene, the pair makes their way around the apartment; Emmi smokes at the kitchen window while Gereon rummages through a desk in his colleague's study. As the song's lyrics describe the secret longings of a housewife, the music covers the noise of Gereon's hasty search for evidence in what media theorist Michel Chion has described as palimpsestic sound—where one sound obscures all the other actions in a scene.[1] The music moves freely through all the rooms in the apartment even as both characters are caught in their own private traps: Emmi's domestic discontent and Gereon's increasing fears about his partner. Only when Emmi closes the lid on the phonograph is each character's deception revealed—Emmi's clandestine drinking and Gereon's suspicious presence in the apartment. The music had accompanied and obscured their secrets, but their "longing" is now plain for others to see and hear.

While viewers and critics of *BB* have noted the plush sets, period costumes, and meticulously re-created cityscape of the capital, the series' aural elements have been selected with no less care. Featuring a sonic pastiche of glitzy Weimar cabaret and popular tunes, classical standards, 1980s' post-punk ballads, and an underscore of out-of-tune pianos and drones, the show includes the work of the Bryan Ferry Orchestra, the Moka Efti Orchestra, and Pale 3, the songwriting trio of showrunner Tom Tykwer and composers Johnny Klimek and Reinhold Heil. In a 2018 interview, Tykwer discussed his musical choices in *BB*, asking "How can we

make our time echo in the '20s and the '20s echo in our time?"[2] For the director, the answer lay in the mixing of musical genres. The blurring of chronology could not be achieved through visual components like the set design or costumes alone, but required a concerted approach to the auditive elements of the series.

In what follows, I will trace the two primary sonic threads of the show, demonstrating how musical selections complement, complicate, and enrich auditors' understanding of Weimar politics and culture. First, by using Weimar sound objects like radios, phonographs, and the theremin, as well as period recordings, *BB* invites the audience into the sound world of late 1920s' Berlin. By depicting aural elements both visually and sonically, the show allows us to hear, as sound theorist Jonathan Sterne has noted, how "sound-reproduction technologies encapsulated a whole set of beliefs about the age and place" of the Weimar period.[3] Second, newly composed works, covers, and classical pieces accompany scenes of trauma in the show, including Gereon's debilitating wartime flashbacks, depictions of urban poverty, and the impending doom of the Nazi rise to power. By musicalizing both personal and collective traumas, the show's creators skillfully impart a sense of sonic immediacy to the era.

Weimar Sounds and Sound Technologies: Music for Use (*Gebrauchsmusik*)

With Germany's defeat in the First World War, government censorship was revoked in 1918, and cultural institutions once controlled by the court were now controlled by the state. For decades, Peter Gay's reading of Weimar culture remained unchallenged—namely, that the era formed a bridge between the traumatic loss of the First World War and fascism's rise. More recent studies, however, have called into question this teleological understanding of National Socialism. As Peter Gordon and John McCormick write in the introduction to their more recent edited volume on Weimar culture, fascism was anything but a foregone conclusion to the era's upheaval. Gordon argues that Weimar's tensions resulted from cultural and political movements that were out of synch, with experimental modernist cultures standing in stark contrast to the rising undercurrent of Nazism.[4] The chasm between Weimar politics and culture is also made audible through *BB*'s soundworld.

The series prominently features historical objects like the radio, telephone, player piano, projector, street organ, sound film, theremin, and gramophone—artefacts that figure the sound culture of Weimar.[5] These technologies enabled

(among other things) new modes of listening: suddenly it was possible to listen both collectively and individually at the same time. During season two, Dr. Schmidt's radio program on "suggestive therapy" is simultaneously broadcast through a loudspeaker to a group of veterans (Figure 5.1), and through Gereon's headphones (Figure 5.2).

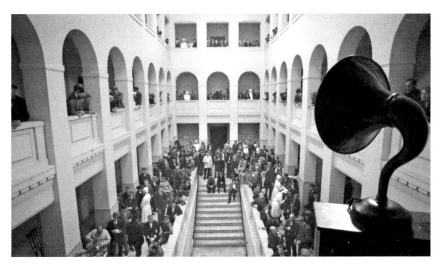

Figure 5.1 Listening to Dr. Schmidt's "suggestive therapy" with a loudspeaker. Screenshot, *Babylon Berlin* (S2, E3).

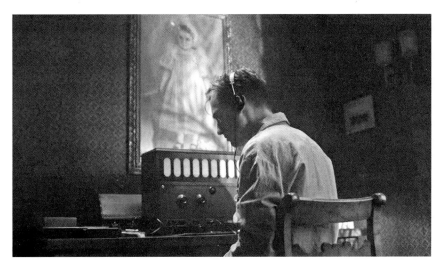

Figure 5.2 Gereon listens to the broadcast alone, over the radio and with his headphones. Screenshot, *Babylon Berlin* (S2, E3).

As *BB* makes clear, radio became a ubiquitous, mass technology during the Weimar Republic. About 100,000 German radio subscribers in 1924 would grow to more than four million by 1932. Writing in 1926, composer Kurt Weill claimed that radio broadcasting was the key to "one of the most essential elements of public life," one that provided unique possibilities for a new form of autonomous art.[6] Brian Currid has written compellingly about radio's role in the creation of German national identity during Weimar, arguing that broadcasting offered a "sonic fantasy" to create the illusion of a unified national community of listeners. This aural construction was comprised primarily of music. From its earliest days, the state controlled the radio industry in an effort to promote democratic ideals rather than private interests, a structure that would ironically enable radio to become an effective and far-ranging mouthpiece of the Nazi regime only a decade later. During the 1920s, music accounted for some 50 percent of radio broadcasts; by the outbreak of the Second World War, nearly 70 percent of airtime was given over to music, as the Nazis created an "acoustic spectacle" of overtly political content in their programming choices.[7] After the war began, the Nazis used sound media like radio broadcasts and loudspeakers to reach the urban public, sending the clear message that they were sonically omnipresent.[8] Yet the potential for mass indoctrination and propaganda during the Nazi era was realizable only because of the explosion of radio ownership during Weimar.

With the capability to reach sonically into the home, the radio could deliver news, music, and politics into every kitchen and living room in the Republic. *BB* depicts the radio as an agent of both politics and culture by acknowledging the aural turn in Weimar society. In season one, detective Stephan Jänicke is abruptly awakened from a deep sleep by a distressing radio report about clashes between the police and communist party members during the violence of the Blood May riots (S1, E3). When he enters the kitchen, his parents, both hearing impaired, are unaware that the broadcast is blaring in the background. In a tranquil, domestic scene that provides a stark contrast to the previous radio report, the three sit at the kitchen table as Gustav Mahler's "I am Lost to the World" from *The Song of the Earth* begins to play. At the behest of his parents, Stephan conveys Friedrich Rückert's lyrics to Mahler's Lied in sign language. The music continues, serving as a sound bridge to images of Gereon, Charlotte (Lotte) Ritter, Alexej Kardakow, and Svetlana Sorokina in various scenes of existential contemplation. Mahler's late Romantic, early modernist sensibility provides the sonic tapestry for these characters to become lost in their own private reveries. As Darcy Buerkle notes, the piece also foreshadows Stephan's impending murder,

a warning to his adoring parents that he is about to be lost to them and to the world.[9] Mahler's orchestral textures, harmonic suspensions, and delayed resolutions mirror the plot devices of the series, where frequent twists and turns keep the viewer guessing who the real culprits are. It is also noteworthy that Stephan can sign Rückert's text relatively easily, but he cannot adequately convey the music itself.

By utilizing the radio and other sound objects, the series skillfully evokes the contemporary concept of "music for use" (*Gebrauchsmusik*), a Weimar fascination for music that was accessible in both form and format. Tuneful, catchy melodies that could be played on a gramophone or over the radio promoted participatory music-making. The concept of music for use was a reaction to the perceived elitism of the Second Viennese School of Arnold Schoenberg, Alban Berg, and Anton Webern, whose compositions generally featured extreme dissonance and an absence of tonality.[10] After reviewing a concert featuring these modernist sounds, one contemporary music critic noted of the listening audience, "to quote Freud, the traumatic experience remained with them."[11]

Early music specialist Heinrich Besseler first developed the idea of music for use by delineating between the two primary currents in Weimar musical culture: music that involved the audience and serious music that remained inaccessible to the public. Stephen Hinton has noted that these culture wars were "characteristic of the Weimar Republic" as composers and musicians had to choose sides between academic esotericism and more popular styles.[12] Music for use could be heard in pieces from Paul Hindemith's experimental works for gramophone to Bertolt Brecht's and Kurt Weill's *Threepenny Opera,* sounds that traded on the Weimar Zeitgeist of clever lyrics, tuneful melodies, and emerging music technologies.[13] Accordingly, "The Ballad of Mack the Knife" from *The Threepenny Opera* accompanies two separate conspiracies in season two. The tune is heard emanating from a street organ (S2, E5) as Greta Overbeck witnesses the police shooting her boyfriend, "Fritz." As we later learn, however, Fritz's death is a deception staged by the National Socialists to turn Greta against her employer and head of the political police, August Benda. *BB*'s use of the street organ is all the more fitting as *The Threepenny Opera* opens with a singer and street organ telling the tale of the infamous Mack through the very same murder ballad (*Moritat*).[14] The intrigue, deception, and death in both stories are encapsulated by the organ's plaintive Weill tune. The melody is then whistled by the conspirators to kill foreign minister Gustav Stresemann (S2, E6), and even by Moritz, Gereon's teenaged nephew, in case audience members missed the Brecht/Weill reference. The Stresemann assassination plot culminates in

a performance of *The Threepenny Opera* at the Theater am Schiffbauerdamm, where Gereon foils the attempt on Stresemann's life.

Weill went so far as to distinguish between "Verbrauchsmusik" and "Gebrauchsmusik": music to be merely used versus music that encouraged active and engaged participation. *BB* often transforms pieces from "Ver—" to "Gebrauchsmusik," aided largely through the Weimar sound technologies used by the show's characters. Here the music of *The Threepenny Opera* is music to be both consumed at the theatre by the political elite and used as a signal for the anti-republican conspirators.

Historical pop recordings extend the show's emphasis on music for use, as characters sing or dance along to these pieces. We hear Paul Godwin's and Leo Monosson's "Mir ist so nach dir" (I'm Longing for You, 1930) in a dream sequence, as Gereon and Helga rise from bed, cook eggs, and dance around the apartment while sun streams in through the windows (S2, E2). Light-hearted and fanciful, the pantomime invites viewers into the happy days of the lovers' long-concealed relationship. The music cannot be traced to a source onscreen, but the dream ends abruptly when the pair knock over the photographs on the phonograph.[15]

"Raus mit den Männern" (Out with the Men), Friedrich Hollaender's 1926 cabaret hit, is sung by Lotte and her younger sister, Toni, as they clean up after their roommate (S3, E1). Hollaender was among the era's most beloved musicians and popular composers in the capital's cabaret circles, a German Jew who fled the country during the Third Reich and found success in Hollywood. Sung by the queer cabaret performer Claire Waldoff, the song creates a starkly poignant contrast between the scene's dingy apartment and the luxurious halls of power occupied primarily by men. As a newly minted criminal assistant, Lotte is the "New Woman" of Weimar who assumes professional roles unthinkable a generation previous, yet she is still saddled with family responsibilities and is the target of gender discrimination by her more senior colleagues.[16] The pantomime of these domestic scenes lets contemporary *BB* viewers hear and see the subversion of Weimar gender roles and class structures.

Hollaender's music allows Lotte and Toni to imagine a world where women can rule, helping them to (temporarily) transcend their impoverished circumstances. Significantly, however, the gramophone is not even theirs, belonging instead to their anonymous (and inconsiderate) roommate. While the song tells of female empowerment and new possibilities for women, it is still Lotte and Toni who are ultimately left cleaning up a mess.

Covers, Classics, and New Works: Hearing Trauma in *Babylon Berlin*

Sara Hall has written about *BB*'s visual imagery as a pastiche of Weimar cinema, an analysis we might extend to the series' use of sonic material as well, as it features pre-existing works that enrich and complicate the narrative across all four seasons.[17] From Romantic-era solo piano works to Roxy Music and Prussian military hymns, this pastiche of aural signifiers figures nostalgic contemplation, Weimar decadence, or the encroaching sound of fascism. Aside from the period recordings and technology discussed above, the show's score and underscore fall into four discrete categories: Berlin-specific pieces, Bryan Ferry's work, classical pieces, and newly composed (or newly covered) music for the series. Many of the show's songs are performed by the Bryan Ferry Orchestra: the ensemble plays various mash-ups from the singer's earlier musical oeuvre, including Roxy Music, glam rock, and disco, selections that reveal as much about Berlin's musical past as they do about the Weimar soundscape. Ferry connected with composers Klimek and Tykwer through their mutual record label, BMG. Tykwer, intrigued by Ferry's music, invited him to contribute to the series.[18] Julia Sneeringer has noted that these unexpected combinations can collapse time and space in the series' musical references.[19] When Ferry appears singing his 1974 hit "Bittersweet" from the Roxy Music album *Country Life*—but with some lyrics translated into German—most audience members are likely uncertain if it is Ferry's own song or a cover of a Weimar tune (S2, E2). This re-singing of "Bittersweet" is certainly a Weimarization of Ferry's original; the *BB* cabaret version is much faster in tempo, and the oom-pah rhythm more prominent with syncopated chords falling on beats 2 and 4.[20] Ferry's involvement also calls up the Berlin musical scene during the late 1970s and early 1980s, when luminaries like David Bowie recorded there.[21]

Other musical references overtly name the city of Berlin. These include a cover of the Marlene Dietrich tune, "Das ist Berlin, wie's weint, Berlin wie's lacht" (That's Berlin as It Cries, Berlin as It Laughs) as a body floats in the Spree (S1, E4) [22], and the pharmacist who hands Gereon his morphine while singing, "Du bist verrückt mein Kind, du musst nach Berlin" (You're Crazy, Kid, You Should Go to Berlin) (S1, E7). (Gereon's morphine addiction and presumed PTSD are frequently thematized in seasons one and two.) Often these Berlin musical allusions are used ironically, mirroring the gallows humor of the show (and the capital city's own signature irony). These pieces invite the auditor to

think of the city variously as both a musical space and a site of trauma—the capital of decadence and a scarred topography of political (and later physical) division. Historian Maria Tumarkin's notion of a "traumascape"—a space irreparably marked by violence and its contested place in cultural memory—accurately describes how the show depicts the metropole.[23] In *BB*, the capital is simultaneously the site of a free-wheeling nightlife *and* home to thousands traumatized by their wartime experiences.

The traumatic soundscape is not just heard by Gereon, however, as *BB* uses music to evoke wartime trauma writ large. The trumpet solo of the Prussian military hymn "Ich hatt' einen Kameraden" (I Had a Comrade) wafts through the halls of the white-walled institution where the maimed veterans gather (S1, E6); it is sung again by a young boy for a gathering of the Black Reichswehr (S1, E7). Where the first appearance of the tune shows the human toll of the First World War, as the patients who stand at attention are often visibly scarred or have prosthetic limbs, the solo for the right-wing veteran's group seems to foretell the rise of fascism.

Aside from scenes that use pre-existing music to explore wartime trauma or Berlin's cityscape, the series also employs solo piano works for scenes of quiet contemplation and nostalgia. When August Benda performs Bach on a church organ (S1, E6), the contemporary audience hears how he cultivates a sense of belonging by performing the quintessential German composer in a Catholic cathedral. Although he tells Gereon he is descended from a Jewish family, he is able to accompany his family (and literally accompany the Mass) by evoking one of the most famed German composers of all time. An episode later Benda plays Grieg's character piece "Arietta" (S1, E7) as we see misleading scenes of domestic tranquility (Greta caring for Benda's children) and criminal justice (Nyssen's arrest) that we sense will later be thwarted.

The romantic *Liebestraum* no. 3 of Franz Liszt features prominently throughout season three in a variety of settings: a version wafts through the background of Gereon's nightmare at the stock exchange (S3, E1); it plays as Helga Rath waits in the lobby of Haus Rheingold (S3, E2); and the melody is arranged for cello and piano for the Seegers sisters' duet (S3, E6).[24] Tellingly, the theme does not return in the final moments of season three as Gereon once again finds himself in the Berlin stock exchange. Hope appears shattered as the country teeters on the verge of economic and political collapse—the dream replaced by the cold, hard reality of history.

BB also features a smattering of new tunes, written alternately in the style of Weimar-era ballads, disco hits, and Baroque fugues—what we might consider

musical counterfeits as they reference earlier examples of these genres. The main theme of the first two seasons, "Zu Asche, zu Staub" features Svetlana Sorokina in Hitleresque drag, evoking both Dietrich and Bowie through crooning and androgyny under the stage name Nikoros.[25] These pop pieces are meant to imitate the sound world of Weimar and are frequently heard by contemporary audiences as the real thing.

Often the show's newly composed score serves as a sonic marker of trauma as well. In his work on shell-shock cinema, Anton Kaes probes how silent film made the trauma of the First World War visible, as the jerky movements within each frame emulated a wartime flashback.[26] Similarly, *BB* makes the trauma of the First World War audible through Klimek's newly composed score, which makes ample use of drones, lack of resolution, pedal points, harmonic instability, and out-of-tune pianos; in short, the music of psychological distress. Composer Klimek was aiming for "a lo-fi feel"; and after more than twenty years of collaborating with Tykwer, he had a clear understanding of how to translate the director's vision into sound.[27] Noting the contemporary rise of far-right parties, Tykwer hears music as a productive way to link the then and now. It is hardly a coincidence that Pale 3 released their work on Trauma Records.[28]

The show's musical selections represent Berlin's aural culture from the 1920s to the age of techno. By featuring the sound of the city through musical allusions to Bowie, Roxy Music, cabaret culture, and techno music, the show's soundtrack is fundamentally the sound of twentieth-century Berlin. Incorporating styles, genres, forms, and instruments from across German musical history, *BB* lets us know that Weimar's problems are not unique to Weimar alone, encouraging us to engage in active, rather than passive, listening.

Notes

1 Michel Chion, *Film: A Sound Art* (New York: Columbia University Press, 2009), 165–71.

2 Tom Tykwer, "How Babylon Berlin Turned 1920s Germany into a Wild, Historical Fantasy Fiction World," interview by Lars Weisbrod, *New York Magazine: The Vulture*, February 12, 2018, https://www.vulture.com/2018/02/babylon-berlin-netflix-tom-tykwer-interview.html.

3 Jonathan Sterne, *The Audible Past: Cultural Origins of Sound Production* (Durham, NC: Duke University Press, 2009), 9.

4 For more, see Peter Gay, *Weimar Culture: The Outsider as Insider* (New York: W.W. Norton, 2001); and Peter E. Gordon and John P. McCormick, Introduction, "Weimar Thought: Continuity and Crisis," in *Weimar Thought: A Contested Legacy*, ed. Gordon and McCormick (Princeton: Princeton University Press, 2017), 4.

5 For more about sonic culture and modernity, see Sterne, *The Audible Past*, 1–26.

6 Kurt Weill, "Radio and the Restructuring of Musical Life," in *Writings of German Composers*, ed. Jost Hermand and James Steakley (New York: Continuum, 1984), 262–5.

7 Brian Currid, *A National Acoustics: Music and Mass Publicity in Weimar and Nazi Germany* (Minneapolis: University of Minnesota Press, 2006), 22.

8 Carolyn Birdsall, *Nazi Soundscapes: Sound, Technology and Urban Space in Germany, 1933–1945* (Amsterdam: Amsterdam University Press, 2012), 11–31.

9 See "Forum: *Babylon Berlin*: Media, Spectacle, and History," ed. Veronika Fuechtner and Paul Lerner, *Central European History* 53 (2020): 835–54. See also Buerkle's essay in this volume.

10 The Second Viennese School is probably best known for their freely Expressionist works and twelve-tone pieces, which pushed the boundaries of audience goodwill.

11 Qtd. in Hanns Gutman, "Music for Use," *Melos* (1929), in *The Weimar Republic Sourcebook*, ed. Anton Kaes, Martin Jay, and Edward Dimendberg (Berkeley: University of California Press, 1995), 579.

12 Stephen Hinton, "Kurt Weill: Life, Work, and Posterity," in *Amerikanismus, Americanism, Weill: Die Suche nach kultureller Identität in der Moderne*, ed. Hermann Danuser and Hermann Gottschewski (Schliengen: Edition Argus, 2003), 209–20.

13 "Gebrauchsmusik," Oxford Dictionary of Music Online, https://www. oxfordreference.com/display/10.1093/acref/9780199578108.001.0001/acref-9780199578108-e-3738;jsessionid=8807944D530F06764443521324E1EBEA. See also Gutman, "Music for Use," 579. In other iterations of music for use, composers used new technologies like the radio and gramophone not just to play but to actually create compositions. Paul Hindemith's "Two Trick Recordings" used the gramophone to both play and then record the resulting compositions.

14 Stephen Hinton, "'Matters of Intellectual Property': The Sources and Genesis of *Die Dreigroschenoper*," in Hinton, *Kurt Weill: The Threepenny Opera* (Cambridge: Cambridge University Press, 1990), 22. Weill procured a barrel organ by the Zucco Maggio company for the scene.

15 Graham Fuller notes that this scene takes its cues from Dennis Potter's *Pennies from Heaven*, a 1978 British miniseries about a troubled marriage. Fuller, "The Musical Masterstrokes of Netflix's *Babylon Berlin*," *Culture Trip*, March 15, 2018, https:// theculturetrip.com/europe/germany/berlin/articles/the-musical-masterstrokes-of-netflixs-babylon-berlin/.

16 See Julia Sneeringer's comments on the New Woman of Weimar in "Forum: *Babylon Berlin*," 840–1.

17 Sara F. Hall, "*Babylon Berlin*: Pastiching Weimar Cinema," *Communications* 44, no. 3 (2019): 304–22. On musical pastiche in *BB*, see Nils Grosch, Roxane Lindlacher, Miranda Lipovica, and Laura Thaller, "Rekonfigurationen der Weimarer Republik: Musikalische Vergangenheiten und Pastiches in *Babylon Berlin* (2018–2020)," *Archiv für Musikwissenschaft* 79, no. 1 (2022): 43–60.

18 Johnny Klimek, *Behind the Audio*, interview by Peter F. Ebbinghaus, October 17, 2017, https://behindtheaudio.com/2017/10/watch-johnny-klimek-speak-music-babylon-berlin/.

19 See Sneeringer in "Forum: *Babylon Berlin*," 847.

20 The original version of the song featured sections in German translated by Constanze Karoli and Eveline Grunwald, who also modeled for the album cover.

21 For more on this point, see Sneeringer's essay in this volume.

22 The piece featured in the episode is Sabine Schwarzlose's 1965 recording of the song, with text and music originally by Willi Kollo, and sung in the style of Marlene Dietrich.

23 Maria Tumarkin, *Traumascapes: The Power and Fate of Places Transformed by Tragedy* (Melbourne: Melbourne University Publishing, 2005), 1–19.

24 The recording is not a vintage one. It comes from a recent album by cellist Ventseslav Nikolov and pianist Ruzhka Tcharaktchieva entitled *Music by Masonic Composers.*

25 "Forum: *Babylon Berlin*," *Central European History* 53 (2020): 835–54.

26 Anton Kaes, *Shell-Shock Cinema* (Princeton: Princeton University Press, 2009), 2; 312.

27 Johnny Klimek, *Behind the Audio*.

28 Tom Tykwer, "How Babylon Berlin."

From Kahn to Kollwitz: Exploring the Significance of Art and Visual Culture in *Babylon Berlin*

Camilla Smith

For anyone familiar with early twentieth-century German art, many scenes in *Babylon Berlin* vividly recall works by prolific Weimar artists George Grosz, Heinrich Zille, Christian Schad, Jeanne Mammen, and Otto Dix, whose images celebrated the glamour of the "Golden Twenties" while also revealing the precarious social and economic realities lurking beneath. Apart from Zille, their works are often considered characteristic of the *Neue Sachlichkeit* style, "Sachlichkeit" meaning matter-of-factness or sobriety in their manner of representation, with an emphasis on the return to figuration and plasticity after the abstraction of Cubism in painting. While Mutti—a sturdy proletarian prostitute—could have stepped out of one of Zille's caricatures of Berlin slums, the women protagonists Charlotte (Lotte) Ritter, Greta Overbeck, and Helga Rath are evocative of the fashionable New Women depicted in Schad's portraits or Mammen's scenes of Berlin. With their bobbed hair and lithe figures, cloche hats, and drop waist dresses, Mammen's figures possess the social fluidity of Ritter and appear to move seamlessly through the cafés, cinemas, nightclubs, and streets so vividly depicted in the artist's watercolors. Conversely, the crueler works of Dix and his erstwhile Dadaist friend Grosz sought to attack the failings of the republic from its inception. Whether reactionary imperialists, greedy industrialists, para-militarists, or political extremists, a motley crew of figures appear in their satirical prints, and here again on our screen in the guise of Wendt, Seegers, Wolter, Kessler, and the Nyssens. Through Dix and Grosz, we recognize them all.

Such visual references to Dix and Grosz potentially shore up the "iconic" status of these Weimar artists and their artworks in museums and galleries.

Put differently, the risk is that *BB* simply encourages us to regard their Weimar artworks as the socially detached objects of scholarly focus. *BB* demands, however, that the viewer reinserts art and visual culture *back* into many of the lived, social spaces in which it would have been originally encountered—on the street, in places of work, in interiors, and in the media. Whether it acts as a valuable commodity, signals political affinities, or is understood as an antidote to a dehumanized society, art has an important role to play *in BB*'s narrative action and mise-en-scène. By focusing on the subjects of politics, gender, and technology, I explore the ways in which art and visual culture are employed throughout the series to reveal some of the instabilities of the new Republic. I move back and forth between both fictional and non-fictional contexts, drawing on works by John Heartfield, Käthe Kollwitz, and Fritz Kahn. In so doing, I show the ways in which the series might be of particular value for art and cultural historians studying the Weimar period.

Political Interiors

Walter Benjamin's assessment of the interior as the dialectical "preserver of traces" of the inhabitant, reminds us that interior space never acts as a passive backdrop.[1] Benjamin focused on the historical emergence of bourgeois domesticity in the nineteenth century. But the notion that the interior has the capacity to be understood as an active constituent of historical consciousness, which reveals clues to historical identities, acts as a useful entry point for our understanding of the role that art and design objects play in revealing the ideological affinities and aversions of *BB*'s characters, be they reflected in private interiors or more public institutional settings.

In some scenes, the use of artworks is unimaginative. A large portrait of Stalin occupies the wall over Colonel Trokhin's desk in the Russian Embassy, and a photograph of Rosa Luxemburg appears in the office of Hans Litten. In other scenes, however, subtle placement of images on walls and art objects on surfaces contributes to the deeper characterization of protagonists. In the public offices of Berlin's Police Headquarters, choice artworks highlight the difficult position of the police as arbiters of law and order in the new Republic. The office and boardroom of Police President Karl Zörgiebel includes an array of diverse objects. There are Meissen vases, a bronze bust of Hindenburg by renowned sculptor Otto Schmidt-Hofer, horse sculptures, and topographic urban scenes in the style of enlightenment draftsman Friedrich Calau. Most striking is the

large imitation "rococo" bronze, after "Clodion"—a tightly intertwined dancing group of three bacchanalian women, with a small putto at their feet, standing on a plinth to the left of Zörgiebel's desk (particularly visible in S2, E2). On the one hand, such works appear to uphold the particularist traditions of the Empire. On the other hand, this "continental" sculpture potentially signals the alignment with reconciliatory attempts with France. The unmistakable presence of reproductions of state portraits of Hindenburg, likewise found in Gustav Stresemann's office (here by the artist Walter Firle; S2, E3), reminds the viewer that the friction between the forces of authoritarian and parliamentary civic rule is nonetheless ever present.

Beyond interior walls, the role of visual culture—in particular print culture—to politically galvanize wider opinion readily spills out onto the street in *BB*. Historicist façades are papered over by newer forms of party-political agitation, making the extent of the political radicalization of working-class neighborhoods clear to the viewer. The left's increasing frustration with shortcomings of Weimar's progressive *Sozialpolitik* are made evident through the many posters depicting the red clenched fist, advertising the International Workers' Day on May 1 (e.g., S1, E1–E3). The latter event was defining in the career of the non-fictional character Zörgiebel, who, far from maintaining republican order, in fact contributed to the desperate sense of political radicalism through his demonization of communists. His prohibition of political demonstrations turned May 1, 1929—*Blutmai* (Blood May)—into a deadly three-day battle. Heated discussions that take place in the series between Zörgiebel, Berlin's Mayor Gustav Böß, and the Head of the Political Police August Benda (S1, E5), not only remind the viewer of the crucial role the press played in shaping the public's opinion of this event, but also draw attention to the unceasing connection between art and politics during this period.

In the wake of the May Day violence, Zörgiebel became the clear target of the leftist press. The *Arbeiter-Illustrierte Zeitung* (*AIZ*; Worker's Illustrated Paper) used dramatic photographs in several 1929 editions showing unarmed workers led away by policemen or being confronted by mounted patrols.[2] Within this context, Zörgiebel also gains art historical significance as the subject of the first photomontage that Berlin Dadaist John Heartfield (1891–1968) would create for the *AIZ* (Figure 6.1). It appeared in the September edition the same year. The photomontage, comprising two portrait photographs, shows Heartfield himself splicing off Zörgiebel's head with a pair of scissors. In one powerful gesture, Heartfield, an ardent left-wing supporter, makes a clever play on both social democracy's brutal use of capital punishment and its longstanding fear

Figure 6.1 John Heartfield, Benütze Foto als Waffe! (Use Photo as Weapon!),
Photomontage for the Arbeiter-Illustrierte-Zeitung, Nr. 37, 1929, 27.7 × 21 cm.
Akademie der Künste, Berlin, Art Collection, inventory no.: JH 430 © The Heartfield
Community of Heirs/DACS 2022.

of the radical left. The decapitation notably calls forth the anti-monarchist
iconography of the revolution. *BB* picks up this theme, with Zörgiebel likening
the ongoing protests outside the Rote Burg to the "storming of the Bastille"
(S1, E5). Yet Heartfield's image is also troubling. As much as the montage seems
to denounce political violence, its publication in the *AIZ* also appears to validate
it at precisely a moment when the KPD (German Communist Party) began to
move toward more militant and aggressive forms of protest. The slogan "Benütze
Foto als Waffe" (Use Photo as Weapon) that was printed twice on the same page
as Heartfield's image in the original magazine permits such a reading.

We cannot expect to find August Benda in contemporary Weimar art. Unlike
Zörgiebel, Benda is a fictional character, based loosely on the German-Jewish
émigré and Head of the Political Police, Bernhard Weiss (1880–1951).[3] Yet
Benda's character, too, is shown to have a marked taste in art. Representations
of Hindenburg are decidedly absent from his office. Instead, a prominent and

sensitive portrait of Stresemann by contemporary artist Robert Kastor hangs near an abstract lithograph by the Bauhaus painter and photographer László Moholy-Nagy (S1, E2).[4] A Hungarian Jew, Moholy-Nagy was a leading professor for over half a decade in the school that by 1929 had firmly established an international reputation for avant-garde industrial design. Benda's support of republican order and progressive outlook is reinforced by the many scenes set in his home, where the viewer encounters trademark Bauhaus tubular steel chairs, among many other international cultural references. The ground floor showcases cubist-style paintings and modern wallpaper, while the stained-glass windows, wood-paneled walls, and William Morris wallpaper speak to architect Hermann Muthesius's advocacy of the modesty and workmanship of English Arts and Crafts design as modern alternatives for conservative bourgeois interiors (e.g., S1, E6; S2, E4 and E7).[5] A cabinet of Judaica on the ground floor acts like a nodal point around which these diverse cultural forms seemingly converge. During the Weimar era, Jews were legally and socially positioned as fully equal German citizens. Although it became "less urgent" to appear non-Jewish, antisemitism was in fact still rife.[6] The verbal slander of Benda by Major General Wilhelm Seegers on several occasions makes this abundantly clear (e.g., S2, E6). The need to "pass" (appear non-Jewish), as Kerry Wallach argues, could nonetheless fluctuate through something as simple as a "shift from public to private [spaces]."[7] Benda is not a convert; rather, like his attitude toward a modern marriage of mixed faith, his dwelling openly symbolizes his Jewish self-identification and his free choice, in which support for modern art and design appear to play an integral role.[8]

The façade of Benda's house, with its distinctive use of clinker bricks, continues to stress modern functionality combined with beauty and simplicity (S1, E6). There are no traces of the historicist *Prunk* (gaudy ornamentation) associated with Berlin villas. Instead, distinct surface pattern is created through the placement of angular and rough bricks at the front of the house. It was built in 1927 by the office of leading modernist architects Walter Klingenberg (1881–1963) and Werner Issel (1884–1974), who designed several pioneering industrial electricity plants around the city.[9] The number of scenes set in the Benda family home deliberately demonstrates Weimar cultural effervescence and social reform in action. As a consequence, the murder of Benda within this setting symbolizes not just the gross violation of one man and his family, but also an outright attack on Weimar plurality. Colonel Gottfried Wendt's order that Benda's office must be "fumigated" after his killing, reinforces the extent to which racial and cultural imperatives were closely

aligned by the right (S2, E8). It is therefore not only family portraits of a liberal Jew that must be removed, but also the artworks by Kastor and Moholy-Nagy.

For Benjamin, the emergence of the interior became paramount to bourgeois attempts at self-definition. Given the dynamic national politics of late nineteenth - and early twentieth-century Germany, one could argue that this need for self-definition remained particularly acute. The domestic interior symbolized a "refuge," in which historicist design and object display were meant to establish a sense of tradition.[10] The domestic interiors of Black Reichswehr figures and their affiliates, Detective Chief Inspector Bruno Wolter, Colonel Gottfried Wendt, and industrialist Alfred Nyssen, can be understood from this perspective. They unambiguously demonstrate a disengagement with Berlin's re-invention as a cultural metropole after the war. Bruno and Emmi Wolter's apartment is typical of outdated "shabby monumental safes crammed with tarnished values" that author Christopher Isherwood noted lined the "solemn massive street[s]" of Berlin in late 1930.[11] The interior reveals the sustained materialism of the Gründerzeit through the surplus knick-knacks and the middle-class desideratum to furnish an abode with oleographs (prints imitative of oil paintings) (e.g., S2, E1, E4, and E6). Artworks depicting alpine scenes of stags and goats, still lives of dead animals, and portraits in the style of popular nineteenth-century artists Carl Rungius, Adolph Menzel, or Johannes Christian Deiker frame the action in almost every scene. Culture that glorified warfare, hunting, or wall-mounted weaponry was pretty much standard fare for conservative revolutionaries. The absence of modernist styles of art—particularly French Impressionism, which once represented the more "liberal" cultural currents of Empire, and now Weimar cosmopolitanism—can only be deliberate.

In contrast, we are given little by way of domestic detail in Colonel Wendt's abode, which makes the prominent position of Carl Blechen's large oil painting *Stormy Sea with Lighthouse* (1826) all the more significant (S3, E7) (Figure 6.2). During his lifetime, Blechen's "northern" landscapes were considered powerful forms of Napoleonic resistance in much the same vein as the work of revered romantic artist Caspar David Friedrich.[12] After unification, reanimation of romantic art became part of attempts to establish a characteristic *German* culture.[13] A painting that so powerfully evokes the Kantian sublime, with its boundless ocean "threatening to overwhelm and engulf everything" doubtlessly added to its allure.[14] Over half a century later, Romanticism

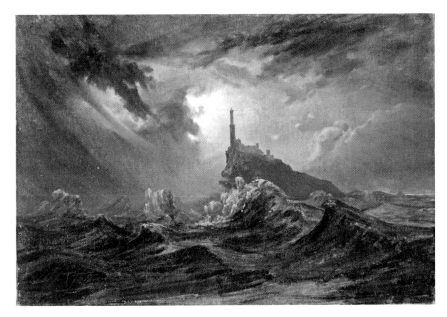

Figure 6.2 Carl Blechen, *Stürmische See mit Leuchtturm* (Stormy Sea with Lighthouse), *c.*1826, oil on canvas, 72 × 115 cm. © bpk/Kunsthalle Hamburg. Photograph © Elka Walford.

remained a nationalist phenomenon, still garnering little attention in Britain or France, suggesting why such a painting would be hanging in the private interior of a veteran colonel and former advisor to Hindenburg. But its subject matter potentially runs deeper than this. It is perhaps no coincidence that we first encounter Blechen's image when the series begins to reveal the lengths Wendt will go to to vanquish democracy. The violent attack on the editorial offices at Ullstein's *Tempo* newspaper (which he does not condemn), plots to bring down the stock market, and the brutal murder of Fritz Hockert occur when Wendt's domestic space comes into view. Indeed, Wendt pointedly reveals his admiration of aesthetic violence in a discussion with Marie-Luise Seegers, heralding the author Ernst Jünger (1895–1998) a "magnificent writer," of whose destructive ideals he approves (S3, E6). In this context, Blechen's depiction of the dramatic intractability of nature gathers renewed fervor, for Jünger's heroic descriptions of war strongly resonate with the Kantian sublime. Yet for the viewer, when read against the grain, a romantic painting of a vulnerable lighthouse beset by menacing forces operates as a striking metaphor for a democracy in peril.

 In both its ideological form and function, Schloss Drachenburg—a palace that serves as the setting for the fictional Nyssen family's estate—demonstrates a type of cultural retrospection allied with the conservative revolution at its most

extreme. Built during a period in which monumental architectural projects were supposed to proclaim the self-assurance of national power and importance, Drachenburg (1882–4) was designed by the architect Wilhelm Hoffmann (c.1820–90). It is an extravagant mélange of Gothic revivalism, with imposing towers and functionless ornamental sculpture—gargoyles, corbels, friezes, tracery rosettes, and crenelated rustic walls (S1, E6). Whereas the industrialists Borsig and Siemens built lavish Neo-Renaissance palazzos in Berlin's wealthy Wilhelmstraße and Charlottenburg, respectively, Drachenburg was instead erected on the banks of the Rhine.[15] The "Art Gallery," a long stretched room in which Nyssen dines with his mother, and later with members of the Reichswehr and moguls of industry and commerce, has extensive stained-glass tracery windows (with portraits of famous German figures) and coffered barrel vaulting with ogival arches often found in medieval churches (S2, E1 and S3, E10).[16] During evening soirees, we also catch sight of an adjoining suite of rooms including the "Nibelung Room," which consists of large, stencilled paintings of Kriemhild and Brünhild on the walls by the artist Frank Kirchbach (1859–1912), and a drawing room (S3, E6).[17] Among Reichswehr compatriots, it is here that Wendt once again proffers violence (via "the fascists") as a means of realizing the conservative revolution (S3, E6). Stresemann's marked intrusion into this circle moments later is only reinforced by the oppressive neo-medieval interior design of Franz Langenberg (1842–95), which appears to symbolize Stresemann's conciliatory attempts as entirely alien.

Closer examination of the residences of Wolter, Wendt, and Nyssen demonstrates the crucial and deliberate role that art, architecture, and design play in their characterization.

As well as reinforcing the extent to which conservative forces were lodged in some of the most powerful institutions in Weimar society, the series establishes a common visual language of the right. Romanticism, naturalism, Gothic, and medieval forms had long-standing origins outside of social democracy and represent the type of reactionary "non-contemporaneity"—a temporal inconsistency that Ernst Bloch would later argue acted as an important precondition of right-wing conformity.[18] Scholarship has persuasively moved away from the ill-fated narrative of German Romanticism under National Socialism, where the style once again found favor.[19] But through figures like Wendt and Nyssen, it is tempting to interpret BB's attempt at its reassertion. Moreover, a dividing line begins to emerge between "high" and "low" art forms, which was far less finite in Weimar Germany. The appearance of fine art objects in interiors signals the

commitment of the conservative elite and bourgeoisie to the hierarchical order of fine art as vestiges of wealth. Conversely, mass print culture points toward modern technological image production. It fosters the social and cultural roots of political radicalism among Berlin's working classes and as a result, it is an art form that is presented in the series as fundamentally shaping the dynamism of the street.

New Women, Old Ideals

Germany's new constitution enshrined freedom and equality as basic rights of the individual. However, throughout the series visual culture is used in definitive moments to reveal the ways in which this constitution in fact left many groups, including women, fighting for acceptance. In one poignant scene, Helga Rath walks alone along the street. In contrast to Ur-Berliner Lotte Ritter, who moves with confidence and intent, the city appears to dictate Helga's tired pace, her overall sense of powerlessness and alienation. Helga's gaze is momentarily arrested by an advertising column (S3, E8). *BB* does little to dispel the connection between the surfeit of advertising addressing women in this period. Yet upon closer scrutiny, the advertisements for films, dance performances, and political parties pasted on this column appear to reveal some of the forces pressuring Weimar women.

One of the most prominent posters promotes Carl Tema's 1929 film *Das Mädel aus der Provinz* (The Girl from the Provinces). Designed by Josef Fenneker, it depicts a young woman in a dower cloche hat and coat, clutching a suitcase, seemingly awe-struck by the bright city lights (Figure 6.3). The metropolis as a place of fame and fortune was a pervasive myth and well-known topos in art, literature, and film during this period. Here, the camera angle invites the viewer to draw parallels between Fenneker's figure and a fashion-conscious Helga, who stands clutching her handbag. Helga has, after all, cashed in her savings and moved to Berlin in the hope of securing the new-found freedom to marry her brother-in-law, Gereon. Above the film poster is a black-and-white expressionist linocut by Curt Wild-Wall, advertising the provocative "Tanzen—klassische Moderne" (classical modern dance) performances of Anita Berber (1899–1928) with her partner Henri Châtin-Hofmann (Figure 6.4). If Fenneker's poster portrays naïve hopes and dreams, the viewer is invited to recognize Wild-Wall's as revealing their brutal reality. An actress and professionally trained dancer, Berber created the expressive signature acts "Morphium" and "Salomé," which

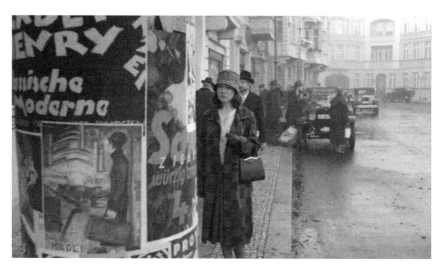

Figure 6.3 Advertising column with Josef Fenneker's poster for Carl Tema's film *Das Mädel aus der Provinz* (The Girl from the Provinces), 1929, and a promotional poster for a dance performance by Anita Berber and Henri Châtin-Hofmann, 1925. Screenshot, *Babylon Berlin* (S3, E8).

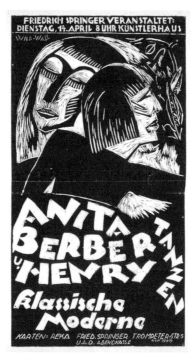

Figure 6.4 Curt Wild-Wall, Anita Berber and Henri Châtin-Hofmann "Tanzen— Klassische Moderne" (Dance—Classic Modern), 1925, linocut and lithograph, 96 × 64 cm © bpk/Deutsches Historisches Museum. Photograph © Arne Psille.

were exciting, fraught, and short-lived, much like her overall career. Berber was not afraid to turn to prostitution to fund her lifestyle. Her notoriety as a "whore of Babylon" was perhaps fueled further by the ubiquity of "Babylonia" in contemporary titles of erotic literature.[20] In a society that craved stimulation—a point the series makes abundantly clear through the heady montages of dancing, soliciting, and performing (S1, E2)—Berber, as Klaus Mann put it, was both the "creation and victim of thrill pushers [*Schieberherrlichkeit*]."[21] Berber had in fact already died of an overdose in November 1928, aged only 29. In *BB*, the (deliberately?) outdated linocut appears to vie for the viewers' attention alongside Tema's new film poster, thus pointing toward Weimar's fickle celebrity culture. In fact, this seemingly arbitrary placement of posters cleverly evokes the insecure position of other female characters in the series. Ritter's borrowed glamour from Moka Efti acts as an important leitmotif. While a number of aspirational actresses viciously compete for the lead in *Demons of Passion*, the much-diminished, opium-smoking actress and singer Esther (Korda) Kasabian waits listlessly at home, until she can, once again, come back into the cinematic spotlight (S3, E2).

Helga, however, is forced to confront her own predicament through the party-political poster by Käthe Kollwitz (1867–1945) on the other side of the column (Figure 6.5). It is this poster that unambiguously demonstrates Weimar's failure to fully embrace women's enfranchisement. And on her way to the hospital to tell Gereon that she is pregnant, it stops Helga in her tracks. The black-and-white lithograph dating from 1923 depicts an impoverished, heavily pregnant mother cradling a small baby in one arm and holding a toddler's hand. The maternal figure is exhausted; her dark-sunken eyes and sallow cheeks symbolize the fate of countless women. The image powerfully links working-class poverty with women's right to decide. However, the figure bears little initial resemblance to Helga, and instead, is more reminiscent of Ilse Ritter, Lotte's older sister. One of a number of posters that were issued by the KPD, the bold printed words, "Nieder mit den Abtreibungs-Paragraphen" (Down with the Abortion Paragraphs), nonetheless, went well beyond working-class dynamics. This was in fact a more universal campaign for the abolition of Paragraph 218 of the Criminal Code, which continued to criminalize abortion. While the new state also guaranteed equality in marriage and protection of children, Kollwitz depicts the mother alone in her caring responsibilities—a far more prescient association for Helga— which Kollwitz had also experienced first-hand and recorded in her diaries. Kollwitz was the wife of a doctor for the poor in the working-class district of Prenzlauer Berg, whose studio was situated in the same house as her husband's

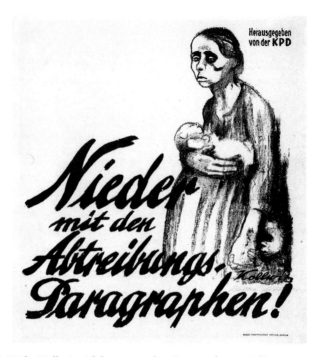

Figure 6.5 Käthe Kollwitz, Plakat gegen den Paragraphen 218 (Poster against Paragraph 218), 1923, chalk lithograph (transfer from a drawing on transparent paper). Kn 198 © Käthe Kollwitz Museum Köln.

practice. The medical and artistic worlds productively intersected; Karl's patients became Käthe's subjects. In a diary entry from August 1923, the artist noted with satisfaction that she had finished this commissioned poster, along with another specifically for the *Internationale Gewerkschaftsbund* (International Federation of Trade Unions), decrying war, and that they had both "turned out reasonably well."[22] Here Kollwitz's ardent pacifism and her criticism of the failings of the state to protect women and the status of motherhood mark equal parts of the artist's activism.

The urgent complexity of Helga's situation is reinforced by the dramatically contrasting political poster issued by *Das Zentrum* (Catholic Center Party), visible in other street scenes (S1, E1). The image depicts a patriarchal family unit set against the backdrop of a bountiful rural settlement, with a church spire at the center. The father figure is cast as the family protector, who holds aloft a large shield brandishing a cross. The rallying cry on the poster, "Wer schützt die Familie" (Who Will Protect Your Family), makes clear the move by conservative parties—even those closer to the political center—by the end of the 1920s to galvanize voters through vilification, not just of the political left, but also of

the social fluidity of the New Woman and her perceived threat to social order. Kollwitz's poster would nonetheless prove dangerously persuasive for Helga. Already lodged in Nyssen's opulent suite in Haus Rheingold, she risks her life—like many women—to undergo a backstreet abortion. This offers little by way of social re-invention, however. The prominent position of paintings of seductive women, *The Siren* (1900) and *The Mermaid* (1901), by English artist John Waterhouse on the walls of the hotel room, appear to betray Helga's inevitable decline to a bourgeois "coquette" (S3, E2).[23]

Bionic Men

Some of most caustic debates during this period relate to the increasing effects of technology on society. The series gives the camera and the ubiquity of photographic representation particular attention. Periodic scenes of Reinhold Gräf working meticulously in his darkroom signal the widespread belief in photographic veracity. This belief was motivated, in part, by the radical shift away from pictorialism, whereby photographs imitate the aesthetic characteristics of painting, to functionalist photographs being considered an optically faithful representation of "reality." Focus on the quotidian in the new experimental genre of photography, *Neues Sehen* or *Neue Optik* (New Vision), inadvertently strengthened such convictions. Accordingly, Gräf's use of the camera to document crime scenes is portrayed as a central method of the homicide detective Ernst Gennat. The idea that the camera could help structure and control investigative work is reinforced by the headquarters' fastidious image archive. However, Gennat's recognition that these images could possibly help "solve" a crime when printed for a "crime hungry readership" in the press signals not only the profusion of photographs in the media, but also their potentially stultifying effects.[24] Indeed, what is at stake—the potential erosion of text in the longer term—is made clear by the editor-in-chief of *Tempo*. "We need images," proclaims Heymann, not theoretical exposition to sell news (S3, E3). This is shown in the series to engender deep disquiet for the investigative journalist Samuel Katelbach, as it also did for Benjamin and others at the time.[25]

The troubling nature of technology becomes obvious in relation to modern conceptualizations of the body. In a pivotal scene in season three, Esther flips through a magazine containing the infographics of German physician Fritz Kahn (1888–1968), in which machine analogues stand in for body organs (S3, E9). One image depicts a human head to explain visual perception and

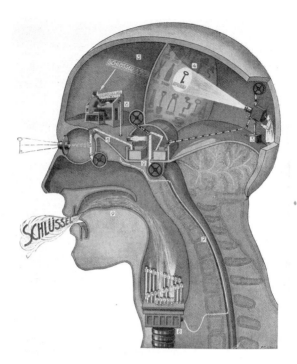

Figure 6.6 Fritz Kahn, Der Sehakt (The Act of Seeing)—Human perception and thinking as theatre and cinema, *Das Leben des Menschen: Eine volkstümliche Anatomie, Biologie, Physiologie und Entwicklungsgeschichte des Menschen* [Human Life: A Popular Anatomy, Biology, Physiology, and Developmental History of Humankind] (Stuttgart: Kosmos Franckh'sche Verlag, 1922–1931), vol. 4, table 8. © Wellcome Institute.

sound through correlations between a cerebral cinema and electric organ music (Figure 6.6). The image, in which a projectionist figure stands at the back of the brain, signals the all-pervasive audiovisual experience of Weimar and was originally featured in Kahn's best-selling multivolume book *Das Leben des Menschen* (The Life of Man; 1922–31). A reproduction of Kahn's most famous image, *Der Mensch als Industriepalast* (Man as Industrial Palace, 1926), in which biological and technological processes inside a human body are uniformly fused, appears on the magazine's cover. The popularity of Kahn's machinist physiology was undoubtedly motivated both by the accelerated investment in technological innovation after the war and the high numbers of returning war-wounded. Germans thus became receptive to corporeal interventions including hormone therapies, rejuvenation operations, and biotechnics.[26]

But although Kahn's intentions may have aided the intersubjectivity of the middle classes, his results were often questionable. Other photographs in Esther's

magazine show the augmented body of a nude model with a camera eye, along with another photograph of a figure wearing robotic body parts. The camera eye (or prosthetic eye) was a recurrent trope in the 1920s, at the intersections of cultural, medical, and manufacturing industries. From a cultural perspective, it became a prominent expression of *Neues Sehen* photography and denoted the idea that the lens of the camera becomes a second eye for looking at the world.[27] However, in the context of Esther's magazine, these images seem to suggest a form of dystopic techno-reductionism, upon which she readily seizes as fodder for *Demons of Passion*. In the film it is not biotechnics that are shown to restore happiness, but rather the human organism and human compassion. Technology thus serves a double logic, acting as both the cause of disquiet and ultimately the creative resolution. But the significance of technology goes well beyond Esther's personal triumph and is shown to have wider societal repercussions. Much like the series' pointed use of posters, Kahn's infographics reveal parallels with the wider narrative unfolding.

Kahn's pictorial eradication of physiological processes leaves little room for individual malfunction or women.[28] The images Esther encounters are of men. *BB* reminds the viewer that men were also expected to adhere to societal norms of gender identity during this period. The First World War affirmed widespread belief that masculinity was predicated on the nation's military culture, aggrandizing the idea that "sacrifice for a cause was now thought to be the highest virtue of which masculinity was capable."[29] There was little toleration in the wider society of shell-shock sufferers, or other perceived digressions from normative masculinity. To be sure, the precarious professional position of Rath or Gräf in an organization rife with ex-Reichswehr and paramilitary figures powerfully demonstrates the fault lines between social acceptance and exclusion. However, it is the scene in which we see Kahn's infographics, coupled with the overplaying of Dr. Schmidt's radio broadcast, that the viewer is made to fully grasp how the reactionary possibilities of technology might inform the therapeutic coercion of *Krüppelfürsorge* (the field devoted to physical and psychological care of war "cripples"). This growing field presumed that physiology—mobile capability and productivity—directly influenced the development of the soul.[30] Kahn's body images appear to coalesce with Schmidt's hypnotic fantasy. Schmidt calls not for "repair" of disabled veterans, but for reparative augmentation by way of "a steel hand" or "camera eye for the gouged-out eye socket" in order to create his ultimate ideal, "an android free of pain and fear." Schmidt's body ideal is autocratic and disciplinary. It goes beyond the troubled state provision of prosthetics for Germany's war-wounded.[31] As with the field of *Krüppelfürsorge*, Schmidt affirms the war veteran as a powerful, exclusive "other," with his own laws and

capabilities forged through a complete body/soul unity.[32] His new evolutionary figure would appear to eradicate biological imperfections entirely, removing human and organic elements altogether through powerful technical auxiliaries. Schmidt's reiteration of "darkness to light" in hypnosis further mechanizes his subjects. The *very process* of self-overcoming for his patients is analogous with the development of a photograph in a darkroom, which brings us back to the importance of the camera. *BB* cleverly brings contemporary developments in postwar technology and the organic body with the radically new perception of Weimar photography into parallel.[33] This parallel would continue apace under the National Socialists, who joined the ideal body image and photography's professed claims to "documentary" together—in Leni Riefenstahl's *Olympia*, for example—as important mechanisms to enforce mass conformity.

Coda: Babylon in Berlin

There can be little doubt that *BB* succeeds in reinforcing the widespread understanding of Weimar as a period of cultural effervescence. It consistently demonstrates the close intersections of art and everyday life and, as a result, instead of assessing whether a scene or figure "looks like" an artwork, it reminds us that it is the mediation and dissemination of artworks during this period that is crucial to our full understanding of them. Nonetheless, the extent to which the series presents culture as a contributing factor in the rise of the right is perhaps self-evident in its name. The formidable city of Babylon conjures fabled notions of prodigious wealth and power. But it is the city's hubris of tower-building that appears to symbolize the belief that Germany's attempt at democracy would inevitably fail. It was, after all, the Babylonian Empire that would serve as an important architectural influence on Hitler's Germania. However, the disintegration of the Weimar Republic did not happen overnight. Debates regarding the value of parliamentarism and social and sexual reforms were enduring. And so, too, were debates regarding culture. The series persuasively demonstrates how some of the fundamental tensions and fissures in society cannot simply be confined to a discrete period of turmoil post-1929 crash. The mediation of politics through the ubiquity of party-political posters reveals a city of radical neighborhoods that is deeply divided. Constructions of the New Woman in the media and the push for sexual reform highlight the sustained conflicts between the long-standing criminal justice system and Weimar's

new constitutional freedoms. Gennat's pioneering emphasis on the value of images as an evidentiary investigatory technique contributes to the troubling sensationalism of ongoing murder investigations in the press. In other words, *BB* remains ambivalent about the merits of modern mass culture in Weimar society, but it tries, at least, to present a complex range of social, political, economic, and indeed, cultural factors that facilitated the rise of the right.

References to Babylon also suggest another meaning, which ultimately places the significance of cultural objects and their historical dialecticism at the very heart of this series.

If the viewer looks beyond the modernist architecture and innovative examples of infographics and photomontage, residual cultural forms of imperial grandeur and authoritarianism are always present. Whether through the sublimity of Blechen, or the more contemporary didactic of Hoffmann's Drachenburg, the series uses culture as a way to expose the extent to which Weimar Germany sluggishly grappled with its past in the present. In doing so, it challenges popular narratives of the Republic that privilege modernist inventions. From this perspective, we might also consider the significant naming of the series after a cultural artifact and museum exhibit linked to Germany's colonial conquest: the Babylonian Ishtar Gate. Although excavations began in the late 1890s, it would take over thirty years before the gate was reassembled, restored, and finally exhibited in the newly opened Pergamonmuseum in 1930.[34] Here the gate caught the imagination of its visitors in a city trying to reinvent itself as the new democratic powerhouse of Europe, but a city, nonetheless, still indelibly shaped by its triumphalist imperial past.

Today, almost nothing of the ancient city of Babylon survives. It is not perhaps without irony, however, that one of its most important remnants should have first been exhibited during a period in German history that also continues to be so persuasively and so powerfully mythologized.

Notes

1 Walter Benjamin, *The Arcades Project* (Cambridge, MA: Harvard University Press, 1999), 20, 227.

2 "Die Toten klagen an!," *AIZ* 20, 1929, 1, and "Die Wahrheit ist 'verboten,'" *Die Rote Fahne,* May 24, 1929, reproductions in Pamela E. Swett, *Neighbours and Enemies: The Culture of Radicalism in Berlin, 1929–1933* (Cambridge: Cambridge University Press, 2004), 128.

3 Weiss became the Head of the Political Police in 1920 and was appointed Vice
 President of the Berlin police force in 1927. He was a staunch democrat and
 left Germany (and settled in London) shortly before Hitler came to power. See
 Handbuch des Antisemitismus: Judenfeindschaft in Geschichte und Gegenwart vol 2:
 Personen, ed. Wolfgang Benz (Berlin: De Gruyter, 2009), 880–2.

4 László Moholy-Nagy, Ohne Titel, (1923), lithograph on cardboard, from the
 folio "6. Kestnermappe—6 Konstruktionen," 59.4 × 43.9 cm. Inv. Nr. 1996/37.5:
 © Bauhaus-Archiv/Museum für Gestaltung.

5 Muthesius's most well-known work, the three-volume *Das englische Haus* (The
 English House) published between 1904 and 1905 offered German readers an in-
 depth study of residential architecture and domestic interior design in Britain from
 the 1860s to the 1900s.

6 Kerry Wallach, *Passing Illusions: Jewish Visibility in Weimar Germany* (Ann Arbor:
 University of Michigan Press, 2017), 7. On Benda's Jewishness, see also Darcy
 Buerkle's chapter in this volume.

7 Wallach, *Passing Illusions*, 7.

8 Of comparison here is the role the interior plays for queer self-identification in
 the passing of Reinhold Gräf through reproductions of artworks such as Édouard
 Manet's *The Fifer* (1866), hanging in Gräf's hallway (S3, E9). David J. Getsy, "How
 to Teach Manet's *Olympia* after Transgender Studies," *Art History* 45, no. 2 (2022):
 342–69, https://doi.org/10.1111/1467-8365.12647.

9 The house (which still exists) was built for the Director of the Märkische
 Elektrizitätswerke, Georg Warrelmann. See "Klingenberg und Issel," *Wasmuths
 Monatsheft für Baukunst* VIII 9/10, 1924, 268–80.

10 Benjamin, *Arcades*, 20.

11 Christopher Isherwood, *The Berlin Novels* (London: Vintage, Random House,
 1999), 246–7.

12 Reinhard Zimmermann, "Carl Blechen und Caspar David Friedrich: Religiöse
 Aspekte im Werk Blechens," in *Die neue Wirklichkeit der Bilder: Carl Blechen im
 Spannungsfeld der Forschung*, ed. Beate Schneider and Reinhard Wegner (Berlin:
 Lukas, 2008), 152–70.

13 For example, the "Jahrhundertausstellung deutscher Kunst" (1906) organized by
 the Director of Berlin's Nationalgalerie, Hugo von Tschudi, foregrounded work
 by German romantic artists. For the exhibition catalogue, see https://archive.org/
 details/ausstellungdeuts01deut/page/n9/mode/2up. Blechen is on page 48.

14 Immanuel Kant, *The Critique of Judgement*, trans. James Meredith, ed. Nicholas
 Walker (Oxford: Oxford Clarendon Press, 2008), 100.

15 The villa was commissioned by the financier Stephan von Sarter (1833–1902). For
 images, see Ulrich Schäfer, *Schloss Drachenburg in the Siebengebirge*, trans. Clara
 Eckert-Framm and Catherine Framm (Berlin & Munich: DKV, 2013), 30–7.

16 Much of the glass was destroyed during Allied bombing in the Second World War.

17 Schäfer, *Schloss Drachenburg*, 46, 51–3. In reality the drawing room is actually a dining room, see 48. For an analysis of the Nibelungen as a central intertext for *BB*, see Carrie Collenberg-González's and Curtis Maughan's contribution to this volume.

18 Ernst Bloch, *Heritage of Our Times*, trans. Neville and Stephen Plaice (Cambridge: Polity Press, 1991), 53–4.

19 See discussions in *The Romantic Spirit in German Art 1790–1990*, ed. Keith Hartley, Henry Meyric Hughes, Peter-Klaus Schuster et al. exh. cat. (London: Thames and Hudson, 1995), particularly Lutz Becker, 390–3, and from a wider cultural perspective, David B. Dennis, "Forging Steel Romanticism," in *Inhumanities: Nazi Interpretations of Western Culture* (Cambridge: Cambridge University Press, 2012), 176–97.

20 Paul Englisch, *Geschichte der erotischen Literatur* (Stuttgart: Julius Püttmann, 1927), 238. Englisch also noted that in order to evade discovery and potential prohibition, erotic publications listed "Babylon" as their place of publication. Paul Englisch, "Der Kampf gegen die Pornographie," *Das Kriminal-Magazin* 8 (1930/31): 578.

21 Klaus Mann, "Erinnerungen an Anita Berber," *Die Bühne* 7, no. 275 (1930): 44.

22 Käthe Kollwitz, "August 5, 1923," in *Die Tagebücher 1908–1943*, ed. Jutta Bohnke-Kollwitz (Berlin: Siedler, 1999), 557.

23 Jill Suzanne Smith, *Berlin Coquette: Prostitution and the New German Woman, 1890–1933* (Ithaca, NY: Cornell University Press, 2013), 2.

24 On Gennat's and colleague Bernhard Weiss's attitudes toward the importance of the press for investigative work, see Todd Herzog, *Crime Stories: Criminalistic Fantasy and the Culture of Crisis in Weimar Germany* (New York: Berghahn, 2009), 94 and 113–14.

25 Walter Benjamin, *Selected Writings*, vols. 1–3, trans. Edmund Jephcott and Howard Eiland, ed. Marcus Bullock, Eiland, and Michael W. Jennings (Cambridge MA: Belknap Press, 1996–2002). See especially "One-Way Street" 1: 444, 476, and "The Storyteller," 3: 147. For a close reading of the exchange between Heymann and Katelbach, see Jochen Hung's essay in this volume.

26 Matthew Biro's work on the emergence of the hybrid organic-technological figure in Weimar visual culture is formative here: "The New Man as Cyborg: Figures of Technology in Weimar Visual Culture," *New German Critique* 62 (1994): 71–110.

27 It was notably used as the title of the art critic and photographer Franz Roh's essay *Foto-Auge*, which explored examples of this new photographic genre (Stuttgart: Akademischer Verlag, 1929).

28 On how Kahn's biopolitics were sustained by the Nazis, see Michael Sappol, *Body Modern: Fritz Kahn, Scientific Illustration, and the Homuncular Subject* (Minneapolis: University of Minnesota Press, 2017), 146–9.

29 George L. Mosse, *The Image of Man* (Oxford: Oxford University Press, 2010), 112.

30 The field was established in Berlin at the Oskar-Helene-Heim by the orthopedic surgeon Konrad Biesalski (1868–1930). For close analysis of his methods, see Philipp Osten, *Die Modellanstalt: Über den Aufbau einer "modernen Krüppelfürsorge" 1905–1933* (Frankfurt: Mabuse Verlag, 2004), 282–319.

31 For extensive discussion on state support and its failures with reference to visual examples, see Mia Finemann "Ecce Homo Prostheticus," *New German Critique* 76, Winter (1999): 85–114.

32 For key beliefs in the field, see Konrad Biesalski, *Grundriss der Krüppelfürsorge* (Leipzig: Leopold Voss, 1926), 97–8. And for in-depth analysis, see Osten, *Die Modellanstalt,* 314–18.

33 Finemann persuasively outlines parallels between developments in *Neues Sehen* photography and body augmentation.

34 For how the gate's and museum's histories intertwine, see Mirjam Brusius, "The Field in the Museum: Puzzling out Babylon in Berlin," *Osiris* 32 (2017): 264–85.

Part Three

Representing Weimar History

Journalists and the Media as Proponents of Modern Life

Jochen Hung

On January 16, 1929, the newspaper *Tempo* reported about a pre-dawn police raid against Berlin's organized crime scene. Front-page photos show chief constable Karl Zörgiebel personally overseeing the raid that targeted the seedy bars around Schlesischer Bahnhof in Friedrichshain (Figure 7.1) On the inside pages, *Tempo* discussed the new scientific discipline of parapsychology, introduced a plucky young woman who had set up her own taxi company, published a behind-the-scenes photo of Ernst Lubitsch's latest film, and reported about a "considerable decline in prices" in the stock market.[1]

At first glance, it would be difficult to say if this kaleidoscopic snapshot of Weimar Berlin, full of crime, movie glamour, modern women, occultism, and crisis, was fact or fiction, a report from the real world or one straight out of the *Babylon Berlin* universe. To be sure, a newspaper of the same name also appears in the fictional world of *BB*, but the main reason for this blurring between the real and the imagined is the fact that the journalists writing for the real-life *Tempo* in 1929 and the *BB* writers of 2017–20 are *both* engaging in the construction of a myth: Weimar-era Berlin as a metropolis full of vice and modernity, and life in it as the proverbial dance on the edge of the volcano. The depiction of Berlin and Weimar society in *BB* taps into a long tradition of Weimar-era tropes, some of which were circulating already in Weimar Germany. This chapter unpacks some of these tropes related to the press and journalists of the Weimar Republic, particularly the newspaper *Tempo* and its publisher, the Ullstein company. Its aim is not to contrast fact with fiction or to highlight factual errors. Much could be (and has been) said about the historical inaccuracies in *BB*'s depiction of Weimar-era Berlin. However, when we historicize these myths and half-truths it turns out that *BB* is often very accurate, in the sense that many of the series' tall tales about

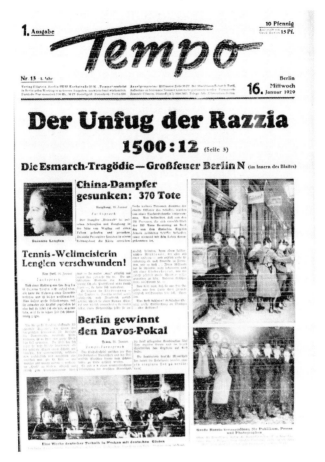

Figure 7.1 Front page of *Tempo* tabloid.

the hard-partying capital full of glamour, squalor, crime, and sensation are very close to the myths Germans themselves told and believed about Berlin at the time.

The booming media industry and their representatives—journalists, reporters, editors, actors, and film directors—were a central aspect of this narrative: the image of the modern metropolis is hardly complete without these characters. In this respect, *BB* stands in a tradition of storytelling that frames the media as both a symbol and driving factor of urban modernity. More than a passive part of the urban scenery, the mass media were in fact instrumental in establishing that image of Berlin as metropolis in the first place. As Peter Fritzsche has argued, during the early twentieth century the modern popular press and Berlin went through a "formative period of mutual definition," in which newspapers established themselves as new metropolitan institutions and constructed the

German capital as a "word city" by creating metropolitan narratives "which allowed readers to make sense of the changing inventory of the city."[2] In short, Berlin made the modern mass media, and the mass media made modern Berlin. The ways in which the media are depicted in *BB* perpetuate these narratives and further establish the historical "word city" of Weimar Berlin for contemporary audiences. This chapter approaches the topic from three angles—investigating the ways in which journalists, the press, and *Tempo* were discussed in Weimar culture—and shows in all three cases how these discourses are reflected in *BB*.

"Journalist! That's What I Wanted to Be!": The Depiction of Journalists in Weimar Culture and *BB*

In German literature and culture, journalists were traditionally portrayed as unprofessional, bumbling, and opportunistic, embodied most prominently by the character Schmock in Gustav Freytag's play *Die Journalisten* (1852).[3] This changed after 1918: in Weimar Germany, journalists were now frequently portrayed as hard-boiled chroniclers of the modern world. This new discourse tapped into a transnational mythology of "journalism as a romantic occupation, full of excitement and adventure" that developed during the interwar years, with the popular Broadway play *The Front Page* (1928) and its subsequent film adaptations—full of "aggressive, anti-academic, blunt, cynical" characters—as one of its most enduring examples.[4] The allure of this transatlantic myth of the journalistic profession—rather than its actual practice in Germany—is reflected in Billy Wilder's motivation to leave Vienna and get into journalism in Weimar Berlin: "On American news, I had seen young men. They wore Burberry coats, and stuck a card in the band on their hat that said 'Press,' and they conducted interviews with a brilliant star actress or a Rockefeller on a luxurious steamship. Journalist! That's what I wanted to be!"[5] This Americanized image of the journalistic profession was most prominently embodied by the archetype of the reporter as an unsentimental and objective observer of modernity. By embracing or rejecting this type, people could position themselves in the struggle to make sense of the ongoing transformation of German society.

BB perpetuates this Weimar-era image of journalism as a modern, hectic profession of truth-seekers. Journalists appear most frequently in crowds at the press conferences held at the police headquarters on Alexanderplatz and in mobs of paparazzi in front of it. The individual journalists featuring most prominently are the investigative reporter Samuel Katelbach and the

Tempo journalists Gustav Heymann and Fred Jacoby. The character of the vivacious, chain-smoking Katelbach, either hacking away at his typewriter or cooking traditional Habsburg specialties, is modeled on a range of Weimar-era journalists, from Carl von Ossietzky, the publisher of the political magazine *Die Weltbühne*, to Egon Erwin Kisch, a writer from the former Austro-Hungarian empire who rose to fame in 1920s' Berlin. Ossietzky, a left-liberal activist and convinced pacifist, had helped to turn the *Weltbühne* into one of the most influential political magazines of the Weimar Republic as a voice of the radical democratic bourgeois left.[6] In 1929, the *Weltbühne*—among other papers, including *Tempo*—reported on the illegal development of a German air force, and the ensuing *Weltbühne-Prozess*, in which the government accused Ossietzky of treason and divulging military secrets, ended in an eighteen-month-long jail sentence for the publisher. The parallels to Katelbach's fears of being hounded by the government and right-wing forces for his revelatory articles are obvious. More important, however, is Katelbach's general nature as an investigative reporter, a profession that in German public memory is indelibly linked to Kisch. Arguably the most famous German-speaking journalist of his time, Kisch lived and worked in Berlin from 1921 to 1933.[7] In the many photos taken and portraits painted of him during the 1920s, usually in a sharp suit with a cigarette on his lips, Kisch strikes the pose of a cool, unflappable observer of modern society. Kisch's early self-fashioning as an investigative reporter is important, as it helped introduce a particular *image* of a kind of journalism that did not really exist in Weimar Germany.

With his most famous work, *Der rasende Reporter* (The Racing Reporter), a collection of his reportages published in 1925, Kisch cemented his reputation as the most influential journalist of the German language. In the preface, he defined the reporter as a new type of journalist, modeled on the American profession, acting as a truthful, objective correspondent of events and facts: "The reporter has no bias, has nothing to justify and no standpoint. He is to serve as an impartial witness and must report as objectively and reliably as possible."[8] This represented a deliberate rejection of the German journalistic tradition, which put distinct emphasis on beliefs before facts.[9] In close connection to the formation of modern political parties over the course of the nineteenth century, the self-image of German journalists had developed as opinion leaders rather than independent correspondents. Accordingly, *Gesinnungsfestigkeit*, the strength of one's political convictions, was seen as the most important trait of a German journalist.[10]

This German journalistic tradition was still dominant in the Weimar Republic. In 1928, Emil Dovifat, one of the founders of German media studies, stressed the importance of a "strong grounding of journalistic work in ideology": "While being able to very quickly research, understand, and summarize a topic is of utmost necessity in journalistic work, it must remain the work of *convincing* one's audience. The purposeful journalist bound by his conviction, rather than the 'racing reporter,' must remain the typical representative of German journalism."[11] The obvious barb against Kisch shows how influential his self-fashioning as a new type of journalist had become. However, Kisch himself, as a dedicated activist for the Communist Party, stood much more in the German tradition of the journalist as propagandist than his professions of impartiality and objectivity suggested. Rather than describing the reality of German journalism, the Weimar-era archetype of the reporter—with the media personality of Kisch as its most prominent embodiment—was used as a shorthand for certain aspects of modernity: rationalization, metropolitanism, and a supposed Americanization of German culture.

The reporter Jacoby and the editor Heymann, the representatives of *Tempo* in *BB*, also embody this myth of interwar journalism: fast-talking and hard-boiled, they are not interested in the lofty ideals of opinion journalism, but only in sensational content that sells copies. Jacoby—whose name can be read as a reference to Lucy von Jacobi, the real *Tempo*'s only female editor, who was responsible for film and fashion—is no political reporter like Katelbach but stands for the sensationalist and titillating side of tabloid journalism.[12] However, in *BB* even his frivolous muckraking is likened to detective work when he invites Charlotte (Lotte) Ritter and Reinhold Gräf to contribute to the Ullstein tabloid: "It's the same job, just much better paid" (S3, E12). Both Jacoby and Heymann are portrayed as enthusiastic chroniclers of modern life, covering, respectively, car races as "the expression, in gasoline and speed, of an accelerated time" and the murder of a silent film star as a sign for the "inner conflict of modern man" (S3, E3). For Heymann, however, circulation numbers count more than anything, leading him to brush Jacoby's pitch aside: "I want an article about the colorful world of film and its moral abysses, without a theoretical superstructure. The readers of *Tempo* are interested in what everyone is interested in: sex and money and buzzwords they can easily remember. Vice, debauchery, jealousy, intrigue, the whole lot" (S3, E3). It has been suggested that Heymann is based on Stefan Heymann, a one-time editor of the communist paper *Rote Fahne*, but there are hardly any parallels between the *BB* character and Heymann's life as a KPD

functionary.[13] More than anything, the fictional editor-in-chief of *Tempo* stands for the Ullstein publishing company in general.

Ullstein was arguably the most influential media company of Weimar Germany, but its success and mass-market orientation gave the company the reputation of a populist "department store for intellectual goods."[14] The company's commercial orientation was freely admitted by its leadership. In 1929, Georg Bernhard, the editor-in-chief of the venerable *Vossische Zeitung* and the company's political figurehead, explained the Ullstein papers' view of their audience: "The only way to achieve higher circulation figures is to give political content the character of human-interest matter and to add supplements which, by catering to the interests of every class of readers, will attract wide circles of the population."[15] However, the Ullstein company was not only a commercial force in Weimar society, but also an important political actor. As a traditionally liberal publishing house and a defender of the new democratic order, Ullstein was generally considered, and often represented itself, "as a pillar of the Weimar state."[16] For these reasons, and in no small part also because of the company's Jewish roots, Ullstein was a *bête noire* for the Nazis, who saw it as an embodiment of the hated "November Republic" and the "Jewish press." The character of Heymann embodies both sides of Ullstein, demanding sensational, easily digestible stories to drive up circulation figures, while also showing his democratic convictions when he faces off with local Nazi leader Walther Stennes during a raid of *Tempo*'s offices, a scene that references a Nazi-led attack on the Ullstein headquarters on May 12, 1933.[17]

"Extended Sensory Organs": The Press in the City

On August 24, 1919, just a few days after Friedrich Ebert had taken the official oath of office as the first President of the new Republic, Ullstein's *Berliner Illustrirte Zeitung* (*BIZ*) published a snapshot of him and Reich Minister of Defense Gustav Noske in white swimming trunks during a short holiday on the Baltic Sea. While it is unclear if this was intentional, the depiction in the nation's best-selling weekly paper of two of the highest representatives of the German state in half-naked, leisurely posture caused an enormous scandal. The state of their aging bodies was immediately weaponized by anti-democratic forces to attack the young Republic, calling for a revitalization of a supposedly degenerate society.[18] This image is referenced in *BB*, when the characters of Fritz Höckert and Otto Wollenberg are introduced: when

Charlotte (Lotte) Ritter and Greta Overbeck are invited to an exclusive rowing club on the Wannsee, Fritz and Otto watch them from the shore (S1, E6). Clad in black swimming trunks, they strike the same poses as Ebert and Noske in the *BIZ* photo, yet they expose youthful, muscular, and lean bodies. Fritz and Otto are first introduced as avid communists, but later turn out to be Nazi stormtroopers in disguise. This makes this scene the first time Nazis appear in the series, albeit incognito, and the reference to the scandalous image of Ebert and Noske, combined with the inversion of the color of the trunks and the physically fit state of Fritz's and Otto's bodies, can be read as ominous hints at their real identities.

The reference to the infamous photo also puts into focus the visualization of Weimar culture, in which the press played a central role. The cultural and social importance of the press in Weimar Germany is hard to overstate. While listening to the radio, and even regular visits to the local cinema, still remained relatively exclusive forms of entertainment for much of the 1920s, newspapers were "omnipresent factors of everyday life," with nearly every German household regularly buying one.[19] The daily newspaper was not only a source of breaking news, it also supplied evening entertainment in the form of serialized novels, crosswords, and popular science supplements.[20] If they had any free time, most Germans filled it with reading "their" newspaper. A representative example is a young female textile worker from Dresden, who in a survey from 1928 mentioned reading the newspaper as her only leisure time pursuit, even on the weekend.[21] Yet the press underwent some profound changes in the Weimar Republic under the pressure of new reading habits and the rise of new media. The dominant position of the press was increasingly challenged by the radio and, most importantly, by the cinema: between 1919 and 1928, the number of cinemas in Germany nearly doubled.[22] This had a profound effect on the press and, together with advancements in printing and innovations such as image telegraphy, led to more visual content in newspapers.[23] In 1928, the designer Johannes Molzahn predicted that images would soon be more important than text for the press and their audience: "'Stop reading! Look!' will be the guiding developmental principle of daily newspapers."[24]

In Weimar Germany, the newspaper type most associated with the increase in visual content was the tabloid. The number of tabloid newspapers grew explosively after the war and, with their lurid headlines and front pages full of photos, they were "widely regarded as the most modern face of newspaper publishing" in the Weimar Republic.[25] They were publications produced for quick consumption, with attention-grabbing layouts, short articles, and much

more visual content than traditional newspapers. Tabloids introduced not only a new design to the German press, but also a new way of reporting: sensational, controversial stories ruled the headlines, and the papers were always fixated on the latest developments and the next big scoop.[26] In 1929, the art historian Rudolf Arnheim bitterly complained about the change in newspaper design in the Weimar Republic: "Short paragraphs, highlights in bold type, the page chopped up into bite-sized pieces. And when somewhere a maid has bitten her employer's leg, you get a headline straight across the front page in a letter size we previously only saw on advertising posters."[27] It is important to note that the image of the tabloids as an Americanized medium only focused on unpolitical sensation was partly a myth. Despite their modern layout and new style of reporting, German tabloid newspapers still retained a highly political and ideological profile.[28] Still, for many contemporaries, the tabloids' speed, modern layout, urban readership, and focus on sensation made them distinct features of Weimar society and symbols for the changes that had overcome Germany after 1918—and, as shown below, no other tabloid embodied those changes more than *Tempo*.

The increasing visualization of the press and the media competition of the 1920s is prominently discussed in *BB* during a meeting of Katelbach with Heymann. After Heymann shelves his investigative reportage about the secret development of a German air force because there are no photos to be printed with the article, Katelbach complains about the new visuality of the press: "We used to have readers, now we have gawkers (*Gucker*)! If people want to see pictures, let them go to the cinema" (S3, E3). Katelbach's negative image of this new media audience, visually stimulated by tabloids and the cinema, echoes the criticism by contemporaries like Groth and Arnheim, but it also establishes a link with *BB*'s own audience, who grew up during a time of profound media transformations. His anger about the "nonsense of images" serves to familiarize today's "gawkers" with the everyday of the Weimar past. While *Tempo* embodies this change, the cinema is clearly seen as its competitor even by Jacoby, who publishes a scathing review of *Demons of Passion* despite the rapturous reaction of the rest of the audience (S3, E12).[29]

Another change the Weimar press went through concerned its infrastructure. Most Germans had traditionally bought "their" paper on subscription and had it delivered to their homes, but during the First World War and the turbulent early years of the Weimar Republic, the demand for breaking news boosted street sales, making the shouts of mobile newspaper hawkers a common aspect of urban life in Germany.[30] Again, the tabloid was associated with this new practice—the German term *Boulevardzeitung* directly referring to its place of sale.

BB's focus on these changes—visualization, increasing media competition, and street sales—has led to a depiction of Weimar-era Berlin curiously devoid of newspapers. Since at least the turn of the twentieth century, the German capital was a "newspaper city," and printed matter was everywhere in public space: Berliners were reading newspapers they either brought from home, bought on the street, or just picked up where another reader had dropped them in cafés, on buses, trams, and the *U-Bahn*.[31] In *BB*, printed matter is hardly part of the scenery, and the lack of newspapers is particularly pronounced in private spaces. Even the gramophone, which was still a relatively expensive medium at the time, is much more common than the humble newspaper, appearing in the back courtyard of the Ritter family's working-class tenement, in Bruno Wolter's petit-bourgeois flat, and in August Benda's upper-middle-class home. If newspapers are consumed at all in the series, they are mostly purchased at a kiosk or read over someone else's shoulder on the tram, but they rarely appear in people's homes.

While the exclusive focus on kiosks as newspaper spaces thus paints a distorted image of the media use in Weimar Germany, it does reflect the heightened importance of these locations. In 1931, the trade journal *Der Zeitungs-Verlag* argued that "the years of tension, political conflict and rising general interest in political and economic matters" during the war and post-war period had increased the significance of the newspaper kiosk in urban space.[32] The walls and windows of these booths, usually plastered with the latest editions of local, national, and international newspapers, acted as an interface between the "word city" and physical urban space. Kiosks also acted as important social meeting points: *Der Zeitungs-Verlag* described how they attracted a constant crowd of readers browsing the wealth of headlines on display.[33] It is only fitting, then, that in *BB* important encounters happen at the newspaper kiosks on Alexanderplatz and the platform at Hermannplatz subway station.

Tempo

Tempo was an afternoon tabloid published from 1928 to 1933.[34] It was part of a range of new tabloid newspapers published between 4:00 and 8:00 p.m. that had appeared on the Berlin market since the mid-1920s, such as Mosse's *8-Uhr-Abendblatt* and Scherl's *Nachtausgabe*. Ullstein designed *Tempo* to outdo them all: it was printed on pink paper and its front page was dominated by big, sensational photos of car accidents, celebrities, and oddities, appearing as "the most radical proponent of American-style tabloid journalism, with [...] an abundance of sensations and catastrophes outdoing everything Berlin had

read so far."[35] At the beginning, *Tempo* appeared three times in the space of four hours. Most German newspapers were published multiple times a day, in morning and evening editions, but this rate of publication was extraordinary. More important than its actual form, however, was the way it was *meant* to be received: its launch on September 11, 1928, was accompanied by a large-scale advertising campaign, with posters and full-page advertisements in Ullstein's other publications touting *Tempo* as "the newspaper of our time." With this, Ullstein positioned *Tempo* as a symbol for a quickened pace of modern life in general, driven by technological change and historical dynamics. While many other newspapers, such as its competitors *8-Uhr-Abendblatt* and *Nachtausgabe*, still bore the time of their publication in their name, *Tempo* elevated speed to a value in itself in its very title. In a programmatic statement in the newspaper's first issue, *Tempo* explicitly embraced this new age of velocity:

> What is the meaning, the intellectual intention of our new publication? The answer is our name. We provide information and entertainment at the pace at which modern man lives. Only to the elderly does this seem like a breathless rush. To the active, striving young person, speed is the momentum of his ambition, his forward thrust. Tempo does not reside in the legs, but in the heart. We are addressing the German generation that no longer groans under our pace of life, but already feels it as an expression of its affirmation of life.[36]

Accordingly, for Ullstein, *Tempo* was "the motto of the twentieth century—and its most modern newspaper!" In a broader perspective, *Tempo* was positioned as a shorthand or symbol for modernity itself and an optimistic embrace of all its aspects, from technological, political, and social progress to a modernist transformation of everyday life. Ullstein's strategy was successful: in the few years of its existence—*Tempo* was the first of the company's papers to be discontinued after Hitler's appointment as Chancellor in 1933—the newspaper firmly established itself in contemporary popular culture. In Fritz Lang's *M* (1931), for example, it appears as the representative of Weimar's sensationalist press when it fans the flames of public outrage by publishing a letter by the fugitive child murderer.[37]

BB perpetuates this Weimar-era narrative of *Tempo* as indicative of the fast pulse of Weimar Berlin. The newspaper's obsession with speed and modernity is referenced prominently when Heymann is introduced eulogizing a car race as the expression of the times. It is also made explicit with the slogan "Berlin has speed" (*Berlin hat Tempo*), which was part of the advertising campaign for the newspaper's launch in 1928, painted on the walls of the fictional editorial offices. This catchphrase is probably the only historically accurate aspect in *BB*'s

portrayal of the everyday life of *Tempo* journalists: the offices are shown to be located in the *Ullsteinhaus* in Tempelhof, which in fact housed the company's printing plant, rather than in the main editorial offices on Kochstrasse in Berlin's Mitte district. Furthermore, the bustling scenes in the open-plan office are quite removed from the actual experience of working for an Ullstein paper. According to Vicki Baum, who worked for Ullstein's magazine department in the 1920s and became one of its best-selling authors, most editors worked alone in small rooms: "In Germany and probably in the whole of Europe it was not like in America, where editors and other press people work in large, crowded, noisy rooms. At Ullstein, every editor had his own individual cell."[38] However, historical accuracy is not the point here. What is supposed to be projected is an Americanized air of modernity, speed, and excitement that characterizes the Berlin of *BB*, and the bustling editorial office is a significant locus for the construction of this image. It is one of the central spaces of modernity, usually located in the center of urban conglomerates, where the streams of information from all corners of the city congregate and the "word city" is produced.[39] From this perspective, it is also not surprising that *Tempo*, rather than the influential *Weltbühne* or the popular *Berliner Morgenpost*, was chosen as *BB*'s representative for Berlin's press. Just like in Lang's *M*, in *BB* the fictitious *Tempo* stands for more than a mere newspaper: it figures the city itself. Already in the Weimar Republic, *Tempo*—as the self-appointed representative of modernity—had transcended its nature as a medium and had become a symbol, signifying the metropolis, speed, Americanism, and sensationalism.

Conclusion

The myth of Weimar Berlin as a glamorous metropolis of vice and modernity did not start with *BB*—or with *Cabaret* (1972), or even with Christopher Isherwood's *Goodbye to Berlin* (1939). As *Tempo*'s own coverage of Berlin and the Weimar-era fascination with the newspaper show, this myth-making was already an important part of Weimar culture itself. The press and its representatives played an integral part in this process, both as subjects in and disseminators of these narratives. As subjects, journalists and newspapers—with *Tempo* as a particularly vivid example—populated the broader narrative of the metropolis and were used as canvases for the hopes and fears that this narrative elicited. As disseminators, they transported this narrative, contributing to the creation of the "word city" Berlin.

What does this mean for our understanding and analysis of *BB*? The construction of Weimar Berlin in the series often tells us more about our own time, our very own fears and hopes about modern life, than about Weimar Berlin. However, the fact that many of the tropes used to conjure up the *BB* universe have roots in Weimar culture should make us aware that this construction is part of a temporal continuum that links and transcends both our time and the Weimar era.

Notes

1 *Tempo*, September 11, 1928, iss. 2: "Junger weiblicher Fahrherr in Berlin," 3; Hans Driesch, "Parapsychologie, die jüngste Wissenschaft," 10; "Ernst Lubitsch und Camilla Horn," 8; "Erhebliche Kursrückgänge," 5. All translations are my own unless otherwise noted.

2 Peter Fritzsche, *Reading Berlin 1900* (Cambridge, MA: Harvard University Press, 1996), 3.

3 James Retallack, "From Pariah to Professional? The Journalist in German Society and Politics, from the Late Enlightenment to the Rise of Hitler," *German Studies Review* 16, no. 2 (1993): 183–7.

4 Norma Fay Green, "'The Front Page' on Film as a Case Study of American Journalism Mythology in Motion" (PhD diss., Michigan State University, 1993), II.

5 Cited in Simón Peña, "The Daredevil Reporter (Der Teufelsreporter) (1929): Billy/ Billie Wilder," *Bright Lights Film Journal*, 2020.

6 Heinz Dietrich Fischer, "Die Weltbühne (1905–39)," in *Deutsche Zeitschriften des 17. bis 20. Jahrhunderts*, ed. Heinz-Dietrich Fischer (Berlin: De Gruyter, 1973), 323–40. For Ossietzky, see Richard Tres, *The Man without a Party: The Trials of Carl von Ossietzky* (New York: Beacon, 2019).

7 On Kisch, see Marcus G. Patka, *Egon Erwin Kisch: Stationen im Leben eines streitbaren Autors* (Vienna: Böhlau, 1997); and Ken Slater, "Egon Kisch: A Biographical Outline," *Labour History*, no. 36 (1979): 94–103.

8 Egon Erwin Kisch, *Der Rasende Reporter* (Cologne: Kiepenheuer & Witsch, 1985), 9.

9 Rudolf Stöber, *Deutsche Pressegeschichte. Einführung, Systematik, Glossar* (Constance: UVK, 2000), 163.

10 Jörg Requate, *Journalismus als Beruf: Entstehung und Entwicklung des Journalistenberufs im 19. Jahrhundert. Deutschland im internationalen Vergleich* (Göttingen: Vandenhoek & Ruprecht, 1995), 396–7; Retallack, "From Pariah to Professional," 175–223.

11 Emil Dovifat, "Die moderne deutsche Redaktion," in *Pressa: Kulturschau am Rhein* (Berlin: Schröder, 1928), 50–2.

12 On Jacobi, see Rolf Aurich et al., eds., *Lucy von Jacobi: Journalistin* (Munich: Edition Text + Kritik, 2009).

13 Hanns-Georg Rodek, "So gut sind die zwölf neuen Folgen von *Babylon Berlin*," *Die Welt*, January 23, 2020.

14 "Ullstein-Ende," *Das neue Tage-Buch*, June 16, 1934, 561.

15 Georg Bernhard, "Die Deutsche Presse," in *Der Verlag Ullstein zum Weltreklamekongress Berlin 1929* (Berlin: Ullstein, 1929), 68.

16 Modris Eksteins, *The Limits of Reason: The German Democratic Press and the Collapse of Weimar Democracy* (Oxford: Oxford University Press, 1975), 156. In reality, the commercial interests and political convictions of the house were often in conflict; for a discussion of Ullstein's political activity, see Jochen Hung, "The 'Ullstein Spirit': The Ullstein Publishing House, the End of the Weimar Republic, and the Making of Cold War German Identity, 1925–77," *Journal of Contemporary History* 53, no. 1 (2018): 158–84.

17 Eksteins, *Limits*, 288.

18 Thomas Mergel, "Propaganda in der Kultur des Schauens: Visuelle Politik in der Weimarer Republik," in *Ordnungen in der Krise: Zur politischen Kulturgeschichte Deutschlands 1900–1933*, ed. Wolfgang Hardtwig (Munich: Oldenbourg, 2014), 531–60; and Erik N. Jensen, *Body by Weimar: Athletes, Gender, and German Modernity* (Oxford: Oxford University Press, 2010), 2–14.

19 Bernhard Fulda, *Press and Politics in the Weimar Republic* (Oxford: Oxford University Press, 2009), 13.

20 Bernhard Fulda, "Industries of Sensationalism: German Tabloids in Weimar Germany," in *Mass Media, Culture and Society in Twentieth-Century Germany*, ed. Karl Christian Führer and Corey Ross (Basingstoke: Palgrave Macmillan, 2006), 184; Michael Meyen, "Zeitungswesen in der Weimarer Republik: Medientenor und Meinungsklima: Das Beispiel Leipzig," in *400 Jahre Zeitung: Die Entwicklung der Tagespresse im internationalen Kontext*, ed. Martin Welke and Jürgen Wilke (Bremen: Edition Lumière, 2008), 444.

21 Alf Lüdtke, ed., *"Mein Arbeitstag, mein Wochenende": Arbeiterinnen berichten von ihrem Alltag 1928* (Hamburg: Ergebnisse, 1991), 48.

22 Corey Ross, *Media and the Making of Modern Germany: Mass Communications, Society, and Politics from the Empire to the Third Reich* (Oxford: Oxford University Press, 2008), 122.

23 Bernhard Fulda, "Die Politik der 'Unpolitischen': Boulevard—und Massenpresse in den zwanziger und dreißiger Jahren," in *Medialisierung und Demokratie im 20. Jahrundert*, ed. Frank Bösch and Norbert Frei (Göttingen: Wallstein, 2006), 64; Stöber, *Pressegeschichte*, 163.

24 Anton Kaes, Martin Jay, and Edward Dimendberg, eds., *The Weimar Republic Sourcebook* (Berkeley: University of California Press, 1994), 648.

25 Fulda, "Industries," 184.

26 Ibid., 193.

27 Rudolf Arnheim, "Die Bilder in der Zeitung," *Die Weltbühne* 25 (1929): 564.

28 Fulda, *Press and Politics*, 34–6.

29 For readings of Jacoby's review, see the contributions to this volume by Mila Ganeva and Carrie Collenberg-González and Curtis Maughan.

30 Otto Groth, *Die Zeitung: Ein System der Zeitungskunde*, vol. 3 (Mannheim: Bensheimer, 1928), 142.

31 Fritzsche, *Reading Berlin*, 17–20; Peter de Mendelssohn, *Zeitungsstadt Berlin: Menschen und Mächte in der Geschichte der deutschen Presse* (Berlin: Ullstein, 1982), 200–380.

32 Bo, "Der Zeitungsstand," *Der Zeitungs-Verlag*, December 5, 1931, 880.

33 Ibid.

34 For a detailed history of *Tempo*, see Jochen Hung, *Moderate Modernity: The Newspaper* Tempo *and the Transformation of Weimar Democracy* (Ann Arbor: University of Michigan Press, 2023).

35 Fulda, *Press and Politics*, 35.

36 "Eine neue Zeitung," *Tempo*, September 11, 1928, 2.

37 *M—Eine Stadt sucht einen Mörder*, dir. Fritz Lang (Nero, 1931). The mock front page is shown in a close-up (13:42) and several times on the desks of the superintendent (14:13) and the interior minister (14:02). I am indebted to Erhard Schütz for alerting me to *Tempo*'s appearances in the film.

38 Vicki Baum, *Es war alles ganz anders: Erinnerungen* (Cologne: Kiepenheuer & Witsch, 1987), 358.

39 Frank Bösch, "Die Zeitungsredaktion," in *Orte der Moderne: Erfahrungswelten des 19. und 20. Jahrhunderts*, ed. Habbo Knoch and Alexa Geisthövel (Frankfurt/Main: Campus, 2005), 71–80.

Reading Queerness in *Babylon Berlin*

Javier Samper Vendrell

Babylon Berlin portrays the German capital during the Weimar Republic as a topsy-turvy place where gender and sexual norms are called into question while the coming horrors of the Third Reich loom on the horizon. It is not surprising that the series' creators capitalize on the spirit of sexual experimentation and the visual appeal of the era.[1] 1920s Berlin deserves credit as the queer capital of the world. Although male same-sex acts continued to be a punishable offence, the relative tolerance of homosexuality by the police led to the development of a vibrant queer scene.[2] The city also had a dark side. Berlin was a sex-tourism destination for well-to-do Europeans. Male prostitution was not uncommon. Young men from the provinces arrived in Berlin lured by its shining lights and economic opportunity, only to be disappointed by the overwhelming misery of the city and to experience abuse by pimps and johns.[3]

Viewers of *BB* interested in the queer *history* of this period will watch in vain. The series does not mention historical figures, such as the sexologist Magnus Hirschfeld, or historical venues, such as the club Eldorado or Hirschfeld's Institute for Sex Research. Although the series superficially considers the discrimination, shame, and pain that queer people experienced at the time, the fact that queer characters seem to live out their sexuality openly could lead some viewers to believe that life in Berlin in 1929 was an uncomplicated affair. Nevertheless, the lack of historical rigor does not make *BB* any less pleasurable for viewers who are just happy to see queer characters, or for others, who, like me, take pleasure in watching television queerly; for example, by insisting on misreading a character's sexual orientation. After a brief reflection on contemporary LGBTQ visibility politics on television and the constraints of the global video-streaming market on queer content creation, I will argue that the queer potential of the series lies less in its inclusion of queer characters than in its depiction of gender and sexual indeterminacy. Some of the queerest

moments can be found in silences and furtive glances that engage our desire to know whether a character *might* be queer.

To make this case, I borrow interpretive frameworks from scholarship on queer Weimar cinema to expose the queerness of a supposedly straight character.[4] Analyzing subtexts has been a common "viewing strategy for sexual minorities" hoping to find gay and lesbian characters in disguise.[5] My analysis of queerness in *BB*, however, goes beyond finding out whether a character is in the closet, although I will suggest that one of them might be. The series is compelling because it underscores the futility of this task. Svetlana Sorokina's male alter ego Nikoros, Gereon Rath's curiosity for his colleague Reinhold Gräf, and Charlotte (Lotte) Ritter's lesbian fling point to the instability of gender and the blurriness of the homo/heterosexual binary. The queerness of these characters makes for a satisfying viewing experience despite some letdowns, such as the use of harmful trans- and homophobic tropes and the focus on heterosexual romance for the narrative climax.

Queer Visibility and Its Limits

BB is part of a global media landscape in which the representation of gender and sexual diversity has become a fashionable political statement and a financial calculation. In the United States, the call for inclusion has been spearheaded by GLAAD (Gay and Lesbian Alliance Against Defamation), an organization that has been tracking the representation of LGBTQ characters on network and cable television for over twenty-five years. Since 2015, GLAAD has included the streaming services Amazon, Hulu, and Netflix in its annual report. GLAAD calls out networks for their homophobia and offers recommendations for change.[6] There is no doubt that calling out production companies and streaming services for their homophobia has led to more nuanced and realistic representation in television. Queer characters used to be either invisible or were portrayed negatively as prostitutes, murderers, victims, or diseased bodies. Since the late 1990s, queer characters lead open and "normal" lives.[7] One of the critiques of this transformation is that, while LGBTQ characters are more diverse than ever before and have more depth, they are also more "respectable": their stories resemble those of the heterosexual majority.[8]

Germany lags behind the United States in matters of LGBTQ representation. Markus Ulrich, the speaker for the Lesbian and Gay Federation in Germany

(LSVD) has noted that the representation of queer lives in German media continues to be negligible and often negative.[9] Christine Strobl, the managing director of Degeto, the agency responsible for producing and purchasing fictional content for German public television (and one of the producers of *BB*), has expressed the agency's intention to create more "diverse and modern" shows, but German television remains fairly conservative.[10] LGBTQ actors criticized the homophobia and transphobia of the industry in a social media campaign in 2021. They protested against the lack of opportunities for openly queer actors and the scarcity of roles that portray queer lives realistically. 185 actors joined this campaign for visibility and inclusion, which was publicized with the hashtag #actout.[11]

To be fair, the demands and restrictions of global media markets determine queer representation in series such as *BB*. Amy Villarejo suggests that too much writing about queerness in television studies focuses on close textual analysis at the expense of the history of institutions, labor, technology, and media policy, which shape what we see on the screen.[12] *BB* is a German production financed with public and private funds; it premiered on Sky, a pay TV platform, it aired subsequently on German public television, and became available in many international markets on the subscription-based streaming service Netflix. A successful business model allows Netflix to take risks with narrowcasting— that is, creating content for a specialized audience, such as LGBTQ viewers. Nevertheless, the streaming giant "bows under local pressures."[13] Scenes showing profanity, substance abuse, and same-sex sexuality have been edited out in countries such as Turkey or India, where there is strict media policy regarding these issues.[14] Although *BB* was not produced by Netflix, the creators of *BB*, the most expensive non-English-language drama ever produced,[15] must have tried to strike a balance between participating in the politics of queer visibility that actors and viewers want and creating a show that is viable in the global streaming market.

BB might strike some viewers as not queer enough because of these political and economic constraints. The series, however, is queer in other ways. It disrupts period, and even history, through its combination of generic police procedural, historical drama, and use of fabulation. An eclectic soundtrack makes viewers wonder *what* golden age is actually being remembered. Is it the crisis-ridden 1920s, the neoliberal 1980s, or is the series perhaps about our own clash with fascism in the twenty-first century?[16] More importantly, I contend that some of its characters challenge the stability of gender and sexuality, inviting viewers to watch the series queerly.

Sorokina's/Nikoros's Mysterious Performance

Countess Svetlana Sorokina, a Russian émigré and cabaret performer, makes us question the stability of gender and identity through her alter ego Nikoros. Sorokina is introduced in the first episode of season one. Her lover, Alexej Kardakow, likewise a Russian exile, finds her staring at a family painting that is out of focus, suggesting outright the indecipherability of the character. Kardakow, who performs with Sorokina at the fashionable club Moka Efti, informs her that the train carrying her family's gold has arrived in Berlin. The gold is supposed to help finance the Red Fortress, an anti-Stalinist organization assisting Leon Trotsky, of which Kardakow is a member. After hearing the news, she exhales, seemingly exasperated, and turns to him feigning a smile: she is putting on an act. While it is puzzling that an aristocrat could become a Trotskyist, the real mystery around Sorokina is not her politics, but who she is at all.

The following day Sorokina turns in Kardakow to Soviet agents, not as herself but as the gender-bending Nikoros, whose clothing and accessories suggest a mixture between magician (tricks), dandy (top hat), Soviet agent (leather coat), and drag king (wig and mustache) (S1, E1). The viewer, however, does not know yet that Sorokina and Nikoros are one and the same. The "masquerade" becomes evident in the next episode (S1, E2), after Nikoros's performance of the song "Zu Asche, zu Staub" (To Ashes, To Dust), one of the series' most memorable moments. Nikoros commands the audience with jerky arm movements. The audience sings along and dances in unison. The slow ballad grows into a dance number with the orchestra playing at full blast. As the tempo of the song speeds up, the scene in the Moka Efti is crosscut with the scene in which Soviet agents open fire on the members of the Red Fortress. All the members of the organization perish, except for Kardakow, who is able to disappear in a pestilent latrine.

Sorokina's drag performance underscores the instability of gender and challenges us to question the nature of its truth. The scene is a literal visualization of Judith Butler's argument about the constructedness of gender: "drag fully subverts the distinction between inner and outer psychic space and effectively mocks both the expressive model of gender and the notion of a true gender identity."[17] Moreover, the character is inspired by a historical context in which women adopted masculine fashions and hairstyles in order to participate in areas formally reserved for men and to assert sexual autonomy.[18] Cross-dressing, on the stage and in real life, also suggested sexual inversion.[19] When all is over, Nikoros takes off the costume in the dressing room, revealing Sorokina's blond bobbed hair and confirming what viewers had supposed all along. The

queerness of Sorokina's drag performance is heightened by the presence of Alfred Nyssen, the son of a wealthy industrialist who looks at her lustfully from the club's balcony. Lars Eidinger's histrionic performance of the character—his exaggerated gestures, eccentric wardrobe, and affected demeanor—could be described as camp.[20] Nyssen's desire for the gender-bending Sorokina places him outside of normative masculinity and heterosexuality. He is a tragicomic queer figure who wants to fit in, even though he is constantly derided by mainstream society, especially by his mother, and ignored by the military officers with whom he associates.

For all its queer camp potential, the scene at the Moka Efti is something of a disappointment. The parallel editing connects Nikoros with betrayal and murder, a recurrent homophobic and transphobic trope in cinema and television.[21] Moreover, the scene revolves around heterosexual desire. Nikoros's performance is designed to appeal to the heterosexual male gaze. The thrill is knowing that Nikoros is actually a woman. At the same time, the comic dance-off between Stephan Jänicke and Rudi to capture Lotte's attention during the performance recenters the scene around heterosexual romantic pursuit. To make matters worse, Sorokina, dressed as Nikoros, betrays Kardakow a second time the following day. "What's with the masquerade?" he asks before being shot in the heart (S1, E5). We wonder, too, who of the two, Sorokina or Nikoros, is actually deceiving us.

The true identity of Svetlana Sorokina eludes the viewer until the very end. The train carrying the Sorokins' gold finally gets to Paris in the final episode of season two (S2, E8), and so does she. The MC of the Cabaret du Néant (Cabaret of Nothingness) introduces her as "the most dazzling star that has fallen from Russia." Dressed as a woman, wearing a black dress with a veil embroidered in gold, the performer sings in Russian. When the song ends, she takes a razor and cuts her throat, shocking the audience with a blood gush, and symbolically killing off this persona. To the viewer's surprise, Kardakow enters the club and visits her in the dressing room after the show. Is he there to seek revenge? Or did both of them deceive everybody with an elaborate trick? Nobody is who they seem to be.

The double character Sorokina/Nikoros illustrates that gender and identity are performative. This fact does not stop the homicide detective Gereon Rath from trying to figure out the truth about the countess. After realizing through the reflection of a playbill on a mirror that Nikoros is Sorokin spelled backward, Gereon confronts her outside the Moka Efti. "You don't know who I am," she parries, and goes on to tell the story of her family's gold and the chauffeur who

murdered all of them (S2, E5). Sorokina, like Nikoros on the stage, disappears from the city immediately after this exchange. Gereon and Lotte try to get to the bottom of this puzzling story. When they return to Sorokina's apartment, they find the abandoned family portrait (S2, E8). The painting contains both a mystery and a clue: Gereon inspects it carefully and realizes that the tank car was made of gold, and, more importantly, that the Sorokins never had a daughter. The youngest child in the painting wears a dress, but it also has a sword with a golden hilt at its side. Despite the gender ambiguity of the child, Gereon is certain that it is a boy. Sorokina must have been Tanya, the chauffeur's daughter, he deduces. The sleuth tries to solve Sorokina's mystery—and the mystery of gender itself—but the truth remains unknowable to him and to us.

Gereon Rath in the Closet

The ambiguity of gender and identity is central to Sorokina/Nikoros's characterization. By contrast, the uncertainty about the sexuality of other characters becomes evident only on the subtextual level. Gereon Rath, a gloomy homicide detective, is by all appearances a straight man: he is cisgender and in love with a woman. Yet his growing curiosity about his queer colleague Reinhold Gräf, the police department's photographer, suggests that his sexuality might not be as fixed as one might have thought. Gereon's indeterminate sexuality draws attention to the fact that there is no stable erotic identity.[22] Is his same-sex desire unconscious or repressed, as many of his memories seem to be? Rather than trying to figure out whether Gereon is a homosexual, I will focus on a few instances that call his straightness into question.

Gereon's drug addiction puts him in an abject position amid the hypermasculine world of Berlin's vice squad. His colleague, Bruno Wolter, a cold-blooded brute, compares him to Franz Krajewski, a man whom they arrest during their first raid together (S1, E1). Krajewski, a former police officer who lost his job because of drug addiction, turns out to be a "trembler" like Gereon. Both men suffer from shell shock, a form of PTSD that was understood in gendered terms at the time, "placing its victims outside of the masculine 'ideal,'" and which was often connected to other sexual disorders, such as homosexuality.[23] It is also implied that Krajewski is a pedophile, a sexual preference often conflated with homosexuality. Before he is captured, we see him prepping underage boys for a film session at the Atelier König, a pornography studio where Gereon is looking for a compromising film involving Cologne's political elite. Confronted by Wolter

about his service in the military, a trigger for all the unspeakable horrors he perpetrated and witnessed while in the service, Krajewski soils himself. Gereon looks away—we do not know whether he does so because of pity, shame, disgust, or empathy. He will find himself in a similar situation soon.

Compared to Krajewski, Gereon looks well adjusted. He has managed to keep his job, although there is something troubling (and sexually symbolic) about a policeman who keeps losing his gun. He is a closeted drug addict, but he will not be able to keep this secret for long. Certainly, Gereon Rath is a traumatized man. The non-consensual psychoanalytic treatment he undergoes reveals the multiple sources of his trauma: an abusive and cheating father; a cold mother who favored his older brother; an affair with his brother's wife; and the guilt he feels for abandoning his wounded brother at the front. As a consequence of these experiences, Gereon has a warped understanding of what family and love mean. Especially the romantic relationship with his sister-in-law, Helga Rath, is a source of distress for this Catholic man. The affair, which the Church, like homosexuality, considers a sin, brings about feelings of shame and guilt. Gereon and Helga write passionate letters to each other, but, once they reunite in Berlin, they realize that they are not happy together and start drifting apart; sex gets cold and rough (S3, E2). In sum, family and the expectations of heterosexuality have led to disappointment, suffering, and violence.

The move to Berlin, an escape from the repressive home environment, allows Gereon to acquire knowledge of erotic possibilities after business hours. Gereon's foray into Berlin's queer nightlife starts as part of an investigative side job. Gereon and Lotte, a secretary at the police department who dreams of becoming a detective, visit the Holländer club well after the end of the workday in search of information about Kardakow's whereabouts (S1, E5). Gereon feels initially uneasy in a space where men dance with men, women with women, and where gender is not determined by biological sex. The presence of Ilja Tretschkow, a drag queen, heightens the scene's queerness. Like with Sorokina/Nikoros, it is hard to pinpoint who they might actually be: the accent, the Flamenco dress, and the ornamental comb do not seem to match the description of a Russian émigré. Tretschkow's queerness, moreover, is accentuated by the exotic cockatoos they keep in their dressing room. These are "birds of paradise" (*Paradiesvögel*), an expression that in German often refers to queer people. The birds, however, are caged, a subtle reminder of the lack of freedom queer people experience.

People express their gender and sexual identities freely at Der Holländer. This is the case for Gräf, the police department's photographer, whom Gereon recognizes wearing a red dress, a hat, and a feather boa, which alludes to the

bird of paradise.[24] "I didn't expect you here," Gereon says, addressing Gräf as "Herr," in what could be seen as an instance of misgendering. Of course, Gräf did not expect their straight colleague there either. Queer bars are for those who are initiated. Recognizing someone there counts almost as a coming out. There is a weird chemistry between them: Gräf waves their feather boa on Gereon's chest, and Gereon smiles coquettishly. But before we are able to revel in this moment of recognition, we are reminded of the pervasiveness of heterosexuality, *even* at a queer club. Lotte returns from the bathroom, cocaine still in her nostrils, transforming the scene into a farce. Snorting, laughing, and making witty remarks, she recenters this moment of promising queer desire around heterosexuality. Gräf, slightly annoyed, returns to their "family." With Lotte back in the picture, and after some energetic dancing, the conversation turns quickly to straight matters. Lotte asks whether Gereon is married or going steady. He admits that his situation is tricky. "Love is not simple. It is very complicated," Lotte concurs.

Gereon's conflicted sexuality becomes more evident in a later moment of fright. Pacing up and down the Friedrichstraße, an area known for male prostitution during the Weimar Republic, he is approached by a hustler while trying to do a prisoner swap (S2, E3). The hustler offers him a variety of services using colorful language that refers to oral and anal sex. The detective tries to get rid of him, but the hustler insists, raising a ruckus that jeopardizes the mission. Another hustler moves toward them, and a fight over who deserves to do business with Gereon ensues. The exchange, while inconsequential for the larger plot about the Black Reichswehr, illuminates Gereon's sexual hang-ups. The discomfort he exhibits when gay sex is spelled out in front of him looks like homosexual panic. This term, invented by the psychiatrist Edward J. Kemp in 1920 to describe situational homosexuality (temporary same-sex acts in prisons, ships, or barracks), has been more widely used in a juridical context to explain violent attacks against gay men by ostensibly straight men who experience a moment of "temporary insanity" after an unwelcome same-sex proposition. Violent reactions to such sexual advances suggest that the masculinity of the gay basher might be insecure, or that he might even be a latent homosexual.[25] Accordingly, Gereon's loss of self-control lays bare an unconscious fear that he might be a homosexual. Although he does not react violently to the hustler's offer, showing his badge invokes the power of a law that ruthlessly punishes male same-sex acts. His action could lead to violent consequences.

Whether Gereon has built a closet around his fears of sexual exposure we do not know. We do know, though, that many queer people were not able

to live out their sexuality in public during the Weimar Republic. People had to conceal their same-sex desire to avoid social and economic repercussions: they hid in what we have come to understand as "the closet." Queer people were able to be in *and* out of the closet depending on the situation: someone could be out in a queer bar, while keeping their sexuality secret from family or colleagues.[26] Gräf occupies such a position. Although introduced to the viewer as a cross-dresser, Gräf presents as a cisgender gay man in later episodes. Lotte and Gereon know he is a homosexual, but he is not out at work. He literally works in a closet, the darkroom where he develops photographs of crime scenes under a tenuous red light, which, in turn, signals his past as a sex worker. The relationship between him and Gereon develops in such windowless spaces, Der Holländer and the darkroom, which stand for secrecy and for same-sex desire.

Gereon's relationship with Gräf is dangerous, especially for the more vulnerable of the two. The photographer goes above and beyond to assist his superior with everything he asks for, to the extent of risking his job and his life. Gräf loses his dignity during an assignment to take pictures of classified documents in the police archives (S3, E4). A hostile archivist who suspects something is amiss threatens him with a poker, calling him "doll-boy" (*Puppenjunge*), a degrading term used at the time to refer to male prostitutes. This time around queer life is depicted in violent and painful terms. Because male homosexuality was still a crime, homosexual men were vulnerable to blackmail by those who knew their secret. The archivist requests oral sex, insinuated by a long shot of the stacks where we discern Gräf on his knees, as compensation for his silence.

Despite his own humiliation earlier in the day, Gräf celebrates the success of his mission with Gereon in a bar that night. Having sighted Gräf's red dress hanging in his apartment, Gereon shows renewed curiosity about his colleague's life (Figure 8.1). Gräf readily tells his coming-out story. His life resembles that of many young same-sex desiring men who left their small towns to go to the big city looking for opportunity, freedom, and love. Initially, he was "on the run from the police," confirming that he was a sex worker. He eventually found an older gentleman who took him under his wing. The man, it turns out, is their mutual boss, Ernst Gennat, a plump criminologist with a sweet tooth—a sugar daddy? Just like Lotte at Der Holländer, who wanted to know whether her boss was available, Gereon enquires into his colleague's romantic life. Gräf does not have a boyfriend, but he acknowledges he has a crush. Gereon smiles, perhaps hoping that he might be the one.

Figure 8.1 Gereon interrogates Gräf about his past; their gaze suggests a deeper connection. Screenshot, *Babylon Berlin* (S3, E4).

Throw Out the Men? Lotte and the Resilience of Heterosexuality

"Love is complicated," Lotte had told Gereon at Der Holländer. Lotte's disillusionment with heterosexuality is caused by not only dissatisfying experiences with men, but also a dysfunctional family. Lotte's brother-in-law is abusive and exploitative. He lives off her work, is violent toward her, and tries to procure her underage sister. Moreover, she is the child of a love affair her deceased syphilitic mother had kept secret. If all this were not enough, men ignore and patronize her at work, and sex with them is transactional or unromantic. Tired of men's lack of attention and abusive behavior, Lotte makes an important decision at the beginning of season three: to get rid of them. Her new position as a police detective allows her to find her own place. She takes her younger sister with her to protect her from their abusive brother-in law, but poverty limits their independence. The two sisters must share their apartment with a "night owl," a man who sleeps during the day and works the night shift, and who does not keep his end of the deal in terms of keeping the apartment in order. When Toni and Lotte return home one night, they find the apartment in disarray. But instead of cleaning up his mess, they put it in a symbolic trash heap to the tune of Claire Waldoff's "Raus mit den Männern" (Throw Out the Men) from 1926 (S3, E1).

The choice of the song marks the queer turn Lotte takes in this season. Waldoff, a lesbian singer with a thick Berlin accent, was famous for her ambiguous love songs set in Berlin's working-class milieu.[27] In this tune, she sings about "a breeze of emancipation" that is blowing through history and that has reached the women of Berlin, who want to sit in parliament. Like Waldoff in the song, Lotte is ready to leave men behind and to claim the power she is entitled to. Lotte and Toni sing along while cleaning up the apartment, attempting to remove all the traces their male roommate has left. Toni is particularly disgusted by their roommate's wet shaving brush, a flaccid phallic symbol. "Throw it away!," the sisters yell. By the end of the song, they collapse on the bed, exhausted but elated.

Lotte means it when she sings "Throw Out the Men!" During the investigation of Betty Winter's murder, she comes across Vera Lohmann, a former coworker at an upscale sex club. Initially surprised that Lotte would be in the studio for a casting, Vera grasps that Lotte has "switched sides." She is on the right side of the law now: she is police and not a prostitute. Lotte and Vera reconnect and go together on a date to Der Holländer (Figure 8.2). The scene, intercut with Gereon's night out with Gräf, suggests that the two lead characters, dissatisfied with heterosexuality, are interested in exploring other options. Intoxicated by the music, the alcohol, and, in Lotte's case, the trays of cocaine, both couples dance in their respective locations, their bodies moving in synchrony. But unlike Gereon and Gräf, who only get to act silly with each other, the two women kiss

Figure 8.2 Lotte and Vera fool around at Der Holländer. Screenshot, *Babylon Berlin* (S3, E4).

while Tretschkow sings about a "gay cockatoo" that says "I love you." Lotte and Vera wake up in the same bed next to Toni, who does not seem surprised at all by this female guest. There is hope for this queer family built on female self-reliance (S3, E4).

The portrayal of two seemingly bisexual women (both are known to sleep with men) is praiseworthy in terms of the politics of visibility. Although the majority of people who identify as LGBTQ are bisexual, bisexuality is rarely represented on television.[28] *BB*, however, does not dwell on this topic, nor does it develop this same-sex relationship, which ends as quickly as it had started. Like in many other instances on television, lesbian love is appropriated to please male viewers.[29] Even worse, Vera is soon thereafter killed by the same misogynistic murderer who has already killed two women at the film studio (S3, E7). The series falls into the so-called "bury your gays" trope, the common practice of killing off queer characters, especially lesbian and bisexual women, "following a moment of happiness or the consummation of same-sex relationship."[30] Same-sex love is thus marked by loss and impossibility.

Gereon consoles Lotte after Vera's burial, showing a level of affection and compassion that he has not had for other women (S3, E8). Their romance has been building up over three seasons and its consummation, or at least a hint of that possibility, is necessary for the climax of a series that has been constructed around this growing erotic tension. Before the viewer is allowed to delight in their kiss, Gereon's ambiguous sexual orientation is addressed once again during Gräf's birthday party. Gennat is there, and so is Fred Jacoby, a journalist for the illustrated magazine *Tempo* and Gräf's actual crush. That Gräf is in love with another man puts an end to our speculations about his interest in Gereon. This twist should dispel doubts about Gereon's interest in him, too. The specter of the closet hovers around the room anyway. Gennat confides in Gereon that "Sometimes our job forces us to make private decisions which are unpleasant, but imperative." Gennat's enigmatic words underscore the ambiguous sexuality of the two men. He could be alluding here to the demands of the job and its incompatibility with romantic or family life, but he could also be referring to *the secret*—homosexuality—and the inevitability of the closet (S3, E9).

Gennat, of course, could have been warning Gereon not to mix work and personal life. Before we are able to mull over this possibility, Gräf starts singing a melancholy love song, "You are everything I want," and sends clear signals of desire to Jacoby. The tune accompanies the much-awaited kiss between the two leads. Lotte does not ditch men after all, and Gereon chooses her. Yet viewers are allowed to witness a moment of queer intimacy in *BB* nonetheless. While

Jacoby is writing a review of the campy expressionist film *Demons of Passion* in the final episode of season three, Gräf caresses him tenderly. The pillow on the bed depicts cockatoos, a reminder that these two *Paradiesvögel* are free—at least for now (S3, E12).

BB delays the audience's expectation for heterosexual closure by including moments of queer possibility. While the series' inclusion of queer characters, plotlines, and aesthetics is praiseworthy, especially given the financial risk this choice poses in the context of global streaming and censorship, their treatment shares some of the common pitfalls of LGBTQ representation on television. Queer characters do not have enough depth or nuance, and the reliance on homophobic and transphobic tropes is regrettable. Nevertheless, the series is appealing because it portrays gender and sexuality in ways that are relatable to queer viewers. Some of the characters do not identify as gay, lesbian, trans, or even as heterosexual. Gender is fluid and desire unrestrained. Gereon's and Lotte's bi-curious interests underscore that "love is complicated," even as the erotic tension between the two characters builds up throughout the three seasons. *BB* might not investigate the queer history of the Weimar Republic in any depth, but it satisfies our desire to see diverse queer lives on television and hence to discover television's queer potential.

Notes

1 For an overview of gender and sexuality during this period, see Eric D. Weitz, *Weimar Germany: Promise and Tragedy* (Princeton: Princeton University Press, 2007), 297–330.

2 For the history of homosexual rights, see Robert Beachy, *Gay Berlin: Birthplace of a Modern Identity* (New York: Alfred A. Knopf, 2014); Laurie Marhoefer, *Sex and the Weimar Republic: German Homosexual Emancipation and the Rise of the Nazis* (Toronto: University of Toronto Press, 2015); and Javier Samper Vendrell, *The Seduction of Youth: Print Culture and Homosexual Rights in the Weimar Republic* (Toronto: University of Toronto Press, 2020).

3 Beachy, *Gay Berlin*, 187–219.

4 Richard Dyer, *Now You See It: Studies in Gay and Lesbian Film* (New York: Routledge, 1990), 7–46, and Alice A. Kuzniar, *The Queer German Cinema* (Stanford: Stanford University Press, 2000), 21–56.

5 Shameem Kabir, *Daughters of Desire: Lesbian Representations in Film* (London: Cassell, 1998), 160. See also Edith Becker, Michelle Citron, Julia Lesage, and B. Ruby Rich, "Lesbians and Film," in *Out in Culture: Gay, Lesbian, and Queer*

Essays on Popular Culture, eds. Corey K. Creekmur and Alexander Doty (Durham, NC: Duke University Press, 1995), 25–42.

6 Recent findings show that 9.1 percent of characters in scripted broadcast are LGBTQ. The 2019–20 report showed that the majority of LGBTQ characters on television were gay (38 percent), followed by lesbians (33 percent), and bisexuals (25 percent). A smaller number of regular and recurring characters are trans or non-binary. Megan Townsend and Raina Deerwater, *Where Are We on TV Now 2020–2021* (Los Angeles: GLAAD Media Institute, 2020), 7; and Megan Townsend and Raina Deerwater, *Where Are We on TV Now 2019–2020* (Los Angeles: GLAAD Media Institute, 2019), 4.

7 For an analysis of this transformation in American media after the watershed moment of the late 1990s, see Larry P. Gross, *Up from Invisibility: Lesbians, Gay Men, and the Media in America* (New York: Columbia University Press, 2001).

8 For critiques of the politics of queer visibility, see Eric O. Clarke, *Virtuous Vice: Homoeroticism and the Public Sphere* (Durham, NC: Duke University Press, 2000); Glyn Davis and Gary Needham, "Introduction: The Pleasure of the Tube," in *Queer TV: Theories, Histories, Politics*, ed. Glyn Davis and Gary Needham (New York: Routledge, 2009), 1–11; Lynne Joyrich, "Queer Television Studies: Currents, Flows, and (Main)streams," *Cinema Journal* 53, no. 2 (2014): 133–9; and Amy Villarejo, *Ethereal Queer: Television, Historicity, Desire* (Durham, NC: Duke University Press, 2014).

9 Markus Ehrenberg, "Wie divers ist das deutsche Fernsehen?," *Der Tagesspiegel*, June 22, 2019, https://www.tagesspiegel.de/gesellschaft/medien/lgbti-check-wie-divers-ist-das-deutsche-fernsehen/24483416.html.

10 Ibid.

11 Carolin Emcke and Lara Fritzsche, "Wir sind schon da," *Süddeutsche Zeitung Magazin* 5/2021 (February 4, 2021), https://sz-magazin.sueddeutsche.de/kunst/schauspielerinnen-schauspieler-coming-out-89811?reduced=true; See also, "Manifest #ActOut," http://act-out.org.

12 Amy Villarejo, "Ethereal Queer: Notes on Method," in *Queer TV: Theories, Histories, Politics*, ed. Glyn Davis and Gary Needham (New York: Routledge, 2009), 48–62.

13 David Opie, "Why Netflix Is Leading the Way When It Comes to LGBTQ+ Representation on TV," *Digitalspy.com*, April 18, 2019, https://www.digitalspy.com/tv/ustv/a27194507/netflix-LGBTQ+-shows/.

14 Turkey's president Recep Tayyip Erdoğan stated in an opinion piece that Netflix seeks to normalize homosexuality. Sertan Sanderson, "Netflix Cancels Turkey Series in Row Over Gay Character," *Deutsche Welle*, July 24, 2020, https://www.dw.com/en/netflix-cancels-turkey-series-in-row-over-gay-character/a-54307855.

15 Heike Mund, "'Babylon Berlin': The Most Expensive Non-English Drama
 Series Ever Produced," *Deutsche Welle*, October 16, 2017, https://www.dw.com/
 en/babylon-berlin-the-most-expensive-non-english-drama-series-ever-
 produced/a-40965401.

16 On the series' destabilization of historicity, see the Introduction and also the
 chapters by Abby Anderton and Julia Sneeringer in this volume.

17 Judith Butler, *Gender Trouble: Feminism and the Subversion of Identity* (New York:
 Routledge, 1990), 186.

18 Katie Sutton, *The Masculine Woman in Weimar Germany* (New York: Berghahn,
 2011), 133.

19 Sutton, *Masculine Woman*, 136.

20 For a general overview of "camp," see Fabio Cleto, "Introduction: Queering the
 Camp," in *Queer Aesthetics and the Performing Subject*, 1–40.

21 Townsend and Deerwater, *Where Are We on TV Now 2019–20*, 30; Jack
 Halberstam, *In a Queer Time: Transgender Bodies, Subcultural Lives* (New York:
 New York University Press, 2005), 76–96.

22 Eve Kosofsky Sedgwick, *Epistemology of the Closet* (Berkeley: University of
 California Press, 2008), 2.

23 Katie Sutton, *Sex between Body and Mind: Psychoanalysis and Sexology in the
 German-Speaking World, 1890s–1930s* (Ann Arbor: University of Michigan Press,
 2019), 95.

24 Portraying Gräf as a cross-dresser corresponds with theories of sexuality circulating
 around the time that conflated gender expression, gender identity, and sexual
 orientation. This aspect of the character is not developed further, leaving the
 experiences of gender non-conforming people out. Because we do not know how
 Gräf identifies in this particular scene, I have chosen to use the nonbinary *they*
 pronoun.

25 Sedgwick, *Epistemology of the Closet*, 19–20.

26 Samper Vendrell, *The Seduction of Youth*, 52–6.

27 Peter Jelavich, *Berlin Cabaret* (Cambridge, MA: Harvard University Press, 1993),
 100–4.

28 Townsend and Deerwater, *Where Are We on TV Now* 2019–20, 26.

29 Anya Josephs, "The Sexualization of Queer Women in Media," *Spark Movement*,
 November 29, 2012, http://www.sparkmovement.org/2012/11/29/the-
 sexualization-of-queer-women-in-media/.

30 Emma Dibdin, "TV Writers Need to Stop Killing Off Their Gay Characters," *Marie
 Claire*, August 9, 2017, https://www.marieclaire.com/culture/news/a28685/gay-
 lesbian-character-deaths-tv/; and Erin B. Waggoner, "Bury Your Gays and Social
 Media Fan Response: Television, LGBTQ Representation, and Communitarian
 Ethics," *Journal of Homosexuality* 65, no. 13 (2018): 1877–91.

The City (Almost) without Jews

Darcy Buerkle

By the time *Babylon Berlin* became available in 2017 in the United States, the state-side invocation of Weimar Germany had already become, however dubiously, a regular occurrence in the press.[1] In the lead up to the 2016 US presidential election, for example, Roger Cohen had penned a cautionary op-ed entitled "Trump's Weimar America."[2] The results of that election and the policies thus produced resulted in numerous references to Weimar Germany as instructive for the devolving situation in the United States. "Will the Trump presidency turn America into a Fascist state?," asked a November 2016 article just ten days after the presidential election, "That remains to be seen. But one has the uneasy feeling that we have seen this movie before and it does not end well."[3] The first two seasons of *BB* thus debuted to a public more primed than it might have been. But it would be difficult to overstate the enthusiasm that the series unleashed among its Netflix viewers. High production values provided ample seductive fodder for *BB* to receive regular recommendation in major outlets, with increasing affective resonance in a US-based audience.[4] With a glimmer of recognizable democratic norms in 2021, even conservative columnist Ross Douthat's *New York Times* headline posed the question "*Babylon Berlin*, Babylon America?," stating that "[t]he major success [of the series] is in evoking a feeling that might be described as almost-familiarity in its portrait of Germany before the fall."[5] Historian Paul Lerner has reached beyond feeling to pose the more pressing but related poignant moral question of whether "there is a danger in presenting the last gasps of Weimar democracy as entertainment, wherein a society on the verge of fascism … is served up as playground for the erotic adventures of two glamorous if seedy protagonists for our viewing pleasure and titillation."[6] An increasingly emboldened enactment of US-based state-sanctioned white-supremacy, antisemitism, and misogyny animated public life as *BB* streamed.

The site of this chapter, however, concerns not danger to democracy generally as entertainment, but the relationship between that danger and the singularly peculiar treatment of Jews in the series as a matter of narrative and spectatorship. Despite the relevance of Jewish contributions to the cultural production that the series celebrates, *BB* elides this specificity. And despite the political events that the series narrates, the role Jews played, and their clear impact on the trajectory of German history, Jewishness remains barely present. In addition to the absences thus produced, the decision to equivocate produces an affective and political economy that relies on a definition of Jewish difference that is, for twenty-first-century viewers, impossible to decouple from antisemitic violence.[7] What is the status of imagination galvanized in terms that specifically evade Jewish presence, let alone the details of such presence? Both the series' creative team and the writer of the novels on which it was based, Volker Kutscher, repeatedly note that the story means to refuse the teleological inevitability of National Socialism and the Holocaust. "We wanted," they say "to tell a story about a time before National Socialism."[8] *BB* appears to assert the absence of Jews as *necessary* in its commitment to the primacy of political innocence in its characters.

The repeated proclamations of careful research on the part of *BB*'s showrunners, then, does not mean that they capitulate to the factual—indeed, most of the cultural production and even events that the series cites post-date 1929.[9] This contradictory reliance on and malleability of truth-claims finds its narratological companion in *BB*'s persistent preoccupation with the fixity of the law and in the related and impossible search for reliable evidence. Storylines seek to prove guilt on the basis of evidence, even as the series urgently puts the notion of evidence itself in question: in this, the story mirrors the conditions of its twenty-first-century spectatorship. That is, most pressingly for this chapter, in its self-conscious efforts to evade representation of history's inevitability, *BB* brackets virtually all evidence of Jews in 1929 Berlin beyond the incidental. In doing so, it reinscribes and thus once again reifies the representation of Jewish life as only emblematic of tragedy. But this explicit avoidance of a teleological, prefascist story produces a narrative and visual language that causes the spectator to do repeated double-takes. A generative, and also disturbed, spectatorial situation results, in which Jews are reduced to near abstraction at best, and the historical proximity of National Socialism to the (later) events and cultural production foregrounded becomes even more glaring. If the spectator thinks of German Jews, they will infer the conditions of their absence.

In other words, just as the series forcefully asserts, and then just as forcefully denies, Dr. Schmidt's admonition to Gereon Rath that truth is immutable, the

absence of Jews in this story suggests both "the source of your fear" that Schmidt seeks to tap into and a reliance on spectatorial gaslighting: On the one hand, *BB* maintains the primacy of political innocence; on the other it suggests that fulsome representation of Jewish life in Weimar Berlin inevitably collapses in an inexorable reference to the Holocaust—and thus inserts a decidedly post-Second World War presupposition. Claims to arduous re-creation and realism on the one hand, and the evasive treatment of Jewishness in the story on the other set up a central contradiction that the seemingly ancillary in the script variously challenges and bolsters.

In an effort to avoid what they regard as inevitable collapsing of Jewishness into a story about the Holocaust, Jewish references are visual and scripted asides. For example, occasional allusions to Jews are typically coupled with antisemitism and, in some cases, murder, again suggesting that it is not possible to mention Jews otherwise. References to Jews appear in lists of complaints from the pharmacist, in an off-hand remark about where to get the best price for Lotte's mother's wedding dress, or in the blatantly antisemitic diatribe that Alfred Nyssen spews about Jews and money. After August Benda is murdered, his successor Gottfried Wendt instructs the maid to fumigate Benda's office, and in one of many references to the destruction of visual evidence (of Jews, in this instance), Wendt removes a framed photo of the deceased Benda and his daughter from his desk, instructing the maid to "get this out of here" (S2, E8). Here, the series inscribes the erasure of Jewish presence as character development.

Other characters coded as Jewish appear and remain only as ancillary visual referents—but usually from some distance. If they are Jewish women, there tends to be death involved. These include Käte Stresemann (Kleefeld) whom we see from afar sitting next to her husband in a theater as a failed assassination attempt unfolds. Actresses killed in season three have names that are stereotypically Jewish: Lohmann, Spielmann—but there is no related comment attached. In all these ways, *BB* could be seen as availing itself of Weimar conventions of discerning Jewishness as the marked without remark, and thus as commentary on an old and bad habit in cinema, but it does so in relationship to a spectatorship that, though eager for parallels with contemporary politics, will not reliably interpolate Jewishness as the Weimar-era spectator would. Sometimes, what might have been direct references are obscured to the barely recognizable and without script-driven explanation for the uninitiated viewer. While establishing guilt is the central plot point in each of the subplots of this project—a project that is predicated on erasure in the service of narrative—this is achieved in part

by inferring a more historically situated spectatorship. In what follows, I chart the fact and character of Jewish absence in this twenty-first-century series that disavows its interpolations, re-reading that absence in an effort to challenge the related narratological and spectatorial logics that both support and undermine it.[10] The character of August Benda embodies and underlines this analysis.

Naming the Jew: August Benda and His Historical Antecedent, Bernhard Weiss

With the exception of a glimpse of Orthodox men in a street scene in episode one, the visual portrayal of deputy police commissioner and head of the political police August Benda is the primary prism through which *BB* refers specifically to Berlin's German-Jewish history: he is the only explicitly Jewish character developed in the first three seasons of the series.[11] Married to the Catholic Irmgard, Benda has two children. He appears as a dignified and lonely person, embodying the price of assimilated German-Jewish masculinity and respectability.[12] In the first two seasons, his character proliferates; in the third, the trial and prosecution for his assassination functions as one of the central plotlines. He both plays the organ during Mass and sneaks off to the Scheuenviertel for (kosher) sausages. In what might be read as an enactment of his assimilation, Benda invokes religion in his first encounter with Cologne-native Detective Rath, asking him, "Are you Catholic? Do come to Mass on Sunday … I play the organ there" (S1, E2). Notably, Benda does not appear in the frame when he issues this invitation; instead, we see Bruno Wolter's face as he listens in from a distance: the camera evades the exchange even as the scene foregrounds it.

During Mass, Benda reads as he waits for his cue—alternately playing the organ, checking for relevant points in the liturgical progression, and leafing through a magazine. The camera captures his glance over the shoulder toward the altar as he plays, out of view of the congregation below. As he turns back around to face his instrument, he touches his nose slightly in a characteristic gesture of barely conscious disapproval, gesturally registering his separation from the enactment of church doctrine unfolding at a distance for the camera. In the back of the church after Mass, Benda introduces Rath to his family. He explains that the church "is not his club" and remains silent when his wife Irmgard superciliously proclaims that her husband's "family is Jewish" and that he "refuses to be baptized" (S1, E6). Here, *BB* participates in a cinematic trope that was familiar to Weimar-era viewers, one that places the question

of intermarriage and the relationship that precedes marriage as a central conundrum.[13] In this instance, the story offers a view of an interfaith couple in which the conceit of the relative (in)visibility of Jewishness and possible passing enables the relationship.

Played evocatively by Willy Brandt's youngest son and accomplished German actor Matthias Brandt, Benda defends democracy and the rule of law and will dissimulate to protect both, fearing that neither will survive attacks from both right and left. His deference to hierarchy in the name of these goals, the simmering tensions within Germany's left, and the rise of violence on the right lead him to keep quiet about police violence in the wake of 1929's May Day demonstrations. Those under his command are encouraged to do the same. Benda's principal aim is to uncover those responsible for right-wing violence and illegal arms trading—a goal that leads him to investigate military men involved in the Black Reichswehr and, once he is in possession of irrefutable evidence, ultimately to arrest them. It is in his defense of democracy that Benda is most like his historical antecedent, the Vice President of the Berlin Police, Bernhard Weiss.

BB proves inconsistent in its adoption of historical figures by name—such as Paul von Hindenburg, Heinrich Brüning, and Karl Zörgiebel—and interpretive approximations of historical figures and fictional characters in Kutscher's novels. The series, however, diverges from the novels, which feature Weiss as a key character, and makes the remarkable choice of renaming the historical character Bernhard Weiss as "August Benda." There is an unwitting historical resonance to this decision. The Weimar-era deputy police commissioner Weiss was an early target of the Nazi party, besieged in particular by Joseph Goebbels in both speech and print. One of the most consistent means of denigration involved referring to Weiss not by name, but by the ostensibly Jewish and unmistakably antisemitic moniker "Isidor." Peter Longerich has observed that only one issue of *Der Angriff* in 1927–8 failed to caricature and humiliate Weiss in this way: playing "the name game," referring to him as Isidor Weiss or printing Weiss's actual name in quotation marks.[14]

The mere invocation of Weiss itself refutes the *BB* creative team's claims that "there were no Nazis in Berlin in 1929."[15] But unlike the character Benda, whose relationship to Jewishness seems limited to kosher sausages and the refusal to convert, Weiss was also a vocal member of the *Central-Verein der deutschen Juden* who pursued—successfully—slander charges on his own behalf against Goebbels. As head of the political police under the leadership of Albert Grzesinksi (born Albert Lehmann), Weiss repeatedly interrupted Nazi activities

in the early years of Weimar and ordered the shuttering of the Berlin branch of the Nazi party in 1927. On that occasion, he was responsible for arresting several hundred members. In his 1928 text *Polizei und Politik* (Police and Politics), Weiss counseled police to exercise "a certain reserve" when it came to political questions, since, as he cautioned, "all political parties vie for the soul of the police ... [and] seek to influence the police force politically."[16] Goebbels exploited this fact, rallying members of the force against Weiss and continuously harassing him explicitly in speeches, as well as in his 1929 screed, *Book of Isidor*.[17] Mocking his name, as Dietz Bering points out, was to declare his German identity as illegitimate, casting aspersions to suggest that his "real name" would reveal him as a Jew and therefore not a "real German."[18] Goebbels's first article in *Der Angriff* assailing Weiss laid his intention out in no uncertain terms and initiated myriad attacks that circulated around name-based humiliations and antagonism. Ultimately, Weiss sought recompense in court.[19] The exchange Benda has when he questions Major General Wilhelm Seegers in his office echoes this circumstance, but the cut in this sequence underlines the point: "Why do you of all people believe that you are called to protect the citizens of Germany," Seegers brazenly asks Benda. Benda answers: "What do you mean by that?" Seegers retorts: "You should leave national matters to the people whose soil you're on." The camera goes to the secretary whose face evinces shame and shock, and then cuts back to Benda's face—who gets a few seconds of a squint at Seegers—but does not answer him; the scene ends (S2, E5). In the next sequence, Benda meets Rath in the hallway as he takes a cigarette break, ostensibly after the exchange above. When Gereon asks how the interview is going, Benda simply says: "Stonewalling." The fledgling democracy was beset by antisemitic attacks against which it had to push back, captured not least in its dissenters' common designation of the Weimar Republic as a "Judenstaat," a fact that Weiss addressed directly in print and in court.[20] In contrast, Benda remains silent in the face of blatant harassment.

By 1932 Weiss had grown ever more direct in his appeals to the Jewish community. He called on Jews to stop stepping away from the political, to have more self-confidence and, as he put it: "Let us protect ourselves from the overly sensitive types who preach restraint in these times, and let us without fail hold ourselves instead to the achievements of Emancipation!"[21] In obscuring the historical Weiss, whose story is differently tragic than that of the character Benda, the obscuration of Jewish history remains a performative feature of the series. Even so, Brandt's version of Benda brilliantly captures Jewishness as a matter of the barely visible, through the slightest movement, through the exchanged glances of recognition, a Yiddish phrase behind closed doors, or a seemingly

off-hand comment. The details about what Benda might think about the status of his subjectivity as specifically Jewish beyond "not converted" remain entirely opaque.

Jewish Representation beyond Benda

If Jews are largely explicitly absent from the storyline in seasons one and two, then in season three, despite fuller articulation of antisemitism, Jewish presence still struggles to make itself known. Here, harbingers of the fight for democracy are again barely evident Jews—but even in the absence of the characters' full understanding of the stakes, this season forges a connection to state-sanctioned murder. Inferences of Jewishness and their fervor for democracy persist nonetheless in the series. For example, the intrepid political journalist Samuel Katelbach could easily have been modeled on the Jewish writer, communist, and activist Egon Erwin Kisch. But no such claim is made on the level of narrative— beyond the culinary—despite the showrunners' references to him as an obviously Jewish character.[22] Reading Katelbach as Kisch, however, as Jochen Hung does in his contribution to this volume, makes an extra-biographical reference evident and puts the importance of Jewish contributions in the temporal and unseen marrow of the series. Katelbach enacts the frantic pace that animates all three seasons to date—the same pacing that the musical compositions evidence.[23] In a further iteration of metaphorics familiar to the contemporary spectator, Katelbach learns that he is being targeted by the political police, headed in season three by Wendt, when Gereon Rath shares "the list." Surveying the names, Katelbach suggests this must be a list of "the good ones … See, Litten is on this list" (S3, E6).

The attorney Hans Litten is a character based on his namesake; in the series he advocates with skill and resolve for justice for the underprivileged. Litten's Jewishness plays no role in his character development in *BB*—though of course it played a very significant role in his biography that even casual readers in the history of the resistance to National Socialism will know. Baptized by his converted father and Protestant mother, Litten nonetheless refused an uncomplicated Christian identity. He participated in an off-shoot of the Jewish youth movement, Schwarzer Haufen, penning such contributions to the 1924 newsletter as "What does the Talmud mean to us?"[24] Litten's Jewishness and its possible relevance remains unmentioned in the series.

Additional connections to German-Jewish history that *BB* fails to make explicit further reverberate in the Litten subplot of the series through the characters of

Marie Luise (Malu) Seegers and her sister. While the most immediate reference to German Jews in that strand of the story to date involves an unmarked quotation from Walter Benjamin, the Seegers sisters in *BB* appear modeled on Marie Luise and Helga von Hammerstein, daughters of Kurt von Hammerstein-Equord, the highest-ranking officer in the Reichswehr. Both sisters, as well as a third, Maria Theresa, were intimate with or married to Jewish men, and participated in a fully integrated world and friendship circle of committed Jewish leftists. As a law student, Marie Luise became active in the Communist party. Much has been made of her affair with the well-known German-Jewish Spartacist Werner Scholem, but Marie Luise's membership in the party and efforts on behalf of it pre- and postdate that liaison.[25] She, along with at least two of her sisters, regularly passed information to Moscow through Leo Roth beginning in 1929. Such information included a transcript of a pivotal meeting her father held with Hitler and some of his generals in 1933. Marie Luise's sister Helga von Hammerstein's partner (and most agree, eventual husband) was German-Jewish communist spy Roth—after Roth's murder, she married another informant, anti-Nazi landscape architect Walter Rossow.[26] As daughters of General von Hammerstein-Equord, the women were not only privy to the military elite, they used that access in an effort to disrupt National Socialism. Their invocation in *BB*, therefore, is another reference that might be inseparable from their efforts to prevent harm to Jews, but that the narrative manages to insulate.[27]

Passing on Innocence

Tom Tykwer has said repeatedly that the showrunners did not feel "obligated to represent the era with absolute precision," a comment clearly at odds with, for example, well-documented herculean efforts in set and costume design.[28] Concessions that German Jews are eclipsed in this series have been answered with the assertion that *BB* does not seek "historical accuracy."[29] The reasons for Jewish absence, we are told by the creative team and critics alike, have to do with the fact that the series seeks an immersive experience in "what it was like to be alive in Berlin in 1929."[30] It is remarkable that this explanation for the evasion of Jewish history has been allowed to stand. But as a result, *BB*'s version of Jews in Weimar produces a complicated glare rather than an absence: a city *almost* without Jews.

The notion that Jewish absence can be understood by noting that the series is not meant to engage in "historical realism" suggests a relation to the past that the field of history has widely disavowed—and a casting of Berlin's Jews

that counters central claims about the history of emotion that the series seeks to make. That is: to understand what it "felt like" to live in Weimar-era Berlin can only legitimately involve a simple evasion of Jewish life in the city at that time if the aim is to foreground what it *felt like* to participate in the marginalization of Jews and Others to the point of near invisibility. The assumption here is that to be alive in 1929 in Berlin need not include Jewish experience on its own terms, but rather Jewish experience as it might be observed by non-Jews, or enacted in public passing by the highly assimilated. Assertions from the creative team and subsequent reviewers also do nothing to address the reasons that other marginalized identities are also rendered as backdrop, such as representations of queer life or of Black performers.[31] If the point of the series, then, is to demonstrate that "Nazis did not just fall from the sky," and to walk with the characters through poverty, shell-shock, the violence of Blood May, the stock-market crash, and into Nazi territory, then that walk firmly centers non-Jewish subjectivities ultimately addressed by National Socialism's promise.[32]

The emplotment through which *BB* unfolds raises more nuanced questions than simple missing pieces and, in fact, tells its story in the terms on which historiography and jurisprudence of emergent and full-fledged authoritarian violence has necessarily relied too: the status of the very notion of evidence, its reliability and its destruction, and the question of what constitutes reliable evidence of innocence or guilt. With this in mind, is there a way of reading *BB* beyond the evasion of Jewish life—a reading that asserts the centrality of the absent Jew in Weimar's history as *the* key absent character in the series, as an indicator of the kind of a more essential historical truth than the narrative might hold? Well beyond the factual, and with the series' goal of conjuring of political innocence, the plot points and metaphorics that pivot on innocence, lying, and the destruction of (particularly visual) evidence find resonance with the twenty-first-century viewer precisely because spectators lack the political innocence that the series asserts. Several scenes derive their power from this lack of innocence in keeping with the incomplete suspension of the future that is our past. For example, having discovered the illegal import of phosgene gas, Rath asks Benda, "Who was the gas for?" Benda answers: "Well, why don't you guess?" (S2, E3).[33] Similarly, the exchange and long pause that follows the request for and then taking of fingerprints as Walter Weintraub prepares to leave prison lasts a little too long for a plot point: "What does the joker want with me?" The forensics official tells him that he needs both fingerprints and some strands of his hair as a "precautionary" measure, just in case (S3, E1). The exchange between the two men infers that they, too, momentarily lose their historical innocence, breaking

an implied historical third wall. *BB* thus avails itself of an unerasable trace in its evasions, invoking a cultural and moral imaginary that permeates the story. But there is a further dimension of absence in evidence, too.

Beyond the narratological and visual language of the series that specifically brackets Jewish life, absent too is any clear reference to the Jewishness of the cultural productions on which the series relies. The specific artifacts of Weimar that appear (and reappear) as citational aesthetics in the series were the creations of Jewish thinkers and artists and they go unremarked as such.[34] For example, European Jewish culture frames a scene that takes place in the home of Stephan Jänicke through Gustav Mahler's *I Am Lost to the World* from his *Rückert Lieder* (S1, E3). Beyond the fact of Mahler's own heritage, his embedding of Jewish music, especially in his 1st symphony, and the antisemitic screeds to which he was subjected, the original manuscript of his *Rückert Lieder* was stolen in 1941 from his friend Guido Adler by the Nazis. Rückert composed hundreds of texts as tribute and mourning for the loss of his children, a fact Mahler claimed as central inspiration for his composition completed before his own daughter's death. Here, again, the narrative exceeds its frame. Historical time and its relation to visual or auditory evidence remains perhaps the most understated and persistent mash-up in *BB*.[35] As Stephan signs the song for his deaf parents—who are unable to hear its timing—the story prefigures their loss and Stephan's murder, as well as the timelessness of the story at hand. The camera cycles through images of suffering and preoccupied characters, ending with Svetlana Sorokina gazing at herself in the window like Fritz Lang's *Dr. Mabuse*, thus making another complicated allusion to Jewishness, to antisemitism, and to the inescapability of the past that haunts the political innocence that the series proclaims as central (S1, E3).

The centrality of photography is another instance in which German-Jewish culture frames the series since Weimar visual culture cannot be separated from Jewish contributions, except by force.[36] Indeed, the repeated invocation of photography in the series has both Jewish and gendered resonance—an inordinate number of photographers in Weimar Berlin were Jewish women. When Jewishness outwits containment and erasure in *BB*, it is primarily through the aforementioned central foregrounding of irrefutable evidence of the image—photos, films, and paintings with Jewish origins that nonetheless meet a script-specific evasion. The creators of the show have repeatedly attested to quotations from the work of the critically important August Sander, known for his magisterial posthumous work "People of the Twentieth Century," which features, among others, a series of photos entitled "Persecuted Jews" in his

eventual "atlas."[37] Notably, the script stipulates a regular and consequentially grotesque lack of care of visual evidence, evidence which can be and is, in other words, destroyed—or ignored as central to the narrative of the show—each time, with dire consequence. Read this way, *BB* invites and even enacts its own condemnation of the act of erasure through its lack of care for evidence.

The close relationship between images in *BB* and the perpetual corpses linked to images throughout—on the autopsy table, in the woods, in the Hof, in the Spree, and the mass graves—proliferates and reinstalls the post-1945 censure on looking away from mass (Jewish) death. But the historical echo with a relationship to European Jewish history by way of its visual vocabulary does not end there. The fetishizing of the train, the assertion that there is gold when there is none, and that, of course, what the train holds mostly is poisonous gas: none of these markers appears without the weight of history, nor does the tattoo that Charlotte (Lotte) Ritter spies on the arm of the dead train operator. Calling attention to it gets her kicked out of the room. In fact, this is Lotte's repeated fate: banished and punished for good detective work, for truth-telling, and for anticipating a future past. The popular song composed for the series "Zu Asche, zu Staub" (To Ashes, To Dust) might itself be read as an incantation of the genocidal history that the series ostensibly seeks to bracket.[38] There are historical claims being made here that complicate the status of apparent absence—depending on who is listening, or watching. So while it could be argued that the elaborate aesthetics might (and have) seduce(d) the spectator into abnegation, I want also to draw attention to a further dimension of the series: that is, to think of the spectacularity of its aesthetics and high production value as documenting failed innocence. *BB* throws into sharp relief the metaphorical terms within which it makes a claim of innocence—a claim that ultimately cannot hold on the level of narrative either, even with limited historical knowledge. Political innocence as stated aim leaves the viewer with a fundamental link between such innocence and the profound flattening of Jewish presence. In the end, inference and the spectatorial lack of political innocence challenges the obliteration of Jewish presence.

In season three, Benda's character is absent—but not fully so, since the trial to prosecute Greta Overbeck for his murder provides a significant subplot. In setting the story up in this way, the series recreates the framing it ostensibly sought to avoid. That is, even though it is not a story about "pre-fascism," it is a series in which a central organizing narrative comes from the murder of a Jew, the too-late realization of the manipulated culprit that she was participating in a murder, the near erasure of the death of a child (Benda's daughter Margot)—and, importantly, the lies that are told in the dock in the wake of those murders.[39]

On first questioning, Greta testifies truthfully about realizing that her purported communist boyfriend was actually a Nazi who set her up to collaborate with him in the assassination of Benda. But the near fool-proof corrupting force of the desire to protect her own child means that her resolute determination to tell the truth crumbles; she changes her story after a visit from the proto-fascist Wendt. As she gazes down from the bars of the prison window, a woman holds Greta's infant as Wendt issues a wordless threat should she refuse to collaborate (S3, E3). Once again in court, Greta reverses and asserts that Communists were indeed responsible for Benda's murder (S3, E4). In a poignant and gendered eye-to-eye, she is sentenced to death as she sits across from Benda's widow. The evidence clearly contradicts Greta's statements, but the judge appears to be a sympathizer and collaborates with Wendt's plan to condemn her. The Communists in attendance yell out in disgust. When Greta returns to the jail, Communist women who are also being held threaten her and demand to know why she changed her story. Greta remains steadfast; in her mind, lying is the only way to save her child—and thus an ultimate good that renders its consequences moot. Lotte uses a version of this logic to convince Greta to allow for Litten to file an appeal on her behalf. She gives her consent, but corruption—the jailer's withholding the truth—will again prove fatal. In this case, the homicide detectives witness Greta's execution and burial in a mass grave. Lotte's line as she stares down into the pit reverberates with culpability: "It is our fault" (S3, E12). Here, too, the grisly visual rhetoric involved can claim innocence all it wants; twenty-first-century spectators have their own visual grammar of mass graves that may have started with representations of the Holocaust, but certainly has not ended there—and *BB* visually quotes that history more than once.[40]

In an iteration of historical research on the Jewish past, the destruction of evidence functions as a central narratological matter, via film and photos in particular. But in its citation of genre and cultural production, *BB* also demonstratively "destroys the film" by barely excising the Jewish history and culture that enables its scaffolding. In this way, it is possible to read *BB*'s diminished and clichéd Jewish representation as a commentary that indicts through claims outside the confines of its own narrative.

Failures of Justice

The *BB* spectator has occasion repeatedly to encounter moments in this story when the question of moral courage and contingency overlap.[41] The repetitive withholding, of justice denied, might be the most poignant for US spectators

when Zörgiebel tells Rath: "Bring me evidence, then you can have your warrant." This utterance, I argue, explicates the popularity of this show in the United States as powerfully as the production values do: claims of political innocence where there can be none have finally tripped up Americans, and the high price of such innocence does not require a return to Weimar. Further, the centrality of dissimulation to the end of the Republic may resonate more urgently than any historian's explication about the (historical) importance of the independence of the judiciary. The resonance of justice deterred, despite overwhelming evidence of violence and violation, has not been more generally palpable in daily life in the United States in decades; the magnitude of the threat has never been greater.

Historians have long recognized the significance of emplotment in historical writing, and the difference between historical facts and historical truth. But *BB* reminds us that lying is a different matter; it is its own kind of destruction of evidence, and it extends to the leaving out of critical details which, in this instance, as I have shown, adds up to a more complicated evasion of Jewish presence that implicates the series. Given the role that the whole range of duplicities play in *BB* and the history thus narrated, dissimulation itself should have been granted a credit. Whether about May Day violence or the culpability of Nazis in Benda's murder or all the ways that Gereon Rath lies to himself and to Helga, all these claims are lethal. "But she is not a murderer," Lotte says to Gereon as they discuss Greta's ultimate verdict. "Yes she is," he says simply. Lotte does not relent; after a long, incredulous, searching stare, she disarms him by exposing a fundamental lie she knows Gereon is telling about his own life, namely the whereabouts of his "wife" (S3, E5). The search for the culprits thus continues, only to be thwarted and far too belated, a circumstance that has delivered, as I noted at the outset, particular spectatorial heft in the US market as the result of the fragile state of our very own twenty-first-century democracy. Gereon, seeking go-ahead to arrest one of Benda's murderers, Horst Kessler (a barely veiled reference to the historical figure Horst Wessel) hears the same phrase that Benda did: "Bring me evidence, then you can have your warrant" (S3, E10). But the framing of the series relies on a range of dissimulations, too—none among them more glaring than the supposition that the representation of political innocence requires— or can survive—the erasure of Jewish life and cultural contributions. Perhaps Dr. Schmidt knows this, and in this realization resides the insidiousness of his admonition: There are, he says repeatedly as he hypnotizes Gereon, "no versions of the truth." Such a claim requires hypnosis indeed. *Babylon Berlin* serves as an arresting reminder to a twenty-first-century public so dazzled by its distractions it might overlook the complicated spectatorship that history stipulates. But

the evidence remains whether the spectator knows it or not, warrant or no warrant. Accountability, though, continues to elude us, still enabling and even demanding claims of innocence and erasure in its wake.

Notes

1 In its discussion of reception, this chapter confines itself largely to viewership in the United States.

2 Roger Cohen, "Trump's Weimar America," *The New York Times* [*NYT*], December 14, 2016.

3 Emanuel Paparella, "Weimar America: Germany 1933, United States 2016," *Modern Diplomacy*, November 15, 2016.

4 See, for example, Esme Nicholson, "Germany's *Babylon Berlin* Crime Series Is Like *Cabaret* on Cocaine," *NPR All Things Considered*, January 30, 2018.

5 As a conservative columnist, Douthat is eager to show the salvageability of the right in the United States, but his emphasis on the parallels remains in keeping with others throughout the 2016–20 administration. Ross Douthat, "*Babylon Berlin*, Babylon America?" *NYT*, March 20, 2021.

6 Veronika Fuechtner and Paul Lerner, eds., "Forum: *Babylon Berlin*: Media, Spectacle, and History," *Central European History* 53, no. 4 (2020): 853.

7 Lisa Silverman has made significant contributions on Jewish difference. Among others, see *Becoming Austrians: Jews and Culture between the World Wars* (Oxford: Oxford University Press, 2012) and *The Postwar Antisemite: Culture and Complicity after the Holocaust* (Oxford: Oxford University Press, forthcoming).

8 "Babylon Berlin," *Bundeszentrale für politische Bildung*, September 2018, https://www.kinofenster.de/bpb.de.

9 ARD Mediathek, 2018. For reference to Kutscher's research for his novels see, for example, Christopher F. Schuetze, "The Writer Who Made Weimar the Talk of Germany," *NYT*, December 1, 2018; Thomas Winkler, "Plötzlich wollen alle auf die Gästeliste," *Die Tageszeitung* [*TAZ*], February 8, 2020; Andreas Kilb and Peter Körte, "Volker Kutscher im Gespräch: Babylon Berlin—Unsere Wilden Jahre," *Frankfurter Allgemeine Zeitung*, October 6, 2017.

10 See my contribution to Fuechtner and Lerner, "Forum: *Babylon Berlin*," in which I briefly explore some of these points.

11 As I discuss below, there are other characters marked as Jewish but their legibility remains opaque at best to most viewers.

12 George Mosse was the first to fully articulate this claim; it has since been explored extensively as a rubric for thinking about the German Jewish middle-class: George L. Mosse, *Nationalism and Sexuality: Middle Class Morality and Sexual Norms*

in Modern Europe (Madison, WI: University of Wisconsin Press, 1985). Notably, Mosse makes a reference to Bernhard Weiss, the historical inspiration for the *BB* character August Benda, in his autobiography that is entirely in keeping with his theory, and with the character in *BB* too. I have argued elsewhere that Norbert Elias's *Civilizing Process* was inscribed with Jewish respectability first of all: Darcy Buerkle, "Caught in the Act: Norbert Elias, Emotion and *The Ancient Law*," *Journal of Modern Jewish Studies* 8, no. 1 (2009): 83–102.

13 Cynthia Walk, "Romeo with Sidelocks: Jewish-Gentile Romance in E. A. Dupont's *Das alte Gesetz* (1923) and Other Early Weimar Assimilation Films," in *The Many Faces of Weimar Cinema*, ed. Christian Rogowski (Rochester, NY: Camden House, 2010), 84–101.

14 Peter Longerich, *Goebbels: A Biography*, trans. Alan Bance, Jeremy Noakes, and Lesley Sharpe (New York: Random House, 2015), 90.

15 Members of the creative team of *BB* have erroneously and repeatedly claimed that there were no Nazis in Berlin in 1929 and that the sense of impending danger was absent. See, for example, Siobhán Dowling, "Sex, Drugs and Crime in the Gritty Drama 'Babylon Berlin,'" *NYT*, November 10, 2017.

16 Bernhard Weiss, *Polizei und Politik* (Berlin: Gersbach & Sohn, 1928), 11.

17 Joseph Goebbels and Hans Schweitzer, *Das Buch Isidor: Ein Zeitbild voll Lachen und Hass* (Munich: Verlag Franz Eher, 1929).

18 The insidious details of the extensive campaign against Weiss can be found in Dietz Bering, *Kampf um Namen: Bernhard Weiss gegen Joseph Goebbels* (Stuttgart: Klett-Cotta, 1992), 241ff.

19 For details, see Bering, *Kampf um Namen*.

20 Ibid., 251.

21 "Mehr Selbstbewusstsein," *CV Zeitung*, June 3, 1931.

22 In Summer 2020 in a reply to Jill Suzanne Smith's question about the near singularity of Benda as a Jewish character in a series about a culture that at the time included varied Jewish life and contributions in Weimar Germany, Henk Handloegten offered a fulsome reply, but he began and returned repeatedly to the importance of Katelbach as "another Jewish character." Season four will have more to say about Jewish culture because "Volker Kutscher's third novel *Goldstein* is the source for that season and it is only here that he engages with Jewish life in Berlin more generally, and that's why we couldn't go into it too soon." Most interestingly for purposes of this chapter, Handloegten also noted that all three creators of the series are "always" in agreement that losing the Benda character is "the only really big mistake that we made … He is very difficult to replace … We suffer for it, all of German culture suffers for the absence. It is not possible to recreate … This is perhaps even one of the reasons we made the choices we did …" ("Studierende der Deutschen Sommerschule am Pazifik führen ein Gespräch mit

Babylon Berlin Regisseur Henk Handloegten," June 26, 2020, 1:22, here 1:10–1:13, Carrie Collenberg-González YouTube Channel, https://www.youtube.com/ watch?v=y2PKSrqDKs8).

23 "Hetzjagd," (2017), an original composition for *BB* appearing in season one, provides the kind of tempo to which I refer here. Composed by Johnny Klimek and Tom Tykwer, its frantic pace is undeniable at 137BPM.

24 Knut Berbauer, Sabine Fröhlich, and Stefanie Schüler-Springorum, *Denkmalsfigur: Biographische Annäherung an Hans Litten, 1903–1938* (Göttingen: Wallstein Verlag, 2008). See also Stefanie Schüler-Springorum, "Hans Litten 1903–2003: The Public Use of a Biography," *Leo Baeck Yearbook* 48, no. 1 (January 2003): 205–19.

25 Jay Geller, *The Scholems: A Story of the German Jewish Bourgeoisie* (Ithaca, NY: Cornell University Press, 2019), 153ff. The literary preoccupation with the Scholem-Hammerstein affair as the reason for Werner Scholem's arrest began early with Arkadi Maslow's 1935 novel *Die Tochter des Generals* (The Daughter of the General), published posthumously in 2011, continued through Franz Jung's published expose *RE: The Hammersteins*, to Alexander Kluge's *Lebendigkeit von 1931* (2003). See Mirjam Zadoff, *Werner Scholem: A German Life*, trans. Dona Geyer (Philadelphia: University of Pennsylvania Press, 2018), 240–2, 248, 282; and Ralf Hoffrogge, *A Jewish Communist in Weimar Germany: The Life of Werner Scholem, 1895–1940* (Chicago: Haymarket Press, 2014/2018) for more on the relationship between Scholem and Hammerstein and its treatment in literature and historiography. Hans Magnus Enzensberger's novel *Hammerstein oder Der Eigensinn* (Frankfurt: Suhrkamp, 2008), translated into English as *The Silences of Hammerstein: A German Story* (New York: Seagull, 2009), is the latest iteration to invoke the Scholem-Hammerstein affair and includes fictionalized interviews, including one with Marie Luise. Enzensberger's novel caused particular division in the pages of *Die Zeit*, where it was reviewed twice, from two perspectives: "pro and contra," *Die Zeit*, January 17, 2008.

26 Adam Kirsch, "Can We Judge General von Hammerstein?" *NYRB*, June 10, 2010.

27 Hammerstein had seven children—several others were also involved in resistance— ranging from Maria Therese who married Joachim Paasche in 1934, to her brother Ludwig who was involved in the July 20 assassination plot. Paasche had been categorized as a "half Jew" and subjugated as the result of his father's pacifist writing—writing that ended with his murder by a group organized by Maria Therese's grandfather during the Kapp Putsch. The couple briefly moved to Tel Aviv in 1934. Maria Therese von Hammerstein helped German Jews escape the country before she left, too—spending the war in Japan before immigrating to the United States in 1948.

28 See, for example, "Babylon Berlin," Bundeszentrale für politische Bildung.

29 Andreas Kilb, "Vor dem Sündenfall," *Frankfurter Allgemeine Zeitung*, April 28, 2021.

30 "Babylon Berlin," Bundeszentrale für politische Bildung. See also, for example, "Mit der Realität kann ich nichts anfangen," *Süddeutsche Zeitung* September 10, 2019.

31 Jill Suzanne Smith draws attention to Jeff Mannes's related critique of the heteronormativity that prevails in the series. See Fuechtner and Lerner, "Forum: *Babylon Berlin*," 839, and Jeff Mannes, "Babylon Berlin? Zum Mythos der wilden 20er Jahre," *Siegesäule.de*, August 28, 2019. See also Javier Samper Vendrell's contribution in this volume.

32 Tobias Grey, "A Hit Drama in Germany, Babylon Berlin Crosses the Atlantic," *Wall Street Journal,* January 28, 2018.

33 As so often in *BB*, the plot-driven answer to that question sits uneasily alongside the spectator's inference.

34 Special thanks to Hester Baer for her help in clarifying this point.

35 Mila Ganeva, Julia Sneeringer, and Smith persuasively argue for the centrality of "the mash-up" in *BB* in Fuechtner and Lerner, "Forum: *Babylon Berlin*."

36 Indeed, the repeated invocation of photography in the series has both Jewish and gendered resonance—an inordinate number of photographers in Weimar Berlin were Jewish women.

37 August Sander, *Antlitz der Zeit* (Munich: Kurt Wolff Verlag, 1929).

38 See Kim Wilkins, "*Babylon Berlin*'s Bifocal Gaze," *Screen* 62, no. 2 (2021): 135–55, for a rich series of intertexts, including "Zu Asche, zu Staub," 146.

39 Reference here is to a connection that Paul Lerner also makes in the "Forum: *Babylon Berlin*," 842; see also Anton Kaes, *Shell Shock Cinema: Weimar Culture and the Wounds of War* (Princeton: Princeton University Press, 2009), 5.

40 I refer here to the mass grave of the murdered Trotskyites from seasons one and two, discovered in the forest outside of Berlin.

41 Peter Fritzsche, "Did Weimar 'Fail?," *The Journal of Modern History* 68 (September 1996): 629–56.

Part Four

Weimar Intertexts

Blood May Footage and the Archive Effect: The Political Ambivalence of *Babylon Berlin* as Appropriation Film

Sara F. Hall

Babylon Berlin and its source novel *Der nasse Fisch* by Volker Kutscher take place during the street violence of May 1, 1929.[1] Known in press coverage and subsequent historical accounts as *Blutmai* (Blood May), this flashpoint concretizes one of the works' major themes: policing's relationship to late Weimar unrest. It also points to the mediation of that relationship through moving images. Extending from its function in the novel, Blood May provides the series with not only narrative grounding, but also an opportunity to repurpose archival source material. By resignifying agitprop footage as a fictional newsreel in a pivotal movie-house scene, *BB* establishes a discrepancy between the source material's style and tone and those of the television show that incorporates it, which contributes to the complex political valence of the series' use of Weimar history to appeal to its spectators.

Consistent with its cool tone, Kutscher's novel (which appeared in English under the title *Babylon Berlin*) presents Blood May first as background; it is what happens to be afoot when Gereon Rath is reassigned to the Berlin Vice Squad following a grave misstep on the Cologne Homicide Squad. Additionally, its presence in the text is diegetically specific and personally significant; May Day tensions set into play a crash course in the pressures on the Berlin police force and its top brass, as well as the attitudes and methods of Rath's corrupt supervisor, Bruno Wolter. Kutscher's literary narrator provides measured details about Social Democratic Police Commissioner Karl Zörgiebel's contested protest ban, the concentration of violence in working-class neighborhoods, and inconsistency in partisan reporting on casualties—all processed in the third-person through the perspective of the hard-boiled protagonist.

By contrast, the first two seasons of *BB* employ Blood May to propel the story's affective build. Presented through informative captions, backstory packaged as dialogue, reenactments enhanced by CGI, second-hand radio reporting, and remediated archival footage, the May Day subplot does more than provide a narrative fulcrum or set of obstacles to overcome; it also penetrates, externalizes, and binds the inner experiences of a range of characters. The momentum of emotions and historical events is especially palpable in season two, episode three when Greta Overbeck (friend to police stenotypist and aspiring detective, Charlotte [Lotte] Ritter) and her love-interest (whom she knows as "Fritz," a purported Communist) visit a movie house playing newsreels before the feature film *People on Sunday*. This scene of scripted sentimentalism precedes by several episodes the revelation that "Fritz" is a right-wing agitator preying on Greta's naiveté to gain access to her employer August Benda, a high-ranking Jewish Social Democratic federal official (whose characterization Darcy Buerkle analyzes in this volume). As I have argued elsewhere, this layering of an intimate exchange with historical visual material illustrates the complex relationship between mass culture, politics, and feelings in the day-to-day of the late 1920s.[2] The scene points to a relationship across various episodes, between the domestic servant's hopes for a connection in an otherwise alienating Berlin; Stephan Jänicke's home life with his deaf parents to whom he poignantly narrates a radio report on May Day preparations; Rath's post-traumatic stress response when dodging fire in the hot zones; and two female bystanders being killed by police bullets in a plot point that weaves Dr. Völcker into Lotte's mother's maudlin death. In the movie house scene, that confluence is supported by historical film material, generating what Jaimie Baron theorizes as "the archive effect" characteristic of the appropriation film.[3]

Anxious Images

In both *Der nasse Fisch* and the first season of *BB*, anxiety around the democratization and pluralization of the cinematic image relays primarily through a storyline about the illicit production of pornography. Historically, a parallel struggle was taking place in the realm of newsreel, actuality, and political image-making. Weimar-era law enforcement gained unprecedented access to the technology to create and circulate images of its work and the state it served while also becoming increasingly concerned that filmmakers across the political spectrum could afford equipment to document and remediate public events. As historian Molly Loberg characterizes the period, "the policing of crowds became

far more complicated because the urban geography of politics changed with new legal freedoms."[4] The right to assemble guaranteed by Article 123 of the Weimar Constitution and the wider availability of reliable, portable movie cameras generated new tensions around the mass mediation of marches, demonstrations, parades, street occupations, and riots.

Related questions of police violence, state and party power, and the force of the recorded image count among parallels that some commentators (including Buerkle in this volume) have drawn between *BB*'s version of Weimar and our own moment.[5] Yet, as Buerkle and other contributors to the forum on the series in a 2020 issue of *Central European History* note, the more closely one examines the details of Weimar history, the more such comparisons lend themselves to critique.[6] As Julia Sneeringer asserts, it is important not to lose sight of the specificity of 1929 in the spell of, in today's parlance, the series' "relatability."[7] Paul Lerner further contends that we are justified in interrogating the misrepresentation of history or the commercial priorities of a culture industry that draws on the historical audio-visual record for fictional fodder.[8] When read in dialogue with these assertions, Baron's model of the appropriation film offers a vocabulary for taking stock of *BB*'s citational practices and their potential "to transcend reified notions about our relationship to the past."[9] It opens up a reading of the movie house scene between Greta and Fritz that points beyond historical referentiality—one that hinges on the kind of extratextual knowledge involving, in Baron's words, the "complex matrix of theoretical, social and technological concerns" from which the appropriated footage emerged.[10] Here this matrix includes the newsreels and agitprop films mobilized in the partisan leadership struggle during the second half of the 1920s.

Archival Appropriation

The May Day scenes that *BB*'s spectators watch along with Greta and Fritz derive from a source documented under a range of titles, including *Blutmai 1929* (Blood May 1929); *Berlin am 1. Mai 1929* (Berlin on May 1, 1929); *Der 1. Mai 1929 in Berlin* (May 1, 1929 in Berlin); *Kampfmai 1929* (Battle May 1929); and *1. Mai—Weltfeiertag der Arbeiterklasse* (May 1—World Holiday of the Working Class).[11] Produced by Willi Münzenberg for Filmkartell Weltfilm GmbH and directed and edited by Piel (Phil) Jutzi, the original footage was recorded for explicitly political purposes.[12] *BB* dramatically scripts its action as suspenseful reenactment in the scenes in season one, episode four involving Rath and Wolter and then integrates ten seconds' worth of its images into the movie-house scene. In so doing, *BB* strips

away signs of this genesis, instead assigning the images the markers of a corporate newsreel via faux title cards rendering "Messter," the name of the main company producing newsreels in the period, as the fictionalized "Meesler-Film." Its shots of the clashes between police and protesters follow a conservatively inflected intertitle reading "Communist Unrest on May 1. The violence escalates." What unfolds retains (and possibly exaggerates through digital means) the graininess and variable lighting of an on-the-ground witness account.

The sequence synergizes with other period clips the series appropriates, reenacts, or quotes visually, several of which were highlighted in early reviews of season one, and which also come up in this volume.[13] Yet it is distinct in the way it signals that the events represented were not scripted for this production. Despite the smooth edges and crispness afforded by twenty-first-century expert technicians working with top-of-the-line software, *BB*'s faux newsreel retains the sense of having come from a different time with a different purpose, embodying what Baron defines as the archive effect's component gestures of temporal and intentional disparity. The scene's freneticism and urgency make it hard for the viewer not to wonder about the details of the images and why they were recorded in the first place. The appropriated footage thus bears what Baron refers to as a "sense of 'something else'—of a document intended for other purposes," which she argues "undermines the establishment of any singular or definitive meaning for these sounds and images recorded in the past."[14] It issues a tangible reminder of history existing in tension with the creative license taken by the show's creators, which allows it to exceed its function in the character-centered plot and to generate a stirring conception of the past and, in Baron's words, "ultimately, of history itself."[15] The result is a noteworthy but ambivalent form of historical consciousness.

Blood May

Operating both iconically (as broadly and conceptually representative) and indexically (as historical evidence), the May Day subplot and the faux newsreel compress the protracted lead-up to and fall-out of this prominent event, primarily to serve the interpersonal drama. Blood May traces to a time when the fictional Rath would still have been in Cologne. On December 13, 1928, Zörgiebel instituted a *Demonstrationsverbot* (ban on open air meetings and marches) in Berlin, arguing that such gatherings posed an immediate threat to public security. As Loberg notes, between 1921 and 1933 he invoked thirty-six times and for as long as up to six months at a time the second

paragraph of the constitution's Article 123, which "qualified that authorities could require these gatherings to register in advance and ban them if they presented 'an immediate danger to public security.'"[16] Complementing this power, Article 48 infamously allowed German presidents to limit or suspend basic freedoms such as the right to assemble upon the declaration of a state of emergency.

BB elides numerous turning points on that timeline.[17] An earlier suspension of emergency restrictions on public assembly was lifted in 1925, leading to a rise in demonstrations. Further actions arose in Spring 1926 when the Communists called for a ballot initiative to determine finally whether the nation's former aristocrats should be dispossessed of their inherited property, staging marches that brought central Berlin traffic to a halt. Violent confrontations with National Socialists took place during a Social Democratic Party (SPD) march on November 11, 1926. National Socialist Party (NSDAP) and Communist Party (KPD) paramilitary units fought a bloody street battle on March 19, 1927. Clashes between police and Communist demonstrators around the elections in May 1928 led to injuries and the deaths of some protestors. Gaining new ground in those elections, the KPD separated further from the ruling Social Democrats. In the meantime, the NSDAP and its suborganizations were denied the right to assemble or demonstrate for almost a year on the grounds that they had been rioting in excess.

In part blaming the press for inflaming partisanship and violence, Zörgiebel remained convinced that police could regain public order by instituting a general ban on open-air demonstrations from December 1928 through June 1929. Communists took this to be directed at preventing their memorial rallies at the graves of Karl Liebknecht and Rosa Luxemburg on May 1, a national holiday they noted was instituted by the SPD. KPD leaders decided in early 1929 to proceed with their planned activities, using newspaper headlines in *Die Rote Fahne*, signs posted around left-wing strongholds in Berlin, and word of mouth to rally sympathizers to the streets. In March, Prussian Minister of the Interior Albert Grzesinski and Commissioner Zörgiebel issued a final warning that police would use whatever means necessary against demonstrators. The city's 14,000 officers were mobilized for a full-scale public emergency and ordered to keep the streets clear under all circumstances. Whereas earlier street fighting had mostly pitted the left against the extreme right, the SPD's attempt to arbitrate those conflicts and prevent a further rise in the tide of the Communist movement resulted in a blow that shattered the already brittle relationship between the two sides of the left. As is hinted around the edges of the drama in *BB*, bitter debates and recriminations began in the newspapers and the Reichstag.

Fighting ended midday on May 4 when Zörgiebel commanded officers to fire only when an opponent was visible, cease shooting into windows, and avoid excessive force. By the time fighting stopped, 13,000 police officers had been deployed, 33 demonstrators killed, and 198 demonstrators harmed. Forty-seven policemen had been injured, only one by a gunshot wound. Ten of the civilian victims standing up and away from the action on balconies or inside apartments were killed, and only one victim was proven to be a member of the Communist party. In the wake of the conflict, Reich Minister of the Interior Carl Severing and Grzesinski agreed to ban *Die Rote Fahne* as a punishment for purported Communist instigation and a measure preventing further incitements. Police and press outlets sympathetic to the SPD explained discrepancies in emerging statistics on civilian versus police casualties with sensationalized descriptions of the arms and actions of the Communist demonstrators. When medical examiners found that all bullets extracted from the day's dead derived from police weapons, Police Commander Magnus Heimannsberg and Police Vice-President Bernhard Weiss (who partially informs the character of August Benda, head of the Political Police in *BB*, as is foregrounded by Buerkle in this volume) decided it would be inappropriate to publish the results. Law enforcement publications made only technical references to the actions without much acknowledgment of civilian losses.

A View from the Left

Numerous camera operators were on the scene during the May Day events, and within months both the National Socialists and the Communists produced films justifying their street actions. An example from the right can be found in *Kampf um Berlin* (The Battle for Berlin), a fragment of which survives at the Deutsche Kinemathek in Berlin.[18] The KPD sent its own team, including cinematographer Erich Heintze and members of the Worker's Union of Photographers, to the streets. As sketched out above, they worked under the direction of Jutzi, who had joined forces with the Communist film company Welt-Film as a newsreel camera man, purportedly recording events during the Kapp-Putsch in 1920 and going on to make some of the most important Weimar films about workers and the proletarian milieu with the Prometheus Film Company, including *Mother Krause's Journey to Happiness* (1929) and *Berlin Alexanderplatz* (1931).[19] Eventually dissatisfied with the Communist party, he joined the NSDAP in 1933 and died in poverty in 1945.[20]

According to a retrospective account of Blood May from 1931 in *Die Rote Fahne*, Jutzi's team positioned itself in trains, on the streets, at windows, and atop roofs around the KPD headquarters on Bülowplatz.[21] The resulting footage appeared under a variety of titles (including those listed above), all produced by Münzenberg as leading propagandist for the KPD. On June 5, 1929, censors approved for release the one-act, 335-meter version called *1. Mai—Weltfeiertag der Arbeiterklasse* (The First of May—World Holiday of the Working Classes).[22] A 222-meter film entitled alternately *Blutmai 1929* (Blood May 1929) or *Die Kämpfe im Mai 1929* (The Battles in May 1929) reconstructed from two incomplete prints and title cards from the archives of the former GDR also survives in the Deutsche Kinemathek.[23] And while the latter does not for certain represent exactly what a late Weimar audience would have seen, it does provide a view into the Communist perspective on the most infamous police operation of the period and illustrate the role that film played in bringing it to wider audiences.

Drawing on these origins, the film seen by the fictional audience in *BB* is only ten-seconds long, starting with the above-cited intertitle presenting the action as Communist (i.e., not police) violence and edited to play to the series' focus on the right-wing threat. A *BB* viewer focused on Greta and Fritz might see the footage as simply providing background evidence of local partisan conflict. It is unclear whether they pay attention to the images or words that roll while they find their seats (Figure 10.1). The sequence appears mostly to underscore that

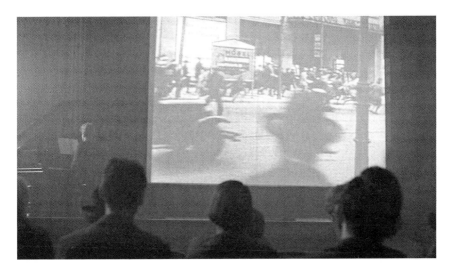

Figure 10.1 Footage of *Blutmai* plays while Greta and "Fritz" find their seats. Screenshot, *Babylon Berlin* (S2, E3).

Greta is more interested in being with Fritz than in politics—to catastrophic results for both her and her employer's family, who die in a bomb that Greta is convinced to place in Benda's desk when she is deceived into thinking that the police have killed Fritz. Preparing the audience for that event, *BB*'s editors evacuate the historical footage of its original left-wing rhetorical emphases in favor of a more easily perceptible sense of chaos and disorder that the Center and Right (which Jutzi would himself end up joining) will then blame on the Left. This then sets up an emotional logic that helps explain how Greta could fall for a Nazi.

A close look at the source material reveals the complexity and nuance of this act of appropriation, which includes a combination of recontextualization, resignification, and elision. The archival film *Blood May 1929/The Battles in May 1929* opens with indications of the ways the KPD called workers to the streets: messages hand-scrawled on walls; a sign outside the party headquarters, the Karl-Liebknecht-Haus; and a headline on the front page of *Die Rote Fahne*. Armed officers stop and frisk civilian pedestrians. A newspaper headline fills the screen, announcing that police have placed thousands of officers at the ready to fulfill their duty to maintain peace and order. Tension mounts as an intertitle recounts, "There, where the demonstrators assembled, hundreds of heavily armed officers appeared on trucks." Shots of copious transport vehicles cut between street-level and above.

It is here that the source material and its appropriation diverge. The portions of footage included in *BB* are bolded below for the purposes of comparison and contrast (*BB* leaves out the portions not in bold). **Pans following officers running down the street convey increasing momentum. Dynamic cuts that create tension and a slight sense of disorientation alternate with matches-on-motion that demonstrate the breadth of police action. A long shot across an open square shows a mass running, then turning back, chased by a yet-unseen threat.** A police vehicle enters the frame from the bottom left in a tight shot that cuts quickly to a bird's-eye view of a crowded street. In a parallel scene, a patrolman confronts a lone pedestrian, directing him to move along. When the man does not respond quickly, the officer pushes him forcefully. **Mounted officers and vehicles loaded with troops continue to enter the streets where civilians gather. Each shot includes a pack on foot, running in from the scene of a previous shot. The masses are swelling, not because they are assembling to demonstrate, but because they are being corralled chaotically from one area to the next.**

An intertitle indicates that police violence is escalating, "The uniformed police struck not only demonstrators but also uninvolved passers-by." A few

people walking down a cobblestone street are taken by surprise as police strike those running by. Medium shots and close-ups display men under arrest—men who bear no pamphlets, protest signs, or weapons. A sequence showing shooting victims precedes one documenting the erection of barricades out of boards, stones, bricks, tree branches, sawed-off streetlamps, and advertising columns. A series of medium shots and close-ups shows upper-story windows riddled with bullet holes. Newspaper headlines dated May 2 overlay the screen, surveying divergent perspectives on the question of who was brutalizing whom the day before. The film closes with a funeral march as Communists honor their dead and bring them to their graves. The final intertitle adjures, "Wake up, damned of this earth," citing the first line of the "International."[24]

Reactionary versus Reflective Nostalgia

The series thus takes advantage of the availability of archival footage to inform—but only partially so. It also uses it to generate emotions and sensations such as tension, immediacy, sympathy, guilt, vulnerability, anxiety, arousal, confusion, regret, and shame in the characters and viewers following their stories. Although *BB*'s general audiences are unlikely to register differences in content, tone, and purpose (which require familiarity with the archival material), they will sense the historicity of the footage due to the formal qualities detailed above. Some might also recognize the images, thanks to the frequency with which they have been used in television documentaries on Weimar history. But rather than reaffirming established historical knowledge, this approach to remediating and reformatting aligns with the model of appropriation films that, as Baron argues, engages:

> [D]irectly with the fragmentary nature of the archive to produce a sense of the "presence" of history rather than its meaning. Indeed, by deploying archival documents as metonymic fragments without fully explaining them or fitting them into a coherent, causal narrative, these films evoke our desire for an affective encounter with the past that cannot be reduced to a desire for meaning. Moreover, these films reveal the fact that our desire for the presence of history is always accompanied by our recognition of its absence and the loss incurred through the passage of time and change. This aspect of the "archive effect" is inextricable from nostalgia.[25]

Baron goes on to explain that this "may either be a 'reactionary' nostalgia that seeks to restore an idealized past that never existed or a 'reflective' nostalgia—a self-conscious awareness of the longing that points to the gaps in the archive and informs the relationship between past and present."[26]

Critics of *BB* tend to see more of the former, especially in its implication that few could have sensed the horrors to come. They find in *BB* a narrative that draws on and feeds what Mila Ganeva has identified as Weimar's mythologization of itself.[27] Indeed, the appropriation, recontextualization, and truncation of the footage risks perpetuating a dynamic wherein the potential of class-based collective political action promoted at the time by Jutzi and Münzenberg is subsumed under the kinds of private and individual concerns that tend to be the focal point of genres that Hester Baer has argued uphold neoliberal value systems.[28] These include but are not limited to German heritage cinema that trades in conservative nostalgia and conciliatory narratives that normalize the past, a dynamic addressed in Ganeva's contribution to this volume.[29]

As Veronika Fuechtner points out, early in the series' reception German critics faulted its artificial, almost quaint, Heinrich-Zille-esque portrayal of poverty and the working-class milieu, which Adrian Daub describes in his review in the *New Republic* as "poor but sexy."[30] On the level of narrative, this aesthetic maps onto the victimization or exploitation of working-class female characters. The origins of antisemitism and the impending genocide are barely alluded to in brief dialogue and are only loosely implied in the murder of Benda (points raised by Jill Suzanne Smith and Buerkle). And, as Buerkle also rightly observes, the role of Nazi violence in the Blood May deaths and the important contributions of Jewish attorneys in the subsequent legal proceedings receive no mention at all.[31]

Conflating the genres of newsreel and agitprop film and evacuating the archival footage of its political origins and its material history—including its participation in a struggle between political parties, extra-parliamentary opposition, street-level activists, and the political and police establishment—does threaten to depoliticize the source material and foreclose the spectator's curiosity about such matters as antisemitism, gendered violence, and complex class politics. Yet Baron's model of textual signification and reception asks us to consider the possibility of a critical response on the part of the spectator, one of reflective rather than reactionary nostalgia. Here her concept of intentional disparity is apposite. Although the digital artistry of the movie house scene skillfully represses the markers of intentional disparity, it does not fully eliminate what Baron describes as "the resistance of these documents to their new textual context."[32] The difference between the unfocused black-and-white footage and its vivid, full-color diegetic context augments the temporal disparity of *BB* and points to the fact that these images tell the televisual audience something Greta does not want to or cannot yet know, namely just how sinister the tactics

of the far right were and how grave the costs of inattention can be. Framing subtly cues the viewer to notice that Greta and Fritz pay little to no attention to what is being shown full-screen to the twenty-first-century audience, thereby fostering a double consciousness and awareness that "the contexts in which we live are subject to change and are neither universal nor permanent."[33] The archive effect thus contributes to the series' rejection of standard teleological treatments of the Weimar period as nothing more than a march toward Hitler. Instead it explores with complexity and ambivalence, as Fuechtner notes, whether the Left is impotent in the face of political opportunism and its role in the rise of the Right.[34]

Cameras and the Police

A view into contemporaneous debates in the realm of non-fiction filmmaking reveals oppositional valences contributing to this ambivalence. In May 1929, *Film-Atelier*, a publication for technical professionals, printed a short but powerful front-page article headlined "Police Against Camera Operators."[35] It charged not only that police had impeded the work of cinematographers during the uprisings, but also that several officers handled newsreel photographers with excessive force when arresting them. *Film-Atelier*'s editors suggested that the camera operators' union, Dacho, take immediate action. The piece ended with the foreboding conclusion that "There is no other country in the world where newsreel reporting is presented with as many obstacles as in Germany."

A 1930 piece entitled "Recordings in Public Spaces" in the same venue charged that police were making it more difficult for movie producers to get the required permission to record in public buildings or open spaces such as parks.[36] Its author encouraged filmmakers to remind anyone who challenged them of a November 1927 memorandum issued by the Prussian Ministry of the Interior (Runderlass des Ministerium des Innerns vom 19.11.27/II D 1476) upholding that the police were there to facilitate, not hinder, the work of the film industry. It decreed that no one should place barriers in the way of these visual reporters, especially when shooting current events, and that only police business or difficult traffic conditions warranted limitations on press access. In the view of critics outside law enforcement, including newsreel photographers, state authorities aimed to monopolize the right to represent interactions between the police and the public on film.

A mid-1930 issue of the *Deutsches Polizei-Archiv* represented a contrasting viewpoint from a Police Major Henrici of Düsseldorf.[37] His long-form article

on the photographic representation of law enforcement argued that, whereas photos of encounters and clashes between police and protestors used to be taken primarily for illustrated newspapers, representatives of certain "party organizations working against the state and authority" were now bringing cameras to such scenes to capture incriminating images of police in order to hound them with threats of blackmail or lawsuits and to coerce officials into firing officers or stepping down themselves. According to the author, many of these images distorted and misrepresented encounters between officers and civilians. He asked, must police officers be subject to photography or recording without their permission or knowledge? Did the legal means exist to challenge what he considered to be an egregious imposition on officers' constitutionally protected right to personal liberty? Certainly, he argued, anyone who came to the scene for the purpose of collecting evidence of police misconduct was guilty of interfering with official police business. The author encouraged authorities to take stricter measures to remove photographers and cinematographers not affiliated with approved news organizations from public disturbances or to confiscate their film, or both. The power of moving images as a form of evidentiary documentation and authoritative argumentation was at stake in 1929, which makes the televisual appropriation of the Blood May footage in *BB* all the more evocative.

Conclusion

The mode of spectatorship engendered by the archive effect invites historical interest in the source material. Through a visual dialecticism engendered by traversing media formats and temporalities, *BB* retains the potential to promote the kind of spectatorial, interpretive, and historical agency that, as shown in the essays in Robert Sklar's and Charles Musser's volume *Resisting Images*, can "overcome the ideological intentions of conventional texts" and offer "resistance to a hegemonic cinema."[38] For, as Baron writes, through their tangibility the archival images:

> [S]eem "closer" to the past they represent and are potentially seductive in their seeming transparent textuality; and although every trace, written or otherwise, is open to interpretation, indexical audiovisual recordings are especially resistant to full comprehension or interpretation [...]. Indeed, archives and the indexical traces they preserve often escape the control of the archons as well as the historians and filmmakers who use them. These traces mean subversively more than we might intend or wish—or subversively less.[39]

Despite the series' overarching logic of selective historical representation and the seamless way in which the sequence studied here remasters archival source material, the latter's energy and urgency pique spectatorial curiosity. Furthermore, the aesthetic of temporal and intentional disparity generates an awareness of the historicity of the image, even where diegetic integration and digital rendering might seek, in Sklar and Musser's words, to strip "texts or practices of their status as oppositional work in their original historical setting."[40] Together these effects fissure the text.

Contextual documentation allows us to look at and through those fissures to discover additional layers of *BB*'s engagement with cinema, not only as a constitutive facet of the art and entertainment side of Weimar culture, but also as a contested tool in policing the capital city and in awakening political consciousness in spectators such as those fictionalized in the series. The case of *Blutmai* demonstrates that the more diverse our exposure to the breadth and depth of Weimar film history beyond the classics, the more equipped we are to understand and evaluate *BB*'s evocation of a combination of emotional and historical consciousness. Paracinematic texts reveal how Jutzi's work existed in tension with other non-fiction film practices at that time. Close reading underscores that the purposiveness and indexicality associated with the historically specific source material should not be mistaken for textual stability. Placed in the context of a plot that offers little in the way of narrative resolution, clear moral judgments, or affirmative rewards for its characters, the archive effect contributes to the sense that historical outcomes are not foregone conclusions.[41] Just as characters in the series were historical subjects, so too are those who watch the series. By generating the archive effect, *BB* presents the viewer with an ambivalent reminder of both the burden and hope of historical possibility.

Notes

1 Volker Kutscher, *Der nasse Fisch* (Cologne: Kiepenheuer & Witsch, 2007).

2 Sara F. Hall, "Babylon Berlin: Pastiching Weimar Cinema," *Communications* 44, no. 3 (2019): 313.

3 Jaimie Baron, *The Archive Effect: Found Footage and the Audiovisual Experience of History* (New York: Routledge, 2014).

4 Molly Loberg, *The Struggle for the Streets of Berlin: Politics, Consumption, and Urban Space 1914–1945* (Cambridge: Cambridge University Press, 2018), 136.

5 Emily St. James, "Cop Shows Won't Just Disappear. How Can We Reinvent Them?" *Vox*, June 11, 2020, https://www.vox.com/culture/2020/6/11/21284719/cop-shows-canceled-the-wire-babylon-berlin.

6 Veronika Fuechtner and Paul Lerner, eds., "Forum: *Babylon Berlin*: Media, Spectacle and History," *Central European History* 53, no. 4 (2020): 837–44.

7 Sneeringer in "Forum," ed. Fuechtner and Lerner, 841.

8 Lerner in "Forum," ed. Fuechtner and Lerner, 849–50.

9 Baron, *The Archive Effect*, 10.

10 Ibid., 11.

11 For a view into these images, see the 37-second *Blutmai* film referred to as "raw footage" provided by the *Bundesarchiv-Filmarchiv*, which appears on the website of the United States Holocaust Memorial Museum without a specific title. "Film of Police Responding to Demonstrations in Berlin," *Experiencing History: Holocaust Sources in Context. German Police and the Nazi Regime*, https://perspectives.ushmm.org/item/film-of-police-responding-to-demonstrations-in-berlin.

12 Anton Kaes, "*Blutmai 1929 (Kampfmai 1929)*," *El Giornate del Cinema Muto: Prog. 3 The Social Question*, http://www.giornatedelcinemamuto.it/en/weimar-prog–3/.

13 Noah Isenberg, "Voluptuous Panic," *New York Review of Books, NYR Daily*, April 20, 2018, https://www.nybooks.com/daily/2018/04/28/voluptuous-panic/.

14 Baron, *The Archive Effect*, 25.

15 Ibid., 7–8.

16 Loberg, *The Struggle*, 137–8.

17 On the events of Blood May, see Chris Bowlby, "Blutmai 1929: Police, Parties and Proletarians in a Berlin Confrontation," *The Historical Journal* 29, no. 1 (1986): 137–58; Peter Leßmann-Faust, "'Blood May': The Case of Berlin 1929," in *Patterns of Provocation: Police and Public Disorder*, ed. Richard Bessel and Clive Emsley (New York: Berghahn, 2002): 11–27; Hsi-Huey Liang, *The Berlin Police Force in the Weimar Republic* (Berkeley: University of California Press, 1970), 106–9; and Loberg, *The Struggle*, 147–8.

18 *Kampf um Berlin* (1928/9; Berlin: Filmhaus Sage/Willi Sage/NSDAP).

19 Gertrud Kühn, Karl Tümmler, and Walter Wimmer, eds., *Film und revolutionäre Arbeiterbewegung in Deutschland 1918–1932. Dokumente und Materialien zur Entwicklung der Filmpolitik der revolutionären Arbeiterbewegung und zu den Anfängen sozialistischer Filmkunst in Deutschland*, vol. 2 (Berlin: Henschelverlag, 1975), 507; Peter Jelavich, *Berlin Alexanderplatz: Radio, Film, and the Death of Weimar Culture* (Berkeley: University of California Press, 2006), 201–19; Helmut Korte, ed., *Film und Realität in der Weimarer Republik* (Munich: Fischer, 1980), 163.

20 Kaes, "*Blutmai 1929 (Kampfmai 1929)*."

21 Ralf Forster, "Das Berliner Scheunenviertel. Dokumente aus sechzig Jahren Kiezgeschichte (1920–1980)," *Filmblatt* 7, no. 18 (2002): 39 fn. 1; Kaes, "*Blutmai 1929 (Kampfmai 1929)*."

22 Phil Jutzi, *1. Mai—Weltfeiertag der Arbeiterklasse* (Berlin: Film-Kartell Weltfilm Gmbh, 1929).

23 Phil Jutzi, *Blutmai* (Berlin: Filmkartell Weltfilm Gmbh, 1929).

24 Kaes, "*Blutmai 1929 (Kampfmai 1929)*."

25 Baron, *The Archive Effect*, 13.

26 Ibid.

27 Ganeva in "Forum," ed. Fuechtner and Lerner, 838.

28 Hester Baer, *German Cinema in the Age of Neoliberalism* (Amsterdam: Amsterdam University Press, 2021).

29 Lutz Koepnick, "'Amerika gibt's überhaupt nicht': Notes on the German Heritage Film," in *German Pop Culture: How American Is It?*, ed. Agnes C. Mueller (Ann Arbor: University of Michigan Press, 2004), 191–208.

30 Fuechnter and Lerner, "Forum," 835; Adrian Daub, "What *Babylon Berlin* Sees in the Weimar Republic," *The New Republic*, February 14, 2018, https://newrepublic. com/article/147053/babylon-berlin-sees-weimar-republic.

31 Smith and Buerkle in "Forum," ed. Fuechtner and Lerner, 839; 843–4.

32 Baron, *The Archive Effect*, 26.

33 Ibid., 9.

34 Fuechnter in "Forum," ed. Fuechtner and Lerner, 842.

35 "Polizei gegen Kameraleute," *Film-Atelier. Die Zeitung für den Produktions-Fachmann* 3 (1929).

36 "Aufnahmen auf öffentlichen Plätzen," *Film-Atelier. Die Zeitung für den Produktions-Fachmann*, 8 (April 1930).

37 Polizeihauptmann Henrici, "Die photographierte Polizeiliche Amtshandlung," *Deutsches Polizei-Archiv* 9, no. 22 (1930): 344–6.

38 Charles Musser and Robert Sklar, "Introduction," in *Resisting Images: Essays on Cinema and History*, ed. Sklar and Musser (Philadelphia: Temple University Press, 1990), 3–11.

39 Baron, *The Archive Effect*, 4.

40 Musser and Sklar, "Introduction," 5.

41 Hester Baer and Jill Suzanne Smith, "Babylon Berlin: Weimar-Era Culture and History as Global Spectacle," *Europe Now* 43 (2021), https://www.europenowjournal.org/2021/09/13/babylon-berlin-weimar-era-culture-and-history-as-global-media-spectacle/.

Glitter and Post-Punk Doom: *Babylon Berlin* through the Lens of 1980s' West Berlin

Julia Sneeringer

Filmmakers create visions of Weimar Berlin that reflect their own sensibilities and positionality.[1] The makers of *I Am a Camera* (1955), for example, pushed against 1950s' heteronormative domesticity, scandalizing censors by broaching the topics of abortion and female promiscuity, even as they erased Christopher Isherwood's homosexuality.[2] Bob Fosse's take on Isherwood's stories, *Cabaret* (1972), mirrored post-1968 theatrical and sexual politics with its Brechtian touches and bisexual love triangle. With *Berlin Alexanderplatz* (1980), R. W. Fassbinder blended New German Cinema aesthetics with melodramatic staging to explore the emotional states of his alter-ego Franz Biberkopf. Berlin itself was merely suggested through lighting and tight shots on prewar buildings, as Fassbinder had little interest in creating a simulacrum of the city.

Whose Weimar is *Babylon Berlin*? On one level, the series reflects our current age of binge-watchable blockbusters, CGI, and audience demands for visual realism. Its producers have gone to great lengths to fashion a historically realistic rendering, down to the vintage textiles that affect how the actors move (unlike the cosplay feel of the aforementioned films).[3] However, the work jettisons accuracy at key points. The Moka Efti scenes, for example, resemble techno culture.[4] A less remarked-upon set of allusions draws on the 1980s. This essay posits that *BB* is a fantasy of late Weimar filtered through West Berlin in the long 1980s. Those "long 1980s" span the late 1970s—characterized by the exhaustion of postwar optimism, revived Cold War tensions, punk's arrival, and new debates around multiculturalism—to the fall of the Berlin Wall. Living in West (and in Henk Handloegten's case, East) Berlin, the series' creators witnessed the particular Weimar nostalgia of that place and time, such as the rediscovery of Irmgard Keun's New Woman novels. AIDS activism awakened

interest in 1920s' gay Berlin. *BB*'s creators encountered Berlin's post-punk scene. And they experienced gray, divided Berlin, whose Potsdamer Platz ruins were a blank screen on which to project fantasies of the Golden Twenties.

Director Achim von Borries's declaration that he and his collaborators "wanted to make a film about … the Berlin that we know"[5] begs the question, *which* Berlin? To my knowledge, none of *BB*'s creators cites 1980s' Berlin as a particular source of inspiration. But attention to the contexts that shape artists can yield new insights into their work, so what can we learn about *BB* by viewing it through this particular lens? *BB* subtly draws on 1980s' West Berlin as source culture to create a distinctive portrait of the Weimar-era city. It participates in an ongoing reassessment of what constitutes German cultural heritage by showcasing a subcultural tradition familiar to fans of post-punk, industrial, and goth, for whom 1980s' West Berlin was a spiritual capital.[6] That helps explain, for example, how allusions to Josephine Baker and Kraftwerk collide in *BB*. This 1980s' filter is most visible in *BB*'s use of music and dance. *BB* displays an ease with genre mashups, pastiche, and bricolage, a collage practice associated with punk.[7] It transcends simple nostalgia by linking "poor but sexy" Weimar to poor, sexy, and divided Berlin.[8] Ironically, in eschewing one form of nostalgia, *BB* participates in another for the walled city.

Filmmakers Made in West Berlin

Defining generations historically and artistically is tricky, but the biographies of *BB*'s creators—Tom Tykwer, Handloegten, Borries, and Johnny Klimek—bear enough similarities that it can be fruitful to consider the traces their personal trajectories have left on the series.[9] Born in the 1960s, each built a career in the 1990s, with Tykwer becoming the face of post-unification German cinema with the international success of *Run Lola Run* (1998). In the 1980s they lived in ungentrified West Berlin with its palimpsests of life before the Wall. For these sons of the comfortable West, Berlin became a zone of discovery subsidized by cheap rent. The East was still fascinatingly Other, another place where Germany's history was visible, offering more fertile ground for fantasizing about Berlin's pasts.

Tykwer's biography offers clues to West Berlin's impact on his development. Born in 1965 in Wuppertal, he regularly pilgrimaged as a teenager to Berlin's repertory cinemas (*Programmkinos*), which exposed him to film history as well as newer auteurs like Fassbinder and Martin Scorsese.[10] In 1985, he moved to

West Berlin and landed a job at Kreuzberg's Moviemento; by the late 1980s, he was a house programmer, which funded his existence until the box-office success of *Run Lola Run*. There he programmed double features and cult favorites for receptive moviegoers. Cheap tickets, uncomfortable apartments, and minimal competition from television made gathering at cinemas an important leisure practice for young Berliners.[11] On Sundays Tykwer hosted breakfasts at Moviemento, bringing together filmmakers such as Dani Levy and Rosa von Praunheim. Reminiscing about these years, Tykwer called Berlin a cineaste's dream where one could experience cinema "embedded in film-historical contexts."[12]

Programmkino culture also shaped Handloegten, who managed Kreuzberg's Eiszeit-Kino. Born in 1968, Handloegten spent his teenage years in East Berlin due to his father's job at the Federal Republic's diplomatic mission in the GDR. He crossed Checkpoint Charlie daily to attend school or make phone calls in the West. He explored how the Wall cut through the city, as well as the East, unlike other West Berliners who were famously indifferent to what lay on the other side. (Handloegten recalls announcing news of the Wall's opening in 1989 to Eiszeit-Kino patrons, who responded with a collective shrug.[13]) An interest in Berlin's pasts marks his early work. He contributed to the *Good Bye, Lenin!* (2003) screenplay[14] and also wrote two films set in the 1980s, *Paul is Dead* (2000) and *Learning to Lie* (2003).

Handloegten's Berlin years also fueled a fascination with Weimar, an interest shared with fellow film student Borries. Born in 1968 in Munich, Borries came to West Berlin to study history and philosophy before switching to film school. He and Handloegten co-wrote *Love in Thoughts* (2004) about the 1927 Steglitz "student tragedy," a tale of teen sex and suicide. That film was produced by X-Filme Creative Pool, founded by Tykwer, Levy, Wolfgang Becker, and Sputnik-Kino programmer Stefan Arndt.[15] Hatched during those Kreuzberg breakfasts, X-Filme nurtured other Weimar-themed projects, culminating in *BB*.

Eighties' West Berlin witnessed a wave of Weimar culture revivalism. Marlene Dietrich's rehabilitation as Berlin icon was boosted by Maximilian Schell's 1984 documentary *Marlene*.[16] The Deutsche Kinemathek mounted exhibitions on Weimar film and the UFA studios, while "Film—Stadt—Kino—Berlin" was a marquee exhibit of the city's 750th birthday celebrations.[17] High-profile exhibitions at the Martin-Gropius-Bau—"Berlin Berlin" (1987) and "Stationen der Moderne" (1988)—equated Berlin culture with Weimar's avant-garde.[18] Elefanten Press published popular illustrated books on the New Woman and artists like John Heartfield, while Weimar's best-selling pop group, the

Comedian Harmonists, was rediscovered through reissues and a documentary.[19] Expressionist dancer Valeska Gert became lionized by Berlin's post-punk avant-garde, the Brilliant Dillettantes [sic], who took their name from Dadaist Kurt Schwitters.[20] When Tykwer gushed about experiencing film in 1980s' Berlin "embedded in film-historical contexts," this is the cultural constellation being referenced.

But Weimar's legacy could also feel oppressive. Myths of Weimar decadence hung over Berlin nightlife for decades.[21] Commentators frequently depicted Berlin as a city of ghosts and voids.[22] Talk of Weimar conjured up Germany's descent into Nazism and Europe's subsequent division. That division made daily life in West Berlin burdensome; many who could leave did. American expatriate Paul Hockenos recalls the city's primitive housing, "deeply grey winters, and front-line claustrophobia," which fed a "dark, misanthropic, end-of-the-world mindset."[23] This mirrored anxieties over nuclear war and dying forests that gripped 1980s' West Germany.[24] Allied military exercises frequently reminded Berliners that they were surrounded. To keep Berlin populated and offset the psychic cost of living on the Cold War's front lines, Bonn annually sent millions in budgetary support, tax benefits, and wage subsidies.[25] With conservatism ascendant under Helmut Kohl, West Berlin now appeared a troublesome "site of dissent and difference, home to a large and growing group of countercultural activists and foreign immigrants."[26] An unspoken divide ran through this half of the walled city: on one side were the unspectacular working residents who dominated its daytime face. On the other were those CDU mayor Eberhard Diepgen dubbed "anti-Berliners": freaks, punks, greens, conscientious objectors, queer people, and squatters.[27]

In the 1980s, these "anti-Berliners" conquered the city's image in the pop culture imagination (the 1981 cult film *Christiane F.* is paradigmatic in this regard). West Berlin attracted exiles from across the Wall and across the world, from West German military service and the straight life in general. British journalist Ian Walker called Berlin "a halfway house between the two Germanies," a place one of his informants went "to escape the German in himself."[28] Paradoxically, its island status liberated those who saw the Wall as keeping out the half-hearted. Musician Blixa Bargeld declared, without the Wall "it would be like living in West Germany, and West Germany is totally uninteresting."[29] Tykwer reveals his own psychic distance from West Germany in a 2007 essay on Fassbinder's idiosyncratic, experimental *Berlin Alexanderplatz*. Recalling the outrage over that film when it was serialized on West German television in 1980, Tywker writes, it "seemed like a dirty thorn ... boring itself

deeper and deeper into the wound of this republic, a country that wasn't very comfortable in its own skin anyway and, accordingly, was soon thereafter to fall into a cultural and political stupor."[30]

An insistence on probing Germany's wounds prevailed among "anti-Berliners" and artists like the Brilliant Dillettantes. Wolfgang Müller, founder of post-punk band Die tödliche Doris, writes, "in Berlin, the present always begins with the past"[31]—a past rooted in seductive myths of doomed Babylon. Wage subsidies that made it possible to survive on casual jobs offered culture creators time to think.[32] In a landscape strewn with detritus from the previous century, they used flea market finds and disused spaces to realize artistic, social, and political possibilities freed from the need for marketability. As historian Belinda Davis writes, "the imposition of fantasy … made the gray, hardscrabble city alive."[33] These Berliners (often exiles from the Federal Republic) luxuriated in brokenness, disunity, and ruin. Self-proclaimed *kaputtniks*, they also rejected the hippie ethos of peace and love as they stared down the barrel of nuclear annihilation. Hence, their fascination with Weimar Berlin. British expatriate Mark Reeder makes that link explicit: "Berlin hadn't been this creative, or abstract, since the era of the Weimar Republic."[34] That same affinity for "glitter and doom" Weimar marks *BB*.

Pastiche, Mashup, Bricolage—Inserting the 1980s into Weimar

Sara F. Hall argues that *BB* presents a pastiche of Weimar cinema. Pastiche is a technique in which a work quotes, recycles, and remixes other works, remaking them to create something new. Pastiche "activates cinematic recall [of Weimar-era films and images], establishes an intermedial dialogue between analog and digital forms, and affectively engenders a historically oriented conversation about the fragility of modern democracy in the Brexit/Trump era."[35] Hall's argument can also be applied to *BB*'s use of musical references, which create a Weimar Berlin in dialogue with the long 1980s.[36]

Film treatments of Berlin routinely use music to portray the city as dynamic and transgressive.[37] The 1980s' transgressive styles were punk, post-punk, and industrial, which *BB*'s opening credits reference, mixing sound with visuals to depict Berlin as a "seething cauldron."[38] Metronomic opening notes evoke *BB*'s leitmotif of hypnosis, while free jazz drumming propels us through shifting, kaleidoscopic images. These sounds laid, for example, under a shot of

Berlin's radio tower—a favorite subject of Weimar-era photographers—typify *BB*'s blending of eras and musical genres. The credits climax in an ominous, industrial blast of low brass notes that carry us from the late twentieth century back to 1929. Here, composer Klimek drew on sounds he first heard through post-punk pioneer Gudrun Gut as well as early collaborations with Reeder that were foundational to techno.[39] This bricolage of sound and vision lays down a sonic marker: *BB* will not restrict itself to Weimar texts, and mashups are the name of the game.

Mashups also infuse *BB*'s nightclub scenes, which are essential to conveying the showrunners' Weimar fantasies. Nightlife spaces serve as sites of sociability, momentary release, and refuge for sexual nonconformists, as well as of treachery and danger. *BB* evokes sites of gay Weimar, such as the Eldorado, and West Berlin transvestite cabarets Chez Romy Haag and Dollywood. The latter, along with Schöneberg's gay/alternative scene hub Das andere Ufer, were instrumental in re-establishing the queer culture that has since become central to Berlin's identity.[40] Compressed into the fictional Holländer and Pepita bars, queer nightlife spaces are foregrounded in *BB* as part of its quest to present a Weimar that appeals to current sensibilities. They also serve as the vehicle for Gereon Rath's journey from western German provincial to enthusiastic *Wahl-Berliner* (Berliner by choice).

Tykwer and Borries have spoken about using nightlife to depict Weimar's pansexual spirit and its fragility. Several scenes give form to this vision. Most prominent is episode two's production number in which the shapeshifting Nikoros/Sorokina/Svetlana sings *BB*'s theme song, "Zu Asche, zu Staub." While the mise-en-scène conjures up techno (production notes refer to the Moka Efti set as "Berghain 1929"[41]), eighties' associations also abound. The Moka Efti—an actual, and by all accounts dignified, 1920s' café—is reimagined as a decadent nightclub whose interior recalls Metropol, the West Berlin dance palace anchoring Nollendorfplatz's gayborhood.[42] Klimek's compositional task for the scene was to re-imagine Frankie Goes to Hollywood's 1983 gay anthem "Relax" as it might have sounded in 1929.[43]

This number's choreography evokes additional 1980s' references such as Michael Jackson's moonwalk and body popping hip-hop dance. Nikoros's jerky moves recall Klaus Nomi's "Kabuki robot" performances.[44] (Those are in turn echoed in the "broken robot" moves Gereon busts out at his local bar, which Hall compares to the "jerky movements and flickering projections associated with silent and early sound movies, making his character an embodiment of the imbrication between shell shock and the medium."[45]) The choreography for

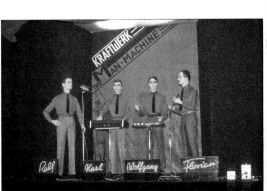

Figure 11.1 Plastic hair: Kraftwerk and Devo. Kraftwerk image courtesy of Sheri Lynn Behr/Alamy Stock Photo. Devo image courtesy of Robert Matheu.

Nikoros's dancers is also a pastiche. Josephine Baker is an obvious reference, conjured up by a Black dancer doing the Charleston and a banana-skirted chorus line. Just as striking are the latter's hairdos, synthetic black *Bubikopf* bobs that resemble both Baker's oiled coif and the plastic hairpieces worn by Devo and *Man Machine*-era Kraftwerk (Figure 11.1). The chorus line mixes robotic spasms with sensuous gyrations, the pasties on their breasts connoting striptease and postmodern burlesque. This tension between the sensual and the mechanical across time and genre recalls Madonna's video for "Express Yourself" (1989), which lifted its visuals of men enslaved to machines from Fritz Lang's *Metropolis* (1927). It also bears similarities with Cold Wave, a post-punk subgenre marked by a "cold, machine-like and [simultaneously] passionate" style.[46] *BB*'s mashups of signifiers from Weimar and the long eighties bring into dialogue the currents of anxiety, hedonism, cultural miscegenation, and fascination with apocalypse that pervaded both eras. Sensations of doom are never far from moments of pleasure.

The Moka Efti's star, Nikoros, recalls another West Berlin reference, David Bowie. Bowie moved to Berlin in 1976, inspired by conversations about Weimar with Isherwood. He found fresh inspiration there over the next two years. In his relationship with transgender chanteuse Romy Haag, Bowie found a kindred spirit who transcended established categories of gay, lesbian, and straight.[47] His Krautrock-inspired album *Low* (1977) constitutes some of his most ambitious work, while "Heroes," his 1978 ode to lovers separated by the Wall, gave Germans a feeling of ownership of the artist. It cemented Berlin's ongoing

love affair with Bowie, his transnational, androgynous image a perfect fit for the city's subcultures of sexual nonconformity and exile. Traces of this crop up in *BB*. Svetlana's slicked-back, peroxided hair recalls Bowie's Thin White Duke phase (when he wore his hair "like a modern-day John Heartfield").[48] On stage, Nikoros's stringy black wig and drag king moustache set against their pale-white visage evoke goth, a style also referenced in Sorokina's grand guignol performance (S2, E8). This character's shifts in persona mirror Bowie's, whose public play with identity exemplified practices of pastiche *BB* uses to great effect.

Bryan Ferry is *BB*'s other musical patron saint. Like Bowie, Ferry has been hailed as a master of pastiche who weaves myriad modern art influences into his style and performances. He morphed from glammed-up leader of 1970s' art rock band Roxy Music into world-weary crooner of "louche cabaret" by 1980.[49] In 2012, he formed the Bryan Ferry Orchestra, which reinterprets his oeuvre in 1920s' jazz style. That work plays a recurring role in *BB*, for which he served as consultant.

Ferry's aesthetic of glamour and ironic detachment pops up throughout BB. His performance of "Bitter-Sweet" (S2, E6) is orchestrated to capture its Teutonic *Weltschmerz*. While his appearance serves mainly as background to the action at the Moka Efti, the camera cuts away to certain lines of his song about an ill-fated affair, most prominently "das ist nicht das Ende der Welt" (this is not the end of the world), pointedly delivered in German. That line gets its charge from the fact that viewers know what *BB*'s characters do not: their world *will*, in fact, soon end. The original rock treatment of "Bitter-Sweet" on Roxy Music's album *Country Life* already channeled Weimar glitter and doom; *BB*'s reworking of it in period style enhances the nightclub scenes' mood of chic depravity and despair.

BB deploys another Ferry song, "Dance Away," as non-diegetic music as Frau Behnke prepares for the arrival of her new boarder, Gereon (S1, E2), and during the lake outing (S1, E6). In both cases its upbeat, jazzy arrangement conveys optimism. Its lyrics, however (which we never hear), are deeply melancholic: "Loneliness [in] a crowded room / Full of open hearts turned to stone / All together, all alone."[50] The refrain, "Dance away the heartache, dance away the tears," offers unspoken commentary on *BB*'s many characters, such as Gereon and Behnke, who are profoundly broken but still holding out for happiness.

The character who most embodies "dancing away the pain" is Charlotte Ritter. A product of Berlin's poorest, dreariest milieu, Lotte uses nightlife as an escape, though her side gig as a sex worker in the Moka Efti brothel makes true escape elusive. *BB*'s identification of Lotte with nightlife sets up interesting parallels

between Weimar and eighties' West Berlin. The latter didn't invent nightlife, but it did invent the club culture emblematic of present-day Berlin. Scenesters repurposed disused spaces for gigs or parties and rediscovered surviving Weimar-era establishments like Café Möhring. The fact that bars had no closing time structured nightlife practices. Midnight assumed special power as the hour when nightlife commenced, which we see in *BB* when Lotte sets that time to meet Gereon for their investigation at Der Holländer.[51] For young people living in spartan apartments, clubgoing was a way to warm up and communicate with friends. Reeder writes, "the scene never slept—at least not at night. You didn't want to miss a thing, you went from club to club, came home briefly, washed, and then went out again."[52] *BB* introduces Lotte in similar terms: we first meet her when she comes home to wash after being out all night, in transit to her day job at the police presidium. She's a club kid from 1929 we could visualize at the Dschungel in 1980 or Berghain in 2016.

Tykwer and Borries cite Berlin club culture as inspiration for the nightlife in *BB*, which is never simply about carefree decadence. Tykwer argues that those scenes have a layer of melancholy because we know that these characters will soon lose their freedom.[53] Similar possibilities of destruction shaped West Berlin club culture. Gut declares, "day in, day out, the apocalypse was right before us and that's why every moment was lived to its fullest."[54] For Reeder, nightlife offered opportunities to create alternative worlds in uncertain times:

> We were stuck in the middle of the Cold War, we played with symbols, with the law and uniforms, with music, stones, and shards. We destroyed things that could be destroyed, we broke taboos, exceeded limits, realized utopias and took what we wanted. We lived history and we also wrote it.[55]

Walker wrote in 1987 of punks and post-punks "whose self-mutilated chic had made its mark all over the West—but they seemed particularly at home in this theater, Berlin, Babylon under occupation."[56] The idea of the club as "home" informs Lotte's character. She is most at home in Der Holländer, where everybody knows her name. The Moka Efti, in contrast, has a more ambiguous relationship to the idea of the club as home. It's not just a space of revelry but a place that confronts Lotte with her lack of autonomy as she sells sex there to support her family. While it would be a stretch to cast her as a self-mutilating punk, she continually remodels herself as she navigates competing worlds, from her working-girl cloche to her nocturnal sequined shift and punky kohl-rimmed eyes ("ein bisschen Technik," she sings while doing her makeup). Nightlife, and pop culture generally, offers opportunities for self-determination and social

capital she otherwise lacks as a daughter of the lumpenproletariat. But she also learns that their freedoms are fleeting and highly delimited.

Lotte's struggle to keep despair at bay through nightclubbing and bodily pleasure is rendered strongly in her final scene of season two (E8). Overwhelmed by conflicting emotions after a near-death experience, Stephan Jänicke's murder, Gereon's return to Helga, and her hard-won acceptance onto the police force, Lotte loses herself in dance at the Moka Efti. The scene visually recalls the climactic sequence of Wim Wenders's *Der Himmel über Berlin* (*Wings of Desire*, 1987), another film that puts Berlin's pasts and present into dialogue. Marian, a French trapeze artist facing an uncertain future in West Berlin, loses herself in dance at a Nick Cave concert. The scene's musical number, "From Her to Eternity," is a taut ballad of sexual longing for a woman so close and yet so far because she's on the other side of a wall. It is larded with references from across Berlin's twentieth century: shot at the Esplanade, a once-grand Potsdamer Platz hotel reduced to a decaying shell abutting the Wall. In the 1980s, the Esplanade was repurposed for exhibitions, including "Film—Stadt—Kino—Berlin," which displayed the set of Marian's trailer among its exhibits. *Wings* channels the spirit of this haunted space on West Berlin's edge but flips it to craft one of German cinema's happiest endings as two creatures cross myriad borders to find love. Lotte's ending, in contrast, is filled with foreboding. *BB* leaves her alone to face a daunting future, one haunted by threats like that of her counterparts in 1980s' West Berlin.

Conclusion: *Babylon Berlin* and West Berlin Nostalgia

Historian Tobias Becker writes that the recent obsession with Weimar ignited by *BB* has much to do with the fact that we know Weimar is doomed.[57] *BB* complicates easy nostalgia for Weimar by deploying "playfully irreverent postmodern" touches.[58] Yet *BB* subtly participates in nostalgia for another place swept away by world-historical events, West Berlin, now the subject of its own retrospective treatments and historical analyses.

The object of this nostalgia boom is not the Berlin of Diepgen but of DIY, a place where creating culture out of the city's junk was a gesture of defiance against bourgeois West German complacency. In the twenty-first century, stressed-out millennials fantasize about a Berlin where one could subsist on casual jobs, coffee, and cigarettes. That pre-digital Berlin's slower pace is conjured up in "Where Are We Now," Bowie's 2013 meditation on his time there. As he namechecks the

Bösebrücke and KaDeWe, the song's elegiac video transports viewers back forty years with grainy footage of urban landmarks and austere streets where Bowie goes "walking the dead." A similar sense of loss ripples through the memoirs, photo books, and other works that have created a wave of "Westalgie," the counterpart of nostalgia for East Germany.[59] Some of this has been generated by the deaths of key figures, particularly Bowie and Tabea Blumenschein. The 2020 death of Blumenschein, star of the cult film *Ticket of No Return* (Ulrike Ottinger, 1979) and "it girl" of West Berlin nightlife, unleashed a flood of remembrances around her singular image—a distinctly eighties' fusion of queer, punk, and Hollywood glamour—and the scene of which she was a linchpin.[60] Her demise in a one-room apartment in Marzahn after a period of homelessness serves as a poignant metaphor for the fate of West Berlin subculture itself: pushed to the margins, gentrified out of existence, and reclaimed as sexy branding image for party city Berlin.

If the opening of the Wall met with shrugs from Handloegten's Eiszeit-Kino patrons, West Berlin's subculture denizens openly mourned it. For them, the end of West Berlin meant the end of a protective island that sheltered those who "could not fit into real existing socialism or the social market economy that became unfettered capitalism after 1990."[61] Looking back, part of the *frisson* of the West Berlin subculture discussed in this essay is that we know it will disappear, just like Lotte's world. It may seem inappropriate, even offensive, to compare the loss of 1980s' West Berlin with the loss of Weimar. The 1990s' "comeback for capital"[62] was difficult for many who had been able to live outside the straight world, but it saw nothing like the horror that followed the end of Weimar. Nonetheless, an important similarity between the ends of both eras was the foreclosing of possibilities for unconventional experiments in art and lifestyle. Both lived under a pervasive aura of unease and threat that proved inspiring to culture creators. *BB*'s pastiches and mashups tap into those emotional states and affinities between the two eras, revealing the imprint the divided city left on its creators. Viewed in that light, *BB* can be seen as a fantasy of Weimar through the lens of 1980s' West Berlin.

Notes

1 Thanks for their feedback to Hester Baer, Jill Smith, Paul Steege, Belinda Davis, Peter Conolly-Smith, the Philadelphia Area Modern Germany Workshop, and my Queens College students in Film and History, especially Ryan King. On the

mediation of Weimar in later periods, see Mel Gordon, *Voluptuous Panic: The Erotic World of Weimar Berlin* (Los Angeles: Feral House, 2008), 17–34. Weimar is surprisingly underrepresented on screen; see Veronika Fuechtner and Paul Lerner, eds., "Forum: *Babylon Berlin*: Media, Spectacle, and History," *Central European History* 53, no. 4 (2020): 835–54.

2 Jerrold Simmons, "A Tale of Two Censors: The British Board of Film Censors, the Production Code Administration, and the Sad Fate of *I am a Camera*," *North Dakota Quarterly* 61, no. 3 (1993): 130–47.

3 They still made errors. See Hanno Hochmuth, "Mythos Babylon Berlin. Weimar in der Populärkultur," in *Weimars Wirkung. Das Nachleben der ersten deutschen Republik*, ed. Hochmuth, Martin Sabrow, and Tilmann Siebeneichner (Göttingen: Wallstein, 2020), 111. See also Mila Ganeva's essay in this volume.

4 Tobias Becker, "'Zu Asche, zu Staub': Babylon Berlin and Weimar Nostalgia," https://nostalgia.hypotheses.org/471; Hochmuth, "Mythos Babylon Berlin," 120.

5 Kai-Hinrich Renner, "Regisseur-Trio: Das haben wir bei 'Babylon Berlin' gedacht," *Berliner Morgenpost*, October 13, 2017.

6 On Berlin as subcultural signifier, see John Schofield, "Characterizing the Cold War: Music and Memories of Berlin (1960–89)," in *Sounds and the City: Popular Music, Place, and Globalization*, ed. Brett Lashua, Karl Spracklen, and Stephen Wagg (New York: Palgrave Macmillan, 2014), 273–84. On German heritage film, see Lutz Koepnick, "'Amerika gibt's überhaupt nicht': Notes on the German Heritage Film," in *German Pop Culture: How American Is It?*, ed. Agnes C. Mueller (Ann Arbor: University of Michigan Press, 2004), 191–208; Hester Baer, *German Cinema in the Age of Neoliberalism* (Amsterdam: Amsterdam University Press, 2021).

7 Sunka Simon, "Weimar Project(ion)s in Post-Unification Cinema," in *Berlin— The Symphony Continues: Orchestrating Architectural, Social and Artistic Change in Germany's New Capital*, ed. Carol-Anne Costabile-Heming et al. (Berlin: De Gruyter, 2004), 304. On punk and bricolage, see Dick Hebdige, *Subculture: The Meaning of Style* (London: Routledge, 1979).

8 Mayor Klaus Wowereit coined the phrase "poor but sexy" in 2003. Mark Reeder writes that 1980s' Berlin "Wasn't Beautiful, but It was Damned Sexy" in *B-Book: Lust & Sound in West Berlin, 1979–1989* (Hamburg: edel, 2015), 37.

9 I omit Volker Kutscher from this category. He never lived in Berlin, and *BB* takes such liberties with his novels that it should be considered a distinct work.

10 Bernd Sobolla, "Tom Tykwer—Die frühen Jahre: Vom Filmvorführer zum Regisseur," https://1000interviews.com/tom-tykwer-die-fruehen-jahre-vom-filmvorfuehrer-zum-regisseur/; "Ein Interview mit Tom Tykwer," *Tip-Berlin*, December 9, 2010, https://www.tip-berlin.de/kino-stream/ein-interview-mit-tom-tykwer-1/.

11 Günter Bentele and Otfried Jarren, *Medienstadt Berlin* (Berlin: VISTAS, 1988), 427–46.

12 Sobolla, "Tom Tykwer."

13 Peter Zander, "Henk Handloegten: Meine Jugend als Mauergänger," *Berliner Morgenpost*, November 3, 2019. Countercultural indifference to the Wall opening is depicted in Leander Haußmann's 2003 film *Herr Lehmann*, adapted from Sven Regener's 2001 novel.

14 Bernd Lichtenberg and Wolfgang Becker got the screenwriting credit but IMDB lists Borries, Handloegten, and Chris Martin Silber as co-collaborators: https://www.imdb.com/title/tt0301357/?ref_=nm_flmg_wr_11.

15 Pierre Gras, *Good Bye Fassbinder! Der deutsche Kinofilm seit 1990* (Berlin: Alexander Verlag, 2014), 36–40.

16 Official rehabilitation came in 2001, when Berlin named a street after her. Wolfgang Müller, *Subkultur Westberlin, 1979–1989* (Hamburg: Philo Fine Arts, 2020), 26–7.

17 Marlies Krebstakies, *Die UFA: Auf den Spuren einer großen Filmfabrik* (Berlin: Elefanten Press, 1987).

18 Marc Schalenberg, "Wall City Visions: Representations of Europe in the Context of Berlin Kulturstadt Europas 1988," in *The Cultural Politics of Europe: European Capitals of Culture and European Union since the 1980s*, ed. Kiran Klaus Patel (London: Routledge, 2012), 117–21.

19 Elefanten Press books include Kristina von Soden, *Neue Frauen* (1988); Anna Tühne and Rina Olfe-Schlothauer, eds., *Frauen-Bilder-Lese-Buch* (1980); and Eckhard Siepmann, *Montage: John Heartfield: vom Club Dada zur Arbeiter-illustrierte-Zeitung* (1983). See also Eberhard Fechner, *Die Comedian Harmonists: Sechs Lebensläufe* (Munich: Heyne, 1988).

20 Müller, *Subkultur Westberlin*, 41, 352–4; Paul Hockenos, *Berlin Calling: A Story of Anarchy, Music, the Wall, and the Birth of a New Berlin* (New York: New Press, 2017), 66.

21 See 1960s' comments to that effect in Horst Günther, *Berlin bei Nacht* (Schmiden bei Stuttgart, n.d., 17–21); Clayton Whisnant, *Male Homosexuality in West Germany: Between Persecution and Liberation, 1945–1969* (New York: Palgrave, 2012), 114.

22 Andreas Huyssen, "The Voids of Berlin," *Critical Inquiry* 24, no. 1 (1997): 57–81; Karen E. Till, *The New Berlin: Memory, Politics, Place* (Minneapolis: University of Minnesota Press, 2005), 66–105.

23 Paul Hockenos, "In Cold and Claustrophobic 1980s West Berlin, You Paid a High Price for Freedom," thelocal.de, January 19, 2018, www.thelocal.de/20180119/confessions-of-a-west-berliner-the-walled-city-was-for-those-who-could-hack-it-which-wasnt-everyone. Hockenos moved there in 1985.

24 Frank Biess, *Republik der Angst: Eine andere Geschichte der Bundesrepublik* (Reinbek: Rowohlt, 2019), 361–5.

25 Hockenos, *Berlin Calling*, 55–6.

26 Emily Pugh, *Architecture, Politics, and Identity in Divided Berlin* (Pittsburgh: University of Pittsburgh Press, 2014), 200.

27 His remark came after violent demonstrations at Kreuzberg squats in 1987; Müller, *Subkultur Westberlin*, 28–9.

28 Ian Walker, *Zoo Station: Adventures in East and West Berlin* (New York: Atlantic Monthly Press, 1988), 20–1.

29 Chris Bohn, "Let's Hear It for the Untergang Show," *New Musical Express*, February 5, 1983.

30 Tom Tykwer, "He Who Lives in a Human Skin," *Berlin Alexanderplatz* DVD reissue by Criterion, 2007. It originally appeared as "Das Kino ist mehr als eine Geschichte," *Frankfurter Allgemeine Zeitung*, February 8, 2007.

31 Müller, *Subkultur Westberlin*, 24.

32 Hockenos, *Berlin Calling*, 62–4.

33 Belinda Davis, "The City as Theater of Protest: West Berlin and West Germany, 1962–1983," in *The Spaces of the Modern City: Imaginaries, Politics, and Everyday Life*, ed. Gyan Prakash and Kevin M. Kruse (Princeton: Princeton University Press, 2008), 247.

34 Reeder, *B-Book*, 88; see also Müller, *Subkultur Westberlin*, 28–9, 73–4; Mirko M. Hall, "Cold Wave: French Post-Punk Fantasies of Berlin," in *Beyond No Future: Cultures of German Punk*, ed. Mirko M. Hall, Seth Howes, and Cyrus M. Shahan (New York: Bloomsbury, 2016), 153.

35 Sara F. Hall, "*Babylon Berlin*: Pastiching Weimar Cinema," *Communications* 44, no. 3 (2019): 304–6.

36 See also Abby Anderton's contribution to this volume.

37 Sean Nye, "Review: *Run Lola Run* and *Berlin Calling*," *Dancecult: Journal of Electronic Dance Music Culture* 1, no. 2 (2010): 121–5.

38 According to Saskia Marka, who created the sequence's visuals: "Babylon Berlin (2018)," https://www.artofthetitle.com/title/babylon-berlin/.

39 Klimek, born in 1962 in Australia to German parents, moved to Berlin in 1983. Andrian Pertout, "Johnny Klimek: Run Lola Run," *Mixdown Monthly* 70 (2000), https://www.pertout.com/Klimek.htm; "Composer Johnny/Klimek on the music in Babylon Berlin," *Tuesday Talks #2*, October 2017, https://www.youtube.com/watch?v=4jzdG6yyphY. Reeder founded electronic dance music label MFS, with Klimek as an early collaborator; Reeder, "Lust & Sound in West-Berlin," https://www.steinberg.net/de/community/storys/2015/mark_reeder.html.

40 Hockenos, *Berlin Calling*, 50–4.

41 Hochmuth, "Mythos Babylon Berlin," 120–1.

42 On Metropol, see Reeder, *B-Book*, 52.

43 Colin van Heezik, "Achim von Borries over Babylon Berlin," *VPRO Cinema*, June 25, 2020, https://www.vprogids.nl/cinema/lees/artikelen/interviews/series/2020/Achim-von-Borries-over-Babylon-Berlin.html; Hester Baer, "Watch-Klatsch: Babylon Berlin season 1, episodes 1–2," Goethe-Institut Washington, April 30, 2020,

https://www.youtube.com/watch?v=Ff8tHkq3G7s. On "Relax," see Adam Sandel, "25 Gay Anthems We Need More Than Ever," *The Advocate*, June 24, 2016.

44 Žarko Cvejić, "'Do You Nomi?' Klaus Nomi and the Politics of (Non)identification," *Women and Music: A Journal of Gender and Culture* 13 (2009): 66–75.

45 Hall, "Pastiching Weimar Cinema," 312.

46 Hall, "Cold Wave," 150–1.

47 On Bowie in Berlin, see Hockenos, *Berlin Calling*, 19, 44–51; Walker, *Zoo Station*, 40; Ulrich Adelt, *Krautrock: German Music in the Seventies* (Ann Arbor: University of Michigan Press, 2016), 148–53.

48 Hockenos, *Berlin Calling*, 44.

49 Simon Reynolds, *Shock and Awe: Glam Rock and Its Legacy, from the Seventies to the Twenty-First Century* (London: faber & faber, 2016), 342–50; Mina Tavakoli, "Almost Anarchy: The Style Council and the Smooth Sounds of Sophisti-pop," *Washington Post*, November 20, 2020.

50 Roxy Music, "Dance Away," *Manifesto*, Polydor, 1979.

51 Iggy Pop's "Sister Midnight" and "Nightclubbing," produced during his Berlin stint, capture that hour's aura. Kevin EG Perry, "'The Perfect Marriage': Why Iggy Pop and David Bowie's Berlin Years Inspired a New Generation of Punks," *NME*, May 26, 2020, https://www.nme.com/features/iggy-pop-david-bowie-berlin-the-idiot-lust-for-life-reissue-2675970. See also Reeder, *B-Movie*, 64.

52 Reeder, *B-Movie*, 88.

53 Renner, "Regiesseur-Trio."

54 Hockenos, *Berlin Calling*, 66.

55 Reeder, *B-Movie*, 202.

56 Walker, *Zoo Station*, 40–1.

57 Becker, "'Zu Asche, zu Staub.'"

58 Fuechtner and Lerner, "Forum: *Babylon Berlin*," 838.

59 Bodo Mrozek, "Vom Ätherkrieg zur Popperschlacht: Die Popscape West-Berlin als Produkt der urbanen und geopolitischen Konfliktgeschichte," *Zeithistorische Forschung/Studies in Contemporary History* 11 (2014): 288–9.

60 Barbara Nolte, "Das Leben nach dem Nachtleben," *Der Tagesspiegel*, June 9, 2014; Richard Brody, "Style as Women's Freedom: The Photographs of Ulrike Ottinger," *New Yorker*, March 1, 2019; Wolfgang Müller, "Tabea Blumenschein ist tot," *Tip-Berlin*, March 3, 2020, https://www.tip-berlin.de/kultur/ausstellungen/abschied-von-tabea-blumenschein-wolfgang-mueller/; Adrian Kreye, "Das Kraftzentrum der Subkulturen," *Süddeutsche Zeitung*, May 5, 2020; Anna Ilin, "David Bowie and West Berlin '70s and '80s Subculture," *Deutsche Welle*, October 29, 2019, https://www.dw.com/en/david-bowie-and-west-berlins-70s-and-80s-subculture/a–16615845.

61 Müller, *Subkultur Westberlin*, 44.

62 Tykwer, "He Who Lives in a Human Skin."

Siegfried, Screen Memories, and the Fall of the Weimar Republic

Carrie Collenberg-González and Curtis L. Maughan

Lauded for its sumptuous representation of the Weimar Republic in 1929, *Babylon Berlin* has garnered critical acclaim far exceeding any previous international German television series. Much of this acclaim stems from the series' remediation of beloved artistic, cinematic, historical, and literary tropes from the Weimar period and its incorporation of these tropes into a loose adaptation of Volker Kutcher's novels. Steeped in these ample references, *BB* depicts the life of protagonist Gereon Rath after he moves to Berlin to work as a detective in the city's vice department. What begins as an attempt to recover a pornographic film that would implicate up-and-coming politician Konrad Adenauer soon reveals itself as a cover for the larger focus of the series: Gereon Rath's psychological journey as Siegfried to overcome his traumatic past and realize his destiny.

This chapter argues that Gereon's quest as Siegfried can be understood as a screen memory that represents and precipitates the fall of the Weimar Republic and critiques its enduring legacy. A screen memory is an altered or fabricated memory that masks a related and more painful truth. Harnessing the affinity between the screen memory and the cinema, *BB* explores how moving image culture impacts our engagement with the past, while it critiques the ever-growing demand for mediated reality and its own role in the creation of screen memories. The chapter is divided into two sections. The first section outlines how screen memories are used throughout the series in the construction of memory and meaning. Special attention is given to *BB*'s frame narrative, which stages the central plot within the parameters of ongoing therapy sessions. The second section focuses on the remediation of the Siegfried legend in particular and its significance as a screen memory. Finally, the conclusion demonstrates that the entire series can be read as a self-reflexive critique of the viewer's own transformation into

a *Menschmaschine*, or human-machine. Gereon's transformation into Siegfried thus embodies a dialectical tension between truth and light and ashes and dust that precipitates the fall of the Weimar Republic, what followed, and a nation's attempt to come to terms with its past through a mediated reality.

Screen Memories and Dr. Schmidt

The concept of screen memories has evolved since it was first introduced by Sigmund Freud in 1899, but the essence of Freud's concept plays a central role in *BB*.[1] Freud describes the process of forming screen memories as follows:

> What is recorded as a mnemic image is not the relevant experience itself—in this respect the resistance gets its way; what is recorded is another psychical element closely associated with the objectionable one [...]. The result of the conflict is therefore that, instead of the mnemic image which would have been justified by the original event, another is produced which has been to some degree associatively *displaced* from the former one.[2]

In this passage, Freud describes tendencies he observed in children to mask or screen painful memories by remembering something else associated with the event instead of the event itself. In work by Freud, this tendency to distort painful memories has also been applied to adults and their engagement with traumatic events formed in both childhood and adulthood.

The German word for screen memory is *Deckerinnerung*; the word *deck* implies a cover, mask, or *screen* of the memory. Gereon, like many veterans of the First World War, suffers from and attempts to transcend his post-traumatic stress disorder (PTSD) by relying on such screens. The first three seasons of *BB* hinge on the experimental PTSD therapy carried out by Dr. Schmidt, a mysterious and powerful figure who treats several central characters including Gereon, Edgar Kasabian, and Franz Krajewski. As Dr. Schmidt demonstrates in his public lectures and therapy sessions, his treatment for PTSD features the manipulation and creation of screen memories that render the subject under Dr. Schmidt's complete control. Reflecting the symbiotic relationship between storytelling and screen memories, Dr. Schmidt's function within *BB*'s narrative logic provides a commentary on cinema and social memory. In the context of film studies, the screen memory is not just something that obscures but can also serve as "a bracketing mechanism that draws attention to the complexities of social memory, as it simultaneously

produces and interrogates knowledge about the past."[3] Similarly, *BB* explores the intersection of moving image culture and national identity formation by both indulging in and critically examining screen memories. Thus Gereon's own struggle to overcome his past embodies his country's national struggle with *Vergangenheitsbewältigung* and the ability or inability to reckon with both the past and the present.

Throughout the first three seasons of *BB*, Gereon is actively engaged in a psychological journey to expose his repressed memories of the past, to locate the source of his fear, and—in the words of Dr. Schmidt—to seek out "truth" and "light." One of the most pronounced screen memories in *BB* is Gereon's memory of a horse with a gas mask that returns him to his original trauma: the moment he loses his brother Anno on a First World War battlefield. From the first episode of season one to the last episode of season two (S2, E8), the horse appears at the beginning of nearly every flashback. As Gereon works his way through the screen—the horse wearing the gas mask—each flashback unveils more information about the traumatic memory involving Anno. In the first episode (S1, E1), a flashback reveals that Gereon is in love with his brother's wife Helga. The flashback returns when Gereon later speaks with veterans who knew his brother (S1, E7), but now Gereon is portrayed as a hero who tried to rescue Anno from the battlefield. Finally, during a hypnosis session (S2, E8), Gereon is confronted with a flashback that reveals what most likely happened: he saw his wounded brother struggling, left him to die, and returned to reclaim his father's love and his brother's wife for himself.

After Anno's death, Gereon's father sends him from Cologne to Berlin to work as a detective with orders to locate and destroy a pornographic film that would incriminate family friend and aspiring politician Konrad Adenauer. One of the first clues Gereon finds is a single celluloid frame from the film that shows two women in lingerie surrounding a half-naked man who has been tied to a chair and whose face has been scratched out. The background of this frame features a painting of a horse with a gas mask, a detail that serves as an essential clue in finding the film as well as a trigger for Gereon's wartime trauma. At the end of season one (S1, E8), Gereon locates the film at the Moka Efti nightclub in a safe belonging to criminal overlord and club owner, Edgar Kasabian. After confiscating the film, Gereon and his partner Bruno Wolter watch it alongside other films depicting prominent politicians, officials, and Gereon's own father in compromising positions. The painting of the horse in the single celluloid frame is a screen that connects Gereon both to his past trauma with his brother and to his fraught relationship with his father.

The image of the horse in a gas mask can be understood as a screen that signals the original event of Gereon's trauma and demonstrates how screen memories function: We go from the image of a horse wearing a gas mask to Gereon's wartime trauma, to the recovery of the lost film, to the truth about Gereon's father, and finally to Gereon's feelings of shame and betrayal. When Gereon discovers it is actually his father in the pornographic film—and not Konrad Adenauer, as he had been led to believe—he recognizes his father's self-interested motive to locate the film. Feeling deeply betrayed, Gereon calls his father to tell him that he has found the film, but he will not be returning to Cologne. Gereon and Bruno burn the film and howl like wolves over the flames. The search for the film mimics Gereon's own search for meaning in his wartime memories; in each case, the screen or screen memory is lifted to slowly reveal his hatred for his father and his guilt for abandoning his brother. Therefore Gereon's search for meaning and the incriminating film are premised on the manipulation of both cinematic images (the scratched out face) and screen memories.

Though Gereon does work through the horse screen memory, his psychological journey becomes the subject of further manipulation by Dr. Schmidt as the show continues. The opening and closing sequences of the three-season arc constitute a frame narrative that embeds the central plot of *BB* within Dr. Schmidt's ongoing therapy sessions with Gereon: as Gereon tumbles ever deeper into his own traumatic memories, we become more immersed in the storyworld of *BB*. The focal point of both the frame narrative and the embedded narrative, Dr. Schmidt implements screen memories as our extradiegetic storytelling guide and as an all-powerful diegetic character. The following section focuses on this frame narrative that places Dr. Schmidt at the center of *BB*'s self-reflexive preoccupation with the overlap of history, (inter)national identity formation, and media technology—and their intersection with *Erinnerungskultur* (culture of remembrance). With the shadowy figure of Dr. Schmidt at its center, *BB* probes the potential dangers of screen memories in the ongoing process of history-making—especially in the context of the Siegfried myth.

In its opening ninety seconds, *BB* introduces Dr. Schmidt and Gereon in a fourth-wall-breaking sequence that conflates psychotherapeutic exploration and cinematic storytelling. The show begins with a black screen and Dr. Schmidt's voice: "Breathe very calmly. Breathe in and out. Don't try to put your thoughts into order." As we receive these directions, we slowly recognize the outline of a hand as it pulls away from the camera lens and Dr. Schmidt's face comes into view—he leads us out of the dark and into the world of *BB*. Yet as the sequence unfolds, we see that Dr. Schmidt has been holding his hand over Gereon's eyes

and the two are sitting across from one another in a dimly lit tunnel. In a matter of seconds, Dr. Schmidt transitions from extradiegetic guide—speaking directly to us—to diegetic character alongside the central protagonist. The opening moments of audience-addressed speech create an interlocutory ambiguity that conflates Gereon's personal experience in the therapy session with our journey into the narrative. Dr. Schmidt continues speaking: "Just let [your thoughts] go. And breathe in very deeply … and out. […] I will now take you back to the source. To the source of your fear. I will guide you step by step. Step by step … all the way to the source of your fear. To the truth." While Dr. Schmidt gives these instructions, we see Gereon walking toward a source of light at the end of the tunnel. His journey through the tunnel is interspliced with a series of flashes from future episodes that dramatize physical motion: Gereon emerges from a body of water and gasps for air; a dead dog is dragged across the floor of an underground sporting hall; and Gereon descends to the lower levels of Police Headquarters in a paternoster elevator. Responding to the rhythm of Dr. Schmidt's hypnotic narration, several of the shots are played in reverse, sped-up, or slowed down, and the shots of Gereon walking in the tunnel are all played in reverse slow-motion, signaling Dr. Schmidt's tight control of Gereon's descent into his own memory as well as our journey into the fictionalized past of *BB*. The tunnel sequence establishes the structural mechanics for both the journey into Gereon's memory and our journey into the narrative web of *BB*—both journeys unfold along conflicting temporalities, just as they hinge on screen memories that simultaneously obscure and reveal trauma and truth. The first ninety seconds of *BB* remind us of the hypnotic power of moving images—we too fall under Dr. Schmidt's spell as we enter the screen world of Gereon's memory.

In the three seasons that follow, we learn various details about Dr. Schmidt's character: he is the head of the Institute for Suggestive Therapy, where he treats and gives orders to an underground organization of criminals and war veterans; he holds public lectures detailing his experimental therapies for war neuroses; he is a consultant to the Berlin Police in occult matters; and he radio broadcasts his therapy sessions with Gereon to an audience that includes the avant-garde of Weimar cinema. Despite these details, Dr. Schmidt remains shrouded in mystery, as his origins, his motivations, and his actual identity are withheld from us—and even further obscured by his intrigue to appear as Gereon's brother Anno. What is clear, however, is that Dr. Schmidt wields unchecked power over swaths of Berlin's inhabitants. His web of influence emanates from a three-part system of manipulation that implements screen memories—a system he employs during his sessions with Gereon. First, Dr. Schmidt utilizes psychotherapeutic

manipulation and hypnosis to send Gereon deep into his wartime memories. Second, Dr. Schmidt orchestrates Gereon's addiction to "barbituric acid derivative," which renders its users pliable to suggestion and the acceptance of altered or fabricated memories. Third, Dr. Schmidt harnesses the power of new media, including radio and film, to construct stories and animate myths that function as screen memories, upending past realities and shaping ominous futures. Dr. Schmidt casts Gereon as Siegfried on a heroic quest for truth, which transforms Gereon's personal journey into a universal tale rife with mythic cues for Dr. Schmidt's radio listeners in *BB* and those of us watching the series at home. Thus Dr. Schmidt embodies *BB*'s dual usage of screen memories as plot element and storytelling mechanism. The significance of Dr. Schmidt's dual roles—as both all-powerful character and storytelling authority—culminates in the closing three minutes of episode twenty-eight.

The closing sequence of season three finds Gereon in the Berlin Stock Exchange on the day of the great stock market crash. Dr. Schmidt accompanies Gereon throughout the sequence in a voice-over, which begins: "Gereon, ready for the next session?" Mirroring the opening ninety seconds of episode one, Dr. Schmidt's voice triggers another shot of Gereon trudging through a tunnel interspliced with startling flashbacks from previously aired episodes, including shots of Dr. Schmidt striking Gereon, wartime explosions, and radio broadcasting equipment. As the flashback-tunnel sequence concludes, we return to Gereon at the stock exchange and Dr. Schmidt continues: "You have embarked on a journey, Siegfried." The cue to this Germanic hero signals the mythic quality of the screen memory Dr. Schmidt has created for Gereon. As his narration dictates the images on screen, we are reminded that Dr. Schmidt is the author and director of Gereon's fate. Indeed, moments later, as Gereon encounters his estranged lover Helga and her new partner Alfred Nyssen, Dr. Schmidt announces that Gereon will lead us to the fusion of man and machine. On cue, Helga and Alfred now appear as characters from *Demons of Passion*, a film directly inspired by Dr. Schmidt's radio broadcasts. Dr. Schmidt then narrates, "We will create the new human," and the shot's color drains to black and white. The aspect ratio changes from widescreen to 4:3, as the literal framing of the show adjusts to fit Dr. Schmidt's vision of an android dystopia. Next, another shot of Helga and Alfred is replaced with a shot of the star couple in *Demons of Passion*, and just as quickly we see a series of Gereon's flashbacks that are immediately replaced by scenes from the film—thus Gereon's past experiences are literally displaced by cinematic screen memories. Through various cinematic techniques—voice over, flashbacks, the recalibration of aspect ratios, and cross-cutting—the closing

sequence of season three enacts the power and the danger of cinematic screen memories, as Gereon's identity and memories are erased and replaced by the mythic and filmic machinations of Dr. Schmidt.

The Siegfried character is essential to the screen memory with which Dr. Schmidt stages Gereon's journey to "the truth." By casting Gereon as the ill-fated hero Siegfried, Dr. Schmidt imbues our watching experience with the volatile history that feudal mythology has played, and continues to play, in Germany's politics of national identity formation.[4] Although Dr. Schmidt exemplifies how *BB* uses and examines screen memories, the Siegfried screen memory distinguishes itself as a unifying reference point amidst *BB*'s patchwork of intertextuality. Nowhere is this more apparent than in the final moments of season three. After Gereon exits the stock exchange, he stares through a street grate at the scales of a dragon slithering through the tunnels below Berlin. The hyperrealistic rendering of a mythological creature signals how Gereon's transformation into Dr. Schmidt's Siegfried has transcended the boundaries of their therapy sessions and complicated the ontological parameters of *BB*. A deeper analysis of the Siegfried myth in *BB* uncovers the significance of this otherwise bewildering moment and all that it portends.

Screening Siegfried

According to Sara F. Hall, *BB* uses methods of pastiche to recast the fear and anxiety depicted in films of the Weimar period and thus to emphasize the precarious political and cultural moment experienced on both sides of the Atlantic today.[5] Hall lists numerous examples and anachronisms that demonstrate how the series redistributes memory and knowledge of the period in multidimensional ways and consciously reminds the contemporary viewer of the anxiety associated with the Weimar era. These numerous yet ultimately fleeting references work together to give the series its mass appeal and anchor the show in its historical context, yet they also mirror the way that cinematic screen memories obscure and recalibrate traumatic events of the past. The many examples of pastiche throughout the series can be understood as screen memories on literal and figurative levels: Weimar film, art, architecture, and other screen or screen-like surfaces are screened through *BB* and then screened again on the viewer's screen via streaming services like Netflix. Among the various screens of Weimar culture in *BB*, the most pervasive and elaborate is the treatment of the Nibelungen material, especially the myth of Siegfried, which provides insight into Gereon

and the viewer's psychological journey. A close reading of the Siegfried screen in *BB* throughout the first three seasons reveals the show's precarious position as it simultaneously indulges in screen memories while also examining them through a critical lens.

Siegfried refers to the name of the legendary hero of medieval German and Old Norse literature whose adventures have been famously recast in Richard Wagner's operas *Der Ring des Nibelungen* (The Ring of the Nibelung, 1848–74), and in Fritz Lang's silent films *Die Nibelungen* (The Nibelungs, 1924). Given the rediscovery of Germanic myth and the Siegfried legend during the Romantic period, the co-option of the Nibelungen material during the 1848 revolutionary period, the Weimar Republic, and the Nazi period, Siegfried is linked to historical moments defined by their preoccupations with German nationalism and identity construction. Despite assumptions associated with Siegfried's strength and valor, the Siegfried myth ultimately relies on a flawed hero who initiates and meets a terrible fate. While he is known for his defeat of a dragon that left him with enhanced strength, he is equally known for enabling the conquest and rape of Brunhild, for the betrayal that leads to his death (getting stabbed in the back), for his sunken gold treasure, and for the genocidal revenge sought by his wife Kriemhild. In *BB*, various adaptations of the Nibelungen material are pastiched together, creating one amalgamation of Siegfried and thus enabling multidimensional interpretations of the myth and its political significance throughout Germany's past and present.

BB might be interpreted as an epic adventure that depicts the journey of its hero Gereon Rath, who shares similarities with the medieval figures of narrative epic poems. The medieval associations of Gereon's name are made clear when co-protagonist Charlotte (Lotte) Ritter—whose own last name means *knight* in German—hears Gereon say his name for the first time and quips: "Gereon? Where do you come from? The middle ages?" (S1, E2). *BB*'s strongest connection to medieval literature is seen in the overlap between the characters Gereon and Siegfried, whose similarities are emphasized within the mythological structure of the archetypal hero as articulated in Joseph Campbell's *The Hero with a Thousand Faces* (1949): They are both called to adventure; they are assisted by or endowed with supernatural forces; they must overcome great obstacles; they are tempted by godless women; and they strive for atonement with a father figure.[6] Despite their heroic trajectory, Gereon and Siegfried are also betrayed and manipulated by the people around them. The similarities Gereon shares with Siegfried constitute a marked departure from the novels upon which the series is based and suggest conscious decisions on

the part of the filmmakers to draw upon Germanic myth to tell their story and deliver a timely warning.

From oblique references to overt connections, *BB* (through and beyond Dr. Schmidt) is deeply invested in the Nibelungen material to portray Gereon's journey and anchor him in a German national context. Names of characters and places from medieval literature and their nineteenth-century adaptations and interpretations are carefully integrated into the plot. For example, Gereon tells Bruno that he fought on the "Siegfried" line in the First World War (S1, E1). In season three, the lead actor in *Demons of Passion* is named Tristan Rot (evoking *Tristan and Isolde*); the hotel belonging to Alfred Nyssen in which Helga stays after she leaves Gereon is called the "Hotel Rheingold"; the hall inside this hotel is the "Lohengrin Saal"; and the tavern there is called the "Gasthaus Lindenblatt"—names that make clear reference to Wagnerian operas and adaptations of medieval literature that were well known during the Weimar Republic. In particular, "Lindenblatt" (linden leaf) refers to the leaf that fell on Siegfried's shoulder as he bathed in the blood of the dragon he slayed, a leaf that blocked the protection of the dragon's blood onto his skin, marked his vulnerability, and ultimately became the target used to plunge a spear into his back. Most significantly, Dr. Schmidt's codename for his patient Gereon, "Siegfried," is corroborated by the last shot of the last episode of season three when Gereon sees the spine of the dragon in the subway that he must, ostensibly, slay in seasons to come.

The themes associated with the Nibelungen material remain nonlinear throughout *BB*. Given the integration of these themes in the first three seasons, one might suspect that Siegfried's slaying of the dragon would come first, and yet the dragon appears in the final scene of season three. Instead, Siegfried's death and the tension between betrayal and loyalty that surround it provide the material upon which much of the action and character relationships in *BB* hinge. In an attempt to endear himself to King Gunther and marry his sister Kriemhild, Siegfried uses his invisibility cloak to betray Brunhild into marrying Gunther. Once Brunhild finds out what happened, she commands her vassal Hagen to kill Siegfried. Siegfried and his wife Kriemhild remain unaware that Brunhild and Hagen are plotting his death, and it is Kriemhild who tells Hagen where the linden leaf mark is located, thinking Hagen will protect Siegfried on the hunting trip fabricated by Hagen. After Hagen stabs Siegfried in the back, he steals and sinks Siegfried's gold in the Rhine River. Kriemhild then vows to avenge Siegfried's death and recover the gold, which leads to the genocide of the Nibelung people. The means by which Siegfried was killed informed the

so-called *Dolchstoßlegende* (stab in the back legend), which permeated the Weimar Republic as a right-wing antisemitic conspiracy theory that claimed that German soldiers did not lose the First World War but were instead betrayed on the home front by Jews, women, and politicians (Social Democrats in particular) who signed the November 1918 armistice.

Alliances and betrayals abound in *BB*. The *Dolchstoßlegende* is referenced numerous times and mentioned explicitly by leaders of the so-called *Schwarze Reichswehr*, the group advocating for the reemergence of a German national army when they meet at Bruno's house to commemorate fallen comrades (S1, E7). They reenact battle scenes, sing songs, and state directly that the Social Democrats betrayed them: "Who betrayed us? Social Democrats." During the evening, Gereon tells the other veterans how he tried to rescue his wounded brother but was captured, which is later revealed as a lie. Together, the veterans imagine that Gereon's missing brother Anno is holding the line until they can retrieve what rightfully belongs to them. In this scene, the fantasy of the *Dolchstoßlegende* unites Gereon's memory with battle reenactments, war songs, and a memorial for fallen soldiers, and introduces characters who will play more formidable roles in the third season. Like Kriemhild, whose vengeance was fueled by Hagen's betrayal, these outraged veterans are fueled by the idea of a fatal stab in the back, which thwarted their delusions of national grandeur and will result in the death of the Weimar Republic, and ultimately lead to genocide.

As in the Siegfried myth, the allure of power and wealth in *BB* is closely connected to gold and its whereabouts. The plot of seasons one and two is dominated by the attempt to locate and obtain the Sorokin gold from the Russian Revolution that links all the major characters, political factions, and parties in *BB*, and even transcends geopolitical borders to connect countries like Russia, Germany, Turkey, and France. The Sorokin gold disappears at the end of the second season but fortune, and the power associated with it, still drives the narrative in season three. Here the Sorokin gold is replaced by the US stock market, which promises wealth and fortune, and then sinks, leaving a trail of devastation in its wake and setting the stage for subsequent seasons. The narratological significance of Siegfried's sunken treasure in *BB* is further confirmed when Gereon leaves the chaos of the Berlin Stock Exchange and sees the slow-moving spine of the dragon below him in the subway tunnel.

As mentioned earlier, these last sequences in season three form a frame narrative that emphasizes the significance of Gereon's psychological journey and transformation, under the guidance of Dr. Schmidt, into a *Menschmaschine*, into Siegfried, who will lead us from darkness to light. Dr. Schmidt's voice-over

demonstrates his motive to transform humans into androids, free of pain and fear—and susceptible to his control:

> Gereon, ready for the next session? We will find a path that makes the wounded soul invulnerable. You have embarked on a journey, Siegfried. To the truth … to the light. You are not afraid. You are free of pain and fear. Your path inevitably leads us to the fusion of man … and machine. We will create the new human. We will create the human-machine. An android, free of pain and fear. […] Will you lead us? From darkness to light? Bring the truth to light?

When Gereon watches the dragon crawling in the tunnel beneath him and responds "To truth … to light," he assumes the role of Siegfried, who—made nearly invulnerable with dragon's blood—can be understood as one of the first examples of an enhanced human machine in German literature.

The potential for Gereon's transition to Siegfried is also supported by the mise-en-scène of these final sequences when he sees Helga and Alfred transform into characters from *Demons of Passion* before his eyes (see Figure 12.1). Helga in particular is depicted in golden armor that protects her skin and prepares her for battle. She resembles not just the characters in the film-within-a-film but also Kriemhild in armor as she is portrayed in *Kriemhild's Revenge* (Lang, 1924). Her armor, and its associations with Siegfried's nearly impenetrable skin, knights in armor, and veterans, corroborates Gereon's own transition to Siegfried. This onscreen transformation of *BB* characters into cinematic screen memories—creations of Weimar cinema—embodies Dr. Schmidt's vision of *Menschmaschinen* that will become free of pain and subject to the whims of the masterminds who control them. Read through the lens of the Siegfried myth that ends in genocide, these new androids will infiltrate the financial, political, and cultural spheres of the shell-shocked Weimar Republic and will lead the way to the ashes and dust that will follow.

Conclusion

By tracing the interwoven elements of screen memories and the Siegfried myth, this chapter demonstrates that *BB*'s engagement with the past exceeds the parameters of factual accuracy or artistic homage often discussed in the context of historical fiction. The series interrogates the expansive—and politically dangerous—intersection of memory, storytelling, and national identity formation by repeatedly calling attention to its own preoccupation with mediacy and the fall of the Weimar Republic, a conceit that finds poignant expression

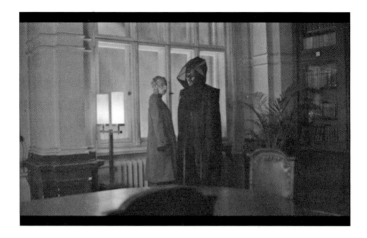

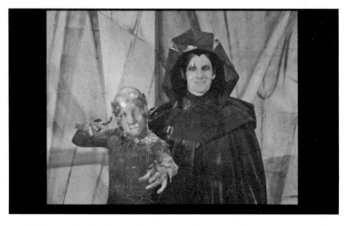

Figure 12.1 Helga and Alfred transform into characters from *Demons of Passion* before Gereon's eyes. Screenshots, *Babylon Berlin* (S3, E12).

in Dr. Schmidt's self-aware appropriation of the Siegfried meme. *BB*'s critical self-analysis is evident in how the series demonstrates both the creative and the destructive potential of screen memories. Just as the Siegfried myth expands the political ramifications of *BB*, so too *BB* extends the relevance of the Siegfried legend in contemporary contexts. Indeed, *BB* reanimates the fallen Siegfried not as a mere intertextual citation, but rather as a crucial challenge: Are we ready to pull back the screens of our contemporary media ecology and examine our past, the source of our fears? Or are we satisfied to fall deeper into the screen memories that promise safety in escapism while they expose us to the dangers of indulging in fantasy?

The success of the series depends on historically cognizant viewers who are as simultaneously delighted by the many references to Weimar culture as they are aware of the fall of the Weimar Republic, the rise of Hitler, the Second World War, and the Holocaust. Like Dr. Schmidt who simultaneously utilizes the screens that lead Gereon to the source of his fear and manipulates Gereon with further screens, the directors seem to distract viewers with screens that obscure the trauma associated with the period. However, by foregrounding screen memories associated with Siegfried, they push viewers to recognize and free themselves from the paradigms of myth and memory, and to question the historical context and the contemporary moment in which they are anchored. The Siegfried material itself serves as a screen that simultaneously depicts and obscures a Germanic hero's journey, his death, and the story's culmination in genocide. When viewed from this ominous perspective, even the most luxurious scenes are revealed to serve the aesthetic agenda to expose the past and confront the present through screens.

Consider the title song "Zu Asche, zu Staub" (To Ashes, To Dust) that was written for the series by Tom Tykwer, Mario Kamien, and Nikko Weidemann. While Nikoros performs the song in the Moka Efti nightclub, the dancers (and viewers) bask in the gold confetti that descends from the ceiling and follow every move the leader in uniform demands, dancing headlong into ashes and dust. These assumptions are as much related to the connotation of the titular Babylon in *BB* (and the punishment implied in the Christian tradition) as they are to Siegfried's demise and the shadow of genocide in German culture. The phrase from Genesis 3.19, "Ashes to Ashes, Dust to Dust," connects the song's title to death and evokes literary representations of the Holocaust and its relationship to ashes and dust as referenced in poems like Nelly Sachs's "O die Schornsteine" ("O the Chimneys," 1947) and Paul Celan's "Todesfuge" ("Death Fugue," 1947). Watching the series, viewers revisit the German genocidal past as they are confronted with their knowledge of how

the story will end, what has happened since, and what is happening in the present moment. The series premiered in 2017, a period marked by social upheaval, a rise in xenophobia, and the deepening of political extremes on both sides of the Atlantic that mirrors the instability of the Weimar Republic. In addition, the anxiety associated with increasingly mechanized humans that pervaded Weimar culture is resonant today as we become more dependent on technology and medication to supplement our corporeal abilities and limitations. The allure of the screens presented throughout the series and the promises of escape implied in their recognition attest to how easily viewers can still be manipulated and how entertainment provides screens that mask the source of the viewers' own fear and inhibit their ability to recognize and confront their own trauma.

Or consider the perspective of Fred Jacoby, a critic with the newspaper *Tempo*, who writes a critical review of *Demons of Passion* in which he calls for films willing "to look life in the face." During the premiere in the last episode of the third season, applause for the film erupts while Jacoby's review is offered in voice-over. Underwhelmed by the film, he reluctantly claps along, rolling his eyes:

> The premiere of the new Bellman film *Demons of Passion* last night was an eagerly awaited event. What the audience witnessed was an indigestible patchwork of outdated Expressionism, melodramatic amateurism, and a story that was obviously constructed only in retrospect, making brazen use of various literary classics. […] But what's the point? The masses will still pour in. The desire for the dream world is too great, as is the fear of reality. It is time to tell Bellman that these painted mannequins no longer have anything to do with us. It is time for films that look life in the face.

While Jacoby's critique anticipates reviews of *BB* that might question the flagrant use of screens employed throughout the series, his criticism of the audience can likewise be extended to the viewers of the series, the "masses" who "pour in" in a desperate attempt to screen reality. His critique is immediately followed by the sequence at the Berlin Stock Market on the day of the Wall Street Crash, a sequence spectacular in its staging and technique. Its visceral jump scares, violence, trauma, and the transformation of Helga, Alfred, and Gereon into the *Menschmaschinen* or "painted mannequins" from the film Jacoby just denounced imply that the audience of the series will also happily continue bingeing a show regardless of whether it revels in the allure and danger of Dr. Schmidt's remediated bliss or "looks life in the face." Given the

series' awareness of its role in the digital ecosystem of streaming services, autoplay, infinity scrolling, and 24/7 late capitalism, *BB* speaks to our reliance on screen memories and the potentially dire consequences of our own gradual metamorphosis into screens.

Notes

1 Sigmund Freud, "Über Kindheits—und Deckerinnerungen," *Monatsschrift für Psychiatrie und Neurologie* (1899): 215–30; and "Über Deckerinnerungen," in *Gesammelte Werke*, vol. 1 (Frankfurt: Fischer Verlag, 1953), 531–54.

2 Sigmund Freud, "Screen Memories" in *The Standard Edition of the Complete Psychological Works of Sigmund Freud*, vol. 3 (1899; London: Hogarth Press, 1994), 307.

3 Lindsey A. Freeman, Benjamin Nienass, and Laliv Melamed, "Screen Memory," *International Journal of Politics and Society on Screen Memory* 26, no. 1 (March 2013): 2.

4 Wolfgang Schivelbusch, *The Culture of Defeat: On National Trauma, Mourning, and Recovery*, trans. Jefferson Chase (New York: Picador, 2003).

5 Sara F. Hall, "*Babylon Berlin*: Pastiching Weimar Cinema," *Communications* 44, no. 3 (2019): 304–22.

6 Joseph Campbell, *The Hero with a Thousand Faces* (New York: Pantheon Books, 1949).

Afterword

Hester Baer and Jill Suzanne Smith

This volume has focused on the kaleidoscopic representation of Weimar history and culture in the first three seasons of *Babylon Berlin*. The fourth season, which aired in Europe in Fall 2022 but had yet to be released in North America when our book went to press, begins on New Year's Eve 1930 and portrays the rising power of the Nazis in Berlin during the first months of 1931. It is altogether bloodier than previous seasons, conveying both the atmosphere of fear and paranoia that accompanied Germany's embrace of authoritarianism and the criminal nature of Nazi intimidation, themes that resonate in the twenty-first-century present with new forms of right-wing populism on the rise.

Hand-in-hand with its attention to the crumbling democracy, intensifying economic precarity, and escalating violence of Weimar Berlin, season four also demonstrates the showrunners' responsiveness to critical assessments of the series' shortcomings and reflects the participation in script development by two new writers, Khyana El Bitar and Bettine von Borries, who contributed to improving *BB*'s representation of women. Even as they are subjected to increased brutality, women in season four exhibit more agency in fighting back—a welcome revision to the egregious sexual violence in Volker Kutscher's third Gereon Rath novel *Goldstein*, published in 2010, which forms the basis for this season. In contrast to previous seasons, there is even room for pure sexual pleasure, as the series' two main protagonists, Gereon Rath and Charlotte Ritter, finally consummate their relationship and appear to have plenty of fun doing so (although the consummation takes place only after Lotte loses her job as a police detective). This season also includes a broader depiction of Berlin's Jewish community, albeit one that is a bit quaint and rife with stereotypes, and features scenes shot in Yiddish.

Season four's first episode picks up where the third season left off, in a realm outside the series' more realist depiction of history: as we do in the first minutes

of the show's very first episode and in the last minutes of season three, we again hear Dr. Schmidt's hypnotic voice while viewing images of Gereon. The Gereon of this most recent season floats in a laboratory bath, his body covered in nodes and wires, becoming, we can assume, the human-machine of Dr. Schmidt's creation, a warrior who can defeat much stronger and larger opponents. In a jarring series of shots set outside the laboratory, and far away from the usual urban setting of the series, Gereon is shown crouching at the base of a linden tree, his naked body covered in blood. A single leaf from the tree lies on Gereon's shoulder, marking him, beyond a doubt, as Siegfried. In this way, season four also picks up where our volume ends, with Carrie Collenberg-González and Curtis Maughan's canny analysis of the Siegfried myth in *BB*. The traces and hints they track through the series are made explicit in the opening minutes of this newest season: Gereon/Siegfried has slayed the dragon and bathed in its blood, but he remains vulnerable to manipulation and betrayal—be it by Dr. Schmidt, by the gangster Edgar Kasabian, or by the nation and people he seeks to defend.

The screens of Weimar cinema are also present, with Fritz Lang's films as frequent citations: the wires on Gereon's body and the figure of Dr. Schmidt as the mad scientist recall Rotwang's creation of the robot Maria in *Metropolis* (1926), cross-cut with Lang's *Siegfried* (1924). Later in the first episode, at a lavish New Year's Eve party that he throws, Alfred Nyssen's pronouncement that he will be the first man on the moon evokes the moon mania captured in Lang's 1929 *Woman in the Moon*, as well as the violent forms into which German astrophilia was channeled: Lang's film was eventually banned by the Nazis during the Second World War because of its remarkable foreshadowing of the V-2 rocket program, a program that Nyssen's company anticipates with its development of ballistic missiles. And Lang's *M*, which premiered in Berlin on May 11, 1931, just after the time period covered by season four, forms an ongoing intertext to this season's portrayal of Weimar Berlin's criminal underworld and its pursuit of extrajudicial forms of revenge and punishment.

If the first minutes before the credit sequence conjure the persistence of Weimar cinema and its chronic fluctuation between depicting modern urbanity and technology, on the one hand, and perpetuating latent nationalist mythologies, on the other, then the first glimpse we catch of Lotte offers a charming nod to popular culture and the purchasing power of the new woman. She enters a record store on the Kurfürstendamm in search of a song whose title she has forgotten but whose catchy tune she hums for the saleswoman, who eventually recognizes it as "Ein Tag wie Gold" (A Day Like Gold) and sells Lotte a record that is prominently marked with the Electrola brand. Queuing

BB's latest soundtrack, this scene also reprises the first two seasons' repeated citation of *People on Sunday*, the 1930 film that follows the everyday experiences of five young people in Berlin, among them the saleswoman Brigitte, who is first introduced in front of the Electrola record store where she works.

The song "Ein Tag wie Gold" is threaded through season four as a leitmotif that is heard in an array of different versions, including notable performances by Max Raabe in the first and last episodes that aptly frame the action of this season. Raabe, the contemporary German jazz vocalist and leader of the dance band Palast Orchester, whose popularity in Germany and abroad is due in large part to his masterful revival of Weimar-era music, performs as the fictional singer Emil Engel. "Ein Tag wie Gold" represents the latest instance of what Julia Sneeringer describes as *BB*'s mashup of Weimar and post-punk aesthetics: the song was penned by Raabe together with the iconic singer Annette Humpe of the Neue Deutsche Welle band Ideal. Season four is rife with appearances by artists known for their contemporary revivals of Weimar culture. Meret Becker continues to portray Esther Korda, the film star and co-owner of the rebuilt club Moka Efti (another reprise of the first two seasons), and the contemporary performance artist Le Pustra returns in the role of sinister conferencier Edwina Morell, who now serves as the host of the infamous Kabarett der Namenlosen (Cabaret of the Nameless), a real venue in Weimar-era Berlin known for both its host's and audience's sadistic humiliation of down-and-out amateur performers. *BB*'s version of the Cabaret of the Nameless takes place within the Moka Efti and, in a clear nod to Bob Fosse's *Cabaret* (1972), is served up to a jeering, beer-slinging crowd of Nazi Brownshirts.

This scene's pairing of Morell and Nazi stormtroopers is emblematic for how queerness is depicted in season four. With the exception of the lasting romance between police photographer Reinhold Gräf and journalist Fred Jacoby, non-normative sexuality and gender queerness are associated either with the political right and muscular masculinity, as we see in the portrayal of Gottfried Wendt and the competing factions of the SA, or with the criminal underworld, evident in the depiction of Eisen-Else and the butch lesbians who run her gang. Like *Cabaret*, this season of *BB* creates disturbing connections between Weimar's queerness and the antidemocratic forces that eventually tore apart Berlin and the Republic itself.

Season four continues *BB*'s trademark refraction of temporalities in tandem with its excavation of media images and forms from Weimar and beyond. The show pays direct homage to the oeuvre of animation pioneer Lotte Reiniger in an extended sequence in episode eleven that is modeled on her *The Adventures*

of Prince Achmed (1926), one of the first feature-length animated films. Lotte's participation in a dance marathon that continues over several episodes invokes both Sydney Pollack's classic Hollywood film *They Shoot Horses, Don't They?* (1969), set in 1932, and the famous 2002 reworking of that film in the beloved US television series *The Gilmore Girls*. The visual language of Francis Ford Coppola's *Godfather* juggernaut informs numerous sequences depicting the illegal activities of the Ringvereine, the criminal gangs whose betrayals and vengeful murders form a major subplot of season four.

Fascination with the criminal underworld and the figure of the gangster is literally transported from the United States to Berlin in the person of an American Jewish gangster, Abe Gold (formerly Goldstein), skillfully played by the multilingual character actor Mark Ivanir, who has been acting in films and television and voicing numerous computer games since he was cast in Steven Spielberg's *Schindler's List* in 1993. Born in Ukraine and raised in Israel, Ivanir has played a gamut of twentieth- and twenty-first-century roles, from Soviet agent to Israeli soldier, from kindly uncle to cold-blooded killer, with notable appearances in prestige series that influenced *BB*, including *Homeland* and *Transparent*. Ivanir's Abe Gold character is itself a mash-up of his previous roles, mixing the Brooklyn accent of the Jewish gangster Bugsy Siegel with the Yiddish-accented German of a Jew from Odessa, which, we are shown very clearly by his father's gravestone, is where his family hails from. The reference to gangsters and Jews from Odessa is a clever nod to the 2010 German crime miniseries *In the Face of the Crime*, written and directed by Dominik Graf, which cast Ivanir alongside Mišel Matičević, *BB*'s gang boss Kasabian, as ruthless rival gangsters who are also Odessa Jews living in post-Wall Berlin. Ivanir is the third actor from Graf's miniseries to be cast in a prominent role in *BB*, after Matičević and Ronald Zehrfeld (Walter Weintraub in *BB* and a plucky Berlin cop in *In the Face of the Crime*), connecting the lavish historical series with Graf's gritty and often tongue-in-cheek representation of contemporary Berlin crime syndicates. Graf's most recent film has shown that inspiration and citation are multidirectional: his acclaimed adaptation of Erich Kästner's 1931 novel *Fabian* is, like *BB*, a representation of Weimar Berlin filtered through a 1980s aesthetic.

What Graf's 2010 miniseries and *BB*'s fourth season have in common is the tendency to depict Jews as either overly muscular (Weintraub, Gold)—the polar opposite of conventional representations of victims of the Shoah—or as Eastern European others. Berlin's Scheunenviertel forms the physical meeting point for all Jewish characters in this season, just as it was the source of August Benda's forbidden kosher sausages in seasons one and two. The Scheunenviertel is where Weintraub goes to synagogue; it is where Abe Gold's German relatives hold a

warm, welcoming Shabbat dinner, complete with songs and conversation in Yiddish. There is, we see in this season, a Jewish community in late Weimar Berlin. However, as journalists and authors of the time like Joseph Roth noted, the Scheunenviertel was mostly home to poor and artisan-class Jews from Eastern Europe. Acculturated German and Austrian Jews like Roth lived elsewhere in Berlin, viewing the Yiddish-speaking, religiously observant Jews of the Scheunenviertel from a distance. The characters in *BB* who are only vaguely marked as Jewish bear a greater resemblance to Roth and the majority of German Jews in Weimar Berlin: journalists Samuel Katelbach and Gustav Heymann are more likely to know about boxing matches and how to bet on them than they are to visit the synagogue in the Scheunenviertel. It is their humor in the face of unjust prosecution by the archly conservative Weimar court system that reads as most genuinely Jewish in *BB*'s latest season.

One of the most sinister, and most resonant, throughlines of season four's disturbing portrayal of the rise of fascism in Weimar Germany is, indeed, its focus on the miscarriage of justice perpetuated by an ever more corrupt court system. Season four emphasizes the close connections between the judiciary, the Berlin police—now increasingly ruled by Nazis—and the White Hand, a right-wing shadow organization that operates "in the service of the true German law" by carrying out show trials and executing criminals whose sentences it perceives as too lenient. The head of the White Hand, Ferdinand Voss, is himself a corrupt judge who uses both his state-sanctioned and illegal platforms (with the borders between the two increasingly blurred) to target and "purge" from German society minoritized groups, including Jews, LGBTQ people, youths, women, leftists, and the urban poor.

At their trial for exposing the workings of the Black Reichswehr, Katelbach and Heymann are convicted of treason without the chance to offer a defense, call witnesses, or introduce evidence. Following the trial, their lawyer Hans Litten proclaims, "If I accurately assess the situation, then the dismantling of our rule of law has just begun here, in this place. A shift in the balance of power seems to be taking place in the back rooms of these walls, which is undermining our free society. I will not allow such arbitrary judgment to endure in our country." Litten is a historical character whose namesake was a Communist attorney of Jewish heritage who defended opponents of the Nazis during the late Weimar Republic, and who later died while imprisoned in Dachau. In *BB* he recognizes that the courts are where rights go to die first, and that ensuring due process for the disenfranchised, bolstering the impartiality of the judicial system, and maintaining a balance of power are crucial to upholding a free society. *BB*'s season four makes palpable the stakes of failing to do so.

Collected Bibliography

"Ab nach Babylon." *Frankfurter Allgemeine Zeitung*, June 22, 2018.

Adelt, Ulrich. *Krautrock: German Music in the Seventies*. Ann Arbor: University of Michigan Press, 2016.

Anon. "Klingenberg und Issel." *Wasmuths Monatsheft für Baukunst* VIII, no. 9/10 (1924): 268–80.

Antrim, Taylor. "Your New Winter TV Binge Is Here." *Vogue*, January 30, 2018. https://www.vogue.com/article/babylon-berlin-netflix-review.

Arnheim, Rudolf. "Die Bilder in der Zeitung." *Die Weltbühne* 25 (1929): 564.

Aurich, Rolf and Wolfgang Jacobsen, editors. *Lucy von Jacobi: Journalistin*. Munich: Edition Text + Kritik, 2009.

"Babylon Berlin." *Bundeszentrale für politische Bildung*. https://www.kinofenster.de/bpb.de.

"Babylon Berlin: The Spectacular TV Series from Berlin." *Visit Berlin*. https://www.visitberlin.de/en/babylon-berlin.

Baer, Hester. *German Cinema in the Age of Neoliberalism*. Amsterdam: Amsterdam University Press, 2021.

Baer, Hester. "Watch-Klatsch: Babylon Berlin." Goethe-Institut Washington, 7 episodes, April–July 2020. https://www.youtube.com/playlist?list=PLMGOpj6NPMDAUn0fDyf6pLZHrEej0vpGO.

Baer, Hester and Jill Suzanne Smith. "Babylon Berlin: Weimar-Era Culture and History as Global Media Spectacle." Spec. Iss. European Culture and the Moving Image. *EuropeNow* 43 (September 2021). https://www.europenowjournal.org/2021/09/13/babylon-berlin-weimar-era-culture-and-history-as-global-media-spectacle/.

Baron, Jaimie. *The Archive Effect: Found Footage and the Audiovisual Experience of History*. New York: Routledge, 2014.

Baum, Vicki. *Es war alles ganz anders: Erinnerungen*. Cologne: Kiepenheuer & Witsch, 1987.

Bauman, Zygmunt. *Liquid Modernity*. Cambridge: Polity Press, 2000.

Beachy, Robert. *Gay Berlin: Birthplace of a Modern Identity*. New York: Alfred A. Knopf, 2014.

Becker, Edith, Michelle Citron, Julia Lesage, and B. Ruby Rich. "Lesbians and Film." In *Out in Culture: Gay, Lesbian, and Queer Essays on Popular Culture*, edited by Corey K. Creekmur and Alexander Doty, 25–42. Durham, NC: Duke University Press, 1995.

Becker, Tobias. "'Zu Asche, zu Staub': Babylon Berlin and Weimar Nostalgia." *Hypotheses: Homesick for Yesterday*, March 13, 2018. https://nostalgia.hypotheses.org/471.

Belden-Adams, Kris. "Everywhere and Nowhere, Simultaneously: Theorizing the Ubiquitous, Immaterial, Post-Digital Photograph." In *Mobile and Ubiquitous Media: Critical and International Perspectives*, edited by Michael S. Daubs and Vincent R. Manzerolle, 163–82. New York: Peter Lang, 2018.

Benjamin, Walter. *Selected Writings*, vol. 1–3, translated by Edmund Jephcott and Howard Eiland, edited by Marcus Bullock, Howard Eiland, and Michael W. Jennings. Cambridge, MA & London: Belknap Press, 1996–2002.

Benjamin, Walter. *The Arcades Project*. Cambridge, MA: Harvard University Press, 1999.

Bentele, Günter and Otfried Jarren. *Medienstadt Berlin*. Berlin: VISTAS, 1988.

Benz, Wolfgang, editor. *Handbuch des Antisemitismus: Judenfeindschaft in Geschichte und Gegenwart*, vol. 2: Personen. Berlin: De Gruyter, 2009.

Berbauer, Knut, Sabine Fröhlich, and Stefanie Schüler-Springorum. *Denkmalsfigur: Biographische Annäherung an Hans Litten, 1903–1938*. Göttingen: Wallstein Verlag, 2008.

Bering, Dietz. *Kampf um Namen: Bernhard Weiss gegen Joseph Goebbels*. Stuttgart: Klett-Cotta, 1992.

Bernhard, Georg. "Die Deutsche Presse." In *Der Verlag Ullstein zum Weltreklamekongress Berlin 1929*, edited by Ullstein Verlag, 57–79. Berlin: Ullstein, 1929.

Biesalski, Konrad. *Grundriss der Krüppelfürsorge*. Leipzig: Leopold Voss, 1926.

Biess, Frank. *Republik der Angst: Eine andere Geschichte der Bundesrepublik*. Reinbek: Rowohlt, 2019.

Birdsall, Carolyn. *Nazi Soundscapes: Sound, Technology and Urban Space in Germany, 1933–1945*. Amsterdam: Amsterdam University Press, 2012.

Biro, Matthew. "The New Man as Cyborg: Figures of Technology in Weimar Visual Culture." *New German Critique* 62 (1994): 71–110.

Blaney, Martin. "Founders of Germany's X-Filme Creative Pool Talk 25 Years in the Business, Move into High-End TV." *Screen Daily*, December 6, 2019. https://www.screendaily.com/features/x-filme-creative-pool-founders-talk-25-years-in-the-business-move-into-high-end-tv/5145385.article.

Blank, Juliane. "Berlin, Capital of Serial Adaptation: Exploring and Expanding a Political Storyworld in *Babylon Berlin*." *Interfaces* 47 (2022): 1–21.

Bloch, Ernst. *Heritage of Our Times*, translated by Neville and Stephen Plaice. Cambridge: Polity Press, 1991.

Bo. "Der Zeitungsstand." *Der Zeitungs-Verlag*, December 5, 1931, 880.

Bohn, Chris. "Let's Hear It for the Untergang Show." *New Musical Express*, February 5, 1983.

Booth, Paul. *Playing Fans: Negotiating Fandom and Media in the Digital Age*. Iowa City: University of Iowa Press, 2015.

Bösch, Frank. "Die Zeitungsredaktion." In *Orte der Moderne: Erfahrungswelten des 19. und 20. Jahrhunderts*, edited by Habbo Knoch and Alexa Geisthövel, 71–80. Frankfurt/Main: Campus, 2005.

Bowlby, Chris. "Blutmai 1929: Police, Parties and Proletarians in a Berlin Confrontation." *The Historical Journal* 29, no. 1 (1986): 137–58.

Brody, Richard. "Style as Women's Freedom: The Photographs of Ulrike Ottinger." *New Yorker*, March 1, 2019.

Brunsdon, Charlotte. "Problems with Quality." *Screen* 31, no. 1 (1990): 67–90.

Brusius, Mirjam. "The Field in the Museum: Puzzling Out Babylon in Berlin." *Osiris* 32 (2017): 264–85.

Bruzzi, Stella. *Undressing Cinema: Clothing and Identity at the Movies*. London: Routledge, 1997.

Buerkle, Darcy. "Caught in the Act: Norbert Elias, Emotion and *The Ancient Law*." *Journal of Modern Jewish Studies* 8, no. 1 (2009): 83–102.

Buß, Christian. "Weltmeister der Angst." *Der Spiegel*, October 13, 2017. https://www.spiegel.de/kultur/tv/babylon-berlin-von-tom-tykwer-serienmeisterwerk-ueber-die-weimarer-republik-a-1170044.html.

Butler, Judith. *Gender Trouble: Feminism and the Subversion of Identity*. New York: Routledge, 1990.

Caldwell, John Thornton. *Production Culture: Industrial Reflexivity and Critical Practice in Film and Television*. Durham, NC: Duke University Press, 2008.

Campbell, Joseph. *The Hero with a Thousand Faces*. New York: Pantheon Books, 1949.

Castendyk, Oliver and Klaus Goldhammer. *Produzentenstudie 2018: Daten zur Film— und Fernsehwirtschaft in Deutschland 2017/2018*. Leipzig: Vistas, 2018.

Chatman, Seymour. *Story and Discourse: Narrative Film Structure in Fiction and Film*. Ithaca, NY: Cornell University Press, 1978.

Chion, Michel. *Film: A Sound Art*. New York: Columbia University Press, 2009.

Clarke, Eric O. *Virtuous Vice: Homoeroticism and the Public Sphere*. Durham, NC: Duke University Press, 2000.

Clarke, Stewart. "'Babylon Berlin,' Mainland Europe's Most Expensive Show, Set for Third Season." *Variety*, August 23, 2018. https://variety.com/2018/tv/news/babylon-berlin-season-three-sky-ard-beta-tom-tykwer-volker-bruch-1202818468/.

Clarke, Stewart. "HBO Europe Picks up German Drama 'Babylon Berlin.'" *Variety*, October 12, 2017. https://variety.com/2017/tv/news/hbo-europe-buys-babylon-berlin-1202588085/.

Cohen, Roger. "Trump's Weimar America." *New York Times*, December 14, 2016.

"Composer Johnny Klimek on the Music in Babylon Berlin." *Tuesday Talks #2*, October 2017. https://www.youtube.com/watch?v=4jzdG6yyphY.

Connolly, Kate. "Babylon Berlin: Lavish German Crime Drama Tipped to Be Global Hit." *The Guardian*. October 29, 2017. http://www.theguardian.com/world/2017/oct/29/babylon-berlin-lavish-german-tv-drama-tipped-global-hit.

Cooke, Paul. "Heritage, *Heimat*, and the German Historical 'Event Television': Nico Hoffmann's teamWorx." In *German Television: Historical and Theoretical Approaches*, edited by Larson Powell and Robert Shandley, 175–92. New York: Berghahn, 2016.

Coté, Mark and Jennifer Pybus. "Learning to Immaterial Labor 2.0: Facebook and Social Networks." In *Cognitive Capitalism, Education and Digital Labor*, edited by Michael A. Peters and Ergin Bulut, 169–94. New York: Peter Lang, 2011.

Cresswell, Tim. "Reading 'A Global Sense of Place." In *Place: A Short Introduction*, 53–79. Malden, MA: Blackwell Publishing, 2008.

"Current Figures." *Visit Berlin*. https://about.visitberlin.de/en/current-figures.

Currid, Brian. *A National Acoustics: Music and Mass Publicity in Weimar and Nazi Germany*. Minneapolis: University of Minnesota Press, 2006.

Cvejič, Žarko. "'Do You Nomi?' Klaus Nomi and the Politics of (Non)identification." *Women and Music*: *A Journal of Gender and Culture* 13 (2009): 66–75.

Daub, Adrian. "What *Babylon Berlin* Sees in the Weimar Republic." *New Republic*, February 14, 2018. https://newrepublic.com/article/147053/babylon-berlin-sees-weimar-republic.

Davis, Belinda. "The City as Theater of Protest: West Berlin and West Germany, 1962–1983." In *The Spaces of the Modern City: Imaginaries, Politics, and Everyday Life*, edited by Gyan Prakash and Kevin M. Kruse, 247–74. Princeton: Princeton University Press, 2008.

Davis, Glyn and Gary Needham. "Introduction: The Pleasure of the Tube." In *Queer TV: Theories, Histories, Politics*, edited by Glyn Davis and Gary Needham, 1–11. New York: Routledge, 2009.

De Mendelssohn, Peter. *Zeitungsstadt Berlin: Menschen und Mächte in der Geschichte der deutschen Presse*. Berlin: Ullstein, 1982.

Dennis, David B. *Inhumanities: Nazi Interpretations of Western Culture*. Cambridge: Cambridge University Press, 2012.

Dibdin, Emma. "TV Writers Need to Stop Killing Off Their Gay Characters." *Marie Claire*, August 9, 2017. https://www.marieclaire.com/culture/news/a28685/gay-lesbian-character-deaths-tv/.

Döblin, Alfred. *Berlin Alexanderplatz*. 1929, translated by Michael Hofmann. New York: New York Review of Books, 2018.

Douthat, Ross. "'Babylon Berlin,' Babylon America?" *New York Times*. March 31, 2021. https://www.nytimes.com/2021/03/30/opinion/babylon-berlin-weimar-america.html.

Dovifat, Emil. "Die moderne deutsche Redaktion." In *Pressa: Kulturschau am Rhein*, edited by Internationale Presse-Ausstellung Köln, 50–2. Berlin: Schröder, 1928.

Dowling, Siobhán. "Sex, Drugs and Crime in the Gritty Drama 'Babylon Berlin.'" *New York Times*, November 7, 2017. https://www.nytimes.com/2017/11/07/arts/television/sex-drugs-and-crime-in-the-gritty-drama-babylon-berlin.html.

Dyer, Richard. *Now You See It: Studies in Gay and Lesbian Film*. New York: Routledge, 1990.

Ehrenberg, Markus. "Wie divers ist das deutsche Fernsehen?" *Der Tagesspiegel*, June 22, 2019. https://www.tagesspiegel.de/gesellschaft/medien/lgbti-check-wie-divers-ist-das-deutsche-fernsehen/24483416.html.

Eichner, Susanne. "Selling Location, Selling History: New German Series and the Changing Marketlogic." In *A European Television Fiction Renaissance: Premium Production Models and Transnational Circulation*, edited by Luca Barra and Massimo Scaglioni, 191–210. New York: Routledge, 2021.

Eichner, Susanne and Andrea Esser. "Key International Markets: Distribution and Consumption of Danish TV Drama Series in Germany and the UK." In *Danish Television Drama: Global Lessons from a Small Nation*, edited by Anna Marit Waade, Eva Novrup Redvall, and Pia Majbritt Jensen, 187–207. Cham, Switzerland: Palgrave Macmillan, 2020.

"Eine neue Spielstätte." *Theater im Delphi*. https://theater-im-delphi.de/en/haus/.

Eksteins, Modris. *The Limits of Reason: The German Democratic Press and the Collapse of Weimar Democracy*. Oxford: Oxford University Press, 1975.

Elsaesser, Thomas. *Weimar Cinema and After: Germany's Historical Imaginary*. New York: Routledge, 2000.

Emcke, Carolin and Lara Fritzsche. "Wir sind schon da." *Süddeutsche Zeitung Magazin* 5/2021, February 4, 2021. https://sz-magazin.sueddeutsche.de/kunst/schauspielerinnen-schauspieler-coming-out-89811?reduced=true.

Englisch, Paul. *Geschichte der erotischen Literatur*. Stuttgart: Julius Püttmann, 1927.

Englisch, Paul. "Der Kampf gegen die Pornographie." *Das Kriminal-Magazin* 8 (1930/31): 574–8.

Enzenberger, Hans Magnus. *The Silences of Hammerstein: A German Story*. Kolkata: Seagull, 2009.

Fechner, Eberhard. *Die Comedian Harmonists: Sechs Lebensläufe*. Munich: Heyne, 1988.

"Film of Police Responding to Demonstrations in Berlin." *Experiencing History: Holocaust Sources in Context. German Police and the Nazi Regime*. https://perspectives.ushmm.org/item/film-of-police-responding-to-demonstrations-in-berlin.

Finemann, Mia. "Ecce Homo Prostheticus." *New German Critique* 76 (1999): 85–114.

Fischer, Heinz Dietrich. "Die Weltbühne (1905–1939)." In *Deutsche Zeitschriften des 17. bis 20. Jahrhunderts*, edited by Heinz-Dietrich Fischer, 323–40. Berlin: De Gruyter, 1973.

Forster, Ralf. "Das Berliner Scheunenviertel. Dokumente aus sechzig Jahren Kiezgeschichte (1920–1980)." *Filmblatt* 7, no. 18 (2002).

Foucault, Michel. "Of Other Spaces: Utopias and Heterotopias." *Architecture/Mouvement/Continuité*, translated by Jay Miskowiec, October 1984.

Freeman, Lindsey A., Benjamin Nienass, and Laliv Melamed. "Screen Memory." *International Journal of Politics, Culture, and Society* 26, no. 1 (2013): 1–7.

Freud, Sigmund. "Screen Memories." 1899. In *The Standard Edition of the Complete Psychological Works of Sigmund Freud*, vol. 3, 301–22. London: Hogarth Press, 1994.

Freud, Sigmund. "Über Deckerinnerungen." In *Gesammelte Werke*, vol. 1, 531–54. Frankfurt: Fischer Verlag, 1953.

Freud, Sigmund. "Über Kindheits—und Deckerinnerungen." *Monatsschrift für Psychiatrie und Neurologie* (1899): 215–30.

Fritzsche, Peter. "Did Weimar 'Fail?'" *The Journal of Modern History* 68, no. 3 (1996): 629–56.

Fritzsche, Peter. *Reading Berlin 1900*. Cambridge, MA: Harvard University Press, 1996.

Fuechtner, Veronika. *Berlin Psychoanalytic: Psychoanalysis and Culture in Weimar Republic Germany and Beyond*. Berkeley: University of California Press, 2011.

Fuechtner, Veronika and Paul Lerner, editors. "Forum: *Babylon Berlin*: Media, Spectacle, and History." *Central European History* 53 (2020): 845–8.

Fulda, Bernhard. "Die Politik der 'Unpolitischen': Boulevard—und Massenpresse in den zwanziger und dreißiger Jahren." In *Medialisierung und Demokratie im 20. Jahrundert*, edited by Frank Bösch and Norbert Frei, 48–72. Göttingen: Wallstein, 2006.

Fulda, Bernhard. "Industries of Sensationalism: German Tabloids in Weimar Germany." In *Mass Media, Culture and Society in Twentieth-Century Germany*, edited by Karl Christian Führer and Corey Ross, 183–203. Basingstoke: Palgrave Macmillan, 2006.

Fulda, Bernhard. *Press and Politics in the Weimar Republic*. Oxford: Oxford University Press, 2009.

Fuller, Graham. "The Musical Masterstrokes of Netflix's *Babylon Berlin*." *Culture Trip*, March 15, 2018.

Ganeva, Mila. "Kleider machen Filme: Die Kostümabteilung der Ufa 1938–1945." In *Ufa International: Ein deutscher Konzern mit globalen Ambitionen*, edited by Jürgen Kasten, Ursula von Keitz, Frederik Lang, and Philip Stiasny, 353–66. Munich: edition text + kritik, 2021.

Gay, Peter. *Weimar Culture: The Outsider as Insider*. New York: W.W. Norton, 2001.

Geller, Jay. *The Scholems: A Story of the German Jewish Bourgeoisie*. Ithaca, NY: Cornell University Press, 2019.

Genette, Gérard. *Narrative Discourse: An Essay in Method*. Ithaca, NY: Cornell University Press, 1980.

"Geschichte des Delphi." *Theater im Delphi*. https://theater-im-delphi.de/geschichte/.

Getsy, David J. "How to Teach Manet's *Olympia* after Transgender Studies." *Art History* 45, no. 1 (2022): 342–69.

Goebbels, Joseph and Hans Schweitzer. *Das Buch Isidor: Ein Zeitbild voll Lachen und Hass*. Munich: Verlag Franz Eher, 1929.

Gordon, Mel. *Voluptuous Panic: The Erotic World of Weimar Berlin*. Los Angeles: Feral House, 2008.

Gordon, Peter E. and John P. McCormick, editors. *Weimar Thought: A Contested Legacy*. Princeton: Princeton University Press, 2017.

Gras, Pierre. *Good Bye Fassbinder! Der deutsche Kinofilm seit 1990*. Berlin: Alexander Verlag, 2014.

Gray, Jonathan. *Show Sold Separately: Promos, Spoilers, and Other Media Paratexts*. New York: New York University Press, 2010.

Green, Norma Fay. "'The Front Page' on Film as a Case Study of American Journalism Mythology in Motion." PhD Diss, Michigan State University, 1993.

Grey, Tobias. "A Hit Drama in Germany, Babylon Berlin Crosses the Atlantic." *Wall Street Journal*, January 28, 2018.

Grosch, Nils, Roxane Lindlacher, Miranda Lipovica, and Laura Thaller. "Rekonfigurationen der Weimarer Republik: Musikalische Vergangenheiten und Pastiches in *Babylon Berlin* (2018–2020)." *Archiv für Musikwissenschaft* 79, no. 1 (2022): 43–60.

Gross, Larry P. *Up from Invisibility: Lesbians, Gay Men, and the Media in America*. New York: Columbia University Press, 2001.

Groth, Otto. *Die Zeitung: Ein System der Zeitungskunde*, vol. 3. Mannheim: Bensheimer, 1928.

Günther, Horst. *Berlin bei Nacht*. Schmiden bei Stuttgart, n.d.

Halberstam, Jack. *In a Queer Time: Transgender Bodies, Subcultural Lives*. New York: New York University Press, 2005.

Hale, Mike. "Escaping into 'Babylon Berlin' and 'My Brilliant Friend.'" *New York Times*, March 22, 2020. https://www.nytimes.com/2020/03/26/arts/television/babylon-berlin-my-brilliant-friend.html.

Hall, Mirko M. "Cold Wave: French Post-Punk Fantasies of Berlin." In *Beyond No Future: Cultures of German Punk*, edited by Mirko M. Hall, Seth Howes, and Cyrus M. Shahan, 149–66. New York: Bloomsbury, 2016.

Hall, Sara F. "Babylon Berlin: Pastiching Weimar Cinema." *Communications* 44, no. 3 (2019): 304–22.

Handloegten, Henk. "Ein Gespräch mit Henk Handloegten." Lecture Series on *Babylon Berlin* at the Deutsche Sommerschule am Pazifik, YouTube Video posted by Carrie Collenberg-González. https://www.youtube.com/watch?v=y2PKSrqDKs8.

Hanfeld, Michael. Interview with Nico Hoffmann. "Jeder braucht heute Bilder, die bewegen." *Frankfurter Allgemeine Zeitung*, June 21, 2018.

Hans, Anjeana. "'These Hands Are Not My Hands': War Trauma and Masculinity in Crisis in Robert Wiene's *Orlacs Hände* (1924)." In *The Many Faces of Weimar Cinema: Rediscovering Germany's Filmic Legacy*, edited by Christian Rogowski, 102–15. Rochester, NY: Camden House, 2010.

Hansen, Kim Toft. "Glocal Perspectives on Danish Television Series: Co-Producing Crime Narratives for Commercial Public Service." In *Danish Television Drama: Global Lessons from a Small Nation*, edited by Anna Marit Waade, Eva Novrup Redvall, and Pia Majbritt Jensen, 83–101. Cham, Switzerland: Palgrave Macmillan, 2020.

Hartley, Keith, Henry Meyric Hughes, Peter-Klaus Schuster, editors. *The Romantic Spirit in German Art 1790–1990*. Exh. cat. Scottish National Gallery of Modern Art and Haywood Gallery. London: Thames and Hudson, 1995.

Hebdige, Dick. *Subculture: The Meaning of Style*. London: Routledge, 1979.

van Heezik, Colin. "Achim von Borries over Babylon Berlin." *VPRO Cinema*, June 25, 2020. https://www.vprogids.nl/cinema/lees/artikelen/interviews/series/2020/Achim-von-Borries-over-Babylon-Berlin.html.

Herman, David. *Narratologies: New Perspectives on Narrative Analysis*. Columbus, OH: Ohio State University Press, 1999.

Herzog, Todd, *Crime Stories: Criminalistic Fantasy and the Culture of Crisis in Weimar Germany*. New York & Oxford: Berghahn Books, 2009.

Hinton, Stephen. "Kurt Weill: Life, Work, and Posterity." In *Amerikanismus, Americanism, Weill: Die Suche nach kultureller Identität in der Moderne*, edited by Hermann Danuser and Hermann Gottschewski, 209–20. Schliengen: Edition Argus, 2003.

Hinton, Stephen. *Kurt Weill: The Threepenny Opera*. Cambridge: Cambridge University Press, 1990.

"History." *Theater im Delphi*. https://theater-im-delphi.de/en/history/.

Hochmuth, Hanno. "Mythos Babylon Berlin: Weimar in der Populärkultur." In *Weimars Wirkung: Das Nachleben der ersten deutschen Republik*, edited by Hanno Hochmuth, Martin Sabrow, and Tilmann Siebeneichner, 111–25. Göttingen: Wallstein, 2020.

Hockenos, Paul. *Berlin Calling: A Story of Anarchy, Music, the Wall, and the Birth of a New Berlin*. New York: New Press, 2017.

Hockenos, Paul. "In Cold and Claustrophobic 1980s West Berlin, You Paid a High Price for Freedom." thelocal.de, January 19, 2018. www.thelocal.de/20180119/confessions-of-a-west-berliner-the-walled-city-was-for-those-who-could-hack-it-which-wasnt-everyone.

Hoffrogge, Ralf. *A Jewish Communist in Weimar Germany: The Life of Werner Scholem, 1895–1940*. Chicago: Haymarket Press, 2014.

Howatson, M. C., editor. *The Oxford Companion to Classical Literature*. 3rd edition. Oxford: Oxford University Press, 2013.

Hoy, Meredith. *From Point to Pixel: A Genealogy of Digital Aesthetics*. Lebanon, NH: University Press of New England, 2017.

"Hub:Big wikis." Fandom. https://community.fandom.com/wiki/Hub:Big_wikis.

Hung, Jochen. "'Babylon Berlin' and the Myth of the Weimar Republic." *Washington Post*, March 20, 2018. https://www.washingtonpost.com/news/made-by-history/wp/2018/03/20/babylon-berlin-and-the-myth-of-the-weimar-republic/.

Hung, Jochen. "'Bad' Politics and 'Good' Culture: New Approaches to the History of the Weimar Republic." *Central European History* 49 (2016): 441–53.

Hung, Jochen. *Moderate Modernity: The Newspaper Tempo and the Transformation of Weimar Democracy*. Ann Arbor: University of Michigan Press, 2023.

Hung, Jochen. "The 'Ullstein Spirit': The Ullstein Publishing House, the End of the Weimar Republic, and the Making of Cold War German Identity, 1925–77." *Journal of Contemporary History* 53, no. 1 (2018): 158–84.

Huyssen, Andreas. "The Voids of Berlin." *Critical Inquiry* 24, no. 1 (1997): 57–81.

Ilin, Anna. "David Bowie and West Berlin '70s and '80s Subculture." *Deutsche Welle*, October 29, 2019. https://www.dw.com/en/david-bowie-and-west-berlins-70s-and-80s-subculture/a-16615845.

Isenberg, Noah. "Voluptuous Panic." *New York Review of Books, NYR Daily*, April 20, 2018. https://www.nybooks.com/daily/2018/04/28/voluptuous-panic/.

Isherwood, Christopher. *The Berlin Stories*. London: Vintage, Random House, 1999.

Jelavich, Peter. *Berlin Alexanderplatz: Radio, Film, and the Death of Weimar Culture*. Berkeley: University of California Press, 2006.

Jelavich, Peter. *Berlin Cabaret*. Cambridge, MA: Harvard University Press, 1993.

Jenkins, Henry. *Convergence Culture: Where Old and New Media Collide*. New York: New York University Press, 2006.

Jensen, Erik N. *Body by Weimar: Athletes, Gender, and German Modernity*. Oxford: Oxford University Press, 2010.

Josephs, Anya. "The Sexualization of Queer Women in Media." *Spark Movement*, November 29, 2012. http://www.sparkmovement.org/2012/11/29/the-sexualization-of-queer-women-in-media/.

Joyrich, Lynne. "Queer Television Studies: Currents, Flows, and (Main)streams." *Cinema Journal* 53, no. 2 (2014): 133–9.

Junghänel, Frank. "Weltpremiere 'Babylon Berlin': Die große Hure in Bestform." *Berliner Zeitung*, September 28, 2017.

Kabir, Shameem. *Daughters of Desire: Lesbian Representations in Film*. London: Cassell, 1998.

Käppner, Joachim. "Es hätte alles anders kommen können." *Süddeutsche Zeitung*. October 11, 2018. https://www.sueddeutsche.de/medien/erfolgsserie-babylon-berlin-es-haette-alles-anders-kommen-koennen-1.4165626.

Kaes, Anton. "*Blutmai 1929 (Kampfmai 1929)*." *El Giornate del Cinema Muto: Prog. 3 The Social Question*. http://www.giornatedelcinemamuto.it/en/weimar-prog-3/.

Kaes, Anton. *Shell-Shock Cinema*. Princeton: Princeton University Press, 2009.

Kaes, Anton, Martin Jay, and Edward Dimendberg, editors. *The Weimar Republic Sourcebook*. Berkeley: University of California Press, 1995.

Kane, Michael. *Postmodern Time and Space in Fiction and Theory*. London: Palgrave Macmillan, 2020.

Kant, Immanuel. *The Critique of Judgement*. 1790, translated by James Meredith and edited by Nicholas Walker. Oxford: Oxford Clarendon Press, 2008.

"Kaum zu glauben, was da alles zu sehen ist." *Frankfurter Allgemeine Zeitung*, October 5, 2017.

Keun, Irmgard. *The Artificial Silk Girl*, translated by Basil Creighton. London: Chatto & Windus, 1933.

Kilb, Andreas. "Vor dem Sündenfall." *Frankfurter Allgemeine Zeitung*, April 28, 2021.

Kilb, Andreas and Peter Körte. "Volker Kutscher im Gespräch: Babylon Berlin—Unsere Wilden Jahre." *Frankfurter Allgemeine Zeitung*, October 6, 2017.

Kirsch, Adam. "Can We Judge General von Hammerstein?" *New York Review of Books*, June 10, 2010.

Kittler, Friedrich A. "The City Is a Medium," translated by Matthew Griffin. *New Literary History* 27, no. 4 (1996): 717–29.

Klimek, Johnny. *Behind the Audio*, interview by Peter F. Ebbinghaus, October 17, 2017. https://behindtheaudio.com/2017/10/watch-johnny-klimek-speak-music-babylon-berlin/.

Koepnick, Lutz. "'Amerika gibt's überhaupt nicht': Notes on the German Heritage Film." In *German Pop Culture: How 'American' Is It?*, edited by Agnes C. Mueller, 191–208. Ann Arbor: University of Michigan Press, 2004.

Koepnick, Lutz. "Reframing the Past: Heritage Cinema and Holocaust in the 1990s." *New German Critique* 87 (2002): 47–82.

Kollwitz, Käthe. *Die Tagebücher 1908–1943*, edited by Jutta Bohnke-Kollwitz. Berlin: Siedler, 1999.

Korte, Helmut, editor. *Film und Realität in der Weimarer Republik*. Munich: Fischer, 1980.

Kracauer, Siegfried. *From Caligari to Hitler: A Psychological History of the German Film*. 1947. Reprinted. Princeton: Princeton University Press, 2004.

Kracauer, Siegfried. *The Salaried Masses: Duty and Distraction in Weimar Germany*, translated by Quintin Hoare. New York: Verso, 1998.

Krauß, Florian. "From 'Redakteursfernsehen' to 'Showrunners': Commissioning Editors and Changing Project Networks in TV Fiction from Germany." *Journal of Popular Television* 8, no. 2 (2020): 177–94.

Krauß, Florian. "'Quality Series' and Their Production Cultures: Transnational Discourses within the German Television Industry." *Series—International Journal of TV Serial Narratives* 4, no. 2 (2018): 47–59.

Krauß, Florian. "Writers' Room and Showrunner: Discourses and Practices in the German TV Industry." In *Handbook of Script Development*, edited by Craig Batty and Stayci Taylor, 251–66. Cham, Switzerland: Palgrave Macmillan, 2021.

Krebstakies, Marlies. *Die UFA: Auf den Spuren einer großen Filmfabrik*. Berlin: Elefanten Press, 1987.

Krei, Alexander. "'Babylon Berlin' fällt hinter Hebammen-Serie im ZDF zurück." *DWDL.de*, October 12, 2018. https://www.dwdl.de/zahlenzentrale/69197/babylon_berlin_faellt_hinter_hebammenserie_im_zdf_zurueck/.

Krei, Alexander. "Starker Auftakt: 'Babylon Berlin' startet auf 'Tatort'-Niveau." *DWDL.de*, October 1, 2018. https://www.dwdl.de/zahlenzentrale/69006/starker_auftakt_babylon_berlin_startet_auf_tatortniveau/.

Kreye, Adrian. "Das Kraftzentrum der Subkulturen." *Süddeutsche Zeitung*, May 5, 2020.

Kühn, Gertrud, Karl Tümmler, and Walter Wimmer, editors. *Film und revolutionäre Arbeiterbewegung in Deutschland 1918–1932. Dokumente und Materialien zur Entwicklung der Filmpolitik der revolutionären Arbeiterbewegung und zu den Anfängen sozialistischer Filmkunst in Deutschland*, vol. 2. Berlin: Henschelverlag, 1975.

Kutscher, Volker. *Der nasse Fisch*. Cologne: Kiepenheuer & Witsch, 2007.

Kutscher, Volker. Public Reading and Discussion of *Der nasse Fisch/Babylon Berlin*, Center for German and European Studies, Brandeis University. October 3, 2018.

Kuzniar, Alice A. *The Queer German Cinema*. Stanford: Stanford University Press, 2000.

Lefebrve, Henri. *The Production of Space*, translated by Donald Nicholson-Smith. Malden, MA: Blackwell, 2012.

Lerner, Paul. *Hysterical Men: War, Psychiatry, and the Politics of Trauma in Germany, 1890–1930*. Ithaca, NY: Cornell University Press, 2003.

Leßmann-Faust, Peter. "'Blood May': The Case of Berlin 1929." In *Patterns of Provocation: Police and Public Disorder*, edited by Richard Bessel and Clive Emsley, 11–27. New York: Berghahn, 2002.

Liang, Hsi-Huey. *The Berlin Police Force in the Weimar Republic*. Berkeley: University of California Press, 1970.

Lobato, Ramon. *Netflix Nations: The Geography of Digital Distribution*. New York: New York University Press, 2019.

Loberg, Molly. *The Struggle for the Streets of Berlin: Politics, Consumption, and Urban Space 1914–1945*. Cambridge: Cambridge University Press, 2018.

Longerich, Peter. *Goebbels: A Biography*, translated by Alan Bance, Jeremy Noakes, and Lesley Sharpe. New York: Random House, 2015.

Lüdtke, Alf, editor. *"Mein Arbeitstag, mein Wochenende": Arbeiterinnen berichten von ihrem Alltag 1928*. Hamburg: Ergebnisse, 1991.

MacDonald, Ian W. "Behind the Mask of the Sceenplay: The Screen Idea." In *Critical Cinema: Beyond the Theory of Practice*, edited by Clive Myer, 111–40. London: Wallflower, 2011.

Mann, Klaus. "Erinnerungen an Anita Berber." *Die Bühne* 7, no. 275 (1930): 43–4.

Mannes, Jeff. "Babylon Berlin? Zum Mythos der wilden 20er Jahre." *Siegesäule.de*, August 28, 2019.

Mantel, Uwe. "Wackelt 'Babylon Berlin'? Alle Partner wiegeln ab." *DWDL.de*, October 20, 2015. https://www.dwdl.de/nachrichten/53133/wackelt_babylon_berlin_alle_partner_wiegeln_ab/.

Mantel, Uwe. "'Babylon Berlin' kehrt auf 'Tatort'-Sendeplatz zurück: Am 11. Oktober geht's los." *DWDL.de*, June 24, 2020. https://www.dwdl.de/nachrichten/78206/babylon_berlin_kehrt_auf_tatortsendeplatz_zurueck/.

Marhoefer, Laurie. *Sex and the Weimar Republic: German Homosexual Emancipation and the Rise of the Nazis*. Toronto: University of Toronto Press, 2015.

Marka, Saskia. "Babylon Berlin (2018)." https://www.artofthetitle.com/title/babylon-berlin/.

Massey, Doreen. "A Global Sense of Place." *Marxism Today* (June 1991): 24–9.

McBride, Patrizia. "Learning to See in Irmgard Keun's *Das kunstseidene Mädchen*." *German Quarterly* 84, no. 2 (Spring 2011): 220–38.

McBride, Patrizia. *The Chatter of the Visible: Montage and Narrative in Weimar Germany*. Ann Arbor: University of Michigan Press, 2016.

McGlone, Jackie. "Babylon Berlin: Kutscher's World of Crime and Sex in the Shadow of Nazism." *The Herald*, October 28, 2017. https://www.heraldscotland.com/life_style/arts_ents/15625762.babylon-berlin-kutschers-world-crime-sex-shadow-nazism/.

Mergel, Thomas. "Propaganda in der Kultur des Schauens: Visuelle Politik in der Weimarer Republik." In *Ordnungen in der Krise: Zur politischen Kulturgeschichte Deutschlands 1900–1933*, edited by Wolfgang Hardtwig, 531–60. Munich: Oldenbourg, 2014.

Merten-Eicher, Riccarda. *Kostümbildner in Film, Fernsehen und Theater*. Leipzig: Henschel, 2012.

"Metropolitan Backlot." Studio Babelsberg. https://www.metropolitanbacklot.com/en/360-virtual-tour/.

Mittell, Jason. *Complex TV: The Poetics of Contemporary Television Storytelling*. New York: New York University Press, 2015.

Moschovi, Alexandra, Carol McKay, and Arabella Plouviez. Introduction to *The Versatile Image: Photography, Digital Technologies and the Internet*, edited by Moschovi, McKay and Plouviez, 11–32. Belgium: Leuven University Press, 2013.

Mosse, George L. *Nationalism and Sexuality: Middle Class Morality and Sexual Norms in Modern Europe*. Madison, WI: University of Wisconsin Press, 1985.

Mosse, George L. *The Image of Man*. New York & Oxford: Oxford University Press, 2010.

Mrozek, Bodo. "Vom Ätherkrieg zur Popperschlacht: Die Popscape West-Berlin als Produkt der urbanen und geopolitischen Konfliktgeschichte." *Zeithistorische Forschung/Studies in Contemporary History* 11 (2014): 288–99.

Müller, Wolfgang. *Subkultur Westberlin, 1979–1989*. Hamburg: Philo Fine Arts, 2020.

Müller, Wolfgang. "Tabea Blumenschein ist tot." *Tip-Berlin*, March 3, 2020. https://www.tip-berlin.de/kultur/ausstellungen/abschied-von-tabea-blumenschein-wolfgang-mueller/.

Mund, Heike. "'Babylon Berlin': The Most Expensive Non-English Drama Series Ever Produced." *Deutsche Welle*, October 16, 2017. https://www.dw.com/en/babylon-berlin-the-most-expensive-non-english-drama-series-ever-produced/a-40965401.

Musser, Charles and Robert Sklar. "Introduction." In *Resisting Images: Essays on Cinema and History*, edited by Sklar and Musser, 3–11. Philadelphia: Temple University Press, 1990.

Nicholson, Esme. "Germany's *Babylon Berlin* Crime Series Is Like *Cabaret* on Cocaine." *NPR All Things Considered*, January 30, 2018.

Niemeier, Timo. "'Babylon Berlin' bricht in der ARD-Mediathek Rekorde." *DWDL.de*, October 10, 2018. https://www.dwdl.de/zahlenzentrale/69174/babylon_berlin_bricht_in_der_ardmediathek_rekorde/?utm_source=&utm_medium=&utm_campaign=&utm_term.

Niemeier, Timo. "'Babylon Berlin' endet einstellig, ZDF bei Jüngeren stark: Die ARD ist trotzdem zufrieden." *DWDL.de*, October 23, 2020. https://www.dwdl.de/zahlenzentrale/79944/babylon_berlin_endet_einstellig_zdf_bei_juengeren_stark/?utm_source=&utm_medium=&utm_campaign=&utm_term.

Nolte, Barbara. "Das Leben nach dem Nachtleben." *Der Tagesspiegel*. June 9, 2014.

Nye, Sean. "Review: *Run Lola Run* and *Berlin Calling*." *Dancecult: Journal of Electronic Dance Music Culture* 1, no. 2 (2010): 121–5.

Olterman, Philip. "Sex, Seafood and 25,000 Coffees a Day: The Wild 1920s Superclub That Inspired *Babylon Berlin*." *The Guardian*, November 24, 2017. https://www.theguardian.com/world/2017/nov/24/babylon-berlin-real-1920s-superclub-behind-weimar-era-thriller.

Opie, David. "Why Netflix Is Leading the Way When It Comes to LGBTQ+ Representation on TV." *Digitalspy.com*, April 18, 2019. https://www.digitalspy.com/tv/ustv/a27194507/netflix-LGBTQ+-shows/.

Osten, Philipp. *Die Modellanstalt: Über den Aufbau einer "modernen Krüppelfürsorge" 1905–1933*. Frankfurt: Mabuse Verlag, 2004.

Paparella, Emanuel. "Weimar America: Germany 1933, United States 2016." *Modern Diplomacy*, November 15, 2016.

Patka, Marcus G. *Egon Erwin Kisch: Stationen im Leben eines streitbaren Autors*. Vienna: Böhlau, 1997.

Peña, Simón. "The Daredevil Reporter (Der Teufelsreporter) (1929): Billy/Billie Wilder." *Bright Lights Film Journal*, 2020.

Perry, Kevin EG. "'The Perfect Marriage': Why Iggy Pop and David Bowie's Berlin Years Inspired a New Generation of Punks." *NME*, May 26, 2020. https://www.nme.com/features/iggy-pop-david-bowie-berlin-the-idiot-lust-for-life-reissue-2675970.

Pertout, Andrian. "Johnny Klimek: Run Lola Run." *Mixdown Monthly* 70 (2000). https://www.pertout.com/Klimek.htm

Phelan, James. *Experiencing Fiction: Judgments, Progressions, and the Rhetorical Theory of Narrative*. Columbus, OH: Ohio State University Press, 2007.

Pugh, Emily. *Architecture, Politics, and Identity in Divided Berlin*. Pittsburgh: University of Pittsburgh Press, 2014.

Reagle, Joseph. *Good Faith Collaboration: The Culture of Wikipedia*. Cambridge, MA: MIT Press, 2010.

Rebhandl, Bert. "Im Rausch, vor dem Untergang." *Frankfurter Allgemeine Zeitung*, September 30, 2018. https://www.faz.net/premiumContent?contentId=1.5811726.

Redvall, Eva Novrup. *Writing and Producing Television Drama in Denmark: From The Kingdom to The Killing*. Basingstoke: Palgrave Macmillan, 2013.

Reeder, Mark. *B-Book: Lust & Sound in West Berlin, 1979–1989*. Hamburg: edel, 2015.

Reeder, Mark. "Lust & Sound in West-Berlin." 2015. https://www.steinberg.net/de/community/storys/2015/mark_reeder.html.

Reichmann, Hans-Peter and Isabelle Bastian, editors. *Filmstoffe! Kostüme Barbara Baum*. Frankfurt a. M.: Deutsches Filmmuseum, 2018.

Renner, Kai-Hinrich. "Regisseur-Trio: Das haben wir bei 'Babylon Berlin' gedacht." *Berliner Morgenpost*, October 13, 2017.

Requate, Jörg. *Journalismus als Beruf: Entstehung und Entwicklung des Journalistenberufs im 19. Jahrhundert. Deutschland im internationalen Vergleich*. Göttingen: Vandenhoek & Ruprecht, 1995.

Retallack, James. "From Pariah to Professional? The Journalist in German Society and Politics, from the Late Enlightenment to the Rise of Hitler." *German Studies Review* 16, no. 2 (1993): 175–223.

Reynolds, Simon. *Shock and Awe: Glam Rock and Its Legacy, from the Seventies to the Twenty-First Century*. London: faber & faber, 2016.

Rodek, Hanns-Georg. "So gut sind die zwölf neuen Folgen von *Babylon Berlin*." *Die Welt*, January 23, 2020.

Roh, Franz. *Foto-Auge*. Stuttgart: Akademischer Verlag, 1929.

Ross, Corey. "Cinema, Radio, and 'Mass Culture' in the Weimar Republic: Between Shared Experience and Social Division." In *Weimar Culture Revisited*, edited by John Alexander Williams, 23–48. New York: Palgrave Macmillan, 2011.

Ross, Corey. *Media and the Making of Modern Germany: Mass Communications, Society, and Politics from the Empire to the Third Reich*. Oxford: Oxford University Press, 2008.

Roxborough, Scott. "How the 'Babylon Berlin' Team Broke the Rules to Make the World's Biggest Foreign-Language Series." *Hollywood Reporter*, December 26, 2018. https://www.hollywoodreporter.com/news/general-news/how-babylon-berlin-team-broke-all-rules-make-worlds-biggest-foreign-language-series-1171013/.

Sagatz, Kurt. "ARD verteidigt Kooperation mit Sky bei „Babylon Berlin"." *Der Tagesspiegel*, November 17, 2017. https://www.tagesspiegel.de/gesellschaft/medien/junge-zuschauer-im-blick-ard-verteidigt-kooperation-mit-sky-bei-babylon-berlin/20600122.html.

Samper Vendrell, Javier. *The Seduction of Youth: Print Culture and Homosexual Rights in the Weimar Republic*. Toronto: University of Toronto Press, 2020.

Sandel, Adam. "25 Gay Anthems We Need More Than Ever." *The Advocate*, June 24, 2016.

Sander, August. *Antlitz der Zeit*. Munich: Kurt Wolff Verlag, 1929.

Sanderson, Sertan. "Netflix Cancels Turkey Series in Row over Gay Character." *Deutsche Welle*. July 24, 2020. https://www.dw.com/en/netflix-cancels-turkey-series-in-row-over-gay-character/a-54307855.

Sappol, Michael. *Body Modern: Fritz Kahn, Scientific Illustration, and the Homuncular Subject*. Minneapolis: University of Minnesota Press, 2017.

Schalenberg, Marc. "Wall City Visions: Representations of Europe in the Context of Berlin Kulturstadt Europas 1988." In *The Cultural Politics of Europe: European Capitals of Culture and European Union since the 1980s*, edited by Kiran Klaus Patel, 117–21. London: Routledge, 2012.

Schäfer, Ulrich. *Schloss Drachenburg in the Siebengebirge*, translated by Clara Eckert-Framm and Catherine Framm. Berlin & Munich: DKV, 2013.

Schivelbusch, Wolfgang. *The Culture of Defeat: On National Trauma, Mourning, and Recovery*, translated by Jefferson Chase. New York: Picador, 2003.

Schofield, John. "Characterizing the Cold War: Music and Memories of Berlin (1960–1989)." In *Sounds and the City: Popular Music, Place, and Globalization*,

edited by Brett Lashua, Karl Spracklen, and Stephen Wagg, 273–84. New York: Palgrave Macmillan, 2014.

Schüler-Springorum, Stefanie. "Hans Litten 1903–2003: The Public Use of a Biography." *Leo Baeck Yearbook* 48, no. 1 (2003): 205–19.

Schuetze, Christopher F. "The Writer Who Made Weimar the Talk of Germany." *New York Times*. December 1, 2018.

Sederberg, Kathryn. "Teaching *Babylon Berlin*: Language and Culture through a Hit TV Series." *Die Unterrichtspraxis/Teaching German* 54, no. 2 (Fall 2021): 200–16.

Sedgwick, Eve Kosofsky. *Epistemology of the Closet*. Berkeley: University of California Press, 2008.

Sgubin, Raffaella. "Women and Work during the First World War: Aspects of Clothing." In *Wardrobes in Wartime 1914–1918*, edited by Adelheid Rasche, 38–47. Leipzig: Seemann, 2014.

Shaw, Caitlin. "To the Truth, to the Light: Genericity and Historicity in *Babylon Berlin*." *Journal of Popular Film and Television* 50, no. 1 (2022): 24–39.

Silverman, Lisa. *Becoming Austrians: Jews and Culture between the World Wars*. Oxford: Oxford University Press, 2012.

Silverman, Lisa. *The Postwar Antisemite: Culture and Complicity after the Holocaust*. Oxford: Oxford University Press, forthcoming.

Simmons, Jerrold. "A Tale of Two Censors: The British Board of Film Censors, the Production Code Administration, and the Sad Fate of *I am a Camera*." *North Dakota Quarterly* 61, no. 3 (1993): 130–47.

Simon, Sunka. "Weimar Project(ion)s in Post-Unification Cinema." In *Berlin—The Symphony Continues: Orchestrating Architectural, Social and Artistic Change in Germany's New Capital*, edited by Carol-Anne Costabile-Heming, Rachel Halverson, and Kristie Foell, 301–20. Berlin: De Gruyter, 2004.

Slater, Ken. "Egon Kisch: A Biographical Outline." *Labour History*, no. 36 (1979): 94–103.

Smith, Jill Suzanne. *Berlin Coquette: Prostitution and the New German Woman, 1890–1933*. Ithaca, NY: Cornell University Press, 2013.

Smith, Jill Suzanne. "Lotte at the Movies: Gendered Spectatorship and German Histories of Violence in *Babylon Berlin*." *Germanic Review* 97 (2022): 254–71.

Sobolla, Bernd. "Ein Interview mit Tom Tykwer." *Tip-Berlin*, December 9, 2010. https://www.tip-berlin.de/kino-stream/ein-interview-mit-tom-tykwer-1/.

Sobolla, Bernd. "Tom Tykwer—Die frühen Jahre: Vom Filmvorführer zum Regisseur." https://1000interviews.com/tom-tykwer-die-fruehen-jahre-vom-filmvorfuehrer-zum-regisseur/.

Soltau, Noah. "'Zu Asche, zu Staub': Netflix Acquisitions and the Aesthetics and Politics of Cultural Unrest in *Babylon Berlin*." *The Journal of Popular Culture* 54, no. 4 (2021): 728–49.

St. James, Emily. "Cop Shows Won't Just Disappear. How Can We Reinvent Them?" *Vox*, June 11, 2020. https://www.vox.com/culture/2020/6/11/21284719/cop-shows-canceled-the-wire-babylon-berlin.

Sterne, Jonathan. *The Audible Past: Cultural Origins of Sound Production*. Durham, NC: Duke University Press, 2009.

Stöber, Rudolf. *Deutsche Pressegeschichte. Einführung, Systematik, Glossar*. Constance: UVK, 2000.

Street, Sarah. *Costume and Cinema: Dress Codes in Popular Film*. London: Wallflower, 2001.

Sutton, Katie. *Sex between Body and Mind: Psychoanalysis and Sexology in the German-Speaking World, 1890s–1930s*. Ann Arbor: University of Michigan Press, 2019.

Sutton, Katie. *The Masculine Woman in Weimar Germany*. New York: Berghahn, 2011.

Swett, Pamela E. *Neighbours and Enemies: The Culture of Radicalism in Berlin, 1929–1933*. Cambridge: Cambridge University Press, 2004.

Sykora, Katharina. "Die Neue Frau: Ein Alltagsmythos der zwanziger Jahre." In *Die Neue Frau: Herausforderung für die Bildmedien der Zwanziger Jahre*, edited by Katharina Sykora et al., 9–24. Marburg: Jonas, 1993.

Tavakoli, Mina. "Almost Anarchy: The Style Council and the Smooth Sounds of Sophisti-pop." *The Washington Post*, November 20, 2020.

Tempo. "Eine neue Zeitung." September 11, 1928.

Thompson, Robert J. *Television's Second Golden Age: From Hill Street Blues to ER*. New York: Continuum, 1996.

Till, Karen E. *The New Berlin: Memory, Politics, Place*. Minneapolis: University of Minnesota Press, 2005.

Tortora, Phyllis G. and Keith Eubank, editors. *Survey of Historic Costume*. London: Bloomsbury, 2006.

Townsend, Megan. *Where Are We on TV Now 2020–2021*. Los Angeles: GLAAD Media Institute, 2020.

Townsend, Megan, and Raina Deerwater. *Where Are We on TV Now 2019–2020*. Los Angeles: GLAAD Media Institute, 2019.

Tres, Richard. *The Man without a Party: The Trials of Carl von Ossietzky*. New York: Beacon, 2019.

Tumarkin, Maria. *Traumascapes: The Power and Fate of Places Transformed by Tragedy*. Melbourne: Melbourne University Publishing, 2005.

Turner, Graeme. "Netflix and the Reconfiguration of the Australian Television Market." *Media Industries Journal* 5, no. 2 (2018): 129–42.

TV Tropes. https://tvtropes.org/.

Tykwer, Tom. "He Who Lives in a Human Skin." *Berlin Alexanderplatz*. Criterion DVD reissue, 2007. Translation of "Das Kino ist mehr als eine Geschichte." *Frankfurter Allgemeine Zeitung*, February 8, 2007.

Tykwer, Tom. "How Babylon Berlin turned 1920s Germany into a Wild, Historical Fantasy Fiction World." Interview by Lars Weisbrod. *New York Magazine: The Vulture*, February 12, 2018.

Tykwer, Tom, et al. "Buch und Regie." https://reportage.daserste.de/babylon-berlin#177075.

"Video Teaser 2: Berlin Alexanderplatz." *Babylon-Berlin.com*. In "Behind-The-Scenes: Virtual Set Visits," June 2016. https://www.babylon-berlin.com/en/behind-the-scenes/virtual-set-visit/.

Villarejo, Amy. *Ethereal Queer: Television, Historicity, Desire*. Durham, NC: Duke University Press, 2014.

Villarejo, Amy. "Ethereal Queer: Notes on Method." In *Queer TV: Theories, Histories, Politics*, edited by Glyn Davis and Gary Needham, 48–62. New York: Routledge, 2009.

"Voll und Warm in the Dark." Archive of Our Own, August 6, 2019. https://archiveofourown.org/works/20132689.

Waggoner, Erin B. "Bury Your Gays and Social Media Fan Response: Television, LGBTQ Representation, and Communitarian Ethics." *Journal of Homosexuality* 65, no. 13 (2018): 1877–91.

Walk, Cynthia. "Romeo with Sidelocks: Jewish-Gentile Romance in E. A. Dupont's *Das alte Gesetz* (1923) and Other Early Weimar Assimilation Films." In *The Many Faces of Weimar Cinema*, edited by Christian Rogowski, 84–101. Rochester, NY: Camden House, 2010.

Walker, Ian. *Zoo Station: Adventures in East and West Berlin*. New York: Atlantic Monthly Press, 1988.

Wallach, Kerry. "Digital German-Jewish Futures: Experiential Learning, Activism, and Entertainment." In *The Future of the German-Jewish Past: Memory and the Question of Antisemitism*, edited by Gideon Reuveni and Diana Franklin, 239–51. West Lafayette, IN: Purdue University Press, 2021.

Wallach, Kerry. *Passing Illusions: Jewish Visibility in Weimar Germany*. Ann Arbor: University of Michigan Press, 2017.

Weill, Kurt. "Radio and the Restructuring of Musical Life." In *Writings of German Composers*, edited by Jost Hermand and James Steakley, 262–5. New York: Continuum, 1984.

Weisbrod, Lars. Interview with Volker Kutscher and Kat Menschik. "Bis die Augen schmerzen." *Die Zeit*, November 2, 2017.

Weiss, Bernhard. "Mehr Selbstbewusstsein." *CV Zeitung*, June 3, 1931.

Weiss, Bernhard. *Polizei und Politik*. Berlin: Gersbach & Sohn, 1928.

Weitz, Eric D. *Weimar Germany: Promise and Tragedy*. Princeton: Princeton University Press, 2007.

Whisnant, Clayton. *Male Homosexuality in West Germany: Between Persecution and Liberation, 1945–1969*. New York: Palgrave, 2012.

Whitford, Leslie. "TV Tropes." *Reference Reviews* 29, no. 1 (2015): 35–6.

Wilkins, Kim. "*Babylon Berlin*'s Bifocal Gaze." *Screen* 62, no. 2 (Summer 2021): 135–55.

Windeler, Arnold, Anja Lutz, and Carsten Wirth. "Netzwerksteuerung durch Selektion: Die Produktion von Fernsehserien in Projektnetzwerken." *montage AV* 10, no. 1 (2001): 91–124.

Winkler, Thomas. "Plötzlich wollen alle auf die Gästeliste." *Die Tageszeitung* [TAZ], February 8, 2020.

Wolter, Gundula. *Hosen, weiblich: Kulturgeschichte der Frauenhose*. Marburg: Jonas, 1994.

Zadoff, Miriam. *Werner Scholem: A German Life*, translated by Dona Geyer. Philadelphia: University of Pennsylvania Press, 2018.

Zander, Pete. "Henk Handloegten: Meine Jugend als Mauergänger." *Berliner Morgenpost*, November 3, 2019.

Zarges, Torsten. "2.200 Stunden Material—und nun auch noch ein Nachdreh: TV-Mammutprojekt 'Babylon Berlin'." *DWDL.de*, February 8, 2017. https://www.dwdl.de/nachrichten/60035/2200_stunden_material__und_nun_auch_noch_ein_nachdreh/.

Zarges, Torsten. "Endlich mehr Output für High-End made in Germany: Serien-Preview 2017." *DWDL.de*, January 10, 2017. https://www.dwdl.de/magazin/59485/endlich_mehr_output_fuer_highend_made_in_germany/.

Zimmermann, Reinhard. "Carl Blechen und Caspar David Friedrich: Religiöse Aspekte im Werk Blechens." In *Die neue Wirklichkeit der Bilder: Carl Blechen im Spannungsfeld der Forschung*, edited by Beate Schneider and Reinhard Wegner, 152–70. Berlin: Lukas, 2008.

"Zuschauerrekord." *Frankfurter Allgemeine Zeitung*, October 17, 2017.

Index